/D\

THE ART OF CALIFORNIA

SELECTED WORKS FROM THE COLLECTION OF THE OAKLAND MUSEUM

Edited and with an introduction by Christina Orr-Cahall

The Oakland Museum Art Department
and Chronicle Books

Front cover: Larry Bell, *Untitled*, 1967
Back cover: Fletcher Benton, *M*, 1974

Library of Congress Catalogue Number: 83-62611
ISBN: 0-87701-347-0
CHRONICLE BOOKS
870 Market Street, San Francisco, CA 94102

This project was supported by grants from the
L. J. Skaggs and Mary C. Skaggs Foundation, the
Women's Board of the Oakland Museum Associa-
tion, and by the National Endowment for the Arts,
Washington, D.C., a Federal agency.

Designed by Gordon Chun
Printed in Japan through Toppan Printing Co.
(America) Inc., San Francisco
Typography by Terry Robinson & Co., Inc.
Photography by M. Lee Fatherree, Nikolay Zurek,
Eddie Dyba, and Joe Samberg

CONTENTS

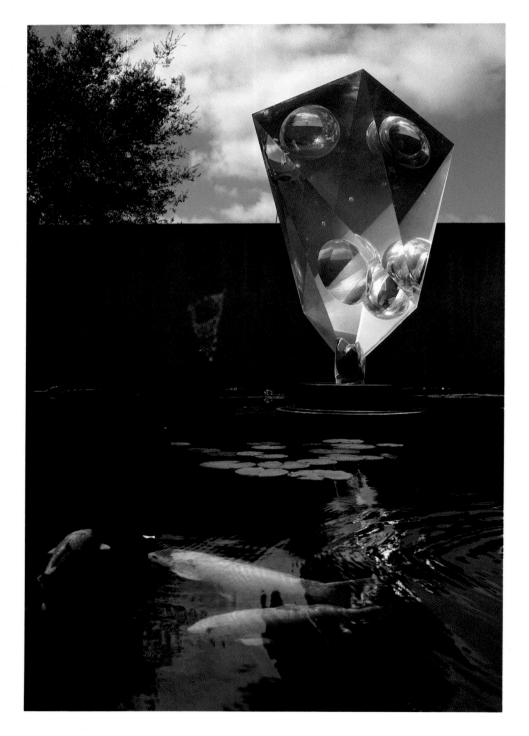

Bruce Beasley
Tragamon, 1972 (72.26)
Lucite
7 × 4 × 4 ft. (213.36 × 121.92 × 121.92 cm.)
Gift of Dr. and Mrs. Frederick Novy

One of the less glamorous aspects of museum work is the documentation of the permanent collections, the arduous research and analysis which go into the complete understanding of works of art. Although curators collect under long-term goals and guidelines, it is often difficult for them to put into succinct terms their understanding of the strengths and lacunae of the collections for which they are responsible. It is, in my opinion, a tremendous advantage to them to put this material into writing, and it is clearly of great benefit to the public at large to have a printed overview of a museum's collection.

The Art of California: Selected Works From The Collection of The Oakland Museum is our effort to provide understanding and a view of the contents of the Art Department's permanent collection. With over 20,000 objects in our hands, it was obviously impossible to do a *catalogue raisonné*, and because so little is known nationally about the art of California, it seemed essential to supply the reader with a certain amount of in-depth information.

As might be expected, the selection of artists and works to be included in this book was a difficult one. The process involved active interchange coupled with consistent and substantial preliminary research on the artists under consideration. Each curator was asked to recommend objects from his or her area of collecting for possible inclusion. All the curators then met over a period of several weeks to discuss the proposed objects and to try to strike the necessary balance. Interestingly enough, there was little dissension, although all acknowledged that it was difficult to limit our selection to 150 objects. We knew that significant artists and works would have to be left out. What is presented here can be only a sampling of our collection. We tried to choose outstanding works and historically important pieces, and to include objects in a wide range of media with attention to geography and chronology. We were also necessarily constrained to limit our choices to objects that photographed well.

The organization of the material in this book is intended to provide both the interested and the scholarly reader with an accessible overview of the art of California. The introductory essay, which provides a brief history of the Art Department and its collection, is followed by five essays by the curators on specific collecting areas. A section devoted to 150 individual California artists follows the essays. For each artist there is biographic information, a reproduction of a work by that artist from the Oakland Museum's collection, brief descriptive information concerning the piece or the artist, bibliographic references, and an indication of the extent of the museum's holdings of the artist's work. Biographical entries for artists whose works are illustrated elsewhere in the book appear at the end of this section. An appendix listing artists represented in the collection, followed by a section on further references and a bibliography on California art, including art publications of The Oakland Museum, completes the book.

Preparing this book for publication has provided many welcome, and some unforeseen, benefits for those of us at the museum. Photographs of principal objects in our collection had been non-existent; we now have high-quality photographs that we can make available to writers, researchers, and other museums. We also have a complete set of slides which will be used in docent training and by the Speakers Bureau, and which will be on sale to the general public. The core selection of 150 objects also served as the pilot for our new art registration computer project, which is now being expanded to cover the full collection. We have been able to inventory all those objects in our hands, to assess our storage facilities, and to correct registration errors of the last sixty years concerning measurements, signature, location, and similar details. Perhaps the most important result of the work that went into preparing this book is that the curators are now in a better position to analyze and develop long-term plans for the art collection.

If a different group of curators had prepared this book, some different selections would have been made. Doubtless, someone's favorite artist has been neglected, and for this, as for all errors found within, the authors can only express their regrets. We trust that you will recognize that in order to present this first publication on the permanent collection, choices had to be made. We hope we have provided something of benefit to you all.

Christina Orr-Cahall
Oakland May, 1984

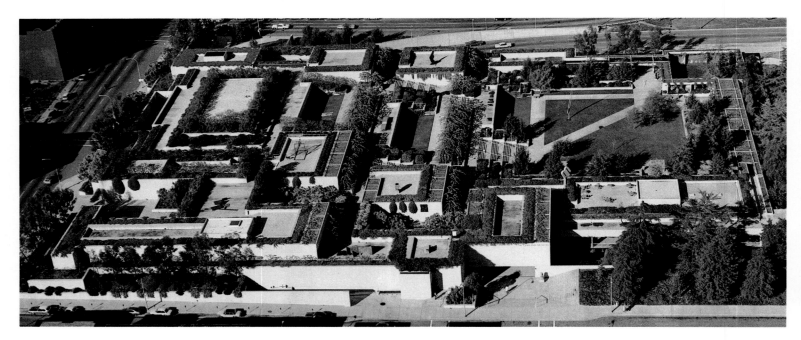

Aerial view of the 7.7-acre site of
The Oakland Museum
Kevin Roche and John Dinkeloo Associates, architects
Daniel Kiley, landscape architect, with
Geraldine Knight Scott

Our funding sources for this publication are most important to us. We wish to acknowledge the National Endowment for the Arts, a federal funding agency, the Women's Board of the Oakland Museum Association, and the L. J. Skaggs and Mary C. Skaggs Foundation for their generous support and commitment to this project.

This book represents the labor of many dedicated people. A wide range of collectors and scholars have helped us with information. Most notably we should cite Joseph A. Baird, Jr., Walter Nelson-Rees, and the late Warren Howell and Paul S. Taylor. Many archivists and librarians have been of assistance; Eugenie Candau at the library of the San Francisco Museum of Modern Art especially comes to mind, as do the many librarians at the Oakland Public Library.

Paul C. Mills, the former curator of the art museum and subsequently of this department, provided much valuable historic information, and his personal perspective on both the growth of the collection and the choice of the California theme. The Art Research Committee of the Art Guild organized our extensive research files, aided by the members of the Library Committee, who kindly put everything back in its proper place. Marjorie Arkelian, who previously served on the staff as a museum researcher, rejoined us for six months to lend her valuable knowledge and research skills.

The behind-the-scenes contributors on our staff deserve recognition. Gary Lopez, Victor Oliver, Don Grant, and Steve Pon unframed all the works to be photographed, reinstalled galleries in remarkably short amounts of time, and constantly moved works in and out of storage. The registrars, Arthur Monroe and Christine Doran, were responsible for much of the coordination of photography, the storage inventory project, and for corrections to registration cards. The computer project, which has been coordinated by Sheila Huth with consultation from Mark Hughes, has made this undertaking less painful. Mary Canham worked diligently and carefully on data entry, while Sheila Huth trained the staff to use the computer for object information, searches, and editing. Photography of most of the works was undertaken by M. Lee Fatherree and Nikolay Zurek, who both worked to get the highest quality image possible. Research for the artists' biographic entries as well as the section on further references was conducted by Barbara Bowman, Ann Lee, and Marjorie Arkelian. Sara Beckner was responsible for biographic information on the photographers included in this book. All were most diligent, careful, and persistent in unearthing much new information.

The decision to include brief comments concerning each work or its artist, a decision seconded by our interpretive specialist, Barbara Henry, was made with the realization that it would be difficult to make a succinct yet truly informative remark; just how challenging we now know. We hope that our public finds, as we do, that the short comments are an important aspect of the book. The following people participated in their writing and they are to be greatly commended: Marjorie Arkelian, Barbara Bowman, Donna Graves, Ann Lee, and all of the curators, including Paul Tomidy.

The curators also brought great depth of knowledge, creativity, and dedication to the preparation of their essays. Hazel Bray, who recently retired as the museum's associate curator of crafts, not only prepared her insightful essay but also worked well beyond her retirement date to prepare comments, assist in the compilation of the appendix, and generally to participate as needed in the production of this book. Therese Heyman, senior curator of prints and photographs, covered well a broad and difficult topic in her essay. Terry St. John, associate curator of painting, provided us with a fine essay on modern art in California, with special attention to the very important Abstract Expressionist and Bay Area Figurative movements. Harvey Jones, deputy curator of art, has given us an intelligent and articulate essay on nineteenth and early twentieth-century art in California. I benefited greatly from the comments of Paul Tomidy, curator of special projects, on my essay concerning contemporary art and from those of Phil Mumma, the museum's senior public information officer, on my introduction which covers the history of the museum.

A book, we learned, is far from complete when the writing stops. Our editor, Mary Jean Haley, was outstanding and receives plaudits from us all. We also owe a great debt of thanks to Gordon Chun, our graphic designer, and to his assistant, Alicia Hart. Gordon's vibrant book design captures the image and spirit of our young California museum. Ellen Lee, Seena Brown, Sheila Huth, and Christine Doran steadfastly typed and corrected numerous manuscript drafts. Felicity O'Meara copy edited, while Suzanne Guitar Chun has, we hope, caught our final errors. Proofing at various stages was carried out by Barbara Bowman, Ann Lee, and Christine Doran. Toppan Printing of San Francisco has been most helpful.

I feel a special gratitude to Gordon Chun, Christine Doran, Mary Jean Haley, and Harvey Jones who for many months have consistently helped and supported me on this project. I could not have persevered without their enormous dedication. A project of this size must be a team effort, and I thank all who have worked together to make this California dream a reality. There were many extra nights and weekends of work, and in recognition of all the loved ones at home who put up with our determination, I would like to thank my own, Richard and Fitz Cahall, who are now surprised if I don't come home with manuscripts to edit.

C.O.-C.

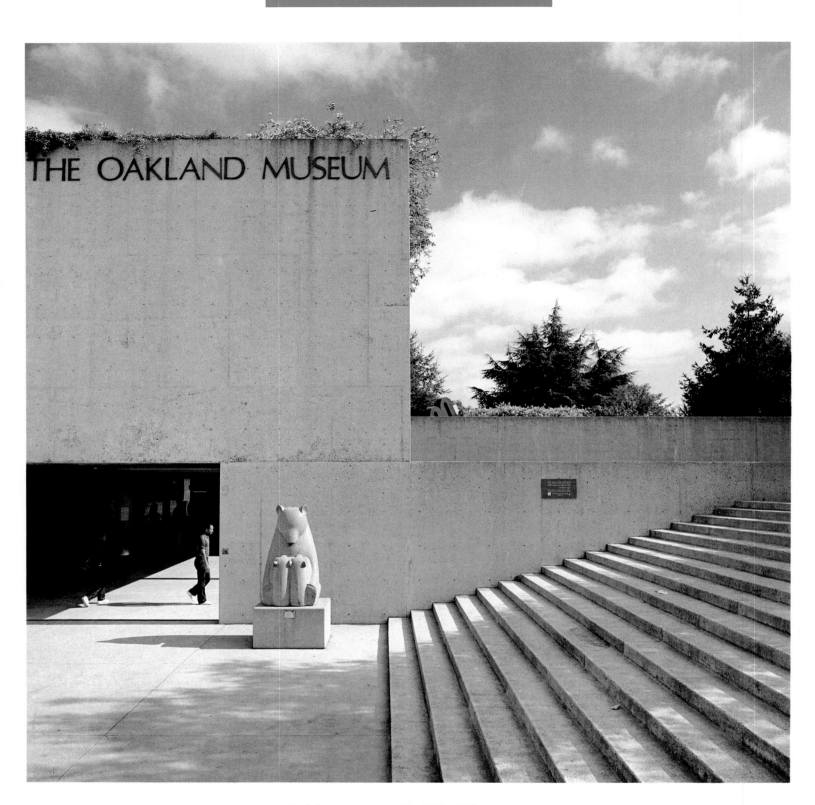

Tenth Street entrance to The Oakland Museum
Beniamino Bufano
Bear Nursing Cubs, n.d. (69.68)
Polished granite on concrete base
62 × 32 × 37 in. (157.5 × 81.3 × 93.9 cm.)
Given in memory of Fenner Fuller by his family and
friends and the Oakland Museum Association

The Oakland Art Gallery, now the Art Department of The Oakland Museum, was founded on February 1, 1916, under the sponsorship of the newly formed Oakland Art Association with Dr. William S. Porter as its president. Interest in art had been spurred by the 1915 Panama-Pacific International Exposition (PPIE) and Oakland had gained sufficient population and sophistication to support its own art museum. Indeed, the Oakland Art Gallery was the first public institution devoted solely to the fine arts established in the Bay Area.

From its inception the museum was seen as both progressive and concerned, although not uniquely, with the arts of California. Due to the critical success of California artists whose work appeared in the PPIE as part of the American exhibition, a "favorite son" attitude began to develop among artists, collectors, and the concerned public. They wished to see the art of California exhibited along with European and other American painting and sculpture.

The Art Gallery's first curators were a key factor in its success. Robert Harshe, who had been the Assistant Director of Fine Arts at the PPIE, was appointed the first director in 1916, although he was soon succeeded by Worth Ryder, who served in 1917 and 1918. Ryder, a painter and teacher who was later instrumental in the development of the Art Department at the University of California at Berkeley, began an active program of single-artist exhibitions. He also managed to borrow several important private collections, including that of Dr. Porter, for display in the permanent galleries at the Civic Auditorium, which housed the Art Gallery.

The outbreak of World War I forced the City of Oakland to stop its appropriations for the gallery, and the fledgling museum would have closed if Dr. Porter had not personally come to its financial

by Christina Orr-Cahall
Chief Curator of Art

rescue. In 1919, the city accepted Porter's donation of his private art collection with the guarantee that a place for its exhibition would be provided. With that guarantee, the City of Oakland began its long-term commitment to the support of a municipal museum and art collection.

After Finn Frolich, a sculptor, briefly replaced Ryder, William H. Clapp began his long and important tenure (1918-1949) as curator. Clapp, one of the Society of Six painters, was an avant-garde force in Bay Area art. He inaugurated a more active program of presenting European and national exhibitions while continuing to exhibit the work of Bay Area artists. Clapp's diplomatic skills contributed to his success. In the gallery's annual national competition Clapp established three categories—conservative, intermediate, and radical—to accommodate all without compromising the exhibition. Among the exhibitions he organized was the first West Coast presentation in 1927 of the Blue Four—Klee, Kandinsky, Feininger, and Jawlensky. Under Clapp's direction the Art Gallery also adopted its policy of attention to the work of black American artists, presenting annual exhibitions of their work in cooperation with the Harmon Foundation. Education was another significant part of Clapp's programming. Guided tours of the collections and exhibitions were offered; Clapp himself gave artists' sketch classes; and the Art League of the East Bay sponsored an active program of children's art classes

in the gallery.

Clapp's retirement in 1949 left a leadership vacuum, and the position of curator was held on an interim basis by several individuals until Paul Mills officially assumed the post in 1953. Mills, who had been an assistant curator at the Henry Gallery at the University of Washington in Seattle, brought the progressive ideas of a museum professional to the gallery. Mills saw the situation in an objective light, "After satisfying myself and the community that the moribund and embattled little gallery could be brought back to a lively existence in modern terms, I began to look for some serious avenue of accomplishment the museum could strive for."

Not wishing to compete against the heavily endowed San Francisco museums and still wanting a collection of great quality and public interest, Mills realized that it was necessary for the museum to claim its own distinctive niche. He decided that a California theme was the answer. He made the important decision to concentrate the museum's permanent collection and temporary exhibitions on the art of California. He recently commented:

The Oakland Art Gallery had grown out of the Panama-Pacific International Exposition, and it had, for almost four decades, been showing and acquiring California art through its annual competitive exhibitions. The history of art in California, with its missions, its Gold Rush illustrators, its nabob art patrons and its fine artists was exciting. . . . Further, it was plentiful, inexpensive and [there was] often a potential of a gift or loan, not an insignificant factor for a little museum with almost no acquisition funds. And what was going on among contemporary painters and craftsmen in the area was very convincing. It is hard today to understand what a variant, radical idea specializing in California art,

especially in its historic phases, was then.

The idea of concentrating on California received important local support. Dr. Peter T. Conmy who, as the head of the Oakland Public Library, was the city administrator for the museum, was a specialist in California history. Several art dealers, especially Warren Howell, R. E. Lewis, and Billy Pearson, took an interest in the project, as did the Keith Art Association, whose loan and subsequent gift of the Keith collection was of great significance to the revived institution. California artists also rallied around the museum, seeing it not only as a vehicle for the exhibition of their own art, but also as a chronicler and supporting institution for all California art. As Paul Mills observed, "If these artists believed in themselves and their work, they could not help but acknowledge that other artists who had gone before them must have too. The proof was in the quality of the work which we were able to display." From the time of Mills' tenure onward, the museum has held firm to a standard of accepting only the highest quality pieces into the collection.

Mills wanted to develop a representative survey of the work of artists especially associated with California. Ideally, the museum tries to collect only California pieces, that is, works depicting or created in California. As Mills defined the guidelines for collecting the art of California, an artist may have been born, raised, or have studied in, moved to, or worked in the state to be considered eligible for the Oakland Museum's collection. In the case of artists who worked in California for only a brief time, the museum collects pieces from that period alone. For example, our William Merritt Chase is one of a very few paintings done by that artist while he was teaching in the area in 1914. An Eastern scene by Chase would not be appropriate for our collection. These early guidelines still largely direct the Art Department's collecting policy, although in this age of fast travel and condominiums on either coast, some

distinctions are becoming increasingly difficult to make. However, many contemporary artists working in California are affected by our geography, culture, art scene, and way of life—their work is intrinsically Californian.

Today, as under Mills' direction, a good part of the museum's strength and uniqueness comes from the strong and active support of California artists. The museum works to see that this vital and exhilarating link is maintained. All of the Oakland Museum's art acquisitions are by donation, either through a direct gift of the work of art, or by contribution of monies designated for the purchase of art selected by the curator. The artists themselves have been among the most generous donors of art for the California collection.

Patrons have been another critical factor in the museum's ability to present quality art to its public. The Art Department has been blessed with an active group of individual and foundation donors. It is essential to acknowledge the Kahn Foundation, which, in the 1960s, provided funds for the acquisition of our core collection of historic California art. This excellent collection has given subsequent donors a standard to follow as we continue to build the museum's permanent collection at the same high level of quality.

The support of volunteers is another essential ingredient for any museum's success. The Oakland Museum has benefited greatly from its strong volunteer base, and it would take many pages to list the names of those who have worked tirelessly and all too often anonymously in the service of the museum. In 1954, the Oakland Museum Association was formed as a non-profit organization dedicated to advancing the causes of the municipal museums. The next year, the Association added the dynamic Women's

Board of the Oakland Museum Association to serve as its activities, fundraising, and social arm. The Women's Board has been responsible for many significant acquisitions for the permanent art collection as well as for the sponsorship of major exhibitions, publications, and projects.

The Art Guild of the Oakland Museum Association was created in 1961 to work for the improvement of the art collection by providing funds for acquisitions, sponsoring activities for Association members and the general public in conjunction with the Art Department, and undertaking special volunteer projects, including exhibition support, research, lectures, and artist awards. The Art Guild has had many marked achievements in the past twenty-five years, adding distinguished objects to the collection and sponsoring important programs and exhibitions.

The Art Docent group, another key aspect of our volunteer public service program, was formed in 1965 with an original class of 100 trainees. Now often looked to as a model by other museums because of its clear sense of purpose and long-term commitment, our docent group continues its active and progressive programming.

In 1961, municipal support once again became a major factor in the museum's ability to grow. That year, recognizing the importance of museums in the East Bay, the citizens of Oakland passed a bond issue to finance construction of a new museum intended to house and combine the separate facilities which then existed for art (Oakland Art Museum), history (Oakland Public Museum), and the natural sciences (Snow Museum). The combined institution was to be called The Oakland Museum and was to focus on California for its collections. A separate Museum Commission was established by an amendment to the city charter in 1962, and the museum was thus removed from the jurisdiction of the city's Library Commission. The position of Director of Museum Services was also established in 1961 to oversee the muse-

um. Since 1964 four men have served in this important city administrative position: James M. Brown, III (1964-1967), Dr. J. S. Holliday (1967-1969), John Peetz (1970-1981), and Julian T. Euell (1982-present).

Voters selected the 7.7-acre site near Lake Merritt, and a sub-committee of citizens, headed by Mrs. Fenner Fuller, chose the architects, Kevin Roche and John Dinkeloo of Roche, Dinkeloo and Associates (formerly Saarinen and Associates) to design the building. Ground was broken in 1967; construction was begun in 1967, and the museum opened in September, 1969. The museum's terraced gardens were designed by Dan Kiley, a noted landscape architect from Vermont, with Geraldine Knight Scott serving as the local consultant.

The building was designed to feature three permanent collection halls: one presenting the ecology of California in the form of a walk across the state through biotic zones from the ocean to the desert, the second presenting the chronological history of the state from the pre-Spanish Indian period to the present, and the third presenting a chronological survey of the art of California from the voyages of exploration to the present. Roche and Dinkeloo also included a 10,000-square-foot exhibition space, the Great Hall, which is shared by all three departments, as well as 3,000-square-foot changing exhibition spaces located adjacent to each department's permanent collections. Two theaters, a print room, and a multi-media viewing room augment our facilities, which also include a restaurant, bookstore, classroom, collectors gallery, and library. The building is regarded as one of the most significant buildings in the Bay Area and is seen as an important early example of progressive museum architecture.

In the 1970s, George Neubert served as the museum's art curator, overseeing the development of the California collection and the goals for the department. Neubert's special area of interest and expertise was contemporary art and sculpture. Through his efforts, the museum began to play a national role in the exhibition of sculpture. Neubert, along with Judge John Sutter, was responsible for the initial idea to develop a sculpture park adjacent to the Oakland Museum grounds. Estuary Park, a twenty-two-acre parcel, which runs from Lake Merritt along the estuary, past Laney College, will eventually connect with the land at the mouth of the Oakland Estuary where several pieces of the museum's sculpture collection are on outdoor exhibition. Estuary Park took the cooperation of many people and several years of work by the museum and other city staff. Artists, art dealers, and donors helped to make the project a reality. The museum staff was particularly pleased to develop and open this park in 1982 when we served as host to an international sculpture conference.

Estuary Park, fashioned after Japan's Hakone Open-Air Museum, is considered important for its presentation of sculpture by California artists and for its wide public use. Among the pieces in the park are works by Mark di Suvero, Stephen De Staebler, and Fletcher Benton, with changes and additions made on a continuing basis. Ephemeral pieces, such as a work by Lita Albuquerque, are also continually incorporated into the project. Estuary Park serves as an enhancement of the museum's on-site sculpture garden, which includes works by Peter Voulkos, Beniamino Bufano, Bruce Beasley, and John Mason.

Since 1981 I have served as chief curator of art, working closely with the staff to develop long-range goals for the growth and strengthening of the permanent collection. We have continued development of the Archives of California Art founded by Paul Mills, which is increasingly used by scholars and the public for research. So little of California art has been chronicled that the curatorial and research staff relies heavily on primary resource materials for the documentation of our permanent collection and the preparation of catalogues supporting our exhibitions. It is not unusual for us to begin with only an artist's name and one example of his or her work. As Paul Mills observed in 1969, "The years from 1954 to the present have been largely given to the rediscovery, collection, and research of the art of the Bay Area and California. It has been a remarkable rediscovery, even for many concerned with American art, [to realize] the flourishing of the arts which occurred here. . . ."

Mills was right. Since the second half of the nineteenth century, California, despite its geographic isolation from eastern American art centers, has been a region with an extremely active visual arts tradition. After fifteen years of serious, ongoing research, the museum curators can now identify critical lacunae in the historical survey. One by one the gaps are being closed by new acquisitions which have been either purchased or donated.

It is our position that historical California art to 1945 has not been studied or seen sufficiently by American art historians and the public. For example, I noted with interest in John Russell's *New York Times* review (March 27, 1984) of the Boston Museum of Fine Art's exhibition, "A New World: Masterpieces of American Painting 1760-1910," the signs of erosion in a widespread provincial attitude toward painting from the American West. In reference to the inclusion of a non-traditional work by the western painter, Frederic Remington, Russell observed that Stebbins had begun to break the stereotypical view of western painting. He continued, "This was one of many instances in which Mr. Stebbins and his colleagues had rethought the traditional image of American painting." It is time to look seriously at American art history as that of a large nation of vast distances and many cultures, and not only as an Eastern regionalist phenomenon practiced by an academically educated elite with a handful of naives thrown in for good measure. The art of Califor-

nia is not all cowboys and Indians. It is long past time to re-examine the myth of the West. As Paul Horgan observed in *Of America East and West*, "Everybody is a regionalist. Tolstoy is a regionalist—one is where one lives, where one writes." Or . . . where one paints.

The Oakland Museum Art Department has been a pioneering institution from its inception, and in its continuing emphasis on the art of California, it has maintained its unique position and importance as a resource both for the general public as well as for scholars. The museum continues to be active in the acquisition and exhibition of art in all media—painting, sculpture, drawing, prints, photography, mixed media, installation, and craft. In addition, since 1980 the Art Department has taken a particularly active role in circulating nationally

exhibitions organized by our curatorial staff. Our commitment to the collecting and exhibiting of California art remains undiminished, and the curators are also continuing their efforts to place art by California artists or art created in California within the broader context of American art.

It is important for this museum to provide documentation of its collection, to spread the vision of California and its art. The curators have each written essays discussing the strengths of their areas of the collection and giving a brief discussion of their art historical context. As might be imagined, the choice of works

to include in this publication was most difficult. Artists and their works were selected to give a solid overview of the direction of California art over the past 150 years, to provide a view of major artists who are recognized nationally, to focus on those Californians who merit more attention, to highlight major pieces within our collection. We also wanted to emphasize the pluralism of our art, to acknowledge the many cultures which have contributed significantly to the arts of California, and to lend understanding to what was Californian and to what remains Californian even in our jet age. Finally, it has been our intention to provide visual and documentary materials to curators, writers, collectors, and admirers of American art who seek a broader awareness of the role of the art of California in the history of American art.

EARLY CALIFORNIA PAINTING AND SCULPTURE

by Harvey L. Jones
Senior Curator of Art

Since the second half of the nineteenth century, California, despite its geographic isolation from European and eastern American art centers, has been remarkably active in the visual arts. Europeans came to California first to explore the wonders and riches of this new land, and they brought artists along to record their discoveries. These were followed at mid-century and later by increasing numbers of artists drawn by the gold rush and the opening of the West. By 1865, California painters were working in studios and sketching in the open air; they were painting landscapes, portraits, interiors, and still lifes. Sculptors too had begun to work in marble and bronze to produce the monuments that the growing cities required. In short, soon after western culture took firm root in California, visual artists were working in every arena.

The Oakland Museum's collection of nineteenth and early twentieth-century California painting and sculpture reflects the liveliness and breadth of the visual and plastic arts of that era to an extent unmatched by any other museum collection. As we work toward the goal of making the collection even more representative and comprehensive, the museum's curators and researchers will continue to unearth more about relatively unknown but significant artists of the time and to acquire better examples of the work of major artists of the nineteenth and early twentieth century.

While they took nothing from the native American culture, and almost nothing from the old Spanish culture which had been here before them, as the nineteenth century drew to a close, California artists had begun to display certain traits which distinguished their work from that of artists working in Europe and Eastern America. The museum's collection of nineteenth and early twentieth-century California painting and sculp-

ture shows that the development of art in California both parallels in general the art historical development in other American art centers and also manifests in particular certain perceptible qualities which are characteristically Californian.

The first quality that California gave to its newly arriving artists was a freshly seen landscape that had not been painted before. Depicting California was in truth an exploration, especially for the cartographers and artists who accompanied the foreign exploration expeditions along the Pacific Coast during the first quarter of the nineteenth century. They were called upon to sketch the prominent and interesting sites along the coastal regions and inland trails. At about mid-century the explorer-artists were succeeded by artists attached to American government geological and geographical survey parties which came to California by way of the overland approach from the east.

While the views of the topography, the inhabitants, and the wildlife of California these early artists produced remain more important as historical documents of the early years in the American West than as high artistic achievement, they are significant evidence of the humble beginnings of a long visual arts heritage in California. The work of those now obscure or anonymous artists reveals a wealth of historical detail within the limits of a rather modest artistic vocabulary that today can be appreciated for its directness of purpose and artful naiveté.

There are, however, other examples of early documentary illustration which exhibit evidence of more sophisticated European artistic influences. Louis Choris, a Russian-born artist trained in Moscow, came to California as the official artist of the Kotzebue expedition of 1815-1816. His sensitively rendered watercolor sketches of California native Americans and wildlife are the earliest paintings in the Oakland Museum's collection. Some thirty years later, in 1849, West Point graduate Alfred Sully came to California on military assignment. Sully, the son of famous portrait painter Thomas Sully, had received art training from his father. While he pursued a distinguished career as an army officer, he made many watercolor sketches of landscape and genre scenes, three of which are represented in the museum's collection. His paintings of frontier life on the California rancho of his wife's family remain his most important legacy.

Significant numbers of professionally trained painters arrived in San Francisco for the first time only after the discovery of gold in California in 1848. Although some artists joined the zealous throng of gold seekers in the mining fields of Northern California, most of the artists came with expectations of commissions for portraits of newly wealthy families and for paintings to decorate their extravagant new homes.

California's first professionally trained resident painter was William Smith Jewett, an Associate Member of the National Academy, who came west from New York in 1849 to seek his fortune. In 1850, he established studios in both San Francisco and Sacramento, and immediately received numerous portrait commissions from socially and politically prominent patrons. In his 1855 portrait of Theodore Judah, the famed builder of the first railroad in California, Jewett

employed the traditional portraiture device of attributions, in this case a landscape with a train in the background, to expand his characterization of the subject.

The emphasis on portrait painting during the first years of a resident local patronage is understandable given the circumstances of a fast-rising new aristocracy of merchants and businessmen who quickly profited from the gold bonanza. Even the growing popularity of photography, particularly among middle-class patrons, did not replace the formal protrait in oil for the social elite in California.

California's newly arrived artists not only created images of the new rich, but they also helped form the mythic dimensions of the gold rush itself. One early forty-niner artist was E. Hall Martin, a portrait painter from Cincinnati, who established himself first in San Francisco and then later in Sacramento. In 1850, only a year before his death from cholera at age 33, he painted *Mountain Jack and a Wandering Miner*. This painting, which is in the Oakland Museum's collection, is a rare example of Martin's work. It was originally one of a series of murals the artist created depicting two archetypal pioneers of the period with a wealth of accurate detail.

Two other artists who are given great credit for creating the enduring pictorial image, both myth and reality, of the California gold miner, were Charles Christian Nahl and his younger half-brother Hugo Wilhelm Arthur Nahl. Descended from a prominent family of painters and sculptors, they came to California in 1851 from Germany, where they were born and trained. The Nahl brothers set high professional standards of excellence and versatility with their portraits and anecdotal genre subjects, as well as with their illustrations for periodicals.

Ernest de Franchville Narjot, a Frenchman with sound Parisian art training, and Alburtus Del Orient Browere, a New York painter of the Hudson River School, were early arrivals who first sought their fortunes in the mining fields

and later returned to their easels to make a living. The museum collection contains works by both artists. Narjot was a successful portraitist and painter of genre subjects, and Browere excelled in both gold rush genre and landscapes of the Sierra Nevada terrain.

As the first fever of the gold rush abated in the 1860s, many more painters from the eastern seaboard states and Europe heeded the lure of California. This time the attraction was not the nuggets of gold buried in the hills west of Sacramento, it was the hills themselves. Landscape was the dominant artistic subject matter in the last half of the nineteenth century. Descriptions of the spectacular western scenery conveyed by the accounts of visitors and the documentary sketches of the geographic surveys had reached landscape painters both here and abroad. Few painters specializing in romantic landscapes could resist the pull of the widely varied and exotic scenery found in the vast wilderness areas of Western America. From the rocky shores of the Pacific Coast with its groves of giant redwood trees, to the rivers that cross the broad fertile valleys, from the heights of the great Sierra Nevada mountain range, including the fabled Yosemite, to the Mojave Desert of the south, California offered the easiest access to the greatest variety of scenery.

At the time, in painting, as in philosophy, poetry, literature, music, and religious thought, there was a preoccupation with the concept of God in nature. Landscape paintings were not merely visual descriptions of picturesque natural wonders; they were also interpreted as symbolic revelations of the supreme forces that regulate the universe. A prominent element in these paintings was the representation of sunlight. Presenting light as a symbol of spiritual force, a quiet, pervasive energy, was a salient feature of a style of Eastern American painting that

came to be known as Luminism. Landscapes enveloped in shimmering hazy light, depicting the dominance of nature over man, were manifestations of American religious and philosophical ideals.

Among the many itinerant painters who came west were Thomas Moran, Albert Bierstadt, and Martin Johnson Heade, all of whom displayed certain influences of Luminism in their work. Albert Bierstadt made extended visits to California during the 1860s and 1870s. He painted some of the state's most spectacular natural wonders, such as the Oakland Museum's *Yosemite Valley*, using lighting effects that bordered on the theatrical. His large-scale views of the West made from sketches gathered during his overland trips with government expeditions were shown as popular roadshow attractions to crowds of awestruck gallery visitors in both Europe and America.

George Brewerton came to California on military assignment. He left a rare, romantic account of a Mojave Desert scene in *Jornada del Muerto*, which is illustrated in this book. Moran and Heade made only brief visits to California in the 1870s and produced fewer paintings of California scenes than Bierstadt. The museum collection contains a relatively rare depiction of a California scene Heade painted in the 1870s. Although Thomas Moran moved to Santa Barbara, California in 1922, where he remained until his death in 1926, the museum does not yet have an important painting by this artist.

While artists coming from the East brought nineteenth-century romantic attitudes to their California landscapes, much of the landscape painting done here at that time displays characteristics particular to California. Working in a landscape which had not been interpreted by generations of preceding painters, the California artists tended to be descriptive rather than interpretive. At times, this fidelity to the particular site took on an almost photographic, picture-postcard quality.

A second characteristic had to do with scale. Whether they worked on a large or small canvas, the California

landscape painters were led by the sheer magnitude of the vistas available to them to paint scenes of grandiose scale and often theatrical intensity. It would not be until the latter part of the century when much of the state had been domesticated that the California painters would move from landscape of majestic scope to smaller and more intimate scenes where human beings were not dwarfed by mighty nature.

The taste for the large-scale, panoramic views of virgin wilderness made popular by Bierstadt extended to the works of California's two most famous resident landscape painters: Thomas Hill and William Keith. The museum collection contains major holdings of Keith's work in all media and styles and a strong representation of Hill's landscape and still-life painting. English-born Thomas Hill was trained in Paris and moved to the American West for health reasons in 1861. He later became known as the "Pioneer Artist of Yosemite." He maintained a studio there and turned out hundreds of scenes that helped to establish Yosemite as a national park and popular tourist attraction. Hill was also noted for his portraits and still lifes. William Keith, born in Scotland and trained in both Düsseldorf and Munich, was California's most popular and successful resident artist during the late nineteenth century.

During his long professional career, Keith embraced a variety of painting styles that ranged from early work that displayed meticulously detailed realism reminiscent of the Hudson River School, through broad vistas influenced by the romantic realism of the Düsseldorf style, and later, to less grandiose views in the broad painterly brushwork of the Munich school. In the 1890s Keith favored intimate scenes in a dark tonal palette that placed more emphasis on mood and painterly qualities than on descriptive realism. His later style was greatly influenced by the famous American landscapist George Inness, whose muted palette and misty paintings evoked spiritual and poetic associations with the landscape.

Inness' 1891 visit with Keith produced only a few rare paintings of California subjects, but his work continued its influence upon Keith and other California artists until well into the twentieth century. Inness' *California*, which is in the museum's collection, was a product of his 1891 visit.

Although Thomas Hill and William Keith were the dominant figures among the state's resident landscape artists, they were certainly not the only ones. Julian Rix, Raymond Dabb Yelland, Jules Tavernier, and Frederick Schafer were among those who found inspiration in somewhat less spectacular scenes than the popular "postcard" views of Yosemite and the high Sierra. These artists traveled extensively, filling sketchbooks with studies that they referred to upon return to their studios. There, they produced large finished canvases portraying scenes that were sometimes composed of fragments of various preliminary sketches.

Working on a smaller scale, Samuel Marsden Brookes was most prominent among the early California painters of still-life subjects. Brookes, an Englishman who learned painting by copying masterworks in London galleries, came to San Francisco in 1862 where he became known as a portrait painter. Later it was his still-life creations of fish and game that were most popular. Brookes' skill in perfectly rendering such details as the iridescent scales of the museum's *Steelhead Salmon* gained him a reputation as one of California's first master painters.

In the 1870s Brookes shared his San Francisco studio with another Englishman, Edwin Deakin, whose still lifes, landscapes, and picturesque scenes were also executed in a sharply delineated, realistic style. Deakin is best known for his paintings of all the California missions, which helped generate interest in their restoration. His *Chinatown Street*

Scene, which is shown elsewhere in this book, is typical of his distinctive handling of masonry on architectural subjects.

Theodore Wores also became known for his San Francisco Chinatown scenes. Wores' color, particularly in landscapes, quickly evolved from the warm brown "old master" tones of the Munich school to the lighter palette of Impressionism after an extended visit to Japan in the 1890s. His study, *A Corner of My Studio*, which is in the museum's collection, is done in the Munich style.

Henry Alexander, another painter of genre subjects, displayed a penchant for richly detailed realism. Alexander was a prolific artist, but relatively few of his works escaped the disastrous fire in the San Francisco warehouse where most of his paintings were stored at the time of the 1906 earthquake. Many of the surviving works are interior scenes. Alexander's *Chinese Tea Room* offers a finely detailed and very rare glimpse behind Chinatown facades of the 1890s. His paintings typically possess an enigmatic quality that makes them fascinating beyond their illustrative features.

The most well-known women artists in California before the turn of the century were Mary Curtis Richardson and Grace Carpenter Hudson. As was typical for women artists of the period, they made portraiture the dominant subject of their work and children a major theme. Richardson's portrait of Joseph Bransten as a boy, which is in the museum's collection, gives ample justification for the high esteem in which she was held by her contemporaries. Grace Carpenter Hudson's work with children's protraiture is remarkable for her long and extraordinary relationship with the Pomo Indians on the coast of Northern California. Her sometimes sentimental portraits of Indian babies and adolescent children form a highly unusual body of work from a period when portraiture was dominated by commissions from a wealthy and socially prominent clientele. *To-Tole*, illustrated in this book, is an excellent example of Hudson's work.

The prominent local artists who established the San Francisco Art Association in 1871 helped establish an enduring commitment to professionalism in both the exhibiting of fine arts and the training of young artists. The Art Association's own academy, later known as the School of Design in the Mark Hopkins Institute, could claim among its faculty and students most of the best artists active in California during the late nineteenth century. Students enrolled at the School of Design received their early training from European-educated artists such as Virgil Williams, the first director. Williams was born in Maine and had studied in Rome. He assumed a major role in the early artistic life of San Francisco and was a friend of Bierstadt, Hill, and Keith. His reputation as a painter and a teacher rests with some surviving works on Italian subjects and a few rare California paintings, one of which, *Mount St. Helena*, is in the museum's collection.

The most promising young painters were drawn after a year or two of study in San Francisco to the art academies of Europe to continue their studies. The Düsseldorf and Munich academies were most popular until the late 1880s, when Paris became the leading center for art. When California's painters returned to San Francisco, their work was shown in several commercial art galleries as well as the annual exhibitions at the Art Association and the Fine Arts exhibitions at the Mechanics' Institute. Despite frequent opportunities for showing work and the generous efforts of an active "art press" among the local newspapers, few artists were able to earn a living from sales of their work. Those who had established connections in the East often sent their work to galleries there. It should be noted that the need for serious artists to go abroad for education and the small size of the local market for their work were not unique to California, and the economic depression of the 1880s affected sales for artists everywhere.

Unlike painting, sculpture as an inde-pendent art form did not begin its evolution from traditional statuary—a medium of public expression—to contemporary sculpture—a medium of artists' self-expression—until nearly the end of the nineteenth century. Public sculpture, or "statuary" as it was popularly called, was little in evidence around San Francisco in the decades between the gold rush and the 1880s. This was the Victorian era when Gothic revival was the dominant architectural style and San Francisco's new rich sought to emulate the taste and manners of fashionable society in the East and in Europe. Those who could afford it often decorated their homes with marble copies of famous European sculptures.

Rupert Schmid, a prominent early sculptor, was a product of the Royal Academy in Munich and was active in San Francisco from about 1892 until his death in 1932. Schmid produced portrait busts and statuary in both marble and bronze. A fine example of Schmid's work, *California Venus*, is illustrated in this book. It is a classical figure in marble intended to symbolize California.

By the 1880s, the European training center for sculptors had shifted from Italy and Germany to France, where the École des Beaux Arts was responsible for a style of sculpture and architecture that emulated classical Greek, Italian Renaissance, and Baroque exemplars. The Beaux-Arts style emphasized the monumental quality of public sculpture and idealized figurative subject matter for the purpose of allegorical or historical representation. With the new interest in public sculpture came the shift from marble to cast bronze as the favored material. The Beaux-Arts style exemplified the classical spirit that prevailed during the rebuilding of San Francisco following the great earthquake and fire of 1906, and where it reached its highest and last major ex-pression in 1915 with the Panama-Pacific International Exposition.

The outstanding sculptor of civic monuments during the early period in San Francisco was Douglas Tilden. Born in Chico, California, and educated in San Francisco and New York City, he was a man of enormous talent and imagination. Tilden's vigorous figure compositions are the most original and exciting sculptures based on allegorical or genre themes ever produced in California. Known as the father of sculpture in California, Tilden, although deaf and mute from a childhood bout with scarlet fever, became the first teacher of sculpture classes on the West Coast. Between 1894 and 1901, while at the Mark Hopkins Institute, he taught most of the California sculptors of the next two decades.

Tilden's most prominent pupil was Robert Ingersoll Aitken, who succeeded him as a teacher at the Hopkins Institute and who quickly achieved a national reputation with major sculpture commissions both in New York City and San Francisco. In his large statues and monuments, Aitken's idealized representations of the figure followed academic tradition. However, in the gracefully flowing lines and contours of his smaller, salon-sized works, which are represented in the Oakland Museum collection, he often revealed a personal style that had an affinity with Art Nouveau.

The confluence of styles produced by the presence of artists trained in diverse places and the high degree of activity in the visual arts combined to create a California atmosphere characterized by a continued freshness of available subject matter and freedom from any one dominant style. Some of the landscape painters were also proficient portraitists, still-life and genre painters, but few in California except the Nahl brothers, Ernest Narjot, and William Hahn specialized in genre subjects. The work of all four artists is represented in the museum's collection.

An interesting illustration of the diversity of styles current in California painting toward the end of the nineteenth

century can be seen in the works of Hahn and those of Domenico Tojetti. The German-born and trained Hahn made his career recording the humble scenes of daily life in the cities and the countryside among California pioneers. His realistic views of frontier life, as in *Return from the Bear Hunt*, have become important as both document and art from a past era. The painting is ironic testimony to the treatment of the grizzly bear, the animal that was chosen as the symbol for the state and which is now extinct here.

A contemporary of William Hahn in San Francisco was Domenico Tojetti, an Italian-born and trained painter whose *Progress of America*, which is in the museum's collection, depicts the participants in the westward movement in allegorical terms expressed by a horse-drawn chariot, torch-bearing cherubs, and classically draped muses reminiscent of Italian Baroque paintings. Tojetti, and his sons Eduardo and Virgilio, who were also artists, continued to paint allegorical, literary, and religious subjects for San Francisco patrons until the end of the last century. There is little evidence of California to be found in the Tojettis' paintings. Tojetti's only rival for paintings of literary subjects was Toby Rosenthal, a San Francisco-born artist who worked in Europe and sent paintings home for exhibition. Both painters found their patronage among the wealthy San Franciscans who equated culture with European styles.

The greatest opportunity for local sculptors came with the advent of the 1915 Panama-Pacific International Exposition (PPIE) and was planned in dual celebration of the completion of the Panama Canal and the rebuilding of San Francisco after the fire. Stylistically and thematically the PPIE was the last of the Beaux-Arts-inspired exposition designs in this country. Under the supervision of A. Stirling Calder, whose father and son were both famous American sculptors, many of America's foremost sculptors came to San Francisco to collaborate with architects and technicians to produce large numbers of monuments, fountains, statues, and architectural embellishments. Most of these, owing to their transitory function and impermanent materials, were destined to be destroyed at the close of the exposition. To insure the preservation of Calder's *Star Figure*, a sculpture used in repetition to adorn the PPIE Court of the Universe, a bronze cast was made from a fragile original plaster version, which is also in the museum's collection.

From amid the sculpture produced in California around the turn of the century, an apparent "American" style emerged in regard to subject matter. Although there is too little evidence to identify a uniquely California style, the western artists seemed to be leaders among sculptors of the period in their preference for naturalism over idealism, particularly in the representation of genre subjects. Arthur Putnam, who was largely self-taught and is known primarily for his bronze animal sculpture, was California's finest exponent of naturalism. The Oakland Museum has several animal sculptures by Putnam, a diligent student of nature, which reveal his profound knowledge of anatomy. Some of his most affecting works are the cats: puma, lion or lynx, shown individually or in pairs in unposed casual attitudes or relaxed positions. His *Puma and Deer* can be seen in the museum's collection.

Farther south in Los Angeles and San Diego, sculpture did not achieve any significant momentum until well after 1900. Los Angeles acquired its first important sculptor in 1902 with the arrival of Felix Peano, who was followed in 1906 by Julia Bracken Wendt. By 1921, the Sculptors Guild had been formed in Los Angeles to foster a greater awareness of public sculpture and support for local sculptors. Although such support was slow in coming, the late 1920s marked the beginning of a period of sculpture in Southern California notable for its variety of subject matter,

its diversity of material, and its emphasis on the Arts and Crafts aesthetic.

By the 1890s painting in California had begun a shift in style from the romantic realism of the grand-scale landscape and descriptive genre subjects of the preceding decade toward the more intimate and personal interpretations that anticipate the Modernism of the twentieth century. This shift can be seen in the work of Emil Carlsen, a Danish-born artist who studied in Copenhagen and Paris, and who was director of the San Francisco Art Association's School of Design from 1887 to 1889. Unlike Samuel Marsden Brookes, who painted similar subject matter, Carlsen emphasized formal issues such as composition, line quality, and color harmony over considerations of descriptive detail and local color. The primacy of aesthetic concerns over subject matter marks the beginning of new trends in California painting and signals the diversity of expression that grew wider throughout the next decades.

Carlsen's successor at the School of Design in 1890 was Arthur Mathews. Mathews, whose early training had been in architecture, studied painting in Paris in the 1880s, where he encountered the equally powerful influences of the French academic style and the various forms of the then emerging Modernism. Mathews assimilated these influences to produce the distinctive blend of artistic components that is now recognized as the California Decorative Style. As an artist, designer, and teacher, Mathews was a dominant influence upon California art during the first quarter of the twentieth century.

Lucia Kleinhans Mathews, who was both pupil and wife of Arthur Mathews, retained her artistic individuality within the distinctive style which they shared. In her own work, particularly in her approaches to watercolor and in the applied decoration of their collaborative pieces, Lucia Mathews made depictions of the abundant fruits and flowers of California her own contribution to the pictorial elements of the California Decorative Style.

The Oakland Museum has the largest and most comprehensive collection of the Mathews' work to be found, including paintings, murals, frames, and several fine examples of the furniture they produced collaboratively in the Furniture Shop, which they founded in San Francisco after the 1906 earthquake.

Exclusive of allegorical themes, certain aspects of Mathews' California Decorative Style, especially his handling of light and color, were continued by several followers working in a decorative, Tonalist approach to painting of landscape, genre, and portrait subjects. George Inness and James MacNeill Whistler were also major influences upon California's Tonalist painters. Tonalist works of the native landscape combined the descriptive fact with poetic sentiment in a synthesis of objective and subjective. The quiet mood of Tonalism was manifested in the mists and hazes of early morning and the softly glowing hours of evening. Gottardo Piazzoni, Xavier Martinez, Francis McComas, Carl Armin Hansen, Eugen Neuhaus, and Charles Rollo Peters among others used Tonalism to express the poetic aspects of the California scene during the years between 1890 and the 1915 Panama-Pacific International Exposition.

A stylistic development in California painting which paralleled Tonalism during the twenty-five-year period between 1890 and 1915 was based on the tenets of French Impressionism. The clear bright colors and vibrant optical effects of Impressionist analytic theory contrasted sharply with the subdued grey-brown hues of the more subjective Tonalist aesthetic. By 1890 in the north and 1915 in the south, exposure to both French and American Impressionists had led many California painters to experiment with the impressionistic mode. The effects of differences in the character of the landscape became evident in the development of regional painting styles. While the hazy light and muted tones of the Northern California landscape seemed ideally suited to Tonalism, the more brilliant light and color of Southern California and the seaside art colonies of Monterey and Laguna Beach were appropriate to Impressionism.

Among the Southern California painters, Guy Rose became strongly identified with the Impressionist approach associated with Monet, even to the extent of painting at Giverny for a brief period in the early 1900s. Joseph Raphael, a San Franciscan, spent many years painting Impressionist works in Belgium and Holland, while E. Charlton Fortune brought back to Monterey her own interpretation of Impressionism from her three periods of study in Europe.

Although the Oakland Museum's collection remains strongest in its representation of Northern California artists of the period, works by artists in the southern part of the state, such as Franz Bischoff, Edgar Payne, Granville Redmond, and Alson Clark, have been recent additions. The work of William Wendt, often considered the dean of Southern California landscape painters, remains to be added to the museum's collection.

Although they were initially inspired by paintings of the French Impressionists, and to a lesser extent by Americans such as Childe Hassam and William Merritt Chase, the stimulating environment and exchange of ideas in California artists' communities led the state's painters to find their own regional identification within the international style. Using impressionistic resources, the artists captured in paint on canvas the distinctive atmospheric conditions and characteristic topographical features that combined to form a recognizable California style of landscape painting.

California painters pursued their imagery more subjectively, perhaps, than other American Impressionists, resulting in a diversity of approach that precluded a truly homogenous California Impressionist style. This tendency toward individual expression and adaptation of existing ways of painting led to an exploration of styles that developed, in the 1920s, into Modernism.

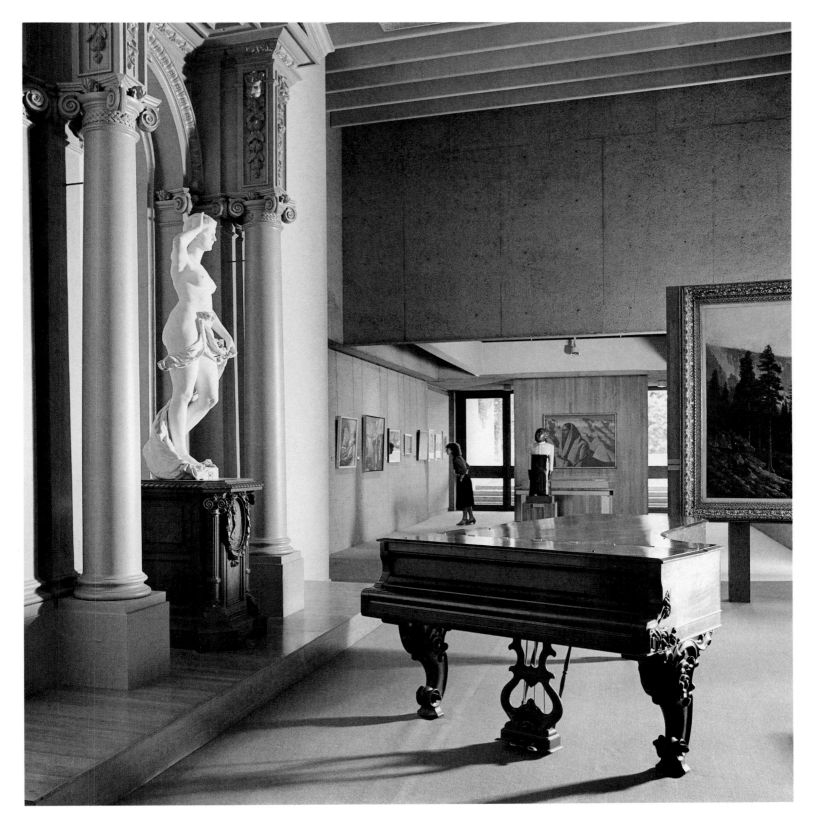

A view of The Oakland Museum's Gallery of California Art

CALIFORNIA PAINTING AND SCULPTURE FROM 1915 TO 1960

by Terry St. John
Associate Curator of Painting

From 1915 to 1960, California artists moved along a path that began in the imitative provinces of modern art and emerged in the forefront of the innovative and avant-garde. During these forty-five years, California artists worked in a variety of modernist art styles—Impressionism, Post-Impressionism, Synchromism, Cubism, Surrealism, Regionalism, Realism, and Abstract Expressionism. The visual enthusiasms of California artists changed and evolved with each passing decade in a development that paralleled the larger American art scene in many ways, yet it reflected the uniqueness of the region in subject matter and adaptation of new styles. Careful selections of the work of this era, chosen from the Oakland Museum's extensive collection of paintings and sculpture by California artists, are always on display in the Gallery of California Art.

In California, as in the rest of America, postwar art contrasts strongly with art created before 1945, and this contrast is evident in the work in our collection. California painters and sculptors produced many excellent works before 1945, but art in California was stylistically subservient to European modern art movements until after World War II. Even the finest work by California artists who had studied in Europe was often mimetic and stylistically dated. The postwar era is represented by radical new visual forms, techniques, and materials that are assertively American in their use, confidently conceived, and visually independent of postwar European vanguard art. From the 1920s Synchromatic color harmonies of Southern California artist Stanton Macdonald-Wright to the rugged, explosive, Abstract Expressionist paint-laden forms of Frank Lobdell in the 1960s, the California artist's drive toward relevant new visual modes is evident.

A major reason for artistic isolation

in California before 1945 was the lack of the modern travel facilities and instant media communication which would later allow a freer exchange of new ideas. Although some California artists did travel to Europe to study modern art, developments were nonetheless slow to arrive in California. Before 1915, art periodicals were the only widely available source of information about art created in other parts of America and in Europe for the many artists who never traveled outside the state. However, the Panama-Pacific International Exposition (PPIE), which was held in San Francisco in 1915, brought a wave of fresh ideas to geographically isolated Californians. The ranks of the state's modernist artists soon burgeoned.

The magnificently grandiose PPIE gave many California artists their first opportunity to view numerous examples of avant-garde European art, ranging from Post-Impressionism to Italian Futurism. The cause of modern art was furthered by the international selection committee, which officially legitimized radical art by selecting it for display. In the years immediately following the exposition, a multitude of art groups and public and private galleries proliferated, encouraging the development of modern art in California. An active modernist community formed. By the 1920s, artists throughout the state were working in a multiplicity of styles, paralleling the various styles which had been developed earlier in the art capitals of Europe.

The most conservative segments of modernist art developments to take root in California following the PPIE were the impressionistic and post-impressionistic schools that are so well represented in our galleries. A visitor can study the influential works of first-generation, European-trained California Impressionists E. Charlton Fortune, Joseph Raphael, and Armin Hansen, who exhibited in the 1915 fair. Also to be seen are selections from the museum's excellent core collection of the more vanguard, relatively small-scale paintings done by the Society of Six, a group of Oakland-based landscape painters. The Six, as they were known, were very impressed by the work of Fortune, Raphael, and Hansen, as well as by many impressionistic works by American and European artists that were displayed at the PPIE.

The Six were William Clapp, August Gay, Selden Gile, Maurice Logan, Louis Siegriest, and Bernard von Eichman, all of whom created intensely colored *plein-air* works in the 1920s. They were regularly exhibited as a group at the Oakland Art Gallery (now the Art Department of The Oakland Museum) in the 1920s. In contrast to the introspective, Whistlerian-inspired Tonalism of an earlier generation of California artists, such as Xavier Martinez, a clear shift in turn-of-the-century visual approaches is evident, not only in the work of The Six, but also in a number of works by other *plein-air* painters such as William Gaw and Eugen Neuhaus. The transition was to a more spontaneous and thickly painted stroke with a high-key use of color. After 1915, it became even more evident that the earth-toned naturalism of nineteenth-century artists, even that of excellent landscapists William Keith and Thomas Hill, no longer inspired artists who had grown tired of the constraints that a limited palette imposed on their work.

Although vanguard European and American artists considered most impressionistic approaches to landscape painting passé by the 1920s, many California artists still found them vital enough to offer a new and viable way to paint the stunningly beautiful California landscape. In Northern California, C. S. Price and Selden Gile, by pursuing post-impressionistic visual approaches, spearheaded some of the most inspired painting done in the state before 1945, although once again their works were rooted in art developments which had occurred almost a half-century earlier in France.

Soon after 1915, the population in the Los Angeles area began to approach that of the San Francisco Bay Area. With newly generated wealth, patronage for landscape painting developed quickly. One of the leading painters of the Southern California terrain was Franz Bischoff, whose work is included in the museum's collection. More important than landscape painting to the twentieth-century development of Southern California art was the increasing experimentation of Los Angeles artist Stanton Macdonald-Wright, one of America's leading abstractionists. Macdonald-Wright returned to Los Angeles in 1919 after gaining an international reputation as the co-founder of the Synchromist group of abstractionists in Paris. His *Seated Man Synchromy* of 1915, which is on display in the gallery, is a prime example of the work he was doing abroad before his return to America. Macdonald-Wright soon led a group of excellent Los Angeles abstractionists who showed together in 1923 as The Independent Artists of Los Angeles. Although this group was not received with the same enthusiasm as the more commercially oriented landscape painters of Southern California, most of the artists involved would be acknowledged after World War II.

Surrealism was another form of vanguard art that California artists pursued vigorously. The Oakland Museum collection has key works by some of the state's leading exponents of Surrealism—Knud

Merrild, Helen Lundeberg, Matthew Barnes, and Hilaire Hiler. Synthetic and Analytical Cubism were less successful in Northern California than various types of cubistic realism as exemplified by such works in the collection as *L'Atelier* by Lucien Labaudt, *Figure* by Otis Oldfield, and *Earth Knower* by Maynard Dixon. All these works employ modified cubistic planes and forms to create solid, monumental figurative images.

Although California painting and sculpture were influenced by Cubist visual approaches in the 1930s, other visual sources can be detected in the work of this decade. Diego Rivera, the great Mexican social muralist who worked in California in 1931, inspired various types of Social Realism in easel painting and frescoes done under the auspices of the Works Progress Administration. In the 1930s, great numbers of farmers displaced by droughts migrated to California from the Southwest. The soft, fleeting forms of 1920s Impressionism gave way to more somber subjects and subdued colors in the work of painters such as John Langley Howard and Maynard Dixon as they observed the widespread despair created by the Great Depression. California painters and sculptors were also aware of and influenced by the heightened social consciousness reflected in the social documentary movement in photography in the 1930s. Government agencies, particularly the Farm Security Administration, employed photographers such as Dorothea Lange, who took direct, straightforward images that revealed the dire economic plight of migratory farmworkers.

Another type of photography that influenced California artists used precisionist images of industrial subjects. The artists celebrated massive, modern, machine-made things such as trains, ships, and bridges. These subjects lent themselves to stylistic treatments appropriate

to the thirties. The artists presented their aesthetically appealing, streamlined forms as symbols of progress that held out hope for a more prosperous future. Many of the painters represented in the Public Works of Art Project murals executed in Coit Tower in 1934 treated the machine.

With the conclusion of World War II, a remarkable new era of modernism was abruptly launched. The United States was thrust into the forefront of international political, social, economic, and cultural developments. Artists from all parts of Europe and America came into greater contact as air travel became easier and cheaper. There was an unprecedented exchange of visual ideas. American artists were increasingly able to follow the latest international art developments in a new flood of newspapers, periodicals, books, and films. No longer inclined to follow the path of European Modernism, American artists began to develop their own highly original visual ideas which, in turn, began to set international visual trends.

California itself was becoming the epitome of the new American spirit. The state was rapidly being transformed from an idyllic "Golden State" to a technologically sophisticated "Super State" unfettered by the social and cultural traditions of the eastern part of the country. A new generation of California artists, including Jeremy Anderson, John Hultberg, Lee Mullican, and Jack Zajac rebelled against once-dominant European aesthetics in a dynamic burst of creative energy. They did not hesitate to discard School of Paris visual conventions that were inappropriate to the development of their own highly individualistic art concerns. They no longer worked in a cultural vacuum but fully participated in the contemporary international art world. The California art scene was not only more assured than it had been in the prewar years, but it was also frequently so innovative that it took the national and international lead. Artists such as Clyfford Still, Mark Rothko, and Richard Diebenkorn set the pace with their Abstract Expressionist developments in the San Francisco Bay Area.

21

The two main art styles in California from 1945 to 1960 were Abstract Expressionism and Bay Area Figurative painting. Five educational institutions that could be singled out as having the greatest impact on the development of California art from 1945-1960 were the California School of Fine Arts (CSFA, now the San Francisco Art Institute), the University of California at Berkeley, The Otis Art Institute, the University of California at Los Angeles, and the California College of Arts and Crafts, Oakland. The CSFA in particular attracted a group of teaching artists who had been primarily associated with the New York art scene—Clyfford Still, Mark Rothko, and Ad Reinhardt. Artists associated with this school, including painters Richard Diebenkorn, Elmer Bischoff, Jack Jefferson, Edward Corbett, James Budd Dixon, and Frank Lobdell, and sculptors Robert Howard and Jeremy Anderson, were creating some of the most innovative, dynamic art that had ever been produced in California. Many of these artists were veterans of World War II, returning to art schools throughout the state with tuition and art supplies paid for by the G.I. Bill of Rights. Several of the artists have told interviewers that the CSFA was a haven from the outside world for them. They felt life in that environment seemed more relevant to their wartime experiences than the day-to-day world they had to cope with when they were not creating art. Work by these artists in the museum's permanent collection is larger in scale, more explosive in its use of painterly materials, less objective in its imagery and, for the most part, more self-assured than any previous California art.

In the 1950s three important painters—Richard Diebenkorn, Elmer Bischoff, and David Park—came from the ranks of the young Abstract Expressionist artists of the area and began to paint more or less realistic imagery, forsaking nonobjectivism for images from everyday life. In 1958, The Oakland Museum Art Department, formerly the Oakland Art Museum, presented an exhibition that included works by the above-mentioned artists and others, such as William Theo Brown, Paul Wonner, and Bruce McGaw, who worked in this new figurative vein. This exhibition soon attracted national attention, temporarily challenging Abstract Expressionism, the most dominant visual mode in which American artists were then working. Excellent works by these artists are on view in the museum's Gallery of California Art, as is the work of James Weeks, an artist who used loose brushwork and figurative images from the start, and who was also associated with the CSFA in the 1940s.

Instead of making contributions to the developments of Abstract Expressionism, Southern California artists in the 1950s were known primarily for three rather distinct stylistic approaches to art. They were Romantic Surrealists, the Dynaton group, and the Hard Edge Abstractionists. The Romantic Surrealist movement was founded by Rico Lebrun and Eugene Berman and further developed by Howard Warshaw and William Brice. Their work is a curious amalgam of cubistic form and gothic surrealistic vision. Somewhat differently, Hans Burkhardt developed a vein of figurative abstraction that shared some of the gestural painterly qualities that Northern California artists pursued so successfully in the forties and fifties. Sculptors Jack Zajac and Robert Cremean also produced work that was rooted in the Romantic Surrealist approach.

In 1951, the members of Dynaton, a Southern California-based group of abstractionists (Gordon Onslow-Ford, Lee Mullican, and Wolfgang Von Paalen), issued a manifesto defining their visual aspirations. Unlike the work inspired by Clyfford Still at the CSFA in which paintings possessed a vocabulary of forms that were arrived at only after weeks of long and hard struggle, Dynaton members placed a far greater emphasis on capturing quickly reached, intuitive visual incidents that they felt paralleled the "informative potentialities of reality." The third approach, Hard Edge Abstraction, was perhaps the strongest painting movement to develop in Southern California after 1945. John McLaughlin, Lorser Feitelson, Helen Lundeberg, and Karl Benjamin continued a tradition of abstraction that was pioneered earlier in Europe by the Constructivists and the de Stijl group. The Los Angeles-based artists, however, did not merely emulate the achievements of European artists. Their work immediately strikes the viewer with the expansive freedom of the geometric shapes they employed, often on a very large scale.

The years between 1945 and 1960 were a period of intense underground activity for California artists. The highly original work developed throughout this era would not be fully acclaimed until the 1960s and 1970s. Although Abstract Expressionism and Bay Area Figurative painting of these years did eventually attain national recognition, the still-gestating movements of assemblage art and Abstract Expressionist ceramics developed relatively unnoticed. As the California art scene continued to mature, such artists as Bruce Conner in San Francisco and Wallace Berman in Los Angeles were recognized for their vanguard roles in developing assemblage art. In the late fifties, Peter Voulkos, working in Los Angeles and Berkeley with a group of students whom he inspired, pioneered a new way of working with ceramics, lifting it out of its crafts tradition into Abstract Expressionist sculpture.

Although California artists achieved some remarkable visual breakthroughs as provincialism lost its hold on the state after 1945, it was not until the 1960s that these achievements were recognized and California art entered into the mainstream of American art. The sixties brought dramatic changes in American society. The civil rights movement, the Vietnam war, population shifts to the west, the growth of consumerism and reaction to it, and the increasing impor-

tance of many ethnic populations all drastically altered our culture. An ever-expanding creative milieu enabled artists to respond to their times. In the late 1950s, art had become increasingly important in the United States, particularly New York City, and this increasing appetite for contemporary art had allowed California's artists to participate more completely than they ever had before.

Building on the foundations laid in the 1940s and 1950s, California artists went on to contribute to contemporary art to a degree that artists who worked earlier would not have imagined possible.

Oak Street entrance to The Oakland Museum
Peter Voulkos
Mr. Ishi, 1969 (70.32)
Cast bronze
27 × 20 × 20 ft. (822.96 × 609.6 × 609.6 cm.)

CALIFORNIA PRINTS, PHOTOGRAPHS AND DRAWINGS

by Therese Thau Heyman
Senior Curator of
Prints and Photographs

Both California and the technologies of photography and modern printmaking were in their infancies in the 1840s and 1850s. They have grown into their complex modern forms side by side. In undertaking a major collection of California prints and photographs, The Oakland Museum has pursued the dual purposes of acquiring works of both historic interest and artistic value to demonstrate that works of art take form within a culture, not in isolation.

The first emphasis of photography and printmaking in California was not primarily artistic, but to record the new land and its people in landscape and portrait images. Photography had spread across the United States by 1850, and interest in the new medium was vigorous. Daguerreotypes were the most notable photographs produced in California at this time, and the portrait studios in San Francisco were highly popular in the years following the gold rush. For the first time, the ordinary man could be pictured in a permanent fashion for all to see; travelers, adventurers, fortune hunters, and the newly successful were able to send daguerreotype portraits of themselves home to relatives. William Shew's daguerreotype copperplate of his studio on wheels shows the line of sample daguerreotypes he displayed outside the van for passersby to consider before they had their own portraits done. The museum's collection has many fine examples of work made in the gold country by itinerant photographers such as Shew, Charles Weed, Isaac Wallace Baker, and Perez M. Batchelder.

Wondrous sights, stories of gold mining adventures, and the chance to start anew drew a constant stream of pioneers to the West, and if one were unable to make the arduous trip, photographs and illustrations were the next best choice. The demand for pictures of the new land was great enough to produce a flood of printed records, including scenes and lettersheets. Sketches and drawings by major artists, such as Thomas Ayres and Thomas Hill, were quickly translated into printed form, sending grand images of the newly explored Yosemite Valley, the high Sierra, and the Giant Sequoias out to an eager audience. Accuracy was not always guaranteed, but as early as 1816, artist Louis Choris accompanied an expedition and drew both local Indians and a California bear as convincingly as a trained scientific illustrator would have. In 1849, Alfred Sully, son of the portrait painter Thomas Sully, made drawings of the rancho life of his wife's family while he waited to join his army regiment. Other well-established artists never reached California, but worked from sketches and daguerreotypes to make their own, quite detailed interpretations. Charles Meryon and Honoré Daumier in France, John J. Audubon on the East Coast, and Currier and Ives in their Brooklyn workshop produced large editions of hundreds of popular prints about the West without having seen it for themselves.

This could not be so for photographers who hauled large cameras and heavy glass plates about in the mountains in order to turn out splendid views for portfolios and albums. The most important international fairs of Europe awarded gold medal prizes to large-scale, brilliant, albumen photographs by the best of the California landscape illustrators from Charles Weed and Carleton Watkins to the younger and more dramatically inclined Eadweard Muybridge. These prizes were awarded for a combination of artistic merit, curiosity value, and adventurous accomplishment. Many of the early prize-winning views, as well as an extensive collection of nineteenth-century Yosemite albums, portfolios, and cabinet photographs, are in the Oakland Museum collection.

Each of the well-known "mammoth plate" photographers also made multiple copies of smaller versions of each picture, often hundreds of each area, to make stereo cards for the popular parlor attraction, the stereo viewer. The geysers, canyons, and spectacular mountain cliffs and ledges of the West were well suited to the special character of the stereo, which popped depth into an otherwise flat image.

The new fortunes made in California helped support the growth of photography and printmaking, as art, historic record, and as scientific experiment. Railroad developer Colonel Leland Stanford sponsored Eadweard Muybridge's famous experiment in split-second photography that showed Stanford's racing horses in motion. This innovative series of photographs is included in the museum's collection. The collection also includes the more grandiose still photographs Muybridge made of Stanford's home, stables and horses, and those C. E. Watkins took of his patron's mining operations. Prominent citizens further documented their wealth and importance by having their portraits taken at the major "galleries" like Houseworth's in San Francisco.

At the same time, remarkable portraits of the land and its natural features were being taken for the United States government by scientists and engineers in a series of what were known as "Great Surveys." Even though the intent of the

surveys was scientific, the photographers thought of landscape as sublime and wild, an evidence of God's awesome creation, and they conveyed this sense of majesty in their work. Photographs in our collection from these significant expeditions include works by Timothy O'Sullivan, Watkins, and Alfred A. Hart. At the turn of the century, Edward Curtis, who was sponsored by private funds, took on his own gigantic documentary task of photographing the disappearing Indians of North America and publishing his multi-volume series of portfolios. The Oakland Museum collection contains a complete set of Curtis' California photogravure images as well as several rare orotone and silk prints, which were particularly favored by collectors.

The market for photographs and colored lithographic prints intended for home decoration grew with the population. To suit the need for multiple copies, printmakers like J. Ross Key made prints after popular oil paintings by Albert Bierstadt and other landscape artists working in California. "Improving" prints such as *The Good Miner* and *The Bad Miner* were another popular home decoration. The collection contains many chromolithographs and engravings that were made and distributed by local publishers Britton and Rey, and by national printing firms such as L. Prang & Co.

The Panama-Pacific International Exposition (PPIE), held in San Francisco in 1915, gave the West a chance to review its own artistic heritage and to see what was happening in other parts of the world in painting, sculpture, printmaking, and photography. Among the photographers showing at the PPIE who are represented in the Oakland Museum's collection, some, such as Willard Worden, Arnold Genthe, and Francis Bruguière, were considered fine artists. To make their work manifestly "artlike," they often used soft-focus lenses, inky printing methods, and textured papers to achieve the atmospheric space popular in European prints. Throughout the 1910s and 1920s, Alfred Stieglitz, early proponent of photography

as art, showed their work along with that of another California photographer, Anne Brigman, in his famous "291" Gallery in New York City. Each of these West Coast "291" Gallery exhibitors is extensively represented in the Oakland Museum's collection.

California photographers took an active part in the debate that flourished in the 1930s about what photography could communicate—the "real" versus the "interpreted." In 1932, when realists Willard Van Dyke, Edward Weston, Ansel Adams, and their friends formed Group f/64, which met in Oakland, they began to assert themselves as artists of straight photographic vision and to articulate their aesthetic in their photographs and writings. Their prints startled the interpretive photographers known as the Pictorialists, who were then the controlling theorists. In the 1930s, the Oakland Art Gallery was progressive in exhibiting Weston's powerful images, each employing the clear, stark California light to illuminate a close-up view of one strong, often sensuous form—a green pepper, a woman's torso, a magnolia.

The Oakland Art Gallery had a small but fine collection of photographs as early as the 1920s. The conscious decision to make photography a link in the museum's California theme—in natural sciences, history, and art—was taken in 1967 by then director James Brown. The museum acquired portfolios by Ansel Adams and rare issues of limited editions by Weston, while photographers such as William Garnett had one-person shows. The Oakes Gallery, established in 1969 by the Roscoe and Mary Oakes Foundation, has held a continuing series of some thirty-six historic and contemporary California photography exhibitions. Major photography collections were acquired from Oscar Maurer, Anne Brigman, Imogen Cunningham, Alma Lavenson,

and Dorothea Lange.

In the 1930s, the fidelity of the camera to the thing photographed appealed to a generation of artists anxious to communicate the effects of the Great Depression. This coincided with an unprecedented level of government support for the arts. Besides employing many photographers, the Works Progress Administration commissioned a remarkable variety of lithographs. From stark cityscapes drawn by T. H. Polos to the seemingly dreamlike "escapist" scenes printed by Helen Lundeberg and George Gaethke, WPA lithographers reflected the pressures of the era. The museum's collection of both photographs and lithographs from WPA projects is extensive.

The outstanding photographs Dorothea Lange took for the Farm Security Administration project are infused with an unusual clarity of vision and grasp of her time. She documented, with memorable results, the struggles of the unemployed, farm migration to the cities, families dislocated by economic hardship, and the irony of beautiful, abundant California unable to support the large numbers of migrants who flooded the state. Lange was a major figure in promoting documentary photography as a social tool. Her belief in the ability of human strength to withstand tragedy is evident in her work. The Oakland Museum's collection of Lange's photographs and negatives is the largest outside the holdings of the federal goverment.

After World War II, photography and printmaking experienced the same surge of revitalization and expansion that poured into other arts, but these two fields received an extra impetus. Out of wartime necessity, the technical sophistication of cameras, film, printing presses, inks, and other tools of these art media leapt far ahead of prewar levels. The same technical revolution that produced an ever-increasing array of cameras and film for amateur photographers gave artists the tools to expand frontiers, mix old and new, and attempt things no one had done previously. The arts of photography and

printmaking began to expand and diverge.

Master photographer Ansel Adams focused student interest on the natural landscape image printed in the full zone system of black through grey to white. Several early and outstanding portfolios of Adams' photographs are in the museum's collection. They firmly document the fine printing techniques Adams perfected. From 1955 until his death in 1984, he continued to expand the influence of his aesthetic systems through the special landscape photography workshops he taught in such spectacular California settings as Yosemite and Carmel.

The explosion of interest in the graphic arts was accelerated by art schools, such as Chouinard Art School in Los Angeles, Brooks Institute in Santa Barbara, California College of Arts and Crafts in Oakland, and the San Francisco Art Institute, where the technological information and machines for printing both photography and graphics were available. Overall, the growing number of students at such schools spread and developed the ideas of their artist-teachers and encouraged a new specialization in photography and the graphic arts. Perhaps, also, an American love of handling materials, building presses, making plates and proofs, a kind of early "do-it-yourself" philosophy, prevailed. Mezzotint was reintroduced for its complex handwork, and William S. Rice mastered woodblock printing while he taught local Bay Area classes. Even obsolete processes were revived in the influential series of ink-toned prints of Mono Lake by Edmund Teske in which expression of his personal feelings can be seen. The Oakland Museum holds an extensive, important collection of Teske's photography.

In Los Angeles, Robert Heinecken's classes at UCLA produced a wave of photography students who were awakened to the possibilities of mixed print and photography media and who often dealt with erotic subjects for their provocative quality. Another important teaching function in Los Angeles was furnished by Hollywood's film industry, which provided sophisticated technical training for

still photographers William Mortensen, Edward Curtis, and others such as Gordon Parks who worked on special filmmaking projects.

While the return to earlier methods of putting ink on paper interested many teachers, there were printmakers, members of the Society of California Etchers like Roi Partridge, John Winkler, and Armin Hansen, who all along had continued to draw and print the plates for their small, hand-held proofs in the traditional mode. They used a linear style to depict trees in the Sierra and local genre scenes, such as Chinatown and the shipyards. The Oakland Museum collected work by these artists as well as the western prints by another noted regional printmaker, Edward Borein. Throughout his career, Borein documented his predominant interest, cowboys on the ranch and in rodeos, although by the 1940s such men were largely the exception in the rapidly urbanizing West. Always popular, prints which returned to western regional topics and celebrated the romantic history of the old West had a particular success in the East. It was in this spirit that The Print Club of Philadelphia awarded prizes to Paul Landacre's fine wood engravings both for their western character and their re-introduction of a largely ignored medium.

By the 1960s, several important printmaking workshops had brought a whole range of forgotten techniques back into use. Under June Wayne's direction, Tamarind Institute specialized in the fine art use of lithography, while in the next decade, Cirrus Editions and Gemini G.E.L. supported highly experimental work such as the metal prints by Billy Al Bengston and the Pepto-Bismol and caviar editions by Edward Ruscha. While it has not yet been possible to acquire more than representative prints from these Southern California workshops, The Oakland Museum

has succeeded in obtaining an example of each print made by California artists who were publishing with Crown Point Press of Oakland. Bringing major artists into printmaking, as Kathan Brown of Crown Point did, redefined lithography and etching as media for artistic creativity rather than as endeavors to be judged on technical skill alone. Tom Marioni and Richard Diebenkorn have produced a new level of complexity in aquatint, and William Wiley has experimented with color woodcuts in the Japanese tradition. Printing in Los Angeles, Masami Teraoka expresses his own cultural heritage in combination with American social commentary and humor through a sophisticated update of nineteenth-century ukiyo-e woodblock prints.

Several other artists both in Northern and Southern California use print media to realize their complex and detailed visions. Vija Celmins' intricately drawn nature studies and Bruce Conner's spiraling linear mandalas seem to originate in the imagination and take form in the offset printing process that each has perfected. Celmins' works, as well as Conner's prints in honor of Dennis Hopper, are in the portfolio collection of The Oakland Museum. Nathan Oliveira has further expanded the versatility of print media with his intricate explorations of the painterly possibilities of the monotype. Beth Van Hoesen has mastered the realist image, as in the memorable aquatint etching of *Sally* in the museum's collection.

In contrast to fine art printing, many posters issued in the 1960s were intended to communicate to large audiences. Rock band concerts were announced in the psychedelic colors of the "Hippie" style, while the posters' typeface was encoded for the initiated. Full sets of these posters for Fillmore Auditorium and Avalon Ballroom were obtained for the collection. Reflecting the interests of another generation of consumers, David Goines' singular style of poster design for prospering restaurants, bookstores, and musical events is also relevant to the popular arts of the 1970s.

Interest in photography proliferated in California in the 1960s. From 1860 to 1960, West Coast photographers, working with innovative methods in magnificent landscapes, defined what could be accomplished with camera and film. However, recognition of their artistic achievement lagged. Government patronage rewarded the remarkable vision of the survey photographers, Watkins, O'Sullivan, and A. J. Russell, but the portfolios they produced were often consigned to the geography sections of natural resource libraries. Before 1960, few art institutions expanded their definitions of collecting to include "documentary" photography, but in the last twenty years, the new, avid interest of critics, teachers and art students, and an ever-increasing number of amateur photographers, have led museums to broaden their collecting vision.

Fortunately, The Oakland Museum began to collect photographs both as art and document in the late 1920s. The curators defined acquisitions to include not only the aesthetically aware "f/64," a Bay Area group, but also the frankly experimental images by Bill Dane, Lew Thomas, and Jack Fulton. Revised 1960 editions of standard histories of photography, such as that of Beaumont Newhall, noted and appreciated the special place of California photographers in the pantheon of masters, while tracing the impressive influence of beloved "gurus" such as Minor White. White's teaching, writing, and almost spiritual devotion posited that photography might enhance inner awareness and lead to self-realization. Such optimistic theories, together with the striking and persuasive re-discovery of photography by painters, led to a new energy that is evident in the many art photography publications such as *Aperture* and *Untitled*. These disseminated California's innovative contributions throughout the country. West Coast photographers both benefited from and contributed to the new vision, as Bill Owens in *Suburbia*, Imogen Cunningham in the *Haight-Ashbury*, and David Hockney in his Los Angeles swimming pool prints created "views" of their California.

While Ansel Adams and Don Worth, Brett Weston and Willard Van Dyke continued to refine their interest in the visualization of the landscape, a new generation of younger artists was turning away from fine art printing methods to the funky means of drugstore printing and snapshot aesthetics. Steve Fitch, Pat Tavenner, and Judy Dater contributed to this movement, expressing a subject matter that derived largely from personal experience revealed in diary-like frankness. "Documentary" took on a challenging new strategy in the works of William Eggleston, Lewis Baltz, and Anthony Hernandez. Richard Misrach and Lee Rice successfully incorporated a modern color sensibility and specially controlled films to create an almost magically colored space. Gail Skoff and Barbara Kasten further arranged the color in their photographs by means of hand painting and lighting. The Oakland Museum has been progressive in exhibiting works from each of these contemporary directions and has acquired significant examples.

In the last decade, the patronizing interest Eastern critics and museums previously showed in California art as a regional phenomenon has changed to a dawning realization that California artists have made significant and needed contributions in photography and printed media. Californians are creating art of national and international import that transcends the awesome landscape and the Western genre of the nineteenth century to communicate the twentieth century in unique, memorable terms.

by Hazel V. Bray
Associate Curator Emeritus
of Crafts

When, in 1956, The Oakland Museum initiated its collection of what are commonly designated by the historical term "decorative arts," it seemed appropriate to use the twentieth-century term "craft." Today, this group of ceramics, glass, textiles, jewelry, metal, wood, and furniture, spans more than a century in time, and represents California's participation in three national periods of growth: the Arts and Crafts movement (1875-1920), the Craftsman or Studio era (1920-1955), and the as yet unnamed post-modern era (1955-present) of plural concepts and directions.

With its acquisitions program for the crafts, The Oakland Museum entered into a relatively new field that was not then clearly defined, but that had demonstrated an amazingly widespread recent national growth. The collection was planned both to take in contemporary development and to encompass as much of the nineteenth and early twentieth-century craft activities as this region had supported.

When the craft collection was begun in the 1950s, links to the past were fragile. Regional art reference sources offered considerable information about painting, but only a few useful notes concerning a very small number of earlier craftworkers and exhibitions. Most leads came from the archives of regional newspapers or the records of art groups. As more data developed, several California craftworkers gave us invaluable first person accounts of their experiences and perceptions of the field. Some of these accounts reached back into the second and third decades of this century. We also learned a great deal by interviewing associates and descendants of early craftworkers, some of whom made objects and memorabilia available to us.

It was soon apparent that each craft medium had both a separate and a shared heritage. However, most of the available information concerned ceramics and its precursor, china painting. This accounts for the fuller representation of the development of works in clay in the collection today. In time, comparable representation of other media will document their periods of growth and rectify the balance of the collection.

It may be difficult today to imagine a time when contemporary American art received less than the full attention it now commands, but in the early twentieth century, museums were generally reluctant to collect or display contemporary art. Reversal of this neglect was spurred on in the 1930s by a wave of regionalism; and then by the exciting and substantial developments in American painting at mid-century. At the same time, however, little thought was given to the antecedents of the burgeoning craft movement. In general, this neglect reflects the absence of the crafts from the arts during the years that academicians were refining their definitions of the separate disciplines of fine and decorative arts. The study of the decorative arts, in turn, was concerned primarily with objects from pre-industrial eras. As a result, thirty years ago there were few guidelines to the recent past within the decorative arts collections of most art museums. The crafts are still under-represented in the twentieth-century collections of many museums, although a small but growing number of museums specialize in the craft media

and others conduct active collecting and exhibition programs. It is only within the past ten to fifteen years that scholarly research into the Arts and Crafts movement, and resultant exhibitions of its work, have begun to give the crafts the attention they deserve.

Following its earlier inception in Great Britain, the American Arts and Crafts era began in the last quarter of the nineteenth century under the broad leadership of architects and artists. As the movement grew, it appealed to a wide and seemingly disparate following. It attracted professionals of considerable standing in the arts, educators, artisans, businessmen, and talented amateurs. Purpose and philosophy varied to include idealists and pragmatists. Yet, there were common goals in this revival of the decorative arts: to improve design, to reinstate skilled craftsmanship, and to renew a sense of value for the unique qualities of handwork. The Arts and Crafts movement heralded the emerging independence of the crafts and offered a broader role to the individual artist.

California's entry into the Arts and Crafts movement was only slightly later than that of the eastern and midwestern states, although it represented the involvement of a relatively small number of individuals. The fuller spirit of the movement was evident in the 1890s with the formation of a Keramic Club and the first Arts and Crafts Society in San Francisco, which brought California into timely accord with other parts of the country. One early manifestation of the movement can be noted in a group of Helen Tanner Brodt's china paintings from the 1880s. The crafts of some regions of the country retained vestiges of their folk traditions despite the cultural upheavals resulting from industrialization. No folk traditions survived the instant Americanization that followed the gold rush to Northern Cali-

fornia. The cultural artifacts of native Americans and the cultural heritage of the Spanish Colonial and Mexican periods in California are not included here. They did not leave a mark on the craftwork of the state after the 1840s, and they are represented by the collection of the museum's History Department. The state's most productive years in the Arts and Crafts movement fell within the early decades of the twentieth century.

An excellent example of the artists' leadership in the Arts and Crafts movement is found in the multidisciplined efforts of Arthur and Lucia Mathews, whose work is amply represented in the collection by decorative furnishings, drawings, and paintings. Many of their paintings were set in frames of their own design and surface execution. Their San Francisco "Furniture Shop" (1906-1920), employed a number of workers to implement Arthur Mathews' designs, and was an outgrowth of his earlier work as a decorative painter of murals and friezes. Lucia Mathews often carved and decorated surfaces of custom-designed furniture and smaller decorative objects. Their goal was to create a coordinated environment in which their painting, furniture, and decorative objects, as well as the architectural detail, would exist in harmonious balance.

The collection contains many other examples of work from this period and is quite strong in Art Pottery. Work from two potteries indicates some of the diversity of backgrounds among the people involved in the movement, and also reveals the eclectic stylistic sources which this revival period encompassed. A rare connection with traditional handwrought pottery is found in Roblin ware (production 1898-1906). Roblin ware came from the first known art pottery in California to specialize in unique thrown, glazed and fired work by a single potter, Alexander W. Robertson, a master potter from Massachusetts. Other examples of Robertson's pottery made with the Alberhill Coal and Clay Company and at the theosophical community at Halcyon are

also included in the museum's collection.

The second major potter, Frederick H. Rhead, established his pottery in Santa Barbara in 1913 after serving for two years as the first director of the pottery of Arequipa Sanitorium in Marin County. Several examples of his Arequipa work are included in the museum's collection along with Rhead Pottery pieces. Rhead's involvement in the Arts and Crafts movement in California was part of a ten-year hiatus in his distinguished design career in the art pottery industry, which began with his art training, teaching, and industrial work in England. His Santa Barbara study of Chinese glazes produced some elegant blacks which attest to his research and technical abilities. Rhead's sophisticated work invites favorable comparison with the best of American art pottery.

Metalwork, another popular field of this time, is well represented in our regional collection by the work of Dirk Van Erp. His copper and brasswares are highly esteemed today, especially the much sought-after lamps with distinctive mica shades that were first produced in partnership with an interior designer, D'Arcy Gaw, in 1909. Van Erp was artisan-trained in his native Holland, and he entered the field of art metal in this country with a background in industrial coppersmithing. His shop employed none of the production shortcuts characterized by the stamped and spun work of lesser firms, which soon emulated craftsman metalwork in their industrial production.

The Arts and Crafts movement faded into genteel obscurity after World War I. Architectural styles returned to historicism, and a popular new wave of interest in antique furnishing swept the country. The collection presents the transitional character of the 1920s through the custom metalwork of Harry Dixon, the art pottery and decorative tiles of the Walrich

Pottery, California Faience, and Ernest Batchelder's later tiles, which continued many aspects of the earlier movement. Many of these artist-led enterprises endured until the Depression years. Meanwhile, a few individual potters, notably Manuel Jalanivich and Glen Lukens, began to work in a manner which introduced the new work and attitudes of early studio pottery.

Regionalism continued to be a strong factor in the twenties and thirties, since there were few opportunities for craftworkers in one part of the country to become aware of developments in other areas. When the noted Southern California teaching potter, Glen Lukens, first showed his work in the newly formed, competitive National Ceramic Exhibitions of the thirties, it was acclaimed in New York for its freshness. Lukens' work differed greatly from the traditionally schooled, refined, and technically superior ceramics of the midwestern and eastern United States. The differences were both conceptual and intrinsic. Virtually self-taught in ceramics, Lukens, by the 1930s, had developed several raw alkaline glazes based on unrefined materials which he and his students gathered in California's deserts. Impurities in these materials produced subtle variations within the rich color of these glazes.

The museum's collection delineates the early development of the Craftsman or Studio era through the work of several individuals such as Lukens, who are acknowledged today as pioneers of modern crafts. The work of several individuals who studied ceramics with Lukens is also included in the collection. Notable among them are Vivika Timeriasieff Heino, Laura Andreson, and F. Carlton Ball, who all contributed their considerable skills as teaching potters to this region.

With very few exceptions the craftworkers of the Studio era had little understanding of the attainments of the earlier movement. As the Studio era gained momentum in the thirties, it was viewed by its newer protagonists as a period of discovery and self-directed study. This

critically important time for the crafts, 1935-1945, is represented candidly by examples of varying quality. It should be noted that the more tentative efforts represent the youth of these media. They are as illuminating in this respect as some of the masterful examples of their rapid maturity.

The role of craft education in the growth of the Studio era and its lack of contact with tradition cannot be overlooked. Until the 1930s, crafts had been taught as an incidental part of teacher training, with little or no reference to tradition or history. The development of the studio crafts was directly related to changing concepts in art education which, by the 1950s, had generally resulted in a transfer of the crafts from adjunct roles in teacher training programs to the art departments of colleges and universities. Increasing numbers of art students were then able to acquire their aesthetics and skills in pottery, jewelry, and weaving in a milieu similar to that consistently offered to students of painting, sculpture, and graphics. After 1950, the crafts exploded into a national phenomenon of handwork that was soon labeled a renaissance.

Another important ingredient in the growth of the crafts at mid-century was the arrival of outstanding designers and craftworkers from Europe, many of them educators. Their influence was felt directly in California through Marguerite Wildenhain's work and philosophy, which brought Bauhaus concepts of the crafts to many students in her school at Pond Farm in the fifties. Her pottery exemplifies a sureness of form and structure that brings concern with function and decoration into balance.

Among several leading individuals of this same era, who were not primarily educators but producing designer-craftsmen, were the studio potters Manuel Jalanivich of San Francisco, and Albert H. King of Los Angeles. One aspect of both men's work was the inspiration that they found in Asian ceramics. The former adapted Chinese forms in his cast and thrown earthenware, for which his partner-technician, Ingevardt Olsen, attained kindred glazes in brilliant color. The latter's quest for high-fire color in glazes produced brilliant celadons, reds, and blues on porcelains during the thirties. In metalsmithing, Harry Dixon's work and influence provided a virtually unique sense of continuity of purpose for twentieth-century crafts. The sensibilities of the earlier Craftsman style, to which he returned in the modern period, were admired by the new craftworkers as Dixon joined in the developments of the forties and continued to work for another twenty years.

Two women who entered the crafts field during the 1930s, Dorothy Liebes and Margaret De Patta, became nationally known leaders in their respective media, and are well represented in the museum's collection. Although Liebes is remembered primarily for her work in industrial design, her early design studio in San Francisco introduced vivid color and texturally innovative handwoven fabrics for interiors. These handloomed fabrics are characterized by her imaginative use of materials such as strips of leather or paper ticker tape from the San Francisco Stock Exchange.

Margaret De Patta was a pioneer of modern jewelry design whose unique studio production began in the 1930s without benefit of formal craft study. By the late thirties, her design was based upon Bauhaus concepts of form and structure. She drew upon its Constructivist roots to strengthen the direction of her work after brief studies with Laszlo Moholy-Nagy. A significant portion of De Patta's work is marked by her concern with optical qualities of transparent stones, refraction of light, and with new, modern design for the twentieth century. A substantial amount of De Patta's jewelry, donated by her widower and co-worker, Eugene Bielawski, is designated as the Margaret De Patta Memorial Collection.

Between 1945 and 1955, California developed into one of the country's most active and populous craft regions. These years soon brought definition to a field that was no longer composed of regionally isolated artists. Communication among craftworkers was now possible within California and throughout the nation through regional and national craft media exhibitions and organizations that all contributed to a broad sense of national development.

Throughout the country, the studio craftworker drew upon the resources of a world of decorative art for inspiration. In California, pottery continued to rely heavily upon Asian sources. Our jewelers found much to learn from ethnic sources and modern design. Textiles made striking advances as weavers drew upon both Scandinavian and Bauhaus influences in design and structure. Furniture also developed from the roots of modern Scandinavian design and other European sources.

The fascination with worldwide resources and techniques resulted in serious study for the advancement of individual skills, but it also opened the craftworker who did not have a firm base in ethnic heritage to the dangers of superficial mimicry and diversion from the goal of personal statement. In time, a typically American characteristic could be observed as influences were assimilated, and in California, a substantial number of artists emerged whose work was independent and individual in character.

A common goal of the time was to achieve acceptance for crafts as handmade objects that were art forms to be valued for their unique qualities. The term "designer craftsman" came into common usage as a concerted effort was begun to elevate the role of the craftworker from its secondary status to that of artist. Respect for the qualities of the media dictated form, structure, and, to some extent, surface design. In many respects, these goals did not differ greatly from those of the Arts and Crafts era.

The concept of handwork continued to be the essence of the crafts. Although collaboration, especially in the work of team studio potters was acceptable, a basic tenet of the time emerged: the object, from inception to completion, must be the work of a single individual.

The work and attitudes which strongly affected continuity and change were generally disseminated by charismatic leaders in educational institutions. There were exceptions, notably in the fields of furniture and enameling. During the 1940s and 1950s, enameling gained its regional strength in the studios of individuals such as Jackson and Ellamarie Woolley, or June Schwarcz, who took a much-abused medium and developed its inherent properties.

California has been well represented in the field of craftsman-made and designed furniture through the work of Sam Maloof and Art Carpenter. Maloof was an industrial designer whose handcrafted furniture designs became classics of the modern idiom and helped define the field. Art Carpenter, also known as Espenet, is another custom-furniture maker whose work expressed the modern style. Unlike Maloof, whose current work exhibits subtle refinement and change over the years, Espenet's designs have undergone several marked progressions. His attention has been given to a broad range of woodwork, including small objects and even the innovative design and construction of a circular house. Despite these outstanding examples, the field of furniture design remained relatively small. The old method of apprenticeship was sometimes practiced, but most training opportunities were found in the manual or industrial arts programs of institutions where the focus was on technique, rather than on design and creativity.

By the mid-1950s, the earlier struggle to achieve fine craftsmanship in all media through the development of skills and technical virtuosity had been achieved. Refinement of individual style or character of the work followed. So many acknowledged leaders emerged at

Ruth Asawa
Untitled, 1974 (75.20)
Bronze wire and copper pipe
Height: 1½ ft. (45.72 cm.)
Diameter: 12 ft. (274.32 cm.)
Gift of the Women's Board of the Oakland Museum Association

31

this time, that it was no longer possible to acquire as large a proportion of their efforts as had been collected from the work of artists active in earlier years. Nevertheless, the museum's collection represents a substantial number of individuals and can offer insight into the dominant concerns and developments of the crafts from World War II on. It should be noted that however expressive and individualized the work became, there was still no challenge to the traditional conventions of craft, and the goal of parity with other forms remained to be achieved.

When the first challenges to tradition emerged in the claywork of Peter Voulkos and a group of his independent students and fellow artists, ripples of astonishment followed. This reaction grew into a national response that varied from cautious approval to outright indignation among the majority of potters. Although Voulkos is usually considered a sculptor, his impact on the crafts, ceramics in particular, placed him in a unique position of leadership. Several examples of his ceramics from the early 1960s are included in the collection, and along with his recent works in clay, ably represent the advent of the post-modern era.

Early exhibitions tagged Voulkos' work as "Abstract Expressionist" ceramics, and indeed it was perceived as being quite similar in effect to the breakthrough in painting a decade earlier. A kinship between the gestural surface of freely worked clay and the surface of abstract painting found a common source in the Zen influence which had earlier broadened the scope of ceramics, but no concerted effort to redefine the vessel concept was as clearly indicated. Several individuals who worked in the free association of discovery which Voulkos en-

gendered in Los Angeles and Berkeley are also represented in the collections. Among them are Jim Melchert, John Mason, Ron Nagle, and Kenneth Price.

The 1960s became a decade of change in the crafts, spearheaded by the appearance of an avant-garde that was at first stronger in California than in most other parts of the country. Experimentation and search for new modes of expression brought significant change to all the crafts. The well-ordered field of weaving began a search for sculptural form, and an explosion of non-loom techniques followed in the 1970s. From its base in Bauhaus theory, the work of Trude Guermonprez responded to these currents of change with a series of tour de force multiple-warp weavings that initiated three-dimensional space hangings in the early sixties. Among the last of the craft media to undergo reinvestigation as an art form in the sixties was blown glass. Two early exponents of this medium, Marvin Lipofsky and Robert Fritz, moved through the developmental stages of traditional form, progressed to object making and then to a concern with sculptural values, all within a period of less than ten years.

The sculpture of a second giant in the field of clay, Robert Arneson, also evolved from the traditional vessel aesthetic. Breaking away from traditional ceramics in the 1960s, Arneson's work amused, startled, and sometimes outraged the viewer's sense of propriety. A succession of steps from Pop Art containers in 1962 to Funk objects and excursions into flaunting of taste and

proscribed subjects led to the significant narrative and biographical sculpture that Arneson's work is today.

The post-modern era is represented by more than icon smashing. There has been a significant broadening of scope in most craft media. The current duality of intent is apparent in the museum's collection through the continuing strength of the classical character of Harrison McIntosh's ceramics and the continuing development of Herbert Sanders' vessel aesthetic. The 1970s developments in trompe l'oeil, with roots in surrealism, are indicated by the work of Richard Shaw, or found in Ron Nagle's objectified cups set in their own precious environments. In fiber, the scale varied from monumental to miniature. The latter is found in the recent work of Kay Sekimachi, whose serene spirit is transferred to the woven book with pictorial references drawn from a rich ethnic heritage.

The viewer will undoubtedly draw some conclusions concerning the Oakland Museum's California crafts collection. California is still a land of newcomers and is traditionally American in this respect. While many of the craftworkers represented in the collection have been trained and nurtured in California, many others were born, trained, and began their professional careers in other parts of this country or abroad. Perhaps one defining California characteristic is a ready acceptance of new ideas and the continuing infusion of new people and new attitudes into its arts. This multimedia group of objects encompasses times when California's craftworkers were followers of national and international trends, and times, especially in recent years, when innovation and leadership have characterized their work.

COLLECTING CONTEMPORARY CALIFORNIA ART

by Christina Orr-Cahall
Chief Curator of Art

The Oakland Museum actively acquires and exhibits contemporary art in all media—painting, sculpture, drawing, prints, photography, mixed media, installation, and craft. These pursuits present the museum curator with challenges not posed to those who specialize in the work of earlier eras, and the diversity and sheer quantity of works created by contemporary artists amplify the task. Time allows a careful assessment of the developments of art, but that luxury is not available to those who deal with the present. Curators of contemporary art must be, to a degree, prognosticators. One esteemed museum director has said that if one in ten acquisitions of contemporary art is deemed significant in the next century, then the curator has outdistanced the odds.

Clearly the museum is charged with a complex and delicate balancing act. It is our responsibility to attempt to collect for the museum's present, and perhaps more important, future publics, art works which are of the highest quality, are most significant, and which, as the common phrase goes, "speak to our own time and yet transcend." The curator must remain objective about the times, remove the issue of personal taste from collecting as much as possible, and maintain an overview on the vast quantities and directions of art being produced.

Perhaps the most difficult aspect of collecting contemporary art is the requirement that one have an objective sense of one's own time. One must continually grapple with an understanding of what exactly one's culture is, and what art is truly representative of it. Contemporary art, with its strident questioning of established values and its avant-garde vitality has never easily suited or accommodated museums, art history, or the public.

A comparative example may help to illustrate the complexity of the problem.

The photographs of Dorothea Lange and the paintings of Maynard Dixon are considered historically and artistically important to our understanding of the Great Depression of the 1930s. These artists chose as subjects issues fundamental to the socio-economic structure of the United States—migrant mothers, strikebreakers. Today, museums prize works with those difficult themes to a greater degree than less problematic works by the same artists. Contemporary artists who treat such themes as nuclear war and Chicano farmworkers, however, tend to be avoided by critics, collectors, and even museums.

Recently, Robert Arneson completed a series of sculptures of bombs which comment on war and death. These works have proven far less popular with critics and the public than his earlier portrait works, filled with tongue-in-cheek humor. Yet, in the 1980s, war has been an almost constant concern of the American public. Does the museum acquire a "typical" Arneson bust or should the museum collect the more difficult, problematic work? Each work "speaks to our time" in a different way. It is clear which piece our present public finds more enjoyable, but it also appreciates difficult work. And what is our responsibility to our public 200 years away? Although the aesthetics and quality of a particular work remain the dominant criteria for curatorial selection, at issue is the degree to which historic or cultural milieu is an aspect of

museum collecting. Clearly, a curator does not acquire a work of art for a museum's collection simply because of topical subject matter. One can, however, find both Arneson bombs and Arneson portraits of varying quality, some exceptional. If a museum is not going to preserve the more difficult war works, who will?

The collecting of contemporary art must be intuitive, and, at the same time, highly discriminating. The curator must respond to trends, but always in the context of the larger perspective. Collecting can be likened to the appreciation of fine wines. To know fine wines of the past, one must study and taste. To discern fine wines of today, one relies on one's knowledge of past wines and one's sense or estimate of a wine's importance in the future. The winetaster cannot say with assurance whether with age the wine will become noteworthy, exceptional, or vinegar. The risk is always there, but it is tempered by intuition and experience. And if the risk is not taken, the decision not made, where is one's wine cellar in fifty years? So, too, with a museum collection of contemporary art.

The key rules for successful collecting are active looking, a honed sense of quality, an ability to understand one's time, an appreciation of, but not a subservience to, trends and directions, and a lack of greed. The too-eager curator can be stampeded into poor judgement in our present art market, where competition for the finest pieces can be fierce. Prices are constantly escalating, and the tendency is for the curator to purchase quickly before prices rise out of institutional reach. The curator must move quickly but not hastily. If the purchase is not made now, can it ever be? There is also the pitfall caused by the misplaced urge to acquire mediocre works by renowned artists simply to have those artists represented in the collection. It is better to resist such urges. Patience

will eventually pay off when a fine piece is offered for purchase or is donated to the institution. The fine work serves the artist, the museum, and its public, both present and future, to far greater advantage.

A curator of contemporary art cannot remain isolated at the office or immersed in books at the library. Familiarity with the opinions of critics, professors, dealers, collectors, and artists is important, and it is necessary to question and to assimilate written materials constantly. Visits to artists' studios, gallery shows, and museum exhibitions are essential. Looking is the single most crucial element in collecting success.

The Oakland Museum, since its inception in 1916 as the Oakland Art Gallery, has been noted for its interest in contemporary art and its progressiveness in introducing artists to the museum-going public. Such highly esteemed contemporary artists as Richard Diebenkorn, Mel Ramos, and Stephen De Staebler received early museum recognition in our institution. Our curators of contemporary art make frequent studio visits. We take risks in support of developing artists. Meanwhile, The Oakland Museum carries on an active exhibition program for more established California artists.

As might be imagined, choosing which contemporary works to include in this book was very difficult. California art today is highly diverse, abundant, often controversial, and decidedly part of the international art scene. Artists and their works were selected to give a solid overview of the direction of California art over the past two decades, to provide a view of major artists who are recognized nationally, and to focus on those Californians who merit more attention. We also wanted to highlight major pieces within our collection, to emphasize the pluralism of contemporary art, to acknowledge the many cultures which have contributed significantly to the arts of California, and to lend understanding to what remains uniquely Californian about our art in this age of travel and mass communication.

It might be of benefit to examine the work of several California artists who have contributed to the pluralism of contemporary American art and who stand as significant figures in the development, and new-found strength, of California art in the past few decades. Robert Hudson's work is most asssuredly Californian. With whimsy and apparent abandon his polychromed sculpture twists and turns, defying prevalent contemporary guidelines for sculpture as the stoic object. Robert Arneson, too, discarded traditional concepts of work in clay to create his early tongue-in-cheek portraits of well-known California figures, including himself. In his more recent works, including his portrait bust of slain San Francisco Mayor George Moscone, Arneson adds graffiti-type phrases and symbols to echo the overall themes.

Such occasionally cryptic but usually telling messages are also found in the paintings, sculptures, and prints of William Wiley. His intricately drawn paintings are, of late, mixed with bold swashes of paint, creating a duality in image and context. In the illustrated woodcut, selected from our collection because it is Wiley's first, the artist has experimented with developing the woodcut to resemble a watercolor. The mysticism of his work is further acknowledged in this West-meets-East approach, which seems the perfect medium for Wiley's printed works.

Nathan Oliveira also strikes one as being singularly Californian. It can be argued that his painting has developed upon the Bay Area Figurative style of the 1950s. The work in the museum's permanent collection clarifies the artist's individual style—broad but not overpowering gesture in the brushstroke, colors which are paradoxically both comforting and, in a positive way, disquieting in their juxtaposition. The viewer wonders about these enigmatic female figures whose faces are always turned or brushed away.

Joan Brown's strong, gestural figures also have their roots in the Bay Area Figurative tradition. Brown's early work, as exemplified in *Girl Sitting*, deals with the everyday, the commonplace, personalized and accessible. Although wit is evident in many of Brown's paintings, it does not dilute the strength and dynamism of her color and composition.

Realism is not widely collected in California, but it has an important place in our arts, especially in terms of its national and international impact. The Oakland Museum continues to collect contemporary California realism in the belief that its role in American art is significant. Wayne Thiebaud is best known for his delicatessen counter paintings, and the museum is fortunate to have a major example in its collection. Illustrated elsewhere in his book is Thiebaud's more recent work of the San Francisco cityscape with an emphasis on that city's steep hills. Thiebaud's composition, although very structured, is rather unorthodox, and his colors—particularly his purples, yellows, and greens—are highly intense.

Robert Bechtle, represented in this book by his complex triptych etching, offers his own particular view of the proverbial California bungalow in stucco. Although the etching is filled with such visual details as cars, telephone poles and lines, the overall impression is vacant, empty. There is a normality, a sense of the matter-of-fact, everyday American existence in Bechtle's realist work. On the other extreme is Mel Ramos' *Browned Bare*, an exaggerated Pop Art response to the myth of the sybaritic West Coast lifestyle based on the much older myth of beauty and the beast. The contrast of the nude blonde woman reclining against the furry brown bear, California's state animal, is presented in a humorous imitation of the style of the Playboy centerfold. Ramos, who has always worked in Northern California, was a principal proponent of American Pop Art in the 1960s.

Ed Ruscha has also dealt with the

mystique associated with living in California. *Hollywood*, the sign which looms larger-than-life in the hills above the city of Los Angeles, is a cavalier comment on the fast-track life of Hollywood. More elusive in its interpretation is Michael McMillen's miniature version of a decaying, burned-out billboard, obscurely inscribed around the base, pierced with arrows, including two which have missed and struck the Plexiglas cover. There is humor and ambiguity in McMillen's comment on our culture, or lack thereof, but there are no direct answers.

California art is enriched by the ethnic and racial diversity of the state's artists. In the 1950s and 1960s, black California artists such as Arthur Carraway and Betye Saar worked in the mainstream of American art using subtle cultural and personal references. Charles White, on the other hand, drew upon his background to create works which more directly celebrate the strengths in the black heritage of America. In White's *Silent Song*, the child is filled with courage and faith which take him beyond his pain and pathos. Rendered in realistic detail, the effect of the monochromatic use of sepia color transcends time to allow the work to speak for all moments, for all children. In Arthur Carraway's *Fetish Form—Series II*, totemic references to African woodcarvings and actual found-object ritual fragments augment the dynamism and mystery created by the gestural paint surface and subdued palette.

In the 1970s, the wide variety of cultures living and working together pushed California art toward greater and more conscious multiethnicity. Increasingly, artists began to comment on our society, its stereotypes, its mistreatment of the non-white or non-Anglo races, and its willingness to destroy ethnic traditions. Rupert Garcia, in a silkscreen print which emphasizes masses of color, simplifies the profile of a native American to highlight his strength and remind us of his fate. Robert Colescott in *My Shadow* takes a satirical approach to race relations with parodied Disneyesque figures in a child's

room setting. Masami Teraoka, in a watercolor style that closely resembles traditional Japanese woodcut prints, portrays America—fast-food hamburgers and, in this case, 31 flavors of ice cream—invading the world. On the other hand, Raymond Saunders' work is highly personal, open for wide social interpretation, and certainly should be appreciated for its abstract qualities.

Another approach to art-making in California involves the creation of pieces that are deceptively simple in appearance. Such works cross boundaries of scale and media. David Simpson's painted black canvas with geometric edges of dissonant, muted color is perfect in its balance. Deceptively simple, the work could only be created by an artist with great knowledge of color, composition, and with significant technical skill, for paint densities and surfaces must be exactly even for this painting to be effective.

Larry Bell's glass cube poses a similar contradiction. Strikingly beautiful and engaging, the piece is at first glance minimalist in its statement, but upon further study it yields much to contemplate. The viewer's first reaction is to presume that the cube is composed of six mirrored surfaces and nothing more. But as the viewer moves, both reflective and transparent surfaces change throughout the sculpture, and it becomes apparent that the artist has displayed a knowledge of lenses and their physical characteristics, as well as an artistic sense of composition and light. Bruce Beasley's *Tragamon*, in the museum's reflecting pool, also deals with light and space. The multi-faceted Lucite piece, pristine in the still water, takes on new dimensions in the rain, fog, and our California light, casting rainbows in unexpected places. Michael Heizer's monumental sculpture, *Platform*, shares this minimalist characteristic, but it too takes on a greater dimension as an envi-

ronmental statement in its site in Oakland's Estuary Park.

Even in 1984, California is an amazingly young state. The gold rush is only a little over 130 years behind us. The arts here have not taken root in the deep soil of long practice, but what we lack in tradition we have gained in a perhaps totally unprecedented freedom. From the gold rush on, Easterners viewed Californians as mavericks, opportunists, Bohemians, Beats, and eventually Hippies. This attitude toward California extended to more than the visual arts—to literature, to music, to religion, to fashion, to our lifestyle in general. As artists with strong individual art identities—Richard Diebenkorn, Sam Francis, Edward Kienholz, and Peter Voulkos—came to the forefront and established clear, strong national and international identities, it became easier for other California artists to break out of California's group identity. Overall, the advantage of the West Coast's physical and perceived isolation was that our artists could work outside of the dictates of the art world, away from the intense competition and relatively unencumbered by the critics' expectations.

The contemporary arts of California have received significant recognition during the past fifteen years. This attention has surfaced, both nationally and internationally, in major exhibitions, public and private collections, and commissions. In the last decade in particular, California has changed from a regional enclave to an active participant in and influence on the mainstream art scene. Increasingly, our artists are being cited for their important individual expressions and their contributions to national and international art. It is interesting to note that those acclaimed represent a remarkably broad stylistic spectrum: Michael Heizer, Robert Irwin, Richard McLean, Joan Brown, Robert Arneson, Ed Ruscha, Wayne Thiebaud, Jonathan Borofsky, Robert Graham, Billy Al Bengston, and William Wiley to name but a few.

Important in the growing significance

of California is the changing focus from a California school to a broader and more comprehensive grasp of the breadth of individual expression among the state's artists. Indeed, regionalism in terms of city, state, and country is diminishing worldwide. California artists go where support and exhibition opportunities present themselves, while the state continues to be a magnet for visiting artists. California artists such as Manuel Neri and Billy Al Bengston spend long periods of time working in Europe or throughout the Pacific and return to their permanent homes in California. Morris Graves, after traveling widely for a lifetime, has, for the past fourteen years, been settled in California. Masami Teraoka, Robert Graham, and many others have joined us from parent cultures. The inherent defensiveness of any regionalism, the "us against them" stance, has all but disappeared in today's wide-angle focus. The worldwide critical attention afforded to our major contemporary artists has led to increased consideration and re-evaluation of all the arts of California.

Michael Heizer
Platform, 1980 (80.109)
Welded steel on concrete base
7 ft. 6 in. × 20 ft. × 24 ft. (228.6 × 609.6 × 731.5 cm.)
Gift of the Art Guild, Women's Board, Concours d'Antiques, private donations, and the National Endowment for the Arts

These works, which have been acquired prior to January 1984, are arranged in approximate chronological order, media integrated within that order.

Dimensions, exclusive of frame, list inches before centimeters, which are placed within parentheses. Unless otherwise noted, height precedes width precedes depth. The Art Department's accession number, also within parentheses, follows the date of the object.

LOUIS CHORIS

Born March 22, 1795, Yekaterinoslaf, Ukraine, Russia
To California 1816
Died March 22, 1828, Mexico

EDUCATION: Trained in Moscow. Studied lithography in Paris following the Otto von Kotzebue expedition to the South Seas, 1815-16.

SELECTED GROUP EXHIBITIONS: Oakland Art Museum, *Early Paintings of California in the Robert B. Honeyman Jr. Collection*, 1956; Santa Barbara Museum of Art, California, *California Pictorial 1800-1900*, 1962; University of California, Davis, *From Frontier to Fire: California Painting from 1816-1916*, 1964.

FURTHER REFERENCES: Van Nostrand, Jeanne. *The First Hundred Years of Painting in California, 1775-1875*. San Francisco: John Howell—Books, 1980.

WORKS IN THE COLLECTION:
2 watercolors

The oldest art works in the Art Department's collection are the watercolor sketches of Louis Choris, who traveled to California with the Russian expedition led by the explorer Otto von Kotzebue. Choris sketched this fine portrait of a local native American when the expedition visited the San Francisco Bay Area in 1816.

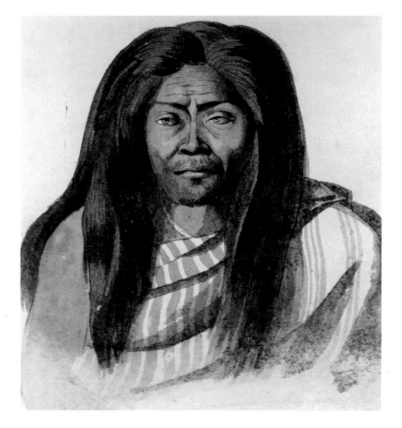

Indian of California, c. 1816 (55.20.1)
Watercolor on paper
5⅜ × 4⅞ in. (13.6 × 12.4 cm.) (image)
Museum Donors' Acquisition Fund

JOHN JAMES AUDUBON

Born April 26, 1785, Les Cayes, Saint-Domingue
Died January 27, 1851, Minnie's Land, New York

EDUCATION: Lessons in oil from John Stein, an itinerant limner, 1822, and from Thomas Sully, 1824.

SELECTED GROUP EXHIBITIONS: Edinburgh Royal Institution, 1826; National Academy of Design, New York, 1833; Academy of Natural Sciences, Philadelphia, Pennsylvania, 1938; National Audubon Society, New York, 1951; Brooks Memorial Art Gallery, Memphis, Tennessee, 1954; Princeton University Library, New Jersey, 1959; Munson-Williams-Proctor Institute, Utica, New York, and The Pierpont Morgan Library, New York, 1965; North Carolina Museum of Art, Raleigh, 1976.

FURTHER REFERENCES: Ford, Alice. *John James Audubon*. Norman: University of Oklahoma Press, 1964.

WORKS IN THE COLLECTION: 2 prints

The California Vulture *has a startling presence. In part the sheer size of this hand-colored aquatint, called a double elephantine folio, demands attention. Each Audubon print was originally issued in an edition of more than one hundred, but so few survive today that this is among the rarest of fine American prints.*

California Vulture (Old Male), n.d. (65.110)
Hand-colored aquatint on paper
33 × 25 in. (83.8 × 63.5 cm.) (image)
Museum Donors' Acquisition Fund

ALFRED SULLY

Born May 20, 1821, Philadelphia, Pennsylvania
In Monterey and Benicia, California 1849-53
Died April 27, 1879, Fort Vancouver, Washington

EDUCATION: United States Military Academy, West Point, New York, 1837-41.

SELECTED GROUP EXHIBITIONS: The Oakland Museum, *Watercolors from the California Collection*, 1977.

FURTHER REFERENCES: Arkelian, Marjorie. *The Kahn Collection of Nineteenth-Century Paintings by Artists in California*. Oakland: The Oakland Museum, 1975. Van Nostrand, Jeanne. *The First Hundred Years of Painting in California, 1775-1875*. San Francisco: John Howell—Books, 1980.

WORKS IN THE COLLECTION:
3 watercolors and 1 drawing

In 1849, Sully was stationed in Monterey, California as a quartermaster in the U.S. Army. He boarded with a Spanish-Californian family and eventually married his landlord's daughter. The artist's letters to his famous father, portraitist Thomas Sully, describe life on his father-in-law's rancho, which is pictured here in this watercolor.

Monterey, California Rancho Scene, c. 1849 (65.43)
Watercolor on paper
8 × 10¾ in. (20.3 × 27.3 cm.) (image)
Kahn Collection

NATHANIEL CURRIER

Born March 27, 1813, Roxbury, Massachusetts
Died November 20, 1888, New York, New York

EDUCATION: Apprentice to William S. and John
Pendleton, Boston, Massachusetts, 1828-33; apprentice to M. E. D. Brown, Philadelphia, Pennsylvania,
1833-34.

FURTHER REFERENCES: Peters, Harry T.
Currier & Ives: Printmakers to the American People.
Garden City, New York: Doubleday, Doran & Co.,
Inc., 1942. Rawls, Walton. *The Great Book of Currier
& Ives' America.* New York: Abbeville Press, 1979.

WORKS IN THE COLLECTION:
6 Nathaniel Currier prints and 10 Currier & Ives
prints

*From the discovery of gold, treated humorously
here in this rare print, to the exploration of the
Sierra Nevada, Nathaniel Currier, working both
alone and later with his partner James Ives, pictured
the great events of the West. Today we recognize
that their lithographs, printed from large stones and
sold plain or hand-colored, are a visual record of
the life and attitudes of the people of the nineteenth
century.*

The Way They Go to California, c. 1849 (68.90.1)
Hand-colored lithograph on paper
10¾ × 17¼ in. (27.31 × 43.82 cm.) (image)
The Oakland Museum Founders Fund

41

E. HALL MARTIN

Born 1818, Cincinnati, Ohio
To California 1849 and settled in San Francisco and Sacramento
Died 1851, Onion Valley, California

EDUCATION: Unknown.

SELECTED GROUP EXHIBITIONS: American Art Union, New York, 1847, 1848; Whitney Museum of American Art, New York, *The American Frontier: Images and Myths*, 1973; National Collection of Fine Arts, Smithsonian Institution, Washington, D.C., *America as Art*, 1976.

FURTHER REFERENCES: Arkelian, Marjorie. "An Exciting Art Department 'Find'." *Art* (Art Guild of the Oakland Museum Association), Vol. II, No. 1 (January-February 1974), n.p.

WORKS IN THE COLLECTION: 1 painting

In this allegorical gold rush mural, Martin, who was both Forty-Niner and artist, presents the "Wandering Miner," with his belongings strapped to his back, taking directions from "Mountain Jack." This mural is one of three known works by Martin featuring the mythical guide, Mountain Jack.

Mountain Jack and a Wandering Miner, 1850 (73.48)
Oil on canvas
39½ × 72 in. (100 × 182.9 cm.)
Gift of Concours d'Antiques

GEORGE D. BREWERTON

Born June 3, 1827, Newport, Rhode Island
In California 1847, 1848, 1878
Died January 31, 1901, Fordham, New York

EDUCATION: United States Military Academy, West Point, New York, 1840s.

SELECTED GROUP EXHIBITIONS: National Academy of Design, New York, 1855, 1859; Pennsylvania Academy of Art, Philadelphia, 1859; Fort Worth Art Center, Texas, *19th-Century Painters of the Southwest*, 1958.

FURTHER REFERENCES: Brewerton, George Douglas. *Overland with Kit Carson: A Narrative of the Old Spanish Trail in '48.* New York: Coward-McCann, Inc., 1930.

WORKS IN THE COLLECTION: 1 painting

Second Lieutenant Brewerton was stationed in San Francisco in 1847 with the First New York Infantry Volunteers. In 1848, accompanied from Los Angeles to Santa Fe by Kit Carson, he traveled over the Old Spanish Trail to join the regular army in Mississippi. The landscape shown in this painting is between Bitter Spring and Resting Spring in the Mojave Desert.

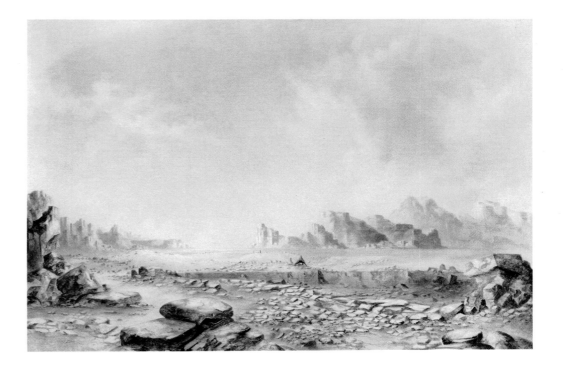

Jornada del Muerto, 1853 (65.60)
Oil on canvas
30 × 44 in. (76.2 × 111.76 cm.)
Kahn Collection

ISAAC BAKER

Born 1810, Beverly, Massachusetts
To California 1849, settled at Murphy's Camp, Vallecita, California 1853
Died in Sumatra, date unknown

EDUCATION: Unknown.

SELECTED GROUP EXHIBITIONS: The Oakland Museum, *Mirror of California: Daguerreotypes*, 1973.

FURTHER REFERENCES: Artist's File, Archives of California Art, The Oakland Museum. Heyman, Therese Thau. *Mirror of California: Daguerreotypes*. Oakland: The Oakland Museum, 1974.

WORKS IN THE COLLECTION:
7 daguerreotypes and 1 ambrotype

Baker traveled through the mining camps in his wagon, making daguerreotypes of workers. This Chinese youth traveled with Baker, and his portrait is among the earliest known of an Asian in California.

Portrait of a Chinese Man, c. 1851 (68.94.1)
Daguerreotype
3¾ × 3¼ in. (9.5 × 8.3 cm.)
Gift of Anonymous Donor

44

WILLIAM SMITH JEWETT

Born August 6, 1812, South Dover, New York
In California 1849-69, 1871
Died December 3, 1873, Springfield, Massachusetts

EDUCATION: Unknown.

SELECTED GROUP EXHIBITIONS: National Academy of Design, New York, 1838-51; Mechanics' Institute Industrial Exhibition, San Francisco, 1857; Ladies' Christian Commission Fair for Wounded Sailors and Soldiers, Union Hall, San Francisco, 1864.

FURTHER REFERENCES: Arkelian, Marjorie. *The Kahn Collection of Nineteenth-Century Paintings by Artists in California.* Oakland: The Oakland Museum, 1975. Evans, Elliot. "William S. and William D. Jewett." *California Historical Society Quarterly*, Vol. XXXIII (December 1954), pp. 309-20.

WORKS IN THE COLLECTION:
3 portrait paintings

In this portrait, Theodore Judah, a young engineer who masterminded California's first railroad, is pictured wearing a gold ring made from a nugget found on the route. One of the three engines belonging to the railroad, a twenty-two-mile line between Sacramento and Folsom, is shown in the background of the portrait.

Portrait of Theodore Dehone Judah, 1855 (65.49)
Oil on canvas
24 × 20 in. (60.96 × 50.8 cm.) (Oval)
Kahn Collection

CHARLES CHRISTIAN NAHL

Born October 18, 1818, Kassel, Germany
Emigrated to New York, New York 1849
To California 1851
Died March 1, 1878, San Francisco, California

EDUCATION: Kassel Academy, Germany; studied with or influenced by Horace Vernet and Paul Delaroche, Paris, 1846.

SELECTED ONE-ARTIST EXHIBITIONS: E. B. Crocker Art Gallery, Sacramento, California, 1976.

SELECTED GROUP EXHIBITIONS: Berlin Art Academy, Germany, 1838; Dresden Academy, Germany, 1842; Paris Salon, 1847, 1848; American Art Union, New York, 1849, 1850, 1852; Mechanics' Institute Industrial Exhibitions, San Francisco, 1857-78; San Francisco Art Association, 1873, 1874; California Midwinter International Exposition, San Francisco, 1894; Alaska-Yukon-Pacific Exposition, Seattle, Washington, 1909.

FURTHER REFERENCES: Stevens, Moreland Leithold. *Charles Christian Nahl: Artist of the Gold Rush, 1818-1878*. Sacramento, California: E. B. Crocker Art Gallery, 1976.

WORKS IN THE COLLECTION: 11 paintings and 3 watercolors

Charles Christian Nahl brought with him the high standards of excellence in painting and the graphic arts he had learned in Paris and his native Germany when he settled in California in 1851. This 1858 portrait, which demonstrates the artist's mastery in rendering natural flesh tones and various fabrics, pictures the proprietress of a millinery and dry goods store in San Francisco.

Portrait of Jane Eliza Steen Johnson, 1858 (77.113.1)
Oil on canvas
34¼ × 26⁵⁄₁₆ in. (87 × 66.8 cm.)
Gift of Dr. Gerald H. Gray

ALBURTUS DEL ORIENT BROWERE

Born March 17, 1814, Tarrytown, New York
In California 1852-56 and 1858-61
Died February 17, 1887, Catskill, New York

EDUCATION: Primarily self-taught, but studied early under father John Henri Isaac Browere, a sculptor.

SELECTED ONE-ARTIST EXHIBITIONS: M. Knoedler & Co., New York, 1940.

SELECTED GROUP EXHIBITIONS: National Academy of Design, New York, 1831-46; American Academy of Fine Arts, New York, 1833; Apollo Association, New York, 1838, 1839; American Art Union, 1848; Metropolitan Museum of Art, New York, *Life in America*, 1939; Santa Barbara Museum of Art, California, *California Pictorial 1800-1900*, 1962; Whitney Museum of American Art, New York, *The American Frontier: Images and Myths*, 1973, and *The Painters' America: Rural and Urban Life, 1810-1910*, 1975.

FURTHER REFERENCES: Arkelian, Marjorie. *The Kahn Collection of Nineteenth-Century Paintings by Artists in California*. Oakland: The Oakland Museum, 1975.

WORKS IN THE COLLECTION: 2 paintings

This view of the Sierra Nevada terrain was probably painted during the artist's second trip to California from his Hudson River home. The reclining figure on the right may be a self-portrait.

South of Tuolumne City, 1861 (65.16.3)
Oil on canvas
30 × 44 in. (76.2 × 111.8 cm.)
Kahn Collection

ALBERT BIERSTADT

Born January 7, 1830, Solingen, Germany
In California 1863, 1871-73, 1880
Died February 18, 1902, New York, New York

EDUCATION: Studied informally under Worthington Whittredge and Emmanuel Leutze, Düsseldorf, Germany, 1853-57. Toured Germany, Italy, and Switzerland with Whittredge, 1856.

SELECTED ONE-ARTIST EXHIBITIONS: Santa Barbara Museum of Art, California, 1964; Amon Carter Museum of Western Art, Fort Worth, Texas, 1972; M. Knoedler & Co., New York, 1972.

SELECTED GROUP EXHIBITIONS: National Academy of Design, New York, 1858-65, 1867, 1868, 1871, 1872, 1874-77, 1880, 1881, 1884-88; California Art Union, San Francisco, 1865; San Francisco Art Association, 1873; Centennial Exposition, Philadelphia, Pennsylvania, 1876; World's Columbian Exposition, Chicago, 1893.

FURTHER REFERENCES: Baigell, Matthew. *Albert Bierstadt*. New York: Watson-Guptill Publications, 1981. Hendricks, Gordon. *Albert Bierstadt: Painter of the American West*. New York: Harry N. Abrams in association with the Amon Carter Museum of Western Art, 1973.

WORKS IN THE COLLECTION: 11 paintings and 5 chromolithographs

Bathed in a glow of light that reveals Bierstadt's affinity to American Luminism, this autumn landscape of Yosemite Valley looks west from the eastern end of the valley, with El Capitan rising on the right and Sentinel Rock on the left. Bierstadt finished this landscape in 1868, several years after his first trip to the valley in 1863.

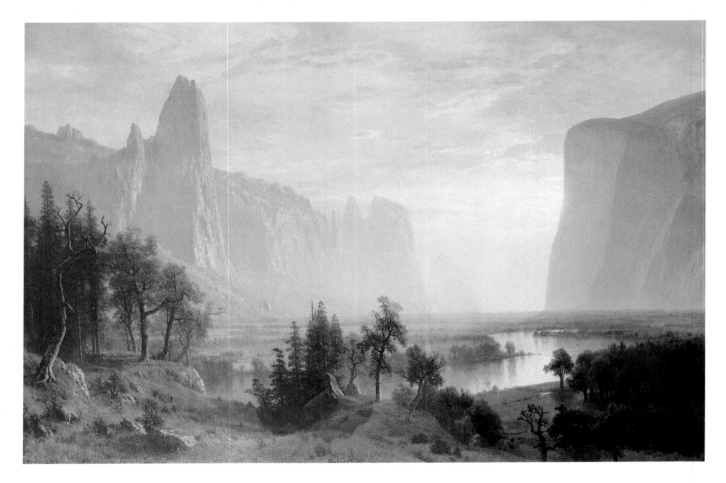

Yosemite Valley, 1868 (64.26)
Oil on canvas
36 × 54 in. (88.9 × 137 cm.)
Gift of Miss Marguerite Laird in memory of Mr. and Mrs. P. W. Laird

MARTIN JOHNSON HEADE

Born August 11, 1819, Lumberville, Pennsylvania
In California 1875
Died September 4, 1904, St. Augustine, Florida

EDUCATION: Studied with Edward Hicks and possibly Thomas Hicks, Newtown, Pennsylvania, c. 1838; informal study in Italy, France, England, c. 1839-41.

SELECTED ONE-ARTIST EXHIBITIONS: Museum of Fine Arts, Boston, Massachusetts, 1969; The Cummer Gallery of Art, Jacksonville, Florida, 1980-81.

SELECTED GROUP EXHIBITIONS: Pennsylvania Academy of the Fine Arts, Philadelphia, 1841-81; National Academy of Design, New York, 1843-90; Brooklyn Art Association, New York, 1864-81; Royal Academy of Arts, London, 1865; British Institution, London, 1865; Boston Athenaeum, Massachusetts, 1867-73; San Francisco Art Association, 1875; Centennial Exposition, Philadelphia, Pennsylvania, 1876.

FURTHER REFERENCES: Stebbins, Theodore E., Jr. *The Life and Works of Martin Johnson Heade.* New Haven and London: Yale University Press, 1975.

WORKS IN THE COLLECTION: 1 painting

San Francisco's Seal Rocks, close offshore near Ocean Beach, provided picturesque subject matter for many nineteenth-century artists, but the subject was quite unusual for M. J. Heade, a painter in the Luminist tradition and a restless traveler who is best known for his tropical subjects. He painted this California scene in the 1870s.

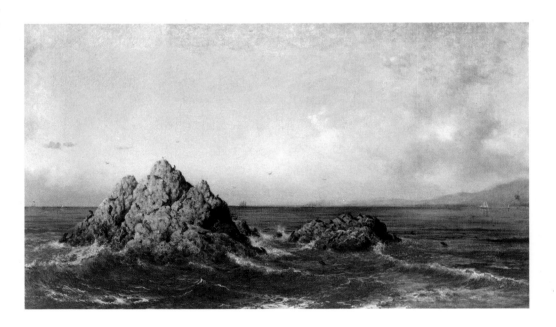

Seal Rocks at San Francisco, c. 1875 (65.50)
Oil on canvas
18 × 30 in. (45.72 × 76.2 cm.)
Kahn Collection

ERNEST NARJOT

Born December 25, 1826, Saint-Malo, France
In California c. 1849-52 and c. 1865-98
Died August 24, 1898, San Francisco, California

EDUCATION: Académie Julian, Paris.

SELECTED GROUP EXHIBITIONS: Mechanics' Institute Industrial Exhibitions, San Francisco, 1871-94; San Francisco Art Association, 1872-90; World's Columbian Exposition, Chicago, 1893; California Midwinter International Exposition, San Francisco, 1894.

FURTHER REFERENCES: Dressler, Albert. *California's Pioneer Artist: Ernest Narjot*. San Francisco: Albert Dressler, 1936.

WORKS IN THE COLLECTION:
7 paintings and 2 prints

Fresh from his studies at the Académie Julian in Paris, Narjot joined the gold rush to California in 1849. In addition to his mining actvities in California and Mexico, Narjot maintained a separate career as an artist, often painting genre subjects involving border life, such as this horserace scene.

Horse Race, n.d. (61.5.2)
Oil on canvas
17¾ × 40 in. (45 × 101.6 cm.)
Gift of Mrs. Leon Bocqueraz

FORTUNATO ARRIOLA

Born 1827, Cosala, State of Sinaloa, Mexico
In San Francisco, California c. 1858-71
Died August 15, 1872, Atlantic Ocean

EDUCATION: Well-educated in literature and history, but self-taught in art.

SELECTED ONE-ARTIST EXHIBITIONS:
California Historical Society, San Francisco, 1974.

SELECTED GROUP EXHIBITIONS: Mechanics' Institute Industrial Exhibitions, San Francisco, 1864, 1865, 1876, 1881, 1890; National Academy of Design, New York, 1872.

FURTHER REFERENCES: Arkelian, Marjorie. *The Kahn Collection of Nineteenth-Century Paintings by Artists in California*. Oakland: The Oakland Museum, 1975.

WORKS IN THE COLLECTION: 1 painting

Working in San Francisco, Arriola painted many tropical scenes from memories of his native Mexico. The viewer's sustained interest in this mysterious painting, aside from the luminous beauty of the setting, remains with the artist's curious depiction of the four figures riding three horses.

Tropical Landscape, 1870 (65.16.1)
Oil on canvas
48 × 76¾ in. (121.9 × 194.9 cm.)
Kahn Collection

CARLETON E. WATKINS

Born November 11, 1829, Oneonta, New York
To California c. 1852
Died June 23, 1916, Napa, California

EDUCATION: Learned daguerreotypy in Robert
H. Vance's gallery, San Jose, California, 1854.

SELECTED ONE-ARTIST EXHIBITIONS:
Goupils Gallery, New York, 1863; Mechanics' Insti-
tute Industrial Exhibitions, San Francisco, 1864-
1880; Paris International Exposition, France, 1867;
Focus Gallery, San Francisco, 1973; Fraenkel Gallery,
San Francisco, 1979; Simon Lowinsky Gallery, San
Francisco, 1979; Amon Carter Museum of Western
Art, Fort Worth, Texas, and The Oakland Museum,
1983.

SELECTED GROUP EXHIBITIONS: Oak-
land Art Museum, *Photography and the West*, 1967;
The Oakland Museum, *Yosemite*, 1979, and *Slices of
Time: California Landscape 1860-1880, 1960-1980*,
1982; Metropolitan Museum of Art, New York, and
Albright-Knox Art Gallery, Buffalo, New York, *Era
of Exploration*, 1975; High Museum of Art, Atlanta,
Georgia, *A Century of American Landscape Pho-
tography*, 1980; Crocker Art Museum, Sacramento,
California, *Western Landscape Photography: A Sur-
vey 1850-1980*, 1980; Museum of Modern Art, New
York, *American Landscape*, 1981; Fresno Arts Center,
California, *Views of Yosemite*, 1982.

FURTHER REFERENCES: Palmquist, Peter.
*Carleton E. Watkins: Photographer of the American
West*. Albuquerque: University of New Mexico Press
for the Amon Carter Museum, Fort Worth, Texas,
1983.

WORKS IN THE COLLECTION:
93 photographic prints (stereoviews and mammoth
plates)

*Watkins stood out among nineteenth-century west-
ern photographers in his mastery of the arduous
technique of wet plate photography and his artfully
balanced compositions. His characteristic use of
light to reveal each texture for its essential surface
can be seen here in the peculiar rocky quality of
the ground around the mine.*

New Almaden Quicksilver Mine, c. 1870 (66.12.2)
Albumen mammoth plate print
15 × 20⅝ in. (38.1 × 52.4 cm.)
Gift of Paul S. Taylor

JOSEPH LEE

Born 1827, England
To California c. 1858
Died January 13, 1880, San Francisco, California

EDUCATION: Unknown. Trained as a sign and
ornamental painter.

SELECTED ONE-ARTIST EXHIBITIONS:
California Historical Society, San Francisco, *Through
a Spyglass*, 1968.

SELECTED GROUP EXHIBITIONS: Me-
chanics' Institute Industrial Exhibitions, San Fran-
cisco, 1858, 1875-77, 1879; San Francisco Art As-
sociation, 1873.

FURTHER REFERENCES: Erskine, Alice Put-
nam. "Joseph Lee, Painter." *Antiques*, June 1969, pp.
805-11.

WORKS IN THE COLLECTION:
3 paintings

*This view of the Badger residence on the estuary in
Brooklyn Township, East Oakland, was painted
just before Captain Badger developed a public park
on the ten-acre estate. A local railroad ran past
the property, and Bay ferries berthed nearby.*

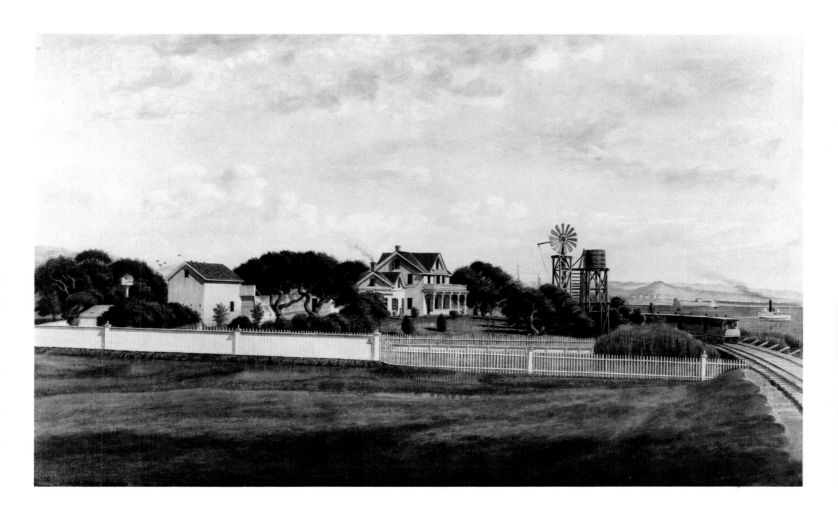

*Residence of Captain Thomas W. Badger, Brooklyn
from the Northwest* (in Oakland, California), c. 1871
(62.80.296)
Oil on canvas
26¼ × 42 in. (72.44 × 106.68 cm.)
Gift of the Oakland Society of Pioneers

53

EADWEARD JAMES MUYBRIDGE
(né Edward James Muggeridge)

Born April 9, 1830, Kingston-upon-Thames, Surrey,
England
In California c. 1855-60 and 1867-81
Died May 8, 1904, Kingston-upon-Thames, Surrey,
England

EDUCATION: Primarily self-taught.

SELECTED ONE-ARTIST EXHIBITIONS:
The Art Room, San Francisco, 1880; Stanford University Museum, California, 1972; Atholl McBean
Gallery, San Francisco Art Institute, 1977; Fraenkel
Gallery, San Francisco, 1981.

SELECTED GROUP EXHIBITIONS: Oakland Art Museum, *f/64 and Before*, 1966, and *Photography and the West*, 1967; The Oakland Museum,
West of the Rockies, 1971, *Yosemite*, 1979, and
American Photographers and the National Parks,
1981; Huntington Library and Art Gallery, San Marino, California, *Early Photographs of the Southwest*,
1968; Robert Schoelkopf Gallery, New York, *Significant 19th and 20th Century Photographs*, 1970; Focus Gallery, San Francisco, *The Glow of Ages*, 1972;
Metropolitan Museum of Art, New York, and Albright-Knox Art Gallery, Buffalo, New York, *Era of
Exploration*, 1975; Fresno Arts Center, California,
*Views of Yosemite: The Last Stance of Romantic
Landscape*, 1982.

FURTHER REFERENCES: Witkin, Lee D.,
and Barbara London. *The Photograph Collector's
Guide*. Boston: New York Graphic Society, 1979, pp.
198-99.

WORKS IN THE COLLECTION:
125 photographic prints

Western landscape photography was in its earliest
stage when Muybridge made this splendid view
of Loya, one of a series of mammoth-plate albumen
prints of Yosemite Valley. Throughout his photographic career, Muybridge reached for the innovative solution, here suggesting the grandeur of
nature through the angle of the photograph.

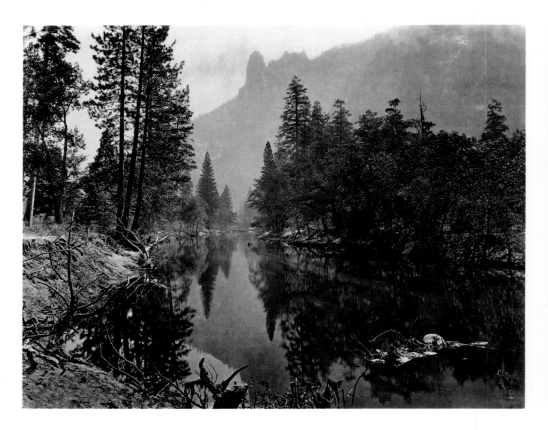

Loya, Valley of the Yosemite, 1872 (57.12.2L)
Albumen print
16¾ × 21½ in. (42.6 × 54.6 cm.)
Gift of Robert B. Honeyman, Jr.

JULIAN RIX

Born December 30, 1850, Peacham, Vermont
In California 1854-57 and 1865-81
Died November 24, 1903, New York, New York

EDUCATION: Self-taught.

SELECTED ONE-ARTIST EXHIBITIONS:
San Francisco Art Association, 1883; Golden Gate
Park Memorial Museum, San Francisco, 1917.

SELECTED GROUP EXHIBITIONS: San
Francisco Art Association, 1876-84; Mechanics' Institute Industrial Exhibitions, San Francisco, 1878-87;
National Academy of Design, New York, 1882-94;
World's Columbian Exposition, Chicago, 1893.

FURTHER REFERENCES: *California Art Research Monographs*. Ed. Gene Hailey. San Francisco:
Works Progress Administration, 1937, Vol. IV, pp.
114-37.

WORKS IN THE COLLECTION:
6 paintings, 1 watercolor, and 2 prints

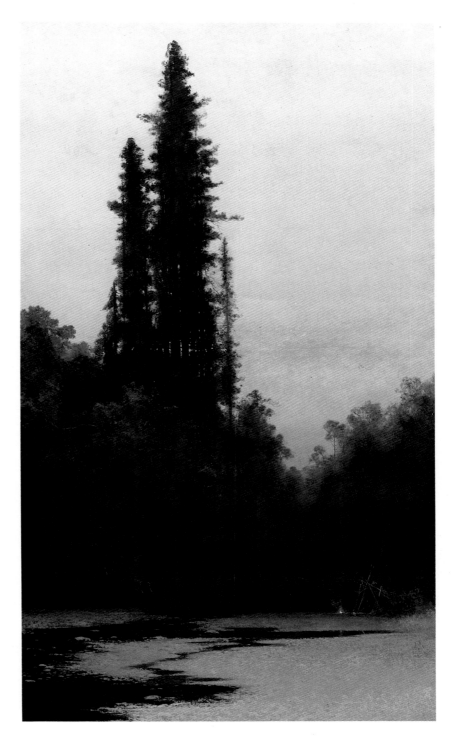

Landscape (Twilight Scene with Stream and Redwood Trees), n.d. (62.25.2)
Oil on canvas
83½ × 46½ in. (212 × 118.1 cm.)
Bequest of Dr. Cecil E. Nixon

Originality and power keynote this luminous twilight landscape, which features towering redwoods against a still-glowing sky. Rix was a self-taught painter who overcame the opposition of his father, a San Francisco judge, to pursue a career in art.

55

DOMENICO TOJETTI

Born 1806, Rome, Italy
To San Francisco, California 1871
Died March 28, 1892, San Francisco, California

EDUCATION: Studied with Vincenzo Camuccini and possibly Giuseppe Murani in Italy.

SELECTED ONE-ARTIST EXHIBITIONS: University of San Francisco, 1959.

SELECTED GROUP EXHIBITIONS: Mechanics' Institute Industrial Exhibitions, San Francisco, 1871-82; San Francisco Art Association, c. 1872-84; Paris Salon, 1879; California Midwinter International Exposition, San Francisco, 1894; Los Angeles County Museum of Art, *American Narrative Painting*, 1974.

FURTHER REFERENCES: Arkelian, Marjorie. *The Kahn Collection of Nineteenth-Century Paintings by Artists in California*. Oakland: The Oakland Museum, 1975.

WORKS IN THE COLLECTION: 3 paintings

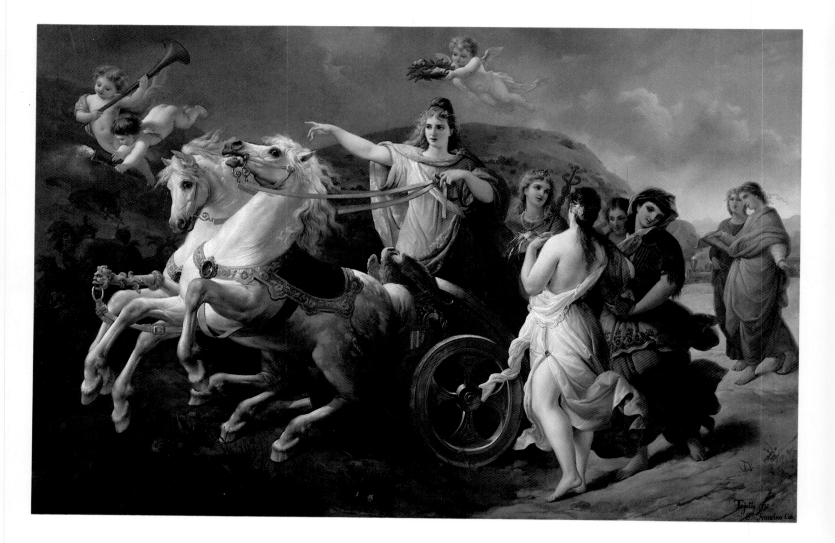

The Progress of America, 1875 (65.16.2)
Oil on canvas
71½ × 102 in. (181.6 × 259 cm.)
Kahn Collection

"Signor Tojetti" continued to paint in the Italian manner of the Vatican Court when he settled in San Francisco in 1871. This allegorical scene, probably prepared for the Centennial, depicts "America" as a maiden in a chariot followed by the muses of Art and Science, while bison and Indians flee before her westward advance.

VIRGIL WILLIAMS

Born October 29, 1830, Dixfield, Maine
To California 1862
Died December 18, 1886, near Mount St. Helena,
California

EDUCATION: Brown University, Providence,
Rhode Island, c. 1848; studied with Daniel Hunting-
ton, New York; studied in Italy, c. 1853-60.

SELECTED GROUP EXHIBITIONS: Cali-
fornia Art Union, San Francisco, 1865; Mechanics'
Institute Industrial Exhibitions, San Francisco, 1864-
94; San Francisco Art Association, 1872-93; World's
Columbian Exposition, Chicago, 1893; California
Midwinter International Exposition, San Francisco,
1894; Alaska-Yukon-Pacific Exposition, Seattle,
Washington, 1909; Golden Gate International Expo-
sition, Palace of Fine Arts, San Francisco, *California
Art in Retrospect—1850-1915*, 1940.

FURTHER REFERENCES: Arkelian, Marjo-
rie. *The Kahn Collection of Nineteenth-Century Paint-
ings by Artists in California*. Oakland: The Oakland
Museum, 1975.

WORKS IN THE COLLECTION: 1 painting

*Williams is best remembered as the first director
and esteemed teacher of the San Francisco Art
Association's School of Design, which opened in
1874. This California landscape of Mount St. Hel-
ena is a rare departure from the many European sub-
jects that comprise the bulk of Williams' paintings.*

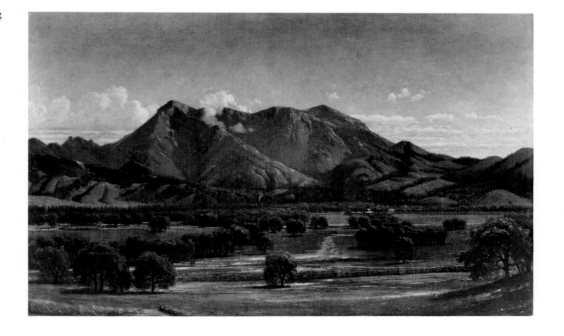

Mount St. Helena (from Knight's Valley), n.d. (65.63)
Oil on canvas
26 × 41½ in. (66 × 105.4 cm.)
Kahn Collection

THOMAS HILL

Born September 11, 1829, Birmingham, England
Emigrated to United States 1844
In California 1861-66, 1871-1908
Died June 30, 1908, Raymond, California

EDUCATION: Carriage painter and furniture decorator, Taunton, Massachusetts, 1845-46; studied in life class of Peter Frederick Rothermel, Pennsylvania Academy of the Fine Arts, Philadelphia, 1853; furniture decorator, Levi Heywood Company, Gardner, Massachusetts, 1859-60; studied with German painter Paul Meyerheim, Paris, 1866.

SELECTED ONE-ARTIST EXHIBITIONS: The Oakland Museum, 1980.

SELECTED GROUP EXHIBITIONS: Mechanics' Institute Industrial Exhibitions, San Francisco, 1864-94; California Art Union, San Francisco, 1865; National Academy of Design, New York, 1866; Paris Universal Exposition, 1867; San Francisco Art Association, 1872-1908; Centennial Exposition, Philadelphia, Pennsylvania, 1876; Pennsylvania Academy of the Fine Arts, Philadelphia, 1877, 1884, 1887; World's Columbian Exposition, Chicago, 1893; California Midwinter International Exposition, San Francisco, 1894.

FURTHER REFERENCES: Arkelian, Marjorie. *Thomas Hill: The Grand View*. Oakland: The Oakland Museum, 1980.

WORKS IN THE COLLECTION: 30 paintings, 12 drawings, and memorabilia

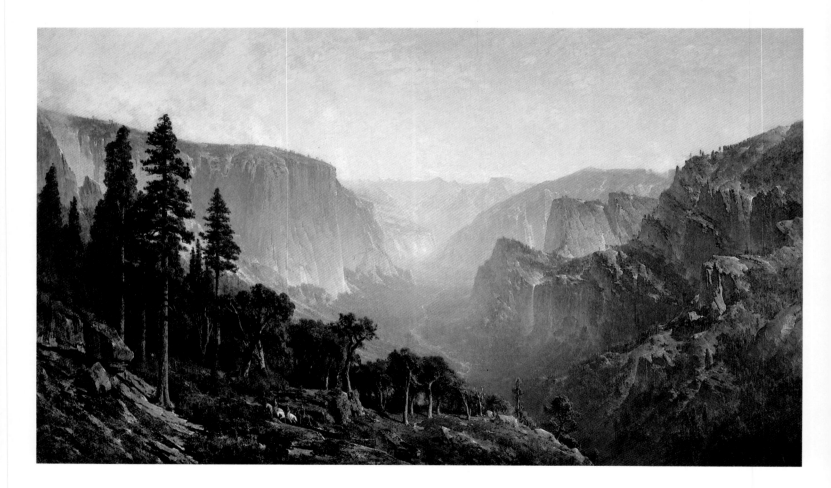

Yosemite Valley, 1876 (68.133.1)
Oil on canvas
72 × 120 in. (182.9 × 304.8 cm.)
Kahn Collection

Versatile and prolific, Thomas Hill is best known for his grand-scale landscapes. This panoramic view depicts Yosemite Valley from below Sentinel Dome as seen from Artist's Point. The three figures on horseback probably represent Yosemite tourists.

WILLIAM KEITH

Born November 21, 1838, Old Meldrum, Aberdeenshire, Scotland
To California 1858 and settled in San Francisco and Berkeley
Died April 13, 1911, Berkeley, California

EDUCATION: Apprenticed as wood engraver, Harper Brothers, New York, 1856; partner of Durban Van Vleck, San Francisco engraver, 1859; informal study in Düsseldorf, Germany, 1870-71; studied portraiture with and received criticism from Carl Marr in Munich, Germany, 1883-85.

SELECTED ONE-ARTIST EXHIBITIONS: Macbeth Gallery, New York, 1893; Vickery, Atkins & Torrey, San Francisco, 1906; San Francisco Institute of Art, 1908; Gump's Galleries, San Francisco, 1931; University of California, Berkeley, 1938; St. Mary's College, Moraga, California, 1938, 1961; San Francisco Museum of Art, 1938; E. B. Crocker Art Gallery, Sacramento, California, and Haggin Memorial Gallery, Stockton, California, 1947-48; Oakland Art Museum, 1961; M. H. de Young Memorial Museum, San Francisco, 1961.

SELECTED GROUP EXHIBITIONS: National Academy of Design, New York, 1870-99; San Francisco Art Association, c. 1873-1905; Mechanics' Institute Industrial Exhibitions, San Francisco, 1874-95; World's Columbian Exposition, Chicago, 1893; California Midwinter International Exposition, San Francisco, 1894; Pan-American Exposition, Buffalo, New York, 1901; Panama-Pacific International Exposition, San Francisco, 1915.

FURTHER REFERENCES: Cornelius, Brother, F.S.C. *Keith: Old Master of California.* New York: G.P. Putnam's Sons, 1942. Mills, Paul. *An Introduction to the Art of William Keith.* Oakland: Oakland Art Museum, 1956. *The Watercolors of William Keith, 1838-1911.* Moraga, California: Hearst Art Gallery, St. Mary's College, 1979.

WORKS IN THE COLLECTION:
Over 300 paintings, drawings, and watercolors

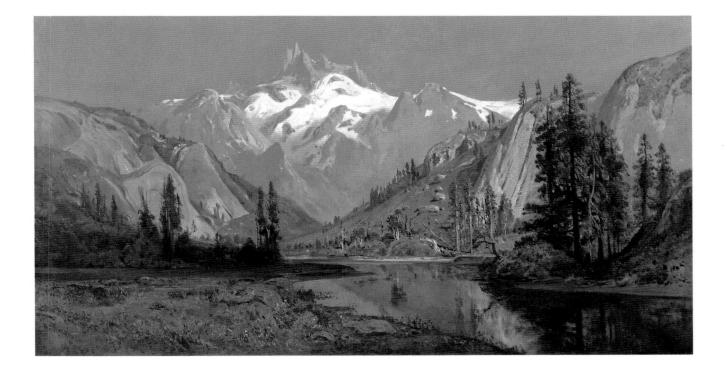

Headwaters of the San Joaquin, 1878 (55.14.150)
Oil on canvas
39¾ × 72¼ in. (118.16 × 189.28 cm.)
Gift of the Keith Art Association

Originally trained as a wood engraver, William Keith became California's major landscape painter in the latter half of the nineteenth century. Headwaters of the San Joaquin *is one of the epic landscapes in which Keith portrayed the grandeur of the then relatively unexplored California Sierra and its rivers with convincing realism.*

WILLIAM A. COULTER

Born March 7, 1849, Glen Ariff, Ireland
To San Francisco Bay Area, California c. 1868
Died March 13, 1936, Sausalito, California

EDUCATION: Primarily self-taught. Studied informally in Antwerp, Brussels, Paris, Copenhagen, and London; studied with Vilhelm Melbye and François Musin, San Francisco, c. 1876-79. Staff artist for *San Francisco Call*, c. 1896-1906.

SELECTED ONE-ARTIST EXHIBITIONS: Many organized by the artist himself, San Francisco, c. 1881-1936.

SELECTED GROUP EXHIBITIONS: San Francisco Art Association, 1874-93; Mechanics' Institute Industrial Exhibitions, San Francisco, 1874-90; World's Columbian Exposition, Chicago, 1893.

FURTHER REFERENCES: "W. A. Coulter, Marine Artist." Text by Elizabeth Muir Robinson. San Francisco: James V. Coulter in conjunction with the Sausalito Historical Society, 1981. Yates, Myrtle. Research Reports. Archives of California Art, The Oakland Museum, 1966-68.

WORKS IN THE COLLECTION: 14 paintings and 1 drawing

For over sixty-five years marine artist William Coulter documented the era of sailing ships on San Francisco Bay. Ship captains and shipowners such as Samuel Merritt, a founding father of Oakland, commissioned Coulter to paint detailed "portraits" of their ships. Merritt's Casco is depicted here in profile at full sail.

The Casco, 1879 (57.7)
Oil on canvas
32 × 48 in. (81.3 × 122 cm.)
Gift of the Women's Board of the Oakland Museum Association

THEODORE WORES

Born August 1, 1859, San Francisco, California
Visited Japan 1885-87, 1892-94, Hawaii and Samoa
1901-03, Spain 1903, Canadian Rockies 1913 and the
American Southwest 1915-17
Died September 11, 1939, San Francisco, California

EDUCATION: Studied with Joseph Harrington,
San Francisco; studied with Virgil Williams, California School of Design, San Francisco, 1874; studied
with Toby Rosenthal, Munich, Germany, 1875; studied with Ludwig Löfftz and Alexander Wagner, Royal
Academy, Munich, Germany, c. 1875-77; Frank Duveneck's art school, Munich, Germany, 1877.

SELECTED ONE-ARTIST EXHIBITIONS:
Morris & Kennedy, San Francisco, 1884, 1885; Tsukuji Gallery, Tokyo, 1887; Reichard Gallery, New York,
1888; San Francisco Art Association, 1888; Dowdeswell Gallery, London, 1889; Bohemian Club, San
Francisco, 1894, 1899, 1902, 1921; Steckel Gallery,
Los Angeles, 1907; Golden Gate Park Museum, San
Francisco, 1917; Century Art Association, New York,
1918; Stanford University Art Gallery, California,
1922; Los Angeles County Museum of Natural History, 1966; California Historical Society, San Francisco,
1968; Kennedy Galleries, New York, 1973; North
Point Gallery, San Francisco, 1975; The Oakland Museum, 1976; Huntsville Museum of Art, Alabama,
1980; Tucson Museum of Art, Arizona, 1981-83.

SELECTED GROUP EXHIBITIONS:
Royal Academy, Munich, Germany, 1876, 1878; National Academy of Design, New York, 1881, 1891,
1895-99; Mechanics' Institute Industrial Exhibition,
San Francisco, 1882; World's Columbian Exposition,
Chicago, 1893; California Midwinter International
Exposition, San Francisco, 1894; Alaska-Yukon-
Pacific Exposition, Seattle, Washington, 1909; Golden
Gate International Exposition, San Francisco, 1939-
40; Henry Art Gallery, University of Washington, Seattle, *American Impressionism*, 1980; The Oakland Museum, *Impressionism, The California View*, 1981-82.

FURTHER REFERENCES: Ferbraché, Lewis.
Theodore Wores: Artist in Search of the Picturesque.
San Francisco, 1968. *Theodore Wores and the Beginnings of Internationalism in Northern California
Painting: 1874-1915.* Ed. Joseph Armstrong Baird, Jr.
Davis, California: Library Associates, University Library, University of California, 1978.

WORKS IN THE COLLECTION:
12 paintings and 1 print

*This painting was probably painted in the studio
lent to Wores as part of a prize awarded him by the
Munich Academy where he studied in the 1870s.
The greys, browns and soft whites, touched with
muted reds, affirm the Munich sensibilities of the
period. The artist later lived and worked in Japan
and turned to clear-color, impressionistic painting
and more picturesque themes.*

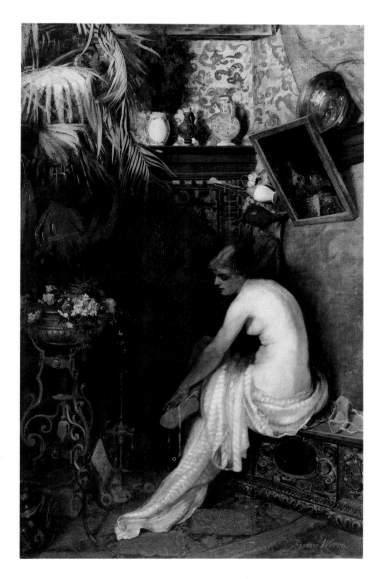

In a Corner of My Studio, c. 1876-84 (67.111.5)
Oil on canvas
56 × 36 in. (142.24 × 91.44 cm.)
Gift of Mrs. Theodore Wores

RAYMOND DABB YELLAND

Born February 2, 1848, London, England
Emigrated to New York, New York 1851
To San Francisco Bay Area, California 1874
Died July 27, 1900, Oakland, California

EDUCATION: National Academy of Design, New York, c. 1869-71; studied with William Page, L. E. Wilmarth, and James R. Brevoort; studied with Luc Olivier Merson, Paris, c. 1886.

SELECTED ONE-ARTIST EXHIBITIONS: California Historical Society, San Francisco, 1964.

SELECTED GROUP EXHIBITIONS: San Francisco Art Association, 1874-1900; Mechanics' Institute Industrial Exhibitions, San Francisco, 1875-96; National Academy of Design, New York, 1882, 1883, 1884, 1886, 1888; Paris Salon, 1886; World's Columbian Exposition, Chicago, 1893; California Midwinter International Exposition, San Francisco, 1894.

FURTHER REFERENCES: *Raymond Dabb Yelland (1848-1900)*. Compiled by Kent L. Seavey. San Francisco: California Historical Society, 1964.

WORKS IN THE COLLECTION:
24 paintings, 14 drawings, 5 watercolors, and sketchbooks

Raymond Dabb Yelland was a well-respected artist and educator who taught at Mills College, Oakland, and at the California School of Design, San Francisco, in the late nineteenth century. In his California landscapes and coastal scenes Yelland sought to capture the poetry and drama created by changes in weather and in the time of day.

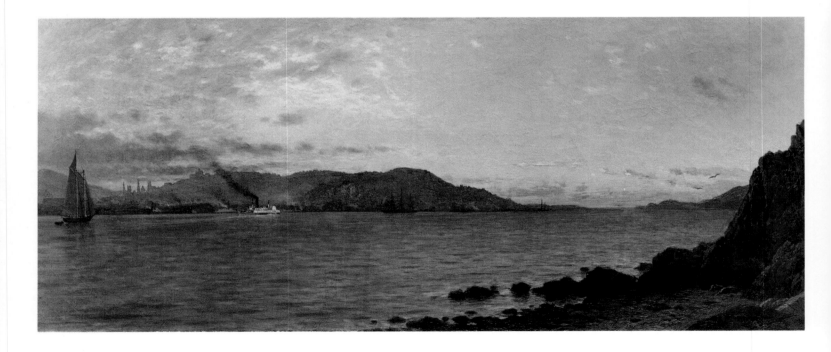

San Francisco from Goat Island, 1881 (60.12.5)
Oil on canvas
12 × 28¼ in. (30.5 × 71.8 cm.)
Gift of Mr. and Mrs. Herbert M. Stoll, Jr.

MARIUS DAHLGREN

Born 1844, Denmark
In California c. 1873-1905
Died c. June 24, 1920, Tucson, Arizona

EDUCATION: Academy of Arts, Copenhagen.

SELECTED GROUP EXHIBITIONS: Pomona College, Claremont, California, and Oakland Art Museum, *Scenes of Grandeur: 19th Century Paintings of California*, 1962-63; University of California, Davis, *From Frontier to Fire: California Painting from 1816 to 1906*, 1964; The Oakland Museum, *The California Collection of William and Zelma Bowser*, 1970; Mission San Francisco Solano de Sonoma, Sonoma, California, *A Selection of American Paintings*, 1976.

FURTHER REFERENCES: Arkelian, Marjorie. *The Kahn Collection of Nineteenth-Century Paintings by Artists in California*. Oakland: The Oakland Museum, 1975.

WORKS IN THE COLLECTION:
4 paintings

The busy and varied marine activity on San Francisco Bay, depicted here in 1887, includes a ferry boat, two schooners, a bark under tow, and men with a net fishing from a small rowboat. Goat Island, so named because goats once grazed on its steep slopes, was later named "Yerba Buena."

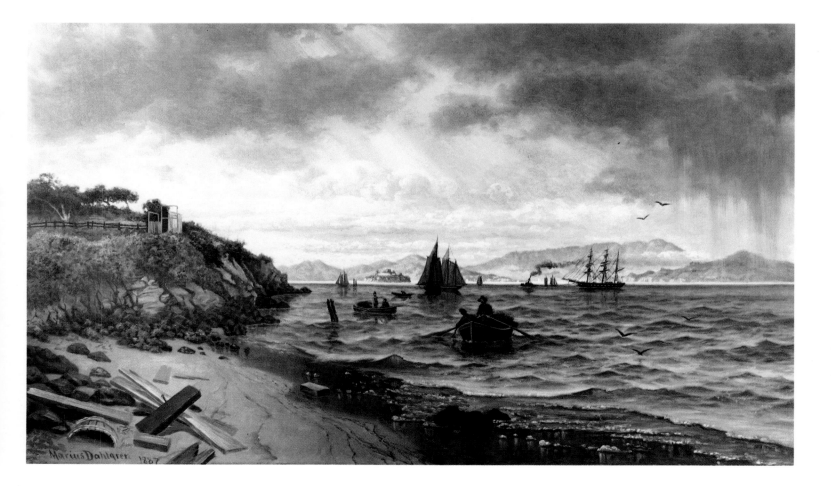

View from Goat Island, San Francisco Bay, 1887
(65.16.5)
Oil on canvas
30½ × 50 in. (77.5 × 127 cm.)
Kahn Collection

SAMUEL MARSDEN BROOKES

Born March 8, 1816, Newington Green, Middlesex, England
Emigrated to Fort Dearborn, Illinois, 1833
To California 1862
Died January 31, 1892, San Francisco, California

EDUCATION: Studied with F. T. Wilkins and Thomas H. Stevenson, itinerant portrait painters in Illinois, c. 1841; studied masterpieces in England, 1845.

SELECTED ONE-ARTIST EXHIBITIONS: California Historical Society, San Francisco, and Oakland Art Museum, 1962-63.

SELECTED GROUP EXHIBITIONS: Mechanics' Institute Industrial Exhibitions, San Francisco, 1864-90; California Art Union, San Francisco, 1865; San Francisco Art Association, c. 1872-86; Centennial Exposition, Philadelphia, Pennsylvania, 1876; World's Columbian Exposition, Chicago, 1893; California Midwinter International Exposition, San Francisco, 1894; University of Southern California, Los Angeles, *Reality and Deception*, 1974-75; Philbrook Art Center, Tulsa, Oklahoma, *Painters of the Humble Truth*, 1981-82.

FURTHER REFERENCES: Arkelian, Marjorie. *The Kahn Collection of Nineteenth-Century Paintings by Artists in California*. Oakland: The Oakland Museum, 1975. Baird, Joseph Armstrong, Jr. *Samuel Marsden Brookes (1816-1892)*. San Francisco: California Historical Society, 1962.

WORKS IN THE COLLECTION: 5 paintings

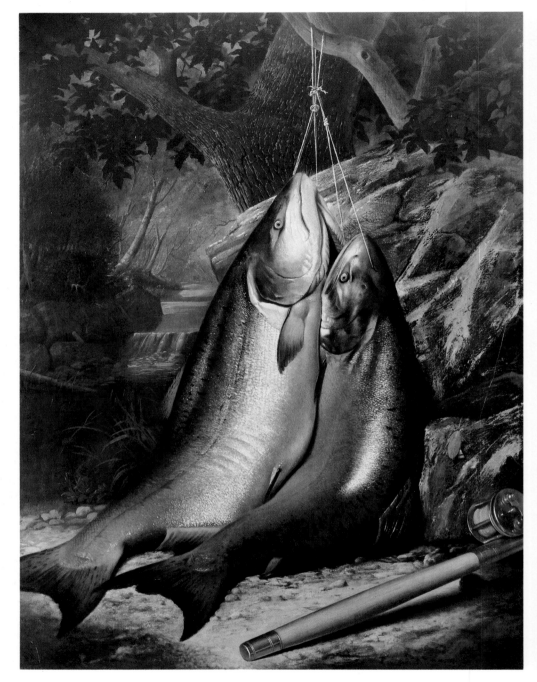

Steelhead Salmon, 1885 (65.100)
Oil on wood panel
40 × 30 in. (101.6 × 76.2 cm.)
Kahn Collection

Brookes, a still-life and portrait painter, spent most of his career in San Francisco. While concentrating on still-life compositions, often using fish as models, he developed remarkable skill in rendering iridescence of fish scales.

64

GRAFTON TYLER BROWN

Born February 22, 1841, Harrisburg, Pennsylvania
In California c. 1860-82
Died March 2, 1918, St. Peter, Minnesota

EDUCATION: Unknown.

SELECTED ONE-ARTIST EXHIBITIONS: *The Colonist* Building, Victoria, British Columbia, 1883; The Oakland Museum, History Department, 1972.

SELECTED GROUP EXHIBITIONS: La Jolla Museum of Art, California, *Dimensions of Black*, 1970; The Oakland Museum, Special Exhibits and Education Department, *Blacks in the Westward Movement*, 1975; University of Southern California Art Galleries, Los Angeles, *Pack-In Painters of the American West*, 1976; Amon Carter Museum of Western Art, Fort Worth, Texas, *Cities on Stone*, 1976; Los Angeles County Museum of Art, *Two Centuries of Black American Art*, 1976-77.

FURTHER REFERENCES: Arkelian, Marjorie. *The Kahn Collection of Nineteenth-Century Paintings by Artists in California*. Oakland: The Oakland Museum, 1975.

WORKS IN THE COLLECTION:
2 paintings and 1 print

A black painter and lithographer, active in California in the 1860s, G.T. Brown traveled in 1882 through Oregon, Washington, and British Columbia where he set up a studio in Victoria. His oil painting of Mount Tacoma (Mount Rainier), Washington, with depictions of Indians camping in the foreground, is of this period.

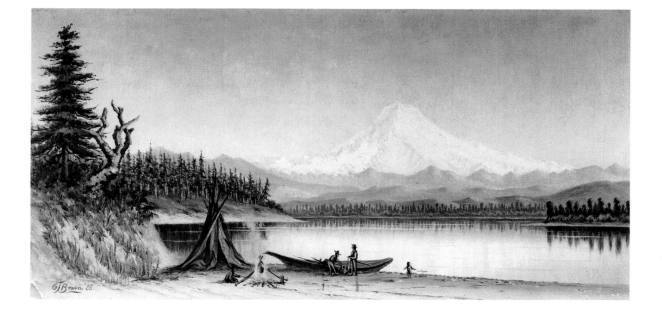

Mount Tacoma (Mount Rainier, Washington), 1885
(65.193)
Oil on cardboard
10 × 20 in. (25.4 × 50.8 cm.)
Kahn Collection

WILLIAM HAHN

Born January 7, 1829, Ebersbach, Saxony, Germany
Emigrated to New England 1871
In California 1872-77, 1879-82
Died June 8, 1887, Dresden, Germany

EDUCATION: Royal Academy of Art, Dresden, Germany, 1844-48; studied in *meisterklasse* of Julius (Rudolf Julius Benno) Hübner, Dresden, Germany.

SELECTED ONE-ARTIST EXHIBITIONS: The Oakland Museum, 1976.

SELECTED GROUP EXHIBITIONS: Dresden Gallery, Germany, 1852, 1854, 1859, 1861, 1864, 1865; San Francisco Art Association, 1873, 1874, 1876, 1880; Mechanics' Institute Industrial Exhibitions, San Francisco, 1874-76; 1878-82; National Academy of Design, New York, 1878-81, 1885; Dresden Academy, Germany, 1887; California Midwinter International Exposition, San Francisco, 1894; Alaska-Yukon-Pacific Exposition, Seattle, Washington, 1909; Metropolitan Museum of Art, New York, *Life in America*, 1939; Los Angeles County Museum of Art, *The American West*, 1972; Whitney Museum of American Art, New York, *Our American Frontier: Images and Myths*, 1973; Los Angeles County Museum of Art, *American Narrative Painting*, 1974; Whitney Museum of American Art, New York, *The Painters' America: Rural and Urban Life, 1810-1910*, 1974-75.

FURTHER REFERENCES: Arkelian, Marjorie Dakin. *William Hahn: Genre Painter 1829-1887.* Oakland: The Oakland Museum, 1976.

WORKS IN THE COLLECTION: 8 paintings

The Return from the Bear Hunt, 1882 (65.39)
Oil on canvas
55 × 89 in. (139.7 × 226.06 cm.)
Kahn Collection

William Hahn's skill in painting subjects taken from everyday life has provided a valuable legacy to the art and history of California. In the 1880s the killing of grizzly bears was considered to be a dangerous but exciting necessity. Hahn made numerous sketches from a hunt in Sonoma County as preparation for this painting.

EDWIN DEAKIN

Born May 21 or 22, 1838, Sheffield, England
Emigrated to Chicago, Illinois 1856
To San Francisco, California 1870
Died May 11, 1923, Berkeley, California

EDUCATION: Primarily self-taught.

SELECTED ONE-ARTIST EXHIBITIONS: Easton and Eldridge, auctioneers, San Francisco, 1886; Palace Hotel, San Francisco, 1889, 1900; Oakland Art Museum, 1958; Los Angeles County Museum of Natural History, 1960; Alta California Bookstore, Berkeley, California, 1963; The Oakland Museum at Kaiser Center Gallery, 1969.

SELECTED GROUP EXHIBITIONS: San Francisco Art Association, 1872, 1873, 1876, 1877, 1881; Mechanics' Institute Industrial Exhibitions, San Francisco, 1875, 1876, 1880, 1881, 1883, 1884, 1886, 1887; Paris Salon, 1879; Studio Building, Berkeley, California, *First and Second Exhibitions*, 1906, 1907; Golden Gate International Exposition, Palace of Fine Arts, San Francisco, *California Art in Retrospect—1850-1915*, 1940; Pomona College, Claremont, California, and Oakland Art Museum, *Scenes of Grandeur: 19th Century Paintings of California*, 1962-63; The Oakland Museum, *Tropical: Tropical Scenes by the 19th Century Painters of California*, 1971-72; Whitney Museum of American Art, New York, *The American Frontier: Images and Myths*, 1973; Philbrook Art Center, Tulsa, Oklahoma, *Painters of the Humble Truth*, 1981-82.

FURTHER REFERENCES: Los Angeles County Museum of Natural History. *A Gallery of California Mission Paintings by Edwin Deakin*. Los Angeles, 1966.

WORKS IN THE COLLECTION:
72 paintings, 24 watercolors, and 1 sketchbook

This painting by an artist who specialized in picturesque views of old buildings includes, on the left, a young Chinese man nonchalantly seated on a box bearing the inscription, "The Chinese Must Go." In 1886, during a regional depression, the local Workingman's Party spearheaded a movement that branded San Francisco's industrious Chinese residents a threat to white employment.

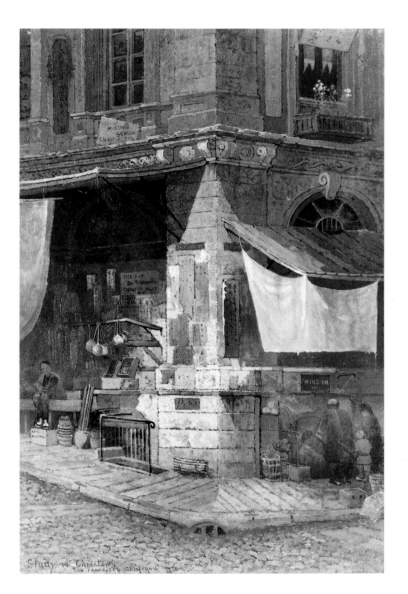

Study in Chinatown, San Francisco, 1886 (58.4.21)
Oil on canvas
30 × 20 in. (76.2 × 50.8 cm.)
Gift of Mr. and Mrs. Howard Willoughby

CARL VON PERBANDT

Born May 12, 1832, Langendorf, Prussia
In California c. 1877-1903
Died April 6, 1911, Nahmgeist, Prussia

EDUCATION: Studied under Andreas Achenbach and Carl Friedrich Lessing, Düsseldorf Academy, Germany.

SELECTED ONE-ARTIST EXHIBITIONS: Morris Schwab and Kennedy, San Francisco, 1877.

SELECTED GROUP EXHIBITIONS: National Academy of Design, New York, 1874; Mechanics' Institute Industrial Exhibitions, San Francisco, 1880, 1884, 1885, 1886, 1887, 1896, 1897, 1899; San Francisco Art Association, 1881, 1883, 1885; Syntex Gallery, Palo Alto, California, *19th Century Painters of the California Landscape*, 1970.

FURTHER REFERENCES: Arkelian, Marjorie. *The Kahn Collection of Nineteenth-Century Paintings by Artists in California.* Oakland: The Oakland Museum, 1975.

WORKS IN THE COLLECTION:
3 paintings

Prussian-born Carl von Perbandt, who settled in San Francisco in 1877, specialized in landscapes and spent most of his time sketching and painting in the redwood forests of Sonoma and Mendocino counties. Fort Ross, the abandoned Russian military post on the coast north of San Francisco, became his favorite retreat.

Indians Camped at Fort Ross, 1886 (68.163)
Oil on canvas mounted on masonite
54 × 84 in. (137.16 × 213.36 cm.)
Kahn Collection

GEORGE HENRY BURGESS

Born June 8, 1830, London, England
To California 1850
Died April 22, 1905, Berkeley, California

EDUCATION: Somerset House School of Design, London.

SELECTED GROUP EXHIBITIONS: Mechanics' Institute Industrial Exhibitions, San Francisco, 1857-91; Mark Hopkins Institute of Art, San Francisco, Loan Exhibition, 1900; Amon Carter Museum of Western Art, Fort Worth, Texas, *Cities on Stone*, 1976.

FURTHER REFERENCES: Arkelian, Marjorie. "A Burgess Panorama." *Art* (Art Guild of the Oakland Museum Association), Vol. VII, No. 1 (January-February 1979), n.p. George Burgess Memorabilia. Archives of California Art, The Oakland Museum. Gifts of Joanne and Don Evers (1978) and Warren R. Howell (1979).

WORKS IN THE COLLECTION:
1 painting and 2 prints

This panoramic view of San Francisco in 1849, begun in 1882 and completed in 1891, was thoroughly researched by the artist from original sources. The hill in the middle distance, Alta Loma, later came to be called Telegraph Hill because news of ships entering the Golden Gate was signaled to the merchants of the town from its heights. It is interesting to note the ethnic diversity of early San Francisco.

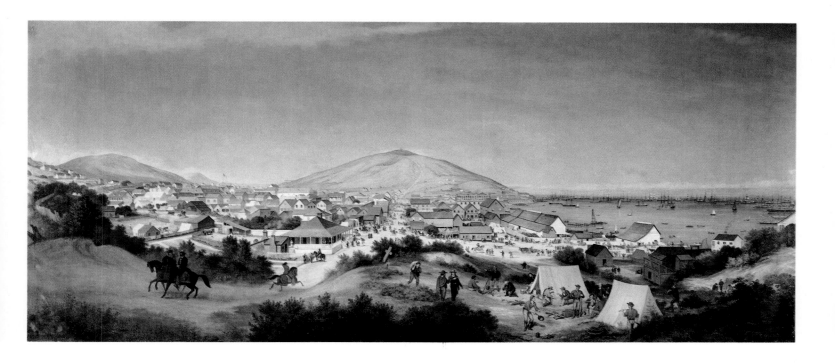

San Francisco in July, 1849, 1891 (78.189)
Oil on canvas
62 × 121¾ in. (157.5 × 365 cm.)
Gift of the Women's Board of the Oakland Museum Association

EMIL CARLSEN

Born October 19, 1853, Copenhagen, Denmark
Emigrated to United States 1872
In San Francisco, California 1887-91
Died January 2, 1932, New York, New York

EDUCATION: Studied architecture, Royal Academy, Copenhagen, 4 years; worked under Danish painter Lauritz Holst, Chicago, 1874; Académie Julian, Paris, 1884-86. Primarily self-taught as painter.

SELECTED ONE-ARTIST EXHIBITIONS: Macbeth Gallery, New York, 1935; Grand Central Art Galleries, New York, 1958; Wortsman-Rowe Galleries, San Francisco, 1975.

SELECTED GROUP EXHIBITIONS: National Academy of Design, New York, 1885-87, 1894-95, 1903, 1905-21, 1923-32; Mechanics' Institute Industrial Exhibitions, San Francisco, 1887, 1888; San Francisco Art Association, c. 1890-97; Louisiana Purchase Exposition, St. Louis, Missouri, 1904; Pennsylvania Academy of the Fine Arts, Philadelphia, 1912; Panama-Pacific International Exposition, San Francisco, 1915; The Oakland Museum, *Impressionism, The California View*, 1981-82; Philbrook Art Center, Tulsa, Oklahoma, *Painters of the Humble Truth*, 1981-82.

FURTHER REFERENCES: Wortsman-Rowe Galleries. *The Art of Emil Carlsen, 1853-1932*. San Francisco: Rubicon-Wortsman-Rowe, 1975.

WORKS IN THE COLLECTION:
5 paintings

Innovative and ahead of his time in California, Carlsen painted still lifes in broad masses of color, preferring mauves, silver greys, ivory whites, and the subtle tones of old pewter and brass. From 1887 to 1889, Carlsen was Director of the San Francisco Art Association's California School of Design.

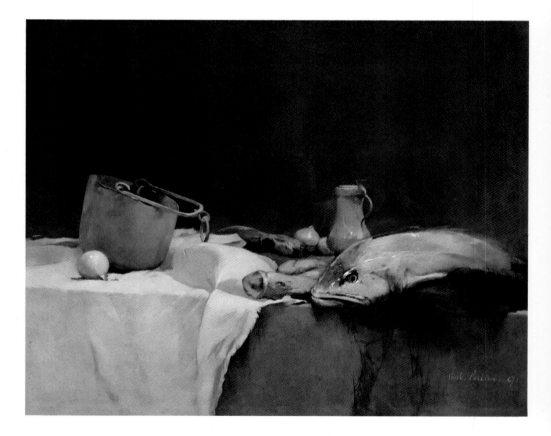

Still Life, 1891 (62.102)
Oil on canvas
35 × 43 in. (88.9 × 109.2 cm.)
Gift of Mrs. Sol Upsher

GRACE CARPENTER HUDSON

Born February 21, 1865, Potter Valley, California
Died March 23, 1937, Ukiah, California

EDUCATION: California School of Design, San Francisco, c. 1879-84.

SELECTED ONE-ARTIST EXHIBITIONS: Schussler Gallery, San Francisco, 1907; Gould Gallery, Los Angeles, 1907; California Historical Society, San Francisco, 1962; Palm Springs Desert Museum, California, 1984.

SELECTED GROUP EXHIBITIONS: San Francisco Art Association, 1881, 1895, 1897; Minneapolis Exposition, Minnesota, 1892; World's Columbian Exposition, Chicago, 1893; Mechanics' Institute Industrial Exhibitions, San Francisco, 1894, 1895, 1896; Paris Exposition, 1900; Alaska-Yukon-Pacific Exposition, Seattle, Washington, 1909.

FURTHER REFERENCES: Boynton, Searles R. *The Painter Lady: Grace Carpenter Hudson.* Eureka, California: Interface California Corporation, 1978.

WORKS IN THE COLLECTION: 9 paintings

In this portrait, To-Tole *(The Star), a Pomo Indian girl is dressed to celebrate a plentiful acorn harvest. Her costume includes a buzzard tail headdress, clam shell beads, and a wildcat skin jacket. The buttons on the jacket, an addition to the traditional costume, reveal the influence of European settlers.*

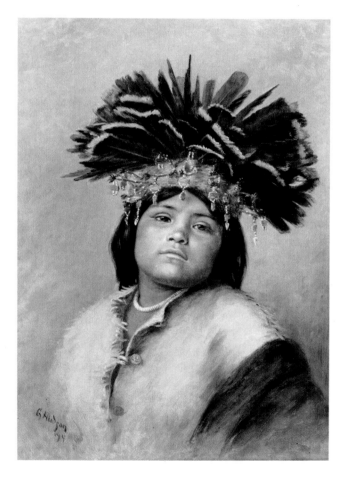

To-Tole (The Star), 1894 (61.5.3)
Oil on canvas
14 × 10 in. (35.6 × 25.4 cm.)
Gift of Mrs. Leon Bocqueraz

HENRY ALEXANDER

Born c. 1860, San Francisco, California
In California c. 1860-74 and 1883-87
Died May 15, 1894, New York, New York

EDUCATION: Studied with Ludwig von Löfftz and Wilhelm Lindenschmit, Munich, Germany, c. 1874-83.

SELECTED ONE-ARTIST EXHIBITIONS: Gump's Gallery, San Francisco, 1937; San Francisco Museum of Art, 1940; M. H. de Young Memorial Museum, San Francisco, 1973.

SELECTED GROUP EXHIBITIONS: Munich, Germany, 1879; San Francisco Art Association, 1884; National Academy of Design, New York, 1884; Mechanics' Institute Industrial Exhibitions, San Francisco, 1884, 1885, 1891; California State Fair, Sacramento, 1886; Brooklyn Art Association, New York, 1892; World's Columbian Exposition, Chicago, 1893; California Midwinter International Exposition, San Francisco, 1894; National Gallery of Art, Washington, D.C., *The Reality of Appearance*, 1970; University of Southern California, Los Angeles, *Reality and Deception*, 1974-75.

FURTHER REFERENCES: Karlstrom, Paul J. "The Short, Hard, and Tragic Life of Henry Alexander." *Smithsonian*, Vol. XII, No. 12 (March 1982), pp. 109-17.

WORKS IN THE COLLECTION:
4 paintings

Alexander was particularly attracted to complex compositions and the portrayal of lighting effects. This rare painting of a San Francisco Chinese tea room is characteristic of the artist's presentation of his figure subjects in a finely detailed setting of still-life objects.

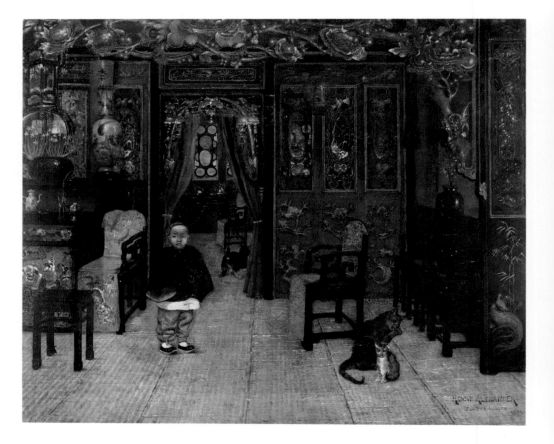

Chinese Tea Room, 1892 (83.23)
Oil on canvas
30 × 36 in. (76.2 × 91.4 cm.)
Gift of the Estate of George Roland Therkof

GEORGE INNESS

Born May 1, 1825, near Newburgh, New York
In California 1891, visited San Francisco, Yosemite,
Monterey Peninsula, and San Diego
Died August 3, 1894, Bridge-of-Allan, Scotland

EDUCATION: Primarily self-taught. Studied with
George Jesse Barker, Newark, New Jersey, c. 1840;
with Régis François Gignoux, c. 1843; with John Jesse
Barker, Newark, New Jersey, 1893. Apprentice engrav-
er with Sherman & Smith, New York, c. 1841-43.

SELECTED ONE-ARTIST EXHIBITIONS:
American Art Galleries, New York, 1884; Rabjohn
and Morcom's Galleries, San Francisco, 1891 (with
William Keith); Fine Arts Building, New York, 1894;
Macbeth Gallery, New York, Inness Centennial Memo-
rial Exhibition, 1925; Montclair Art Museum, New
Jersey, 1935, 1964; George Walter Vincent Smith Art
Museum, Springfield, Massachusetts, 1946; Univer-
sity Art Museum, University of Texas, Austin, 1965;
The Oakland Museum, 1978.

SELECTED GROUP EXHIBITIONS: Na-
tional Academy of Design, New York, 1844-89; Amer-
ican Art Union, New York, 1845-50; San Francisco
Art Association, 1879, 1891; Mechanics' Institute In-
dustrial Exhibition, San Francisco, 1884; Paris Ex-
position, 1889, 1891; World's Columbian Exposition,
Chicago, 1893; Panama-Pacific International Expo-
sition, San Francisco, 1915.

FURTHER REFERENCES: Arkelian, Marjo-
rie Dakin, and George W. Neubert. *George Inness
Landscapes: His Signature Years 1884-1894*. Oak-
land: The Oakland Museum, 1978. Ireland, LeRoy.
*The Works of George Inness: An Illustrated Cata-
logue Raisonné*. Austin: University of Texas Press,
1965.

WORKS IN THE COLLECTION: 1 painting

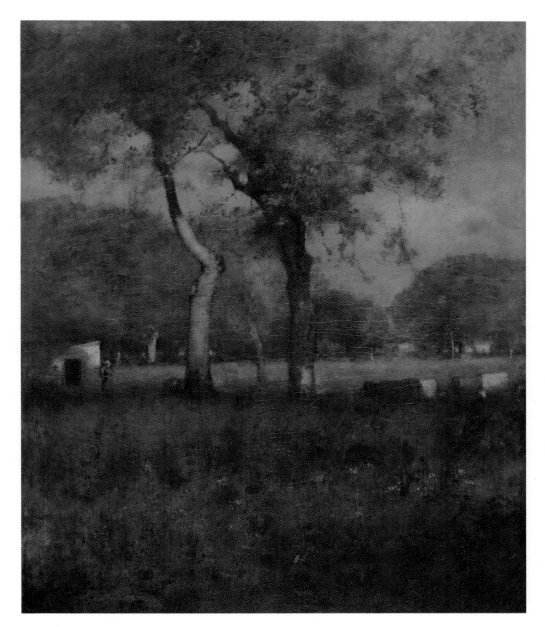

California, 1894 (75.131)
Oil on canvas
60 × 48 in. (152.4 × 121.9 cm.)
Gift of the Estate of Helen Hathaway White and the
Women's Board of the Oakland Museum Association

*Rendered in the low-keyed, closely related hues of
Tonalism, this atmospheric view of a pair of
white oaks near the Del Monte Hotel in Monterey
was painted during George Inness' visit to Califor-
nia under the title* Monterey Oaks. *This painting
was inexplicably renamed* California *and dated
1894 prior to the executor's auction of the Inness
estate in 1895.*

RUPERT SCHMID

Born September 16, 1864, Munich, Germany
Emigrated to United States 1885
To San Francisco, California c. 1889. After San Francisco earthquake and fire, traveled in Europe and Mexico 1906-13
Died August 14, 1932, Alameda, California

EDUCATION: Royal Academy, Munich, Germany, early 1880s.

SELECTED GROUP EXHIBITIONS: Mechanics' Institute Industrial Exhibitions, San Francisco, 1889-95; San Francisco Art Association, c. 1891-96; World's Columbian Exposition, Chicago, 1893; California Midwinter International Exposition, San Francisco, 1894; National Academy of Design, New York, 1895; California Palace of the Legion of Honor, San Francisco, *American Sculpture*, 1982; The Oakland Museum, *100 Years of California Sculpture*, 1982.

PUBLIC WORKS: *California Venus—California Poppies*, World's Columbian Exposition, Chicago, 1893; *Story of Civilization*, frieze, Memorial Arch, Stanford University, California, 1900 (destroyed in 1906 earthquake); McKinley Monument, St. James Park, San Jose, California, 1902-03; statue of Ulysses S. Grant, Golden Gate Park, San Francisco, 1908; *Queen of the Pacific*, Panama-Pacific International Exposition, San Francisco, 1915.

FURTHER REFERENCES: The Oakland Museum. *100 Years of California Sculpture*. Oakland, 1982, p. 8, plate p. 7.

WORKS IN THE COLLECTION:
3 sculptures

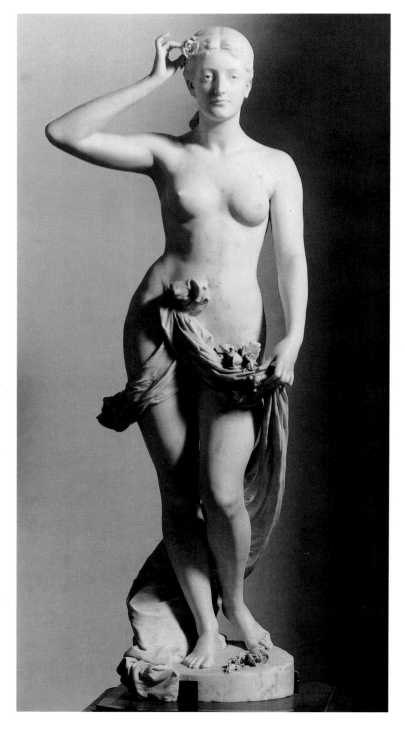

California Venus, c. 1895 (53.409)
Marble
Height: 6 ft. (182.88 cm.)
Gift of Mrs. Frank M. Smith

Seizing every opportunity to relate his figurative works to California and western themes, Schmid sculpted this version of a California Venus in marble. The classic, life-size nude figure of a young woman is semi-draped and decorated with California poppies.

MARY CURTIS RICHARDSON

Born April 9, 1848, New York, New York
To California 1850
Died November 1, 1931, San Francisco, California

EDUCATION: Studied drawing with father, Lucian Curtis, San Francisco, 1860s; Cooper Union School, New York, 1868-69; studied painting with Benoni Irwin, San Francisco, 1872-77; studied with Virgil Williams, California School of Design, San Francisco, 1874; studied with William Sartain and at the Art Students League, New York, 1886-87.

SELECTED ONE-ARTIST EXHIBITIONS: Vickery, Atkins & Torrey, San Francisco, 1909; Macbeth Gallery, New York, 1910; California Palace of the Legion of Honor, San Francisco, 1932.

SELECTED GROUP EXHIBITIONS: Mechanics' Institute Industrial Exhibitions, San Francisco, 1885, 1887, 1894; National Academy of Design, New York, 1885-87, 1894; San Francisco Art Association, 1895-97, 1900, 1901; World's Columbian Exposition, Chicago, 1893; Panama-Pacific International Exposition, San Francisco, 1915.

FURTHER REFERENCES: *California Art Research Monographs*. Ed. Gene Hailey. San Francisco: Works Progress Administration, 1937, Vol. V, pp. 16-31.

WORKS IN THE COLLECTION:
3 paintings

This portrait is characteristic of Richardson's skilled presentation of her subjects. She came from a family of painters and engravers, and from the 1880s through the turn of the century, her studio on the crest of Russian Hill was a favorite gathering place for regional painters, visiting artists, and art patrons.

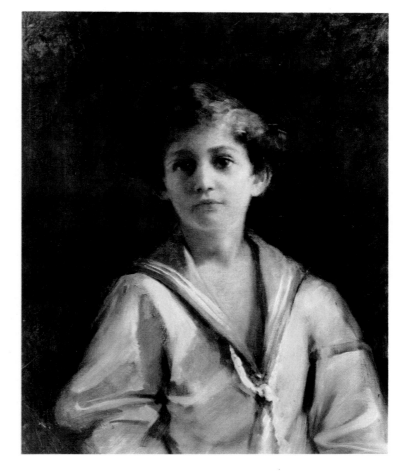

Portrait of Joseph M. Bransten, n.d. (66.127.2)
Oil on canvas
22 × 18 in. (55.9 × 45.7 cm.)
Gift of Mr. Joseph M. Bransten and Mrs. Charles H. McDougall

ROBERT AITKEN

Born May 8, 1878, San Francisco, California
In California 1878-1904
Died January 3, 1949, New York, New York

EDUCATION: Studied with Arthur Mathews and
Douglas Tilden, Mark Hopkins Institute of Art, San
Francisco, c. 1895; studied in galleries and museums,
Paris, c. 1897.

SELECTED ONE-ARTIST EXHIBITIONS:
Bohemian Club, San Francisco, 1905.

SELECTED GROUP EXHIBITIONS: San
Francisco Art Association, c. 1896-1904; Paris Salons,
1906, 1907; National Academy of Design, New York,
1907-12, 1915, 1917, 1920-21, 1925, 1930, 1932,
1934; International Exhibition, Rome, 1911; Inter-
national Exhibition of Modern Art (Armory Show),
New York, 1913; Panama-Pacific International Ex-
position, San Francisco, 1915; National Sculpture So-
ciety at Albright-Knox Art Gallery, Buffalo, New York,
Exhibition of Contemporary American Sculpture,
1916; National Sculpture Society, New York, *Exhi-
bition of American Sculpture*, 1923; National Sculp-
ture Society at California Palace of the Legion of
Honor, San Francisco, *Contemporary American
Sculpture*, 1929; California Palace of the Legion of
Honor, San Francisco, *American Sculpture*, 1982; The
Oakland Museum, *100 Years of California Sculpture*,
1982.

PUBLIC WORKS: Spandrels, Spreckels Music Pa-
vilion, Golden Gate Park, San Francisco, 1898; Dewey
Monument, Union Square, San Francisco, 1901-02;
statue of William McKinley, Golden Gate Park, San
Francisco, 1904; statue of Hall McAllister, Civic Cen-
ter, San Francisco, 1904-05; *The Four Elements* and
Fountain of Earth, Court of Abundance, Panama-
Pacific International Exposition, San Francisco, 1915.

FURTHER REFERENCES: *California Re-
search Monographs*. Ed. Gene Hailey. San Francisco:
Works Progress Administration, 1937, Vol. VI, pp.
60-94. Proske, Beatrice Gilman. *Brookgreen Gar-
dens: Sculpture*. Brookgreen, South Carolina: Trust-
ees of Brookgreen Gardens, 1943, pp. 147-49.

WORKS IN THE COLLECTION:
6 sculptures (plaster and bronze)

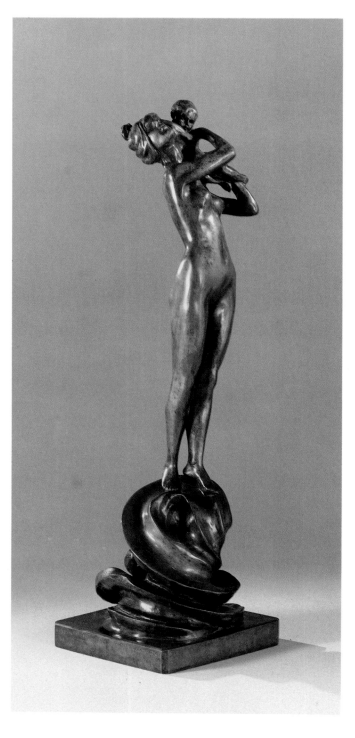

Love's Guidance, 1899 (76.51)
Bronze
25 × 7⅛ × 7¼ in. (83.5 × 20.98 × 24.18 cm.)
Original plaster, gift of Mrs. C. Lawrence Bisbee. Cast
in bronze courtesy of Museum Donors' Acquisition
Fund.

Love's Guidance, *executed in an adaptation of the
Art Nouveau style, is an example of this sculptor's
salon-sized works on allegorical themes. Although
much of Aitken's work was destroyed in the 1906
San Francisco fire, several of his larger scale out-
door sculptures can be seen in San Francisco's parks
as monuments or portraits in bronze.*

ARNOLD GENTHE

Born January 8, 1869, Berlin, Germany
In California 1894-1911
Died August 8, 1942, New York, New York

EDUCATION: University of Berlin, c. 1890; University of Jena, Germany, 1894 (PhD, Philosophy); Sorbonne, Paris, 1895.

SELECTED ONE-ARTIST EXHIBITIONS: Vickery, Atkins & Torrey, San Francisco, c. 1911; Museum of the City of New York, 1941; Carmel Museum of Art, California, 1968; Allan Frumkin Gallery, Chicago, 1975; Robert Schoelkopf Gallery, New York, 1975; Staten Island Institute of Arts and Sciences, New York, 1975; Thackrey & Robertson, San Francisco, 1978.

SELECTED GROUP EXHIBITIONS: California Camera Club, San Francisco, Salons, c. 1925, 1926; Gallery of Science and Art, International Business Machines Corporation Building, World's Fair, New York, 1940; Oakland Art Museum, *f/64 and Before*, 1966, and *Photography and the West*, 1967; San Francisco Museum of Modern Art, *California Pictorialism*, 1977.

FURTHER REFERENCES: Carmel Museum of Art. "The Magic Lens of Arnold Genthe" (brochure). Carmel, California, 1968. Witkin, Lee D., and Barbara London. *The Photograph Collector's Guide.* Boston: New York Graphic Society, 1979, pp. 149-50.

WORKS IN THE COLLECTION:
60 vintage photographic prints

Observing and recording in the poetic manner of the Pictorialists, Genthe made an extensive study of daily life in Chinatown, San Francisco. Following the photographic conventions of the Pictorialists, he printed soft focus scenes on textured paper, as if they were inked on stone.

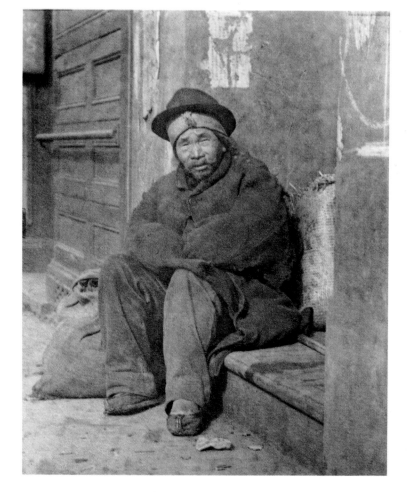

The Paper Gatherer, c. 1900 (72.57.1)
Gelatin silver print
8¾ × 6¾ in. (22.2 × 17.1 cm.)
Gift of Anonymous Donors in memory of Paul Gerson

ALEXANDER ROBERTSON

Born December 15, 1840, England
Emigrated to United States 1853
To San Francisco, California 1884
Moved to Los Angeles 1906
Died October 10, 1925, Glendale, California

EDUCATION: A fifth generation artisan potter.

SELECTED GROUP EXHIBITIONS: California Keramic Club, San Francisco, 1899, 1900; Panama-California Exposition, San Diego, 1915; Pasadena Center, California, *California Design 1910*, 1974; The Oakland Museum, and Lang Gallery, Scripps College, Claremont, California, *The Potter's Art in California, 1885 to 1955*, 1978.

FURTHER REFERENCES: Bray, Hazel V. *The Potter's Art in California, 1885 to 1955*. Oakland: The Oakland Museum, 1978. Evans, Paul. *Art Pottery of the United States*. New York: Charles Scribner's Sons, 1974.

WORKS IN THE COLLECTION: 7 ceramic vases

California's first wheel-thrown art pottery was developed by the artisan-trained master, Alexander W. Robertson, toward the end of the nineteenth century. Illustrated here is one of the few surviving collaborative creations by the potter and his partner, Linna V. Irelan, who decorated some of Robertson's well-proportioned works.

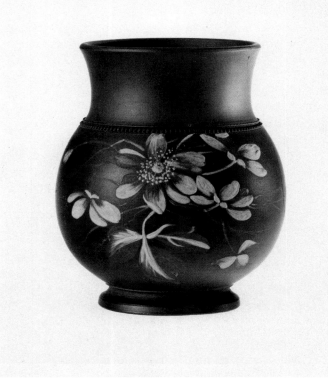

Vase, 1898 (75.75.25)
Earthenware with slip design by L. Irelan
Height: 3⅝ in. (9.2 cm.)
Diameter: 3 in. (7.6 cm.)
Gift of the Estate of Helen Hathaway White

WILLARD E. WORDEN

Born November 20, 1868, Philadelphia, Pennsylvania
To California c. 1900
Died September 6, 1946, Palo Alto, California

EDUCATION: Self-taught while serving as military photographer in the Philippines during the Spanish-American War.

SELECTED ONE-ARTIST EXHIBITIONS: Focus Gallery, San Francisco, 1977.

SELECTED GROUP EXHIBITIONS: Oakland Art Museum at Kaiser Center Gallery, *Photography and the West*, 1967; The Oakland Museum, *Recent Acquisitions*, 1978.

FURTHER REFERENCES: Artist's File, Archives of California Art, The Oakland Museum.

WORKS IN THE COLLECTION:
165 photographic prints

In this evocative photograph of the famous Cliff House improbably balanced at the edge of San Francisco Bay, Worden uses the brilliance of reflected light to compose this grand scene of clouds and water.

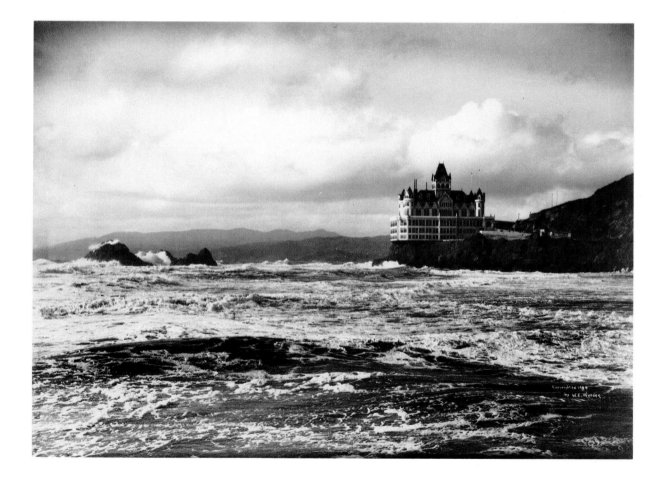

Cliff House, 1904 (76.187.4)
Gelatin silver print
10⅛ × 13⅜ in. (25.7 × 34 cm.)
Gift of Mr. and Mrs. Willard M. Nott

ARTHUR PUTNAM

Born September 6, 1873, Waveland, Mississippi
In California 1880-1921
Died May 27, 1930, Ville d'Avray, France

EDUCATION: Art Students League, San Francisco, 1894; assistant to Rupert Schmid, San Francisco, 1894; apprentice to Edward Kemeys, Chicago, 1897.

SELECTED ONE-ARTIST EXHIBITIONS: California Palace of the Legion of Honor, San Francisco, 1930, 1932, 1940, 1958, 1976; The Oakland Museum, 1978.

SELECTED GROUP EXHIBITIONS: San Francisco Art Association, 1900-19; Rome Salon, 1906; Paris Salon, 1907; Macbeth Gallery, New York, *Bronzes by a Group of American Artists*, 1908; International Exhibition of Modern Art (Armory Show), New York, 1913; Panama-Pacific International Exposition, San Francisco, 1915; National Sculpture Society at California Palace of the Legion of Honor, San Francisco, *Exhibition of American Sculpture*, 1929; California Pacific International Exposition, San Diego, 1935; San Francisco Museum of Art, *Thirty Years of Sculpture in California*, 1935; Golden Gate International Exposition, Palace of Fine Arts, San Francisco, *California Art in Retrospect—1850-1915*, 1940; California Palace of the Legion of Honor, San Francisco, *American Sculpture*, 1982; The Oakland Museum, *100 Years of California Sculpture*, 1982.

PUBLIC WORKS: *Winning of the West*, friezes, Market and Sutter street lamp bases, San Francisco, 1908; friezes, Bank of California and First National Bank, San Francisco, 1908; ceiling, Pacific Union Club, San Francisco, 1910.

FURTHER REFERENCES: Heyneman, Julie H. *Arthur Putnam, Sculptor*. San Francisco: Johnck and Seeger, 1932.

WORKS IN THE COLLECTION:
10 sculptures

Putnam's preferred subjects were wild animals he observed and admired during his early years on the western ranges. Master of the lost wax method of metal casting, Putnam retained spontaneity and a sensual vitality in his individual and group creations of pumas, jaguars, mountain lions, and other animals.

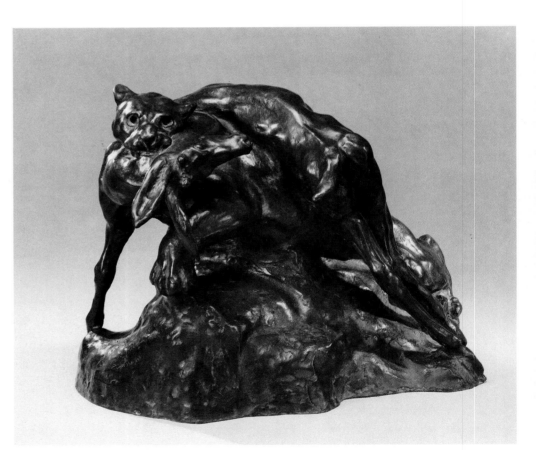

Puma and Deer, 1902 (65.180.5)
Bronze
11½ × 14½ × 9¾ in. (85.7 × 71.1 × 54.6 cm.)
Gift of Mrs. Walter A. Haas

EDWARD S. CURTIS

Born 1868, Whitewater, Wisconsin
To California c. 1918
Died October 19, 1952, Los Angeles, California

EDUCATION: Self-taught as a photographer.

SELECTED ONE-ARTIST EXHIBITIONS:
Washington Club, Washington, D.C., 1905; Cosmos
Club, Washington, D.C., 1905; Waldorf-Astoria Ho-
tel, New York, 1905; George Eastman House, Roch-
ester, New York, 1952; J. Pierpont Morgan Library,
New York, 1971; Witkin Gallery, New York, 1972;
E. B. Crocker Art Gallery, Sacramento, California,
1975; Silver Image Gallery, Seattle, Washington, 1975;
Cabrillo Gallery, Cabrillo College, Aptos, California,
1975; ADI Gallery, New York, 1976; Gallery 101,
University of Wisconsin, River Falls, 1977; Prakapas
Gallery, Loyola Marymount University Art Gallery,
Los Angeles, 1979; Cronin Gallery, Houston, Texas,
1980; Flury & Co., Seattle, Washington, 1982.

SELECTED GROUP EXHIBITIONS: The
Oakland Museum, *Fantasy Photographs*, 1972, and
Silver & Ink, 1978; Museum of Modern Art, New
York, *American Landscapes*, 1981.

FURTHER REFERENCES: Boesen, Victor,
and Florence Curtis Graybill. *Edward Sheriff Curtis:
Visions of a Vanishing Race*. New York: Thomas Y.
Cromwell Co., 1976. Lyman, Christopher. *The Van-
ishing Race and Other Illusions*. Washington, D.C.:
Smithsonian Institution Press, 1982.

WORKS IN THE COLLECTION:
31 photographic prints

*Curtis took as his life's work the gigantic job of
photographing the surviving native Americans and
recording their traditional stance and costumes.
Curtis published 2,200 photographs in a monu-
mental series of volumes.* Prayer to the Stars *com-
bines Curtis' interest in native American ways with
a romantic view of the heroic individual.*

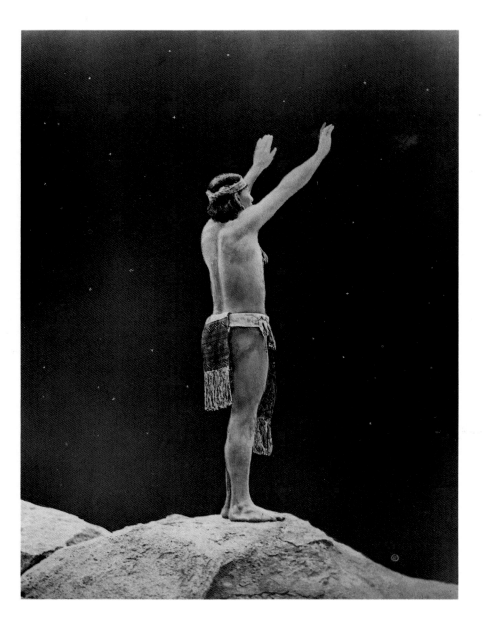

Prayer to the Stars, n.d. (66.104.11)
Gold toned photograph on glass (orotone)
13⅜ × 10¼ in. (34 × 26 cm.)
Gift of Mr. and Mrs. Howard Willoughby

ANNE BRIGMAN

Born December 3, 1869, Oahu, Hawaii
To California c. 1886
Died February 8, 1950, Eagle Rock, California

EDUCATION: Primarily self-taught as a photographer.

SELECTED ONE-ARTIST EXHIBITIONS:
Corcoran Gallery of Art, Washington, D.C., 1904; Carnegie Institute, Pittsburgh, Pennsylvania, 1904; Oakland Art Gallery, 1918; Metropolitan Museum of Art, New York, 1971; The Oakland Museum, 1974.

SELECTED GROUP EXHIBITIONS:
Mark Hopkins Institute of Art, San Francisco, *Third San Francisco Photographic Salon*, 1903; "291" Photo-Secession Gallery, New York, 1907; Albright-Knox Art Gallery, Buffalo, New York, *International Photo-Secession Exhibition*, 1910; Palace of Fine Arts, San Francisco, *First Annual International Exhibition of Pictorial Photography*, 1923; Oakland Art Museum, *f/64 and Before*, 1966; The Oakland Museum, *West of the Rockies*, 1972, and *Silver & Ink*, 1978; San Francisco Museum of Modern Art, *Women and Photography*, 1975, and *California Pictorialism*, 1977; Currier Gallery of Art, Manchester, New Hampshire, *The Photo-Secession: The Golden Age of Pictorial Photography in America*, 1983.

FURTHER REFERENCES: Heyman, Therese Thau. *Anne Brigman*. Oakland: The Oakland Museum, 1974.

WORKS IN THE COLLECTION:
105 photographic prints, 7 relief prints, and assorted memorabilia

In this toned photograph, Brigman uses a human figure carrying the precious element water as a symbol of the forces of nature. Brigman's pantheism grew out of her early contact with the myths and folklore of the native people on remote islands of Hawaii. Alfred Stieglitz brought Brigman's work to his landmark New York gallery, "291," in the early years of this century.

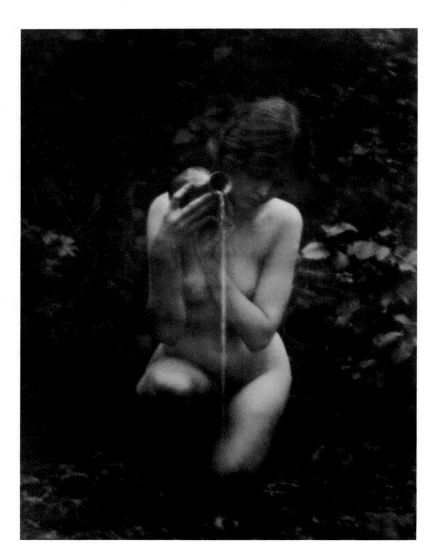

The Source, 1908 (65.163.59)
Gelatin silver print
9⅝ × 7¼ in. (24.5 × 18.4 cm.)
Gift of Mr. and Mrs. Willard M. Nott

DOUGLAS TILDEN

Born May 1, 1860, Chico, California
Died August 6, 1935, Berkeley, California

EDUCATION: Studied with Virgil Williams, California School of Design, San Francisco, 1882; studied with Marion Wells, San Francisco, 1883; studied with John Quincy Adams Ward, National Academy of Design, New York, 1887; Gotham Students League, New York, 1887; studied with Paul Chopin, Paris, 1888.

SELECTED ONE-ARTIST EXHIBITIONS: M. H. de Young Memorial Museum, San Francisco, 1980.

SELECTED GROUP EXHIBITIONS: Société des Artistes Français and Société Nationale des Beaux-Arts, Paris, 1889-92, 1894; World's Columbian Exposition, Chicago, 1893; Pan-American Exposition, Buffalo, New York, 1901; Louisiana Purchase Exposition, St. Louis, Missouri, 1904; Alaska-Yukon-Pacific Exposition, Seattle, Washington, 1909; San Francisco Museum of Art, *Thirty Years of Sculpture in California*, 1935; The Oakland Museum, *100 Years of California Sculpture*, 1982.

PUBLIC WORKS: *Baseball Player*, Golden Gate Park, San Francisco, 1888-91; Admission Day Monument, Market, Post and Montgomery streets, San Francisco, 1895-97; Mechanics Monument, Market, Bush and Battery streets, San Francisco, 1897-1901; California Volunteers Monument, Market and Dolores streets, San Francisco, 1903-06; *Twelve Stages of Man*, McElroy Memorial Fountain, Lakeside Park, Oakland, California, 1910-11.

FURTHER REFERENCES: Albronda, Mildred. *Douglas Tilden: Portrait of a Deaf Sculptor.* Silver Spring, Maryland: T. J. Publishers, Inc., 1980.

WORKS IN THE COLLECTION: 3 sculptures (plaster and bronze)

Whether creating large public monuments or salon-sized compositions, California's deaf-mute sculptor Douglas Tilden produced imaginative and vigorous works. The Golden Gate is an allegorical vision of the mysteries of the sea at the entrance to San Francisco Bay. Tilden, the first important teacher of sculpture on the West Coast, broadened his horizons through studies in Paris.

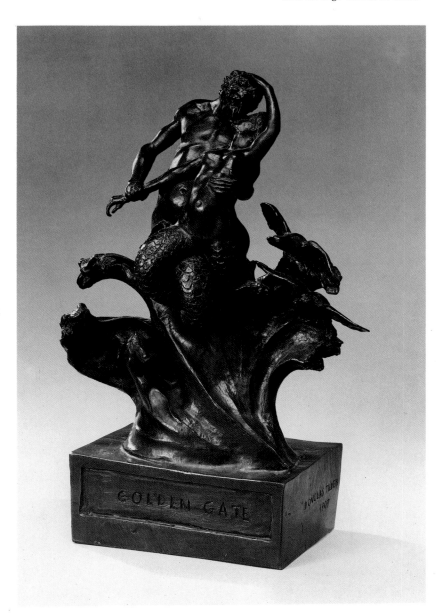

Golden Gate, 1907 (69.74)
Cast bronze
16¼ × 10½ × 6¼ in. (41.3 × 26.7 × 15.9 cm.)
Original plaster, gift of Mr. and Mrs. Robert Neuhaus. Cast in bronze courtesy of The Oakland Museum Founders Fund.

DIRK VAN ERP

Born 1861, Leeuwarden, Friesland, Holland
Emigrated to Merced, California 1886
Died 1933, San Francisco, California

EDUCATION: Learned metalsmithing from his
father in Holland.

SELECTED GROUP EXHIBITIONS:
Alaska-Yukon-Pacific Exposition, Seattle, Washington, 1909; Panama-Pacific International Exposition, San Francisco, 1915; The Oakland Museum, *Metal Works 1910-1940*, 1971; Art Museum, Princeton University, Princeton, New Jersey, and Art Institute of Chicago, *The Arts and Crafts Movement in America*, 1972-73; Pasadena Center, California, *California Design 1910*, 1974.

FURTHER REFERENCES: Andersen, Timothy J., Eudorah M. Moore, and Robert W. Winter. *California Design 1910*. 2nd ed. Santa Barbara and Salt Lake City: Peregrine Smith, Inc., 1980, pp. 78-81.

WORKS IN THE COLLECTION: 6 bowls and vases

The Arts and Crafts movement in California benefited from the presence of this artisan-trained metalsmith. The tall copper vase with soldered joints, shown here, is a very early piece done before the character of Van Erp's later production was fully established. The simplicity of form and design, enriched by hammered and toned surfaces, exemplifies the restrained aspects of the Craftsman style.

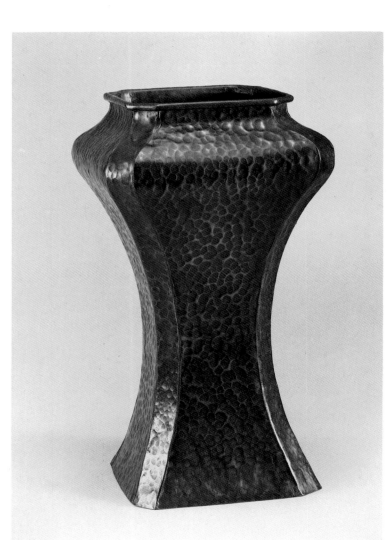

Vase, c. 1909 (69.16.2)
Shaped and hammered copper sheet
15¾ × 8¾ × 8¾ in. (40 × 22.2 × 22.2 cm.)
Gift of Mr. and Mrs. William Van Erp

LUCIA K. MATHEWS

Born August 29, 1870, San Francisco, California
Died July 14, 1955, Los Angeles, California

EDUCATION: Mills College, Oakland, 1892-93;
Mark Hopkins Institute of Art, San Francisco, 1893-
94; James A. McNeill Whistler's Académie-Carmen,
Paris, 1898-99.

SELECTED ONE-ARTIST EXHIBITIONS:
The Oakland Museum, 1972 (Arthur and Lucia Ma-
thews).

SELECTED GROUP EXHIBITIONS: San
Francisco Art Association, 1896-1930s; Panama-Pa-
cific International Exposition, San Francisco, 1915;
Golden Gate International Exposition, Palace of Fine
Arts, San Francisco, *California Art in Retrospect—
1850-1915*, 1940; Pasadena Center, California, *Cal-
ifornia Design 1910*, 1974; San Francisco Museum of
Modern Art, and National Collection of Fine Arts,
Smithsonian Institution, Washington, D.C., *Painting
and Sculpture in California: The Modern Era*, 1976-
77; The Brooklyn Museum, New York, *The American
Renaissance, 1876-1917*, 1979.

FURTHER REFERENCES: Jones, Harvey L.
*Mathews: Masterpieces of the California Decorative
Style*. 2nd ed. Santa Barbara, California, and Salt Lake
City, Utah: Peregrine Smith, Inc., 1980.

WORKS IN THE COLLECTION: Over 200
paintings, drawings, watercolors and memorabilia

In its sensitivity to its subject, this watercolor,
Portrait of a Red-Haired Girl, *exemplifies Lucia
Kleinhans Mathews' special contributions to the
California Decorative Style. The harmoniously
conceived frame featuring a motif of oranges is
similar to the designs for low-relief carving which
can be seen in the furniture Lucia Mathews pro-
duced with her husband, Arthur Mathews.*

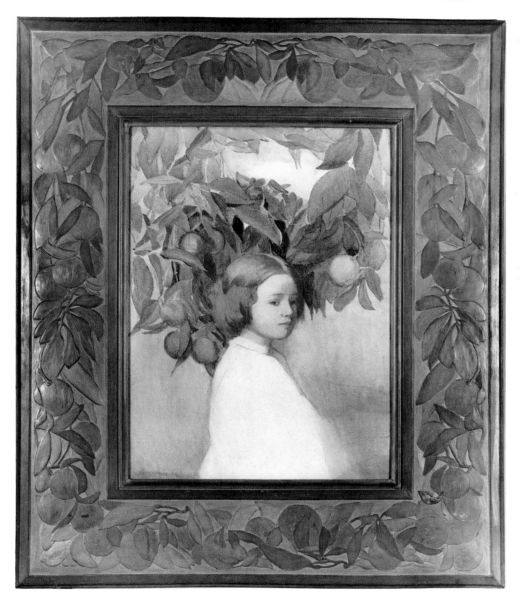

Portrait of Red-Haired Girl, 1910 (64.59.140)
Watercolor on paper
25½ × 18¼ in. (64.77 × 46.36 cm.)
Gift of Mr. Harold Wagner

FURNITURE SHOP

Arthur F. Mathews and Lucia K. Mathews, artists/designers
Located at 1717 California Street, San Francisco, 1906-1920

Custom designed and manufactured furniture, picture frames, and decorative objects, all in wood. Employed as many as fifty craftsmen, including designers, cabinet makers, and wood carvers.

SELECTED COMMISSIONS : Savings Union Bank, San Francisco, 1911; Masonic Temple, San Francisco, 1913; numerous domestic, as well as commercial, furnishings and interiors.

SELECTED ONE-ARTIST EXHIBITIONS: The Oakland Museum, 1972 (Arthur and Lucia Mathews).

SELECTED GROUP EXHIBITIONS: Pasadena Center, California, *California Design 1910*, 1974; The Brooklyn Museum, New York, *The American Renaissance, 1876-1917*, 1979.

FURTHER REFERENCES: *California Design 1910*. Eds. Timothy J. Andersen, Eudorah M. Moore, and Robert W. Winter. 1974; rpt. Santa Barbara, California, and Salt Lake City, Utah: Peregrine Smith, Inc., 1980, pp. 88-95. Jones, Harvey L. *Mathews: Masterpieces of the California Decorative Style*. 2nd ed. Santa Barbara, California, and Salt Lake City, Utah: Peregrine Smith, Inc., 1980.

WORKS IN THE COLLECTION : Over fifty items, including furniture, frames, and decorative objects

Arthur and Lucia Mathews, along with a partner, John Zeile, founded the Furniture Shop in San Francisco soon after the 1906 earthquake and fire. Their collaboratively produced furniture and decorative arts objects are notable for the strong architectural features of Arthur Mathews' structural designs, while Lucia Mathews' applied decorations are characterized by low-relief carving and soft colors highlighted with the golden orange of the California poppy.

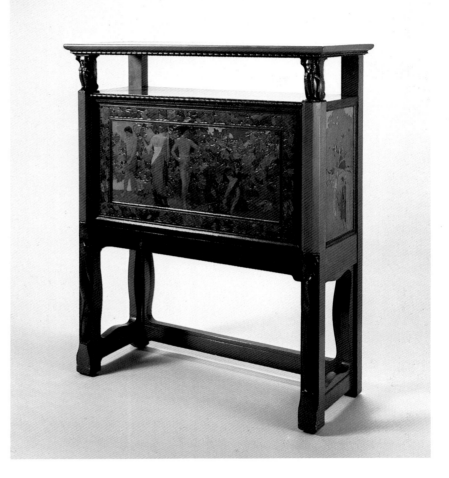

Desk, c. 1912 (72.15)
Carved and painted wood
59 × 48 × 20 in. (149.86 × 121.92 × 50.8 cm.)
Gift of Mrs. Margaret R. Kleinhans

ARTHUR F. MATHEWS

Born October 1, 1860, Markesan, Wisconsin
To California 1866
Died February 19, 1945, San Francisco, California

EDUCATION: Apprenticed as architectural draftsman at father's office, Oakland, 1875-79; designer and lithographer, Britton & Rey, 1881-84; studied with Gustave Boulanger and Jules Lefebvre, Académie Julian, Paris, 1885-86.

SELECTED ONE-ARTIST EXHIBITIONS: Mark Hopkins Institute of Art, San Francisco, 1898; Vickery, Atkins & Torrey, San Francisco, 1905; The Oakland Museum, 1972 (Arthur and Lucia Mathews).

SELECTED GROUP EXHIBITIONS: Paris Salons, 1887-89; San Francisco Art Association, c. 1889-1916; World's Columbian Exposition, Chicago, 1893; Panama-Pacific International Exposition, San Francisco, 1915; California Pacific International Exposition, San Diego, 1935; Golden Gate International Exposition, Palace of Fine Arts, San Francisco, *California Art in Retrospect—1850-1915*, 1940; Pasadena Center, California, *California Design 1910*, 1974; San Francisco Museum of Modern Art, and National Collection of Fine Arts, Smithsonian Institution, Washington, D.C., *Painting and Sculpture in California: The Modern Era*, 1976-77; The Brooklyn Museum, New York, *The American Renaissance, 1876-1917*, 1979; National Collection of Fine Arts, Smithsonian Institution, Washington, D.C., *Post-Impressionism Exhibition*, 1980.

FURTHER REFERENCES: Jones, Harvey L. *Mathews: Masterpieces of the California Decorative Style.* 2nd ed. Santa Barbara, California, and Salt Lake City, Utah: Peregrine Smith, Inc., 1980.

WORKS IN THE COLLECTION: Over 300 paintings, drawings, watercolors and memorabilia

In his easel paintings, murals, and decorative furnishings, Arthur Mathews worked in the unique California Decorative Style. He often painted figures inspired by classical mythology in the rolling hills and bright, hazy atmosphere of the California landscape. Through his work and his teaching at the Mark Hopkins Institute, Mathews was a major influence on California artistic life at the turn of the century.

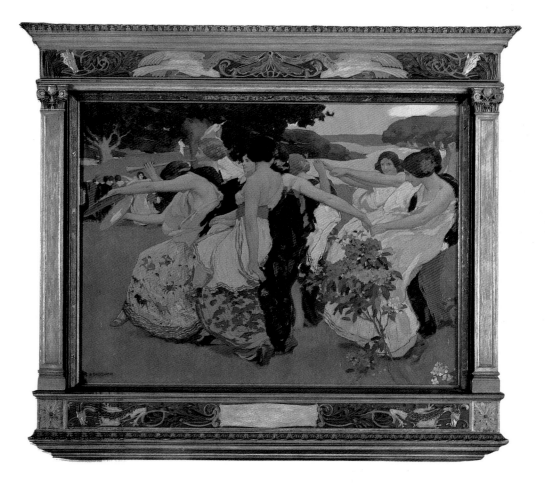

Youth, c. 1917 (66.196.24)
Oil on canvas
39 × 51 in. (99 × 121.5 cm.)
Gift of Concours d'Antiques

XAVIER MARTINEZ

Born February 7, 1869, Guadalajara, Mexico
To San Francisco, California 1893
Died January 13, 1943, Carmel, California

EDUCATION: California School of Design, San
Francisco, 1893-97; studied in the atelier of Jean-Léon
Gerôme at L'École des Beaux-Arts, Paris, 1897-99;
studied under Eugène Carrière, 1900.

SELECTED ONE-ARTIST EXHIBITIONS:
Vickery, Atkins & Torrey, San Francisco, 1905; Mac-
beth Gallery, New York, 1905; Helgesen Gallery, San
Francisco, 1915; Hill Tolerton, The Print Rooms, San
Francisco, 1915; California College of Arts and Crafts,
Oakland, 1941, 1967; Oakland Art Gallery, 1951;
The Oakland Museum, 1974.

SELECTED GROUP EXHIBITIONS: San
Francisco Art Association; Paris International Expo-
sition, 1900; Panama-Pacific International Exposi-
tion, San Francisco, 1915; California Pacific Inter-
national Exposition, San Diego, 1935; Golden Gate
International Exposition, Palace of Fine Arts, San
Francisco, *California Art in Retrospect—1850-1915*,
1940; M. H. de Young Memorial Museum, and Cali-
fornia Palace of the Legion of Honor, San Francisco,
The Color of Mood: American Tonalism, 1880-1910,
1972; Pasadena Center, California, *California Design
1910*, 1974.

FURTHER REFERENCES: Neubert, George
W. *Xavier Martinez*. Oakland: The Oakland Muse-
um, 1974.

WORKS IN THE COLLECTION:
17 paintings, 9 watercolors, 77 drawings, 12 prints,
sketchbooks, and scrapbooks

*Martinez was one of the most gifted of the Cali-
fornia Tonalists, whose approach to painting used
closely related, greyed-down colors to establish
moods of quietude and reverie. Afternoon in Pied-
mont depicts Martinez' young wife, Elsie, lost in
her thoughts before a window overlooking the San
Francisco Bay.*

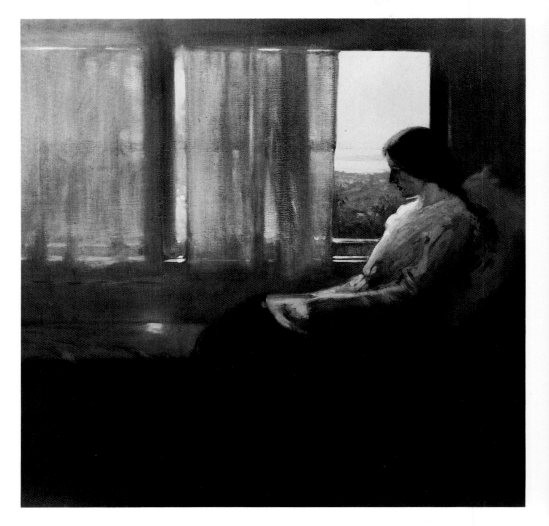

Afternoon in Piedmont, c. 1911 (53.257)
Oil on canvas
36 × 36 in. (91.4 × 91.4 cm.)
Gift of Dr. William S. Porter

FRANCIS McCOMAS

Born October 1, 1874, Fingal, Tasmania
To California 1898 and settled on the Monterey Peninsula
Died December 28, 1938, Pebble Beach, California

EDUCATION: Sydney Technical College, Australia, c. 1890; studied with Arthur Mathews, San Francisco, 1899; Académie Julian, Paris, 1899.

SELECTED ONE-ARTIST EXHIBITIONS: Vickery, Atkins & Torrey Gallery, San Francisco, 1899, 1902, 1906, 1908, 1910, 1914; Carfax Gallery, London, 1908; Macbeth Gallery, New York, 1910; Wildenstein & Co., New York, 1920; Courvoisier Galleries, San Francisco, 1935; California Historical Society, San Francisco, 1965.

SELECTED GROUP EXHIBITIONS: International Exhibition of Modern Art (Armory Show), New York, 1913; Panama-Pacific International Exposition, San Francisco, 1915; California Palace of the Legion of Honor, San Francisco, *Exhibition of American Painting*, 1935; Golden Gate International Exposition, Palace of Fine Arts, San Francisco, *California Art in Retrospect—1850-1915*, 1940; Pomona College Art Gallery, Claremont, California, and Oakland Art Museum, *Scenes of Grandeur: 19th Century Paintings of California*, 1962-63; Monterey Peninsula Museum of Art, Monterey, California, *Artists of the Monterey Peninsula, 1875-1925*, 1981.

FURTHER REFERENCES: *California Art Research Monographs*. Ed. Gene Hailey. San Francisco: Works Progress Administration, 1937, Vol. IX, pp. 64-88. Seavey, Kent L. *Francis John McComas*. San Francisco: California Historical Society, 1965.

WORKS IN THE COLLECTION:
16 watercolors

McComas, known chiefly as a watercolorist, was one of only three California artists selected for the landmark Armory exhibition in 1913 in New York. California Twilight *is an excellent example of his early tonal style, which employed low-keyed, closely related colors and emphasized an introspective, almost halcyon, view of the California landscape.*

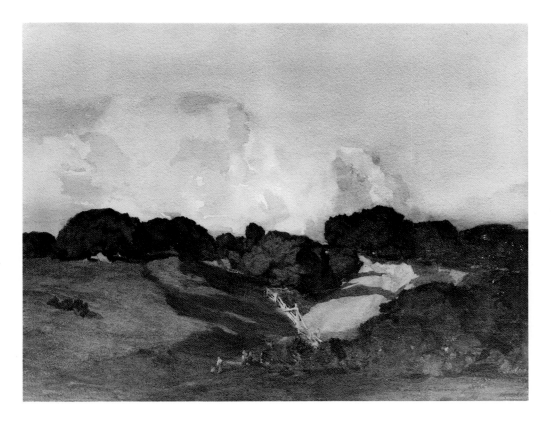

California Twilight, 1912 (59.37.3)
Watercolor on paper
23½ × 30 in. (59.7 × 76.2 cm.)
Gift of Mrs. Lucy Sprague Mitchell

FREDERICK RHEAD

Born August 29, 1880, Hanley, Staffordshire, England
Emigrated to United States 1902
In California 1911-17
Died November 2, 1942, New York, New York

EDUCATION: Wedgewood Institute, Burslem, England; Stoke-on-Trent Government Art School, England; apprentice with Brownfields Pottery, Cobridge, England.

SELECTED GROUP EXHIBITIONS: Panama-California Exposition, San Diego, 1915; Art Museum, Princeton University, New Jersey, and Art Institute of Chicago, *The Arts and Crafts Movement in America 1876-1916*, 1972-73; Pasadena Center, California, *California Design 1910*, 1974; The Oakland Museum, and Lang Gallery, Scripps College, Claremont, California, *The Potter's Art in California, 1885 to 1955*, 1978.

FURTHER REFERENCES: Bray, Hazel V. *The Potter's Art in California, 1885 to 1955*. Oakland: The Oakland Museum, 1978. Evans, Paul. *Art Pottery of the United States*. New York: Charles Scribner's Sons, 1974.

WORKS IN THE COLLECTION: 5 Rhead Pottery and 9 Arequipa Pottery pieces

One of the early and more thoroughly schooled ceramicists to come to California, Rhead had the skill to work with an unornamented glazed surface, but his penchant for intricate design and technique is here illustrated by a low bowl with a scarab motif. Its design is developed by inlays of slips that were carved before glazing.

Low Bowl, 1913-17 (75.75.4)
Glazed earthenware with incised slip design
Height: 1½ in. (3.8 cm.)
Diameter: 8½ in. (21.6 cm.)
Gift of the Estate of Helen Hathaway White

A. STIRLING CALDER

Born January 11, 1870, Philadelphia, Pennsylvania
In Pasadena, California 1906-10, and San Francisco,
California c. 1913-15
Died 1945, New York, New York

EDUCATION: Pennsylvania Academy of the Fine
Arts, Philadelphia, 1886-90; studied with Henri
Chapu, Académie Julian, Paris, and with Alexandre
Falguière, L'École des Beaux-Arts, Paris, 1890-92.

SELECTED GROUP EXHIBITIONS: Pan-
American Exposition, Buffalo, New York, 1901; Lou-
isiana Purchase Exposition, St. Louis, Missouri, 1904;
Alaska-Yukon-Pacific Exposition, Seattle, Washing-
ton, 1909; Panama-Pacific International Exposition,
San Francisco, 1915; National Sculpture Society, New
York, *Exhibition of American Sculpture*, 1923; Na-
tional Sculpture Society at California Palace of the
Legion of Honor, San Francisco, 1929; Pennsylvania
Academy of the Fine Arts, Philadelphia, *The One
Hundred and Fiftieth Anniversary Exhibition*, 1955;
The Oakland Museum, *100 Years of California Sculp-
ture*, 1982.

PUBLIC WORKS: Spandrel figures, Throop Poly-
technic Institute, Pasadena, California, 1906-10;
Fountain of Energy, South Gardens, Panama-Pacific
International Exposition, San Francisco, 1915; *Swann
Memorial Fountain*, Philadelphia, Pennsylvania,
1924.

FURTHER REFERENCES: Baigell, Matthew.
Dictionary of American Art. New York: Harper and
Row, 1979, p. 58. Moure, Nancy Dustin Wall.
*Dictionary of Art and Artists in Southern California
Before 1930*. Los Angeles: privately printed, 1975, pp.
36-37.

WORKS IN THE COLLECTION:
2 sculptures (plaster and bronze)

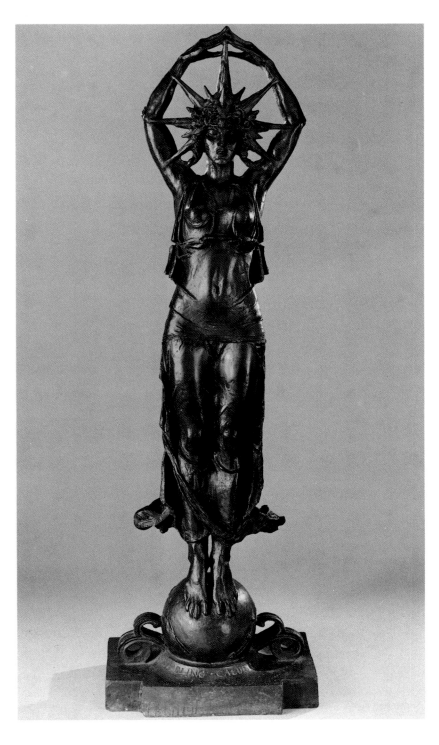

Star Figure, 1914 (74.75)
Bronze
51 × 15¼ × 9 in. (129.5 × 38.7 × 22.9 cm.)
Original plaster, gift of Dr. William S. Porter. Cast in
bronze courtesy of The Oakland Museum Founders
Fund

*This classic yet vital form was the finial figure for
the Colonnade of Stars, Court of the Universe at
the Panama-Pacific International Exposition held in
San Francisco in 1915. A. Stirling Calder, Activity
Chief for the Sculpture Department at the fair,
was the "second Alexander" in three generations
of celebrated Calder family sculptors.*

STANTON MACDONALD-WRIGHT

Born July 8, 1890, Charlottesville, Virginia
To Santa Monica, California 1900
Died August 22, 1973, Los Angeles, California

EDUCATION: Studied under Joseph Greenbaum, and at the Art Students' League, Los Angeles, 1904-05; La Sorbonne, Paris, 1907-09; Académie Colorossi, Académie Julian, and L'École des Beaux-Arts, Paris, c. 1909-12.

SELECTED ONE-ARTIST EXHIBITIONS: Der Neue Kunstsalon, Munich, Germany, 1913 (with Morgan Russell); "291" Photo-Secession Gallery, New York, 1917; Oakland Art Gallery, 1927 (with Morgan Russell); An American Place, New York, 1932; Stendahl Galleries, Los Angeles, 1942, 1943, 1945; Los Angeles Museum of History, Science and Art, 1956; La Galerie Arnaud, Paris, 1956; National Collection of Fine Arts, Smithsonian Institution, Washington, D.C., 1967; Joseph Chowning Gallery, San Francisco, 1979, 1980, 1983; Seattle Art Museum, Washington, 1980.

SELECTED GROUP EXHIBITIONS: International Exhibition of Modern Art (Armory Show), New York, 1913; Whitney Museum of American Art, New York, *Pioneers of Modern Art in America*, 1946; Museu de Arte Moderna, São Paulo, Brazil, *III Bienal*, 1955; Corcoran Gallery of Art, Washington, D.C., *The New Tradition: Modern Americans Before 1940*, 1963; National Collection of Fine Arts, Smithsonian Institution, Washington, D.C., *Roots of Abstract Art in America 1910-1930*, 1965; Museum of Modern Art, New York, *Synchromism and Related Color Principles in American Painting: 1910-1930*, 1967; San Francisco Museum of Modern Art, and National Collection of Fine Arts, Smithsonian Institution, Washington, D.C., *Painting and Sculpture in California: The Modern Era*, 1976-77; Whitney Museum of American Art, New York, *Synchromism and American Color Abstraction*, 1978-79.

FURTHER REFERENCES: National Collection of Fine Arts. *The Art of Stanton Macdonald-Wright*. Washington, D.C.: Smithsonian Press, 1967. *Stanton Macdonald-Wright Paintings: 1903-1973*. Los Angeles: ARCO Center for Visual Arts, 1979.

WORKS IN THE COLLECTION: 1 painting

Seated Man Synchromy, *painted in Paris before World War I, is an important example of early Synchromist painting by California artist Stanton Macdonald-Wright. Macdonald-Wright and Morgan Russell were the first Americans to pioneer a modern painting movement. The theories of Synchromism combined Cubist ideas with the primacy of color over form.*

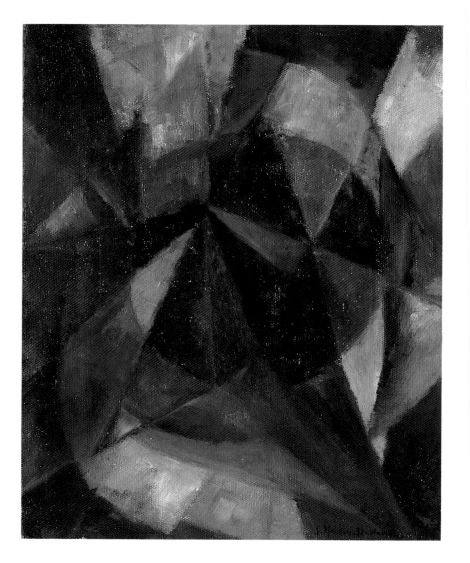

Seated Man Synchromy, 1915 (75.93)
Oil on canvas
14⅛ × 11 in. (38.76 × 27.94 cm.)
Gift of the Estate of Helen Hathaway White

RALPH STACKPOLE

Born May 1, 1885, Williams, Oregon
In California 1901-49, then moved to France
Died December 10, 1973, Chauriat Puy-de-Dôme,
France

EDUCATION: Mark Hopkins Institute of Art, San
Francisco, 1901; studio assistant to Arthur Putnam
and Gottardo Piazzoni, San Francisco, c. 1902-05;
studied with Antonin Mercié, L'École des Beaux-Arts,
Paris, 1906-08; studied with Robert Henri, New York,
1911.

SELECTED ONE-ARTIST EXHIBITIONS:
Gump's Gallery, San Francisco; Galerie Beaux Arts,
San Francisco, 1926; Adams-Danysh, San Francisco,
1934; town of Clermont-Ferrand, France, 1978;
Douglas Elliott Gallery, San Francisco, 1983.

SELECTED GROUP EXHIBITIONS: San
Francisco Art Association, 1906, c. 1916-35; Paris
Salon, 1907; Panama-Pacific International Exposi-
tion, San Francisco, 1915; Salon des Tuileries, Paris,
1921; Salon des Indépendants, Paris, 1923; Museum
of Modern Art, New York, *Painting and Sculpture
from 16 American Cities*, 1933; California Pacific
International Exposition, San Diego, 1935; San Fran-
cisco Museum of Art, *Thirty Years of Sculpture in
California*, 1935; Golden Gate International Expo-
sition, Palace of Fine Arts, San Francisco, *California
Art in Retrospect—1850-1915*, 1940; California Pal-
ace of the Legion of Honor, San Francisco, *American
Sculpture*, 1982; The Oakland Museum, *100 Years
of California Sculpture*, 1982.

PUBLIC WORKS: *Mother Earth* and *Man and
His Inventions*, carved pylons, Pacific Coast Stock
Exchange, San Francisco, 1929-32; *Major Industries
of California*, fresco panel, Coit Tower, San Francisco,
1933; *Sculpture* and *Architecture*, lunettes, Anne
Bremer Memorial Library, California School of Fine
Arts, San Francisco, 1936; *Pacifica*, statue, Golden
Gate International Exposition, Treasure Island, San
Francisco, 1939 (destroyed 1942).

FURTHER REFERENCES: *California Art Re-
search Monographs*. Ed. Gene Hailey. San Francisco:
Works Progress Administration, 1937, Vol. XIV, pp.
1-62.

WORKS IN THE COLLECTION:
1 sculpture and 2 drawings

*Best-known as a modernist proponent of mam-
moth-size, cut-direct stone sculptures, Stackpole
also created more traditional, smaller, studio
works. This early bronze of a seated nude combines
simplicity of contour with an overall surface mod-
eling relating to Expressionism.*

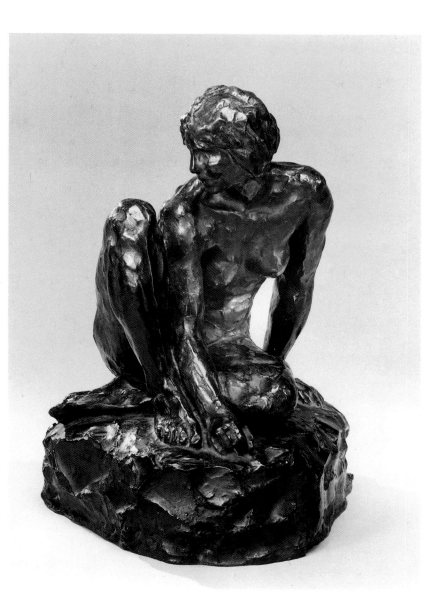

Untitled (Seated Nude), c. 1916 (82.100)
Bronze
14 × 11 × 9 in. (35.6 × 28 × 22.9 cm.)
Gift of Earl and Virginia Simburg

F. CHILDE HASSAM

Born October 17, 1859, Dorchester, Massachusetts
In California 1908, 1914-15, 1927
Died August 27, 1935, Easthampton, New York

EDUCATION: Apprentice to wood engraver, George E. Johnston, Boston, Massachusetts, 1876; free-lance illustrator for *Scribner's, Harper's, Century*, etc., 1876-78; Boston Art Club, c. 1877-78; studied with Dr. William Rimmer at Lowell Institute, Boston, c. 1878; studied with Ignaz-Marcel Gaugengigl, Boston, c. 1879; studied with Gustave Boulanger and Jules Lefebvre at Académie Julian, Paris, c. 1886.

SELECTED ONE-ARTIST EXHIBITIONS: Williams and Everett, Boston, 1883; Doll's and Richard's Gallery, Boston, 1889; Montross Gallery, New York, 1905; Frederick Keppel and Co., New York, 1916; William Macbeth Gallery, New York, 1919; Los Angeles Museum of History, Science and Art, 1919; Durand-Ruel Gallery, New York, 1926; American Academy of Arts and Letters, New York, 1927; California Palace of the Legion of Honor, San Francisco, 1929; Albright Art Gallery, Buffalo, New York, 1929; Milch Gallery, New York, 1935; Hirschl and Adler Galleries, New York, 1964; Corcoran Gallery of Art, Washington, D.C., 1965; University of Arizona Museum of Art, Tucson, 1972.

SELECTED GROUP EXHIBITIONS: National Academy of Design, New York, 1883, 1886-87, 1890, 1898-1928, 1930-36; Mechanics' Institute Industrial Exhibition, San Francisco, 1886; Paris Salons, 1887, 1888; Internationalen Kunstaustellung, Munich, 1892; World's Columbian Exposition, Chicago, 1893; Durand-Ruel Gallery, New York, *Ten American Painters* exhibitions, 1898-1918; Exposition Universelle, Paris, 1900; Pan-American Exposition, Buffalo, New York, 1901; Louisiana Purchase Exposition, St. Louis, Missouri, 1904; International Exhibition of Modern Art (Armory Show), New York, 1913; Panama-Pacific International Exposition, San Francisco, 1915; Philadelphia Sesquicentennial Exposition, Pennsylvania, 1926.

FURTHER REFERENCES: Hoopes, Donelson F. *Childe Hassam*. New York: Watson-Guptill Publications, 1979. Steadman, William E. *Childe Hassam, 1859-1935*. Tucson: University of Arizona Museum of Art, 1972.

WORKS IN THE COLLECTION: 1 painting and 1 etching

Hassam, a leading American Impressionist who studied in Europe, visited California several times. In this painting, with its play of light and shadow on a hillside, Hassam applied Impressionism to a San Francisco Bay Area subject.

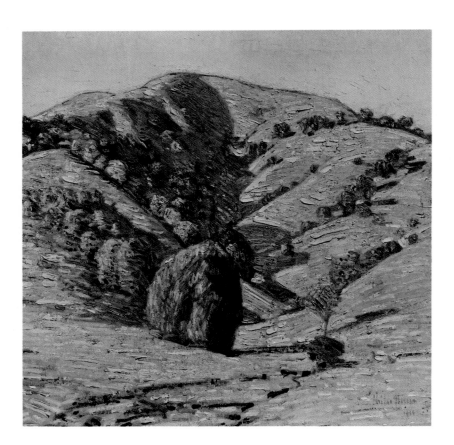

Hill of the Sun, San Anselmo, California, 1914
(80.84)
Oil on canvas
24 × 24 in. (60.7 × 60.7 cm.)
Gift of the Women's Board of the Oakland Museum Association, in honor of George W. Neubert

JOSEPH RAPHAEL

Born June 2, 1869, San Francisco, California
In California 1869-1902 and 1939-50; intervening years were spent mostly in Uccle, Belgium, and Oegstageest, Holland
Died December 11, 1950, San Francisco, California

EDUCATION: California School of Design, San Francisco, 1887-97; L'École des Beaux-Arts, Paris, 1902; studied with Jean-Paul Laurens, Professor at Académie Julian, Paris, 1902.

SELECTED ONE-ARTIST EXHIBITIONS: San Francisco Institute of Art, 1910; Oakland Art Gallery, 1933; San Francisco Museum of Art, 1935, 1939, 1940, 1951; Gump's Gallery, San Francisco, 1941; California Historical Society, San Francisco, 1960; Stanford University Museum of Art, California, 1980.

SELECTED GROUP EXHIBITIONS: San Francisco Art Association, c. 1896-1939; Paris Salons, 1904-06; Panama-Pacific International Exposition, San Francisco, 1915; Panama-California Exposition, San Diego, 1915; Oakland Art Gallery, *Impressionist Paintings by Western Artists*, 1924; Golden Gate International Exposition, Palace of Fine Arts, San Francisco, *California Art Today*, and *California Art in Retrospect—1850-1915*, 1940; Henry Art Gallery, University of Washington, Seattle, *American Impressionism*, 1980; The Oakland Museum, *Impressionism, The California View*, 1981-82.

FURTHER REFERENCES: The Oakland Museum. *Impressionism, The California View*. Oakland, 1981.

WORKS IN THE COLLECTION:
6 paintings, 1 watercolor, and 9 prints

In this painting, which is typical of the artist's Post-Impressionist style, thick, swirling brushstrokes grow into a grand view of rhododendrons in the fields. Raphael's work was important in introducing innovative art styles to the region in the first quarter of the twentieth century.

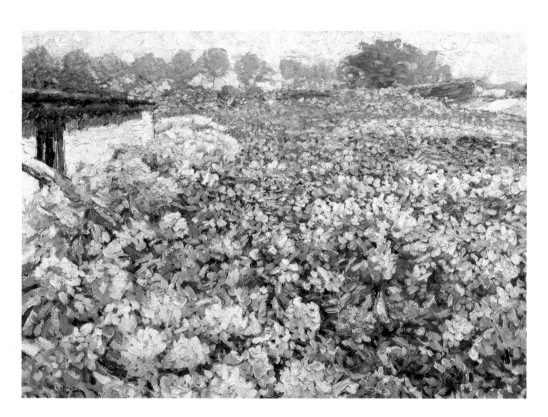

Rhododendron Field, 1915 (53.256)
Oil on canvas
30 × 40 in. (76.2 × 101.6 cm.)
Gift of Dr. William S. Porter

E. CHARLTON FORTUNE

Born January 15, 1885, Sausalito, California
Died May 15, 1969, Carmel Valley, California

EDUCATION: Edinburgh College of Art, Scotland; St. John's Wood School of Art, London, 1904; Mark Hopkins Institute of Art, San Francisco, 1905; studied with Frank Vincent DuMond, F. Luis Mora and Albert Sterner at Art Students League, New York, c. 1907-10; studied with William Merritt Chase, Carmel, California, 1914.

SELECTED ONE-ARTIST EXHIBITIONS: N. R. Helgesen Gallery, San Francisco, 1918, 1921; Gieves Gallery, London, 1921; Galerie Beaux Arts, San Francisco, 1927; Oakland Art Gallery, 1927; E. B. Crocker Art Gallery, Sacramento, California, 1927; Los Angeles Museum of History, Science and Art, 1928; Santa Barbara Art League Gallery, California, 1928; Carmel Art Gallery, California, 1928; San Diego Fine Arts Gallery, California, 1928.

SELECTED GROUP EXHIBITIONS: Del Monte Art Gallery, Monterey, California, c. 1907-28; Royal Scottish Academy, c. 1911-23; San Francisco Art Association, c. 1913-34; Panama-Pacific International Exposition, San Francisco, 1915; Panama-California Exposition, San Diego, 1915; National Academy of Design, New York, 1921, 1922, 1924, 1925, 1929, 1932; Société des Artistes Français, Paris Salons, 1923, 1924, 1926, 1927, 1934; Golden Gate International Exposition, San Francisco, 1939-40; The Oakland Museum, *Impressionism, The California View*, 1981-82.

FURTHER REFERENCES: Fortune, E. C. Scrapbook. Archives of California Art, The Oakland Museum. *California Art Research Monographs*. Ed. Gene Hailey. San Francisco: Works Progress Administration, 1937, Vol. XII, pp. 54-76. The Oakland Museum. *Impressionism, The California View*. Oakland, 1981.

WORKS IN THE COLLECTION: 1 painting

E. Charlton Fortune, who studied in Europe from 1910 to 1912, became one of California's leading Impressionists upon her return. Here, she adroitly uses impressionistic, broken color brushwork to capture the fleeting effects of flickering light dancing on Monterey Bay.

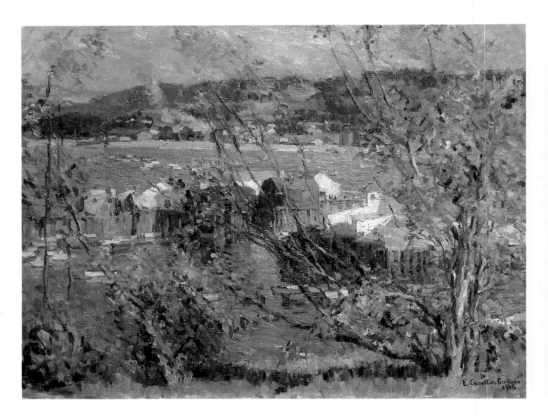

Monterey Bay, 1916 (58.10.2)
Oil on canvas
30 × 40 in. (76.2 × 101.6 cm.)
Museum Donors' Acquisition Fund

GUY ROSE

Born March 3, 1867, San Gabriel, California
In Paris and New York, 1888-1914, then returned to California
Died November 17, 1925, Pasadena, California

EDUCATION: Studied with Emil Carlsen, California School of Design, San Francisco, c. 1887-88; studied with Jules Lefebvre, Benjamin Constant, and Lucien Doucet, Académie Julian, Paris, 1888-91.

SELECTED ONE-ARTIST EXHIBITIONS: Los Angeles Museum of History, Science and Art, 1916, 1918, 1919; Stendahl Galleries, Los Angeles, 1922, 1926.

SELECTED GROUP EXHIBITIONS: World's Columbian Exposition, Chicago, 1893; Paris Salon, 1894; National Academy of Design, New York, 1896; Pan-American Exposition, Buffalo, New York, 1901; Panama-Pacific Exposition, San Francisco, 1915; Panama-California Exposition, San Diego, 1915; Oakland Art Gallery, *Impressionist Paintings by Western Artists*, 1924; California Pacific International Exposition, San Diego, 1935; Golden Gate International Exposition, Palace of Fine Arts, San Francisco, *California Art in Retrospect—1850-1915*, 1940; Los Angeles County Museum of Art, *Painting and Sculpture in Los Angeles, 1900-1945*, 1979; The Oakland Museum, *Impressionism, The California View*, 1981-82.

FURTHER REFERENCES: Moure, Nancy Dustin Wall. *Dictionary of Art and Artists in Southern California Before 1930*. Los Angeles: privately printed, 1975, pp. 214-15. Stendahl, Earl L. *Guy Rose*. Los Angeles: Stendahl Galleries, 1922.

WORKS IN THE COLLECTION: 2 paintings

Southern California's foremost painter in the Impressionist style, Rose has combined palette, brushwork and vision to produce this impressionistic painting of a tranquil scene near Monet's home at Giverny. Rose made an extended visit to France around the turn of the century.

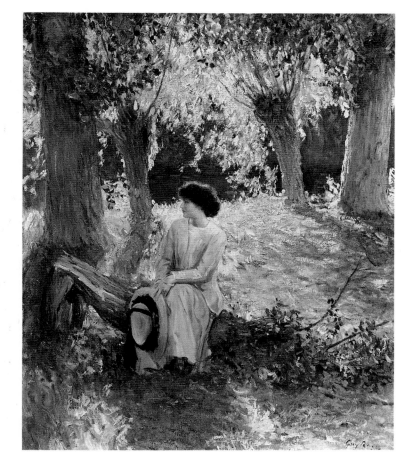

Warm Afternoon, before 1915 (67.43)
Oil on canvas
29 × 23½ in. (73.66 × 71.12 cm.)
Museum Donors' Acquisition Fund

GOTTARDO PIAZZONI

Born April 14, 1872, Intragna, Switzerland
To California 1886
Died August 1, 1945, Carmel Valley, California

EDUCATION: California School of Design, San
Francisco, c. 1891-93; Académie Julian, Paris, 1895-
96; L'École des Beaux-Arts, Paris, 1896-98.

SELECTED ONE-ARTIST EXHIBITIONS:
Paul Elder Galleries, San Francisco, 1914; Bohemian
Club, San Francisco, 1923; Adams-Danysh Galleries,
San Francisco, 1934; Lucien Labaudt Art Gallery, San
Francisco, 1946 (with Rinaldo Cuneo); California
Historical Society, San Francisco, 1959.

SELECTED GROUP EXHIBITIONS: San
Francisco Art Association, c. 1898-1935; Louisiana
Purchase Exposition, St. Louis, Missouri, 1904; In-
ternational Exposition of Fine Arts, Rome, 1906; Sa-
lon de la Société Nationale des Beaux-Arts, Paris,
1907; Panama-Pacific International Exposition, San
Francisco, 1915; California Palace of the Legion of
Honor, San Francisco, *Exhibition of American Paint-
ing*, 1935; Golden Gate International Exposition, Pal-
ace of Fine Arts, San Francisco, *California Art in
Retrospect—1850-1915*, 1940; San Francisco Muse-
um of Modern Art, and National Collection of Fine
Arts, Smithsonian Institution, Washington, D.C.,
*Painting and Sculpture in California: The Modern
Era*, 1976-77.

FURTHER REFERENCES: Artist's File, Ar-
chives of California Art, The Oakland Museum.

WORKS IN THE COLLECTION:
6 paintings, 1 print, and scrapbook

*Piazzoni combines Post-Impressionist brushwork
with Tonalist color harmony to heighten the ro-
mantic mood in this twilight scene on the channel
of San Francisco Bay.*

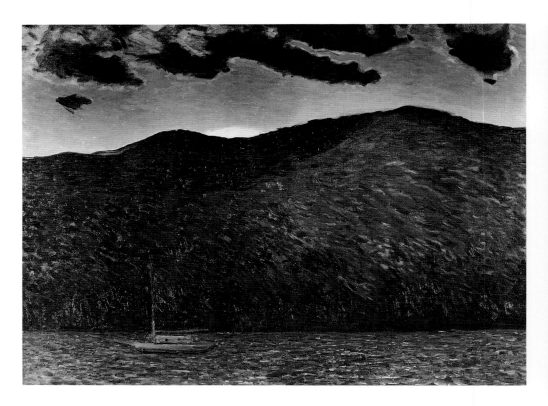

On the Channel, 1918 (71.17)
Oil on canvas
34¾ × 46½ in. (88.3 × 118.1 cm.)
The Oakland Museum Founders Fund

ANNE BREMER

Born May 21, 1868, San Francisco, California
Died October 26, 1923, San Francisco, California

EDUCATION: California School of Design, San Francisco; Art Students League, New York; Académie Moderne and La Palette, Paris.

SELECTED ONE-ARTIST EXHIBITIONS: Hill Tolerton Gallery, San Francisco, 1916, 1922; Arlington Galleries, New York, 1917; The Print Rooms, San Francisco, 1923; Palace of Fine Arts, San Francisco, 1923.

SELECTED GROUP EXHIBITIONS: California Society of Artists, San Francisco, 1902; San Francisco Art Association, 1900-23; Del Monte Art Gallery, Monterey, California, c. 1907-14; Salon d'Automne, Paris, 1911; Panama-Pacific International Exposition, San Francisco, 1915; Western Association of Art Museums, *Selected Work by Western Painters*, 1922, 1923; The Oakland Museum, *Impressionism, The California View*, 1981-82.

FURTHER REFERENCES: *California Art Research Monographs*. Ed. Gene Hailey. San Francisco: Works Progress Administration, 1937, Vol. VII, pp. 88-128.

WORKS IN THE COLLECTION:
7 paintings

In her Sketch No. 1 *(The Inlet), Anne Bremer masterfully employs Post-Impressionist color and form. Ignoring both a panoramic and a more naturalistic view, she presents this closely cropped scene with the boldness of a Japanese woodblock.*

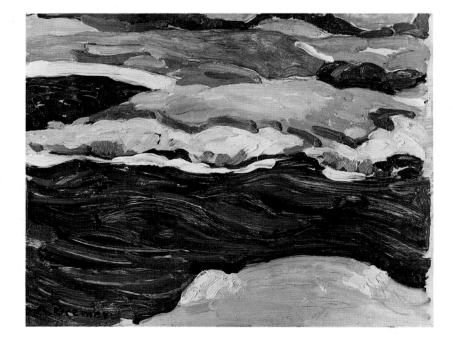

Sketch No. 1 (The Inlet), n.d. (53.2)
Oil on panel
8½ × 10½ in. (21.6 × 26.7 cm.)
Bequest of Albert Bender

FRANCIS BRUGUIÈRE

Born October 16, 1869, San Francisco, California
In California until 1918, then moved to New York,
New York, and to London, England 1927
Died May 8, 1945, London, England

EDUCATION: Unknown.

SELECTED ONE-ARTIST EXHIBITIONS:
Art Center, New York, 1927; Der Sturm Gallery, Berlin, c. 1928; Warren Gallery, London, c. 1928; Lund,
Humphries Galleries, London, c. 1934; The Focal
Press, London, 1949; George Eastman House, Rochester, New York, 1959; Witkin Gallery, New York,
1977; Friends of Photography, Carmel, California, and
The Oakland Museum, 1978.

SELECTED GROUP EXHIBITIONS:
Mark Hopkins Institute of Art, San Francisco, *Third
San Francisco Photographic Salon*, 1903; Albright-
Knox Art Gallery, Buffalo, New York, *International
Photo-Secession Exhibition*, 1910; Bohemian Club,
San Francisco, 1916; Deutsche Werkbund, Stuttgart,
Germany, *Film und Foto*, 1929; Oakland Art Museum, *f/64 and Before*, 1966, and *Photography and
the West*, 1967.

FURTHER REFERENCES: Enyeart, James L.
Bruguière: His Photographs and His Life. New York:
Knopf, 1977.

WORKS IN THE COLLECTION:
124 photographic prints and memorabilia

*In a strong, balanced composition of blacks and
whites, Bruguière looked beneath the festive surface
of San Francisco's 1915 Panama-Pacific International Exposition to record it as a place of fantasy
and mystery, shrouded in deep shadow. Bruguière
is also known for his later experimental series
exploring the many shapes of clouds and skyscrapers.*

*Altar Before Rotunda, Palace of Fine Arts, Panama-
Pacific International Exposition, San Francisco*, 1915
(65.169.4) Gelatin silver print
13⅜ × 10½ in. (34 × 26.7 cm.)
Purchased with funds donated by Dr. and Mrs. Dudley
P. Bell

EDWARD WESTON

Born March 24, 1886, Highland Park, Illinois
To California 1911 and settled in the San Francisco Bay Area
Died January 1, 1958, Carmel, California

EDUCATION: Illinois College of Photography, Effingham, 1908; self-taught after 1908.

SELECTED ONE-ARTIST EXHIBITIONS: Guadalajara State Museum, Mexico, 1925; Los Angeles Museum of History, Science and Art, 1927; St. Louis Public Library, Missouri, 1930; M. H. de Young Memorial Museum, San Francisco, 1931; Denver Art Museum, Colorado, 1932; Museum of Modern Art, New York, 1946, 1975; Stanford University Museum, California, 1964; Museum of Art, University of Oregon, Eugene, 1965; George Eastman House, Rochester, New York, 1968; Metropolitan Museum of Art, New York, 1972; Dayton Art Institute, Ohio, and The Oakland Museum, 1979; San Francisco Museum of Modern Art, 1983.

SELECTED GROUP EXHIBITIONS: San Francisco Museum of Art, *Perceptions*, 1954; University of California, Davis, *Eleanor and Van Deren Coke Collection of Photographs*, 1974; San Francisco Museum of Modern Art, *California Pictorialism*, 1977; Art Gallery, University of Missouri, Columbia, and The Oakland Museum, *Group f/64*, 1978; Phoenix Art Museum, Arizona, *Visitors to Arizona*, 1980.

FURTHER REFERENCES: Maddow, Ben. *Edward Weston: Fifty Years*. New York: Aperture, Inc., 1973. *Edward Weston: His Life and Photographs*. Revised edition. Millerton, New York: Aperture, Inc., 1979.

WORKS IN THE COLLECTION:
49 photographic prints

This photograph of male nudes bathed in light is a rare early version of a subject Weston returned to many times. Streams of light define the nude figures, reflected light creates an overall abstract pattern, and diffused light softens the focus. By the 1930s, Weston turned to straight, sharp focus defined by the aperture f/64.

Bathing Pool, 1919 (69.19.2)
Platinum print
9½ × 7½ in. (24.1 × 19 cm.)
Purchased with funds donated by Dr. and Mrs. Dudley P. Bell
© 1981, Arizona Board of Regents, Center for Creative Photography

101

EDWARD BOREIN

Born October 21, 1872, San Leandro, California
In Mexico 1897-1900, 1903; in New York City 1907-19 except for brief visits to Oakland, California 1909, 1913; settled in Santa Barbara, California 1921
Died May 19, 1945, Santa Barbara, California

EDUCATION: Primarily self-taught. Made thousands of sketches while a cowhand. Studied at California School of Design, San Francisco, 1891 (one month); studied etching with Vojtech Preissig, Art Students League, New York, 1914-15.

SELECTED ONE-ARTIST EXHIBITIONS: Frederick Keppel & Co., New York, 1915, 1917; Cobb Gallery, Boston, Massachusetts, 1919; Gump's Gallery, San Francisco, 1922; Art League of Santa Barbara, California, 1927; Amon Carter Museum of Western Art, Fort Worth, Texas, 1962; Southwest Museum, Highland Park, California, 1965; Santa Barbara Museum of Art, California, 1965; Achenbach Foundation for Graphic Arts, California Palace of the Legion of Honor, San Francisco, 1971.

FURTHER REFERENCES: Davidson, Harold G. *Edward Borein: Cowboy Artist.* Garden City, New York: Doubleday and Company, Inc., 1974. Moure, Nancy Dustin Wall. *Dictionary of Art and Artists in Southern California Before 1930.* Los Angeles: privately printed, 1975, p. 22.

WORKS IN THE COLLECTION: 1 painting, 1 watercolor, 2 drawings, and 4 etchings

Fine draughtsmanship and sensitivity to form and effect are characteristic of Borein's watercolor paintings and sketches of cowboys and Indians. A native of San Leandro, California, the artist romantically depicted the ordinary activities of life on the western frontier.

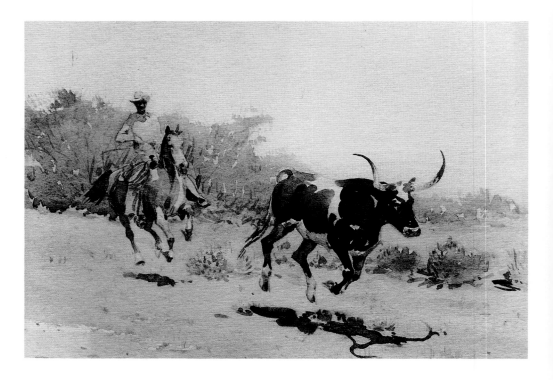

Cowboy Chasing Longhorned Steer, n.d. (67.109)
Watercolor on paper
18¼ × 19⅞ in. (46.4 × 49.5 cm.)
Museum Donors' Acquisition Fund

ARMIN C. HANSEN

Born October 23, 1886, San Francisco, California
Died April 23, 1957, Monterey, California

EDUCATION: Early lessons from father, Hermann
Wendelborg Hansen; Mark Hopkins Institute of Art,
San Francisco, 1903-06; studied with Carlos Grethe,
Royal Academy, Stuttgart, Germany, 1906-08.

SELECTED ONE-ARTIST EXHIBITIONS:
Helgesen Gallery, San Francisco, 1913, 1916; Oakland
Art Gallery, 1917; The Print Rooms, San Francisco,
1920; Grafton Galleries, San Francisco, 1934 (with
William Ritschel); Penthouse Gallery, American Art-
ists' Professional League, San Francisco, 1944; Oak-
land Art Museum, 1959; Maxwell Galleries Ltd., San
Francisco, 1982.

SELECTED GROUP EXHIBITIONS: In-
ternational Exposition, Brussels, 1910; Pennsylvania
Academy of the Fine Arts, Philadelphia, 1914; Pan-
ama-Pacific International Exposition, San Francisco,
1915; San Francisco Art Association, c. 1915-25;
Western Association of Art Museums, *Selected Work
by Western Painters*, 1922, 1923, 1924-25; Victoria
and Albert Museum, London, 1929; Golden Gate In-
ternational Exposition, Palace of Fine Arts, San Fran-
cisco, *California Art in Retrospect—1850-1915*,
1940; The Oakland Museum, *Impressionism, The
California View*, 1981-82.

FURTHER REFERENCES: *California Art Re-
search Monographs*. Ed. Gene Hailey. San Francisco:
Works Progress Administration, 1937, Vol. IX, pp.
105-33.

WORKS IN THE COLLECTION:
2 paintings, 2 drawings, and 79 prints

*In the early decades of the twentieth century,
seaport activities were popular topics for etchers
and printmakers. In this print, the inky black burr
of the drypoint technique is apparent. Hansen,
one of the first fine art etchers in California, pro-
duced very limited editions of his small, finely
drawn images.*

Sardine Barge, 1922 (61.56.8)
Drypoint on paper
12⅝ × 14⅝ in. (32 × 37.1 cm.) (image)
Museum Donors' Acquisition Fund

WILLIAM H. CLAPP

Born October 29, 1879, Montreal, Canada
In California 1885-1900 and c. 1918-54
Died April 21, 1954, Piedmont, California

EDUCATION: Studied with William Brymner, Montreal Art Association School, Canada, 1900-1904; Académie Julian, Académie Colarossi, and L'École de la Grande Chaumière, Paris, 1904-08.

SELECTED ONE-ARTIST EXHIBITIONS: The Arts Club of Montreal, Canada, 1914; Johnson's Art Galleries Ltd., Montreal, 1914; Oakland Art Gallery, 1917, 1920, 1922, 1933, 1942, 1944, 1947; Oakland Art Museum, 1954; Laky Gallery, Carmel, California, 1966; Erickson Gallery, Palo Alto, California, 1970.

SELECTED GROUP EXHIBITIONS: Salon d'Automne, Paris, 1906; Canadian National Exhibition, Toronto, 1913, 1915; San Francisco Art Association, 1918, 1919, 1920, 1927, 1937; Western Association of Art Museums, *Selected Work by Western Painters*, 1922, 1924-25; Oakland Art Gallery, *Society of Six* exhibitions, 1923-28; Golden Gate International Exposition, Palace of Fine Arts, San Francisco, *California Art in Retrospect—1850-1915*, and *California Art Today*, 1940; The Oakland Museum, *Society of Six*, 1972; Art Gallery of Ontario, Toronto, *Impressionism in Canada, 1895-1935*, 1973; San Francisco Museum of Modern Art, and National Collection of Fine Arts, Smithsonian Institution, Washington, D.C., *Painting and Sculpture in California: The Modern Era*, 1976-77; The Oakland Museum, *Impressionism, The California View*, 1981-82.

FURTHER REFERENCES: St. John, Terry. *Society of Six*. Oakland: The Oakland Museum, 1972.

WORKS IN THE COLLECTION: 56 paintings, 17 drawings, 1 watercolor, 11 prints, and memorabilia

Clapp was the only member of the Society of Six to study painting in Europe. In this early work, Bird-nesting, *the artist took an approach to plein-air painting that was first pursued by the French Impressionists, who intensified local colors and applied them with broken brushstrokes.*

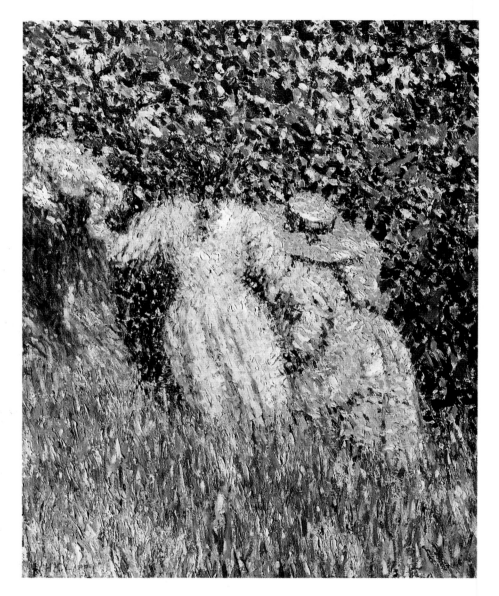

Bird-nesting, n.d. (58.64.59)
Oil on canvas
36½ × 28¾ in. (92.7 × 73 cm.)
Gift of Mr. and Mrs. Donn Schroder

LOUIS SIEGRIEST

Born February 24, 1899, Oakland, California
Lives in Oakland, California

EDUCATION: California School of Arts and
Crafts, Berkeley, 1914-16; California School of Fine
Arts, San Francisco, 1916-18; Van Sloun School of
Art, San Francisco, 1918-20; studied with Glenn Wessels, San Francisco, 1938-39.

SELECTED ONE-ARTIST EXHIBITIONS:
Gump's Gallery, San Francisco, 1931, 1933, 1946;
E. B. Crocker Art Gallery, Sacramento, California,
1946; M. H. de Young Memorial Museum, San Francisco, 1952; Oakland Art Museum, 1954, 1960; University Art Gallery, Berkeley, California, 1963; Art
Center, San Francisco, 1964; San Francisco Art Institute, 1965; Triangle Gallery, San Francisco, 1969-83; The Oakland Museum, 1972, 1979; Capricorn
Asunder, San Francisco Art Commission Gallery,
1975; Charles Campbell Gallery, San Francisco, 1980
(with Selden Connor Gile).

SELECTED GROUP EXHIBITIONS: Oakland Art Gallery, *Society of Six* exhibitions, 1923-28;
San Francisco Art Association, 1934-63; Golden Gate
International Exposition, Palace of Fine Arts, San
Francisco, *California Art Today*, 1940; Metropolitan
Museum of Art, New York, 1952; University of Illinois, Champaign-Urbana, *Contemporary American
Painting and Sculpture*, 1963; The Oakland Museum,
Society of Six, 1972; Whitney Museum of American
Art, New York, *Contemporary American Painting
and Sculpture*, 1973; San Francisco Museum of Modern Art, and National Collection of Fine Arts, Smithsonian Institution, Washington, D.C., *Painting and
Sculpture in California: The Modern Era*, 1976-77;
The Oakland Museum, *Impressionism, The California View*, 1981-82.

FURTHER REFERENCES: St. John, Terry.
Louis Siegriest: Retrospective. Oakland: The Oakland Museum, 1972.

WORKS IN THE COLLECTION:
22 paintings and 4 drawings

*With Selden Gile's encouragement, Siegriest discarded his Tonalist palette for one that featured
intense color as he began to try his hand at plein-air painting. Siegriest was the only member of the
Society of Six to participate successfully in the
contemporary art scene after World War II.*

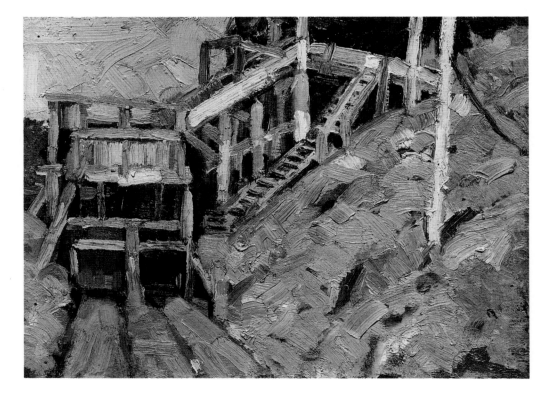

Oakland Quarry, 1920 (75.143.10)
Oil on cardboard
12 × 16¼ in. (30.5 × 41.4 cm.)
Gift of Louis Siegriest

MAURICE LOGAN

Born February 21, 1886, San Francisco, California
Died March 22, 1977, Orinda, California

EDUCATION: Studied with Clara Cuff, Oakland, 1896; Partington Art School, San Francisco; Mark Hopkins Institute of Art, San Francisco, c. 1907-14; Art Institute of Chicago; California School of Arts and Crafts, Berkeley.

SELECTED ONE-ARTIST EXHIBITIONS: Oakland Art Gallery, 1933, 1938, 1941; Courvoisier Gallery, San Francisco, 1933; San Francisco Museum of Art, 1940; M. H. de Young Memorial Museum, San Francisco, 1957; Maxwell Galleries, San Francisco, 1961; Bohemian Club, San Francisco, 1975.

SELECTED GROUP EXHIBITIONS: Oakland Art Gallery, *Society of Six* exhibitions, 1923-28; Golden Gate International Exposition, Department of Fine Arts, Treasure Island, San Francisco, *Contemporary Art*, 1939; M. H. de Young Memorial Museum, San Francisco, Society of Western Artists exhibitions, c. 1949-61; National Academy of Design, New York, c. 1954-68; The Oakland Museum, *Society of Six*, 1972; San Francisco Museum of Modern Art, and National Collection of Fine Arts, Smithsonian Institution, Washington, D.C., *Painting and Sculpture in California: The Modern Era*, 1976-77; The Oakland Museum, *Impressionism, The California View*, 1981-82.

FURTHER REFERENCES: St. John, Terry. *Society of Six*. Oakland: The Oakland Museum, 1972.

WORKS IN THE COLLECTION:
6 paintings and 1 drawing

Maurice Logan, a member of the Society of Six, often used Post-Impressionist color in his landscape paintings of the greater San Francisco Bay Area. Alaska Packers Yard, Alameda, however, is painted in the muted colors of an overcast day.

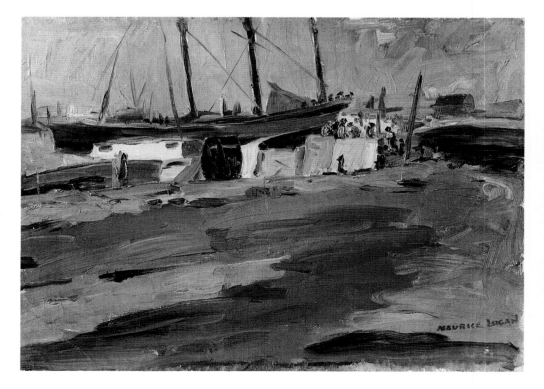

Alaska Packers Yard, Alameda, c. 1920 (73.20.2)
Oil on canvas
13 × 18 in. (33.02 × 45.72 cm.)
Gift of Dr. and Mrs. Frederick Novy

AUGUST GAY

Born June 16, 1891, Rabou, France
To California c. 1900
Died March 9, 1949, Carmel, California

EDUCATION: California School of Fine Arts, San Francisco, 1918-19; California School of Arts and Crafts, Berkeley, 1918-19.

SELECTED GROUP EXHIBITIONS: Oakland Art Gallery, *Society of Six* exhibitions, 1923-28; San Francisco Art Association, 1928, 1935; Galerie Beaux Arts, San Francisco, 1929; Del Monte Art Gallery, Monterey, California, 1919; Carmel Art Association, California; The Oakland Museum, *Society of Six*, 1972; San Francisco Museum of Modern Art, and National Collection of Fine Arts, Smithsonian Institution, Washington, D.C., *Painting and Sculpture in California: The Modern Era*, 1976-77; The Oakland Museum, *Impressionism, The California View*, 1981-82.

FURTHER REFERENCES: St. John, Terry. *Society of Six*. Oakland: The Oakland Museum, 1972.

WORKS IN THE COLLECTION:
21 paintings and 5 prints

August Gay, a member of the Society of Six, developed a painting style in the 1920s that in some ways anticipated the Bay Area Figurative movement of the 1950s and 1960s. Gay often painted on location, producing landscapes with angular shapes that he treated in a broad, intensely colored manner.

Ranch in Carmel Valley, 1925 (73.28)
Oil on paperboard
12¾ × 15 in. (32.4 × 38 cm.)
Gift of Dr. and Mrs. Frederick Novy

SELDEN CONNOR GILE

Born March 20, 1877, Stowe, Maine
To California 1900 or 1903
Died June 8, 1947, Marin County, California

EDUCATION: Primarily self-taught; some classes at California School of Arts and Crafts, Berkeley.

SELECTED ONE-ARTIST EXHIBITIONS: Oakland Art Gallery, 1928 (with Bernard von Eichman); Galerie Beaux Arts, San Francisco, 1928 (with Amy D. Flemming); Paul Elder Gallery, San Francisco, 1930; Charles Campbell Gallery, San Francisco, 1975, 1976, 1977; North Point Gallery, San Francisco, 1975, 1977; Sohlman Art Gallery, Oakland, 1982; Walnut Creek Civic Arts Gallery, California, 1983.

SELECTED GROUP EXHIBITIONS: San Francisco Art Association, c. 1919-35; Oakland Art Gallery, *Society of Six* exhibitions, 1923-28; The Oakland Museum, *Society of Six*, 1972; San Francisco Museum of Modern Art, and National Collection of Fine Arts, Smithsonian Institution, Washington, D.C., *Painting and Sculpture in California: The Modern Era*, 1976-77; The Oakland Museum, *Impressionism, The California View*, 1981-82.

FURTHER REFERENCES: St. John, Terry. *Society of Six*. Oakland: The Oakland Museum, 1972.

WORKS IN THE COLLECTION: 19 paintings

Boat and Yellow Hills is one of the largest and most accomplished of Gile's plein-air paintings. The artist departed from the actual colors of the subject and used intense cadmium yellow and ultramarine blue to give his painting a greater visual impact. Gile was considered the leader of the Society of Six.

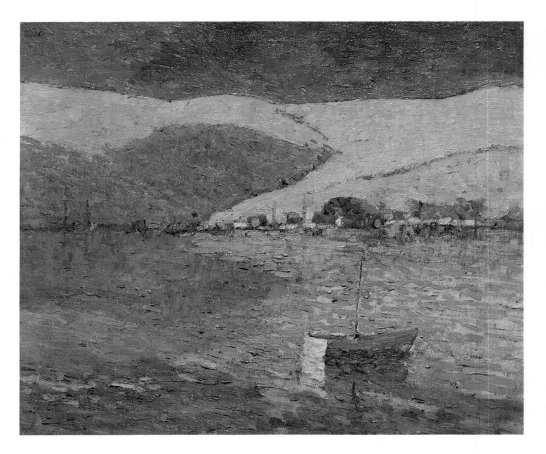

Boat and Yellow Hills, n.d. (76.95)
Oil on canvas
30½ × 36 in. (77.5 × 91.4 cm.)
Gift of Dr. and Mrs. Frederick Novy

BERNARD VON EICHMAN

Born October 4, 1899, San Francisco, California
Died November 4, 1970, Santa Rosa, California

EDUCATION: California College of Arts and Crafts, Oakland.

SELECTED ONE-ARTIST EXHIBITIONS: Oakland Art Gallery, 1928 (with Selden Connor Gile).

SELECTED GROUP EXHIBITIONS: Oakland Art Gallery, *Society of Six* exhibitions, 1923-28; San Francisco Art Association, 1927, 1928, 1929, 1932; The Oakland Museum, *Society of Six*, 1972; San Francisco Museum of Modern Art, and National Collection of Fine Arts, Smithsonian Institution, Washington, D.C., *Painting and Sculpture in California: The Modern Era*, 1976-77; The Oakland Museum, *Watercolors from the California Collection*, 1977.

FURTHER REFERENCES: St. John, Terry. *Society of Six*. Oakland: The Oakland Museum, 1972.

WORKS IN THE COLLECTION: 7 paintings and 27 watercolors

Bernard von Eichman was the most visually adventurous member of the Society of Six. From 1918 to 1928 he experimented with a wide variety of expressionistic styles which often verged on total abstraction.

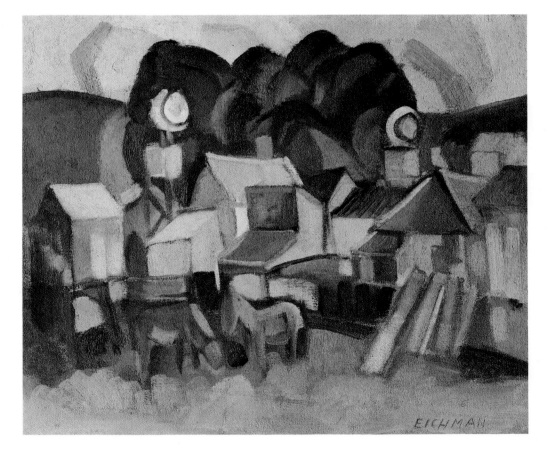

Backyards, n.d. (53.219)
Oil on canvas
19½ × 23¼ in. (49.53 × 59.06 cm.)
Museum Acquisition

CLAYTON S. PRICE

Born May 11 or 24, 1874, Bedford, Iowa
In Anaheim and the San Francisco Bay Area, California 1915, and Monterey, California 1918-28
Died May 1, 1950, Portland, Oregon

EDUCATION: St. Louis School of Fine Arts, Missouri, 1905-06; outdoor painting classes with Armin Hansen, Monterey, California, c. 1918-20.

SELECTED ONE-ARTIST EXHIBITIONS: Galerie Beaux Arts, San Francisco, 1925; Berkeley League of Fine Arts, California, 1927; Portland Art Museum, Oregon, 1942, 1949, 1951, 1976; Valentine Gallery, New York, 1945; Reed College, Portland, Oregon, 1948; Willard Gallery, New York, 1949; The Downtown Gallery, New York, 1958; Fine Arts Patrons of Newport Harbor, Newport Beach, California, 1967.

SELECTED GROUP EXHIBITIONS: San Francisco Art Association, 1923, 1925; Galerie Beaux Arts, San Francisco, *The Monterey Group*, 1927; M. H. de Young Memorial Museum, San Francisco, *Frontiers of American Art*, 1939; Museum of Modern Art, New York, *Romantic Painting in America*, 1943; Detroit Institute of Arts, Michigan, *Advance Trends in Contemporary American Art*, 1944; Museum of Modern Art, New York, *Fourteen Americans*, 1946; Art Institute of Chicago, *Abstract and Surrealist American Art*, 1947; San Francisco Museum of Modern Art, and National Collection of Fine Arts, Smithsonian Institution, Washington, D.C., *Painting and Sculpture in California: The Modern Era*, 1976-77; The Oakland Museum, *Impressionism, The California View*, 1981-82.

FURTHER REFERENCES: Portland Art Museum. *C. S. Price, 1874-1950: A Memorial Exhibition*. Oregon: Portland Art Association, 1951. Portland Art Museum. *A Tribute to C. S. Price*. Portland, Oregon, 1976. The Oakland Museum. *Impressionism, The California View*. Oakland, 1981.

WORKS IN THE COLLECTION: 1 painting

During his thirteen-year stay in California, C. S. Price created a remarkable body of paintings that clearly established him as one of the most influential landscape painters active in California in the 1920s.

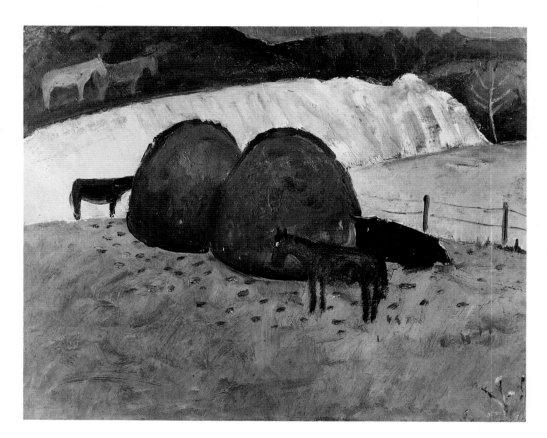

Haystacks, n.d. (75.143.8)
Oil on cardboard
16 × 20 in. (40.6 × 50.8 cm.)
Gift of Louis Siegriest

YUN GEE

Born February 22, 1906, near Canton, China
In San Francisco, California 1921-27
Died June 5, 1963, New York, New York

EDUCATION: Studied with Chinese master Chu, China, 1918-19; studied with Otis Oldfield and Gottardo F. P. Piazzoni, California School of Fine Arts, San Francisco, c. 1925-27.

SELECTED ONE-ARTIST EXHIBITIONS: Modern Gallery, San Francisco, 1926; Galerie Carmine, Paris, 1927; Galerie des Artistes et Artisans, Paris, 1928; Galerie Fermé La Nuit, Paris, 1928; Galerie Bernheim-Jeune, Paris, 1929; "In Tempo" Gallery, New York, 1931; Art Center, San Francisco, 1933; Montross Gallery, New York, 1940; Milch Gallery, New York, 1942; Lucien Labaudt Art Gallery, San Francisco, 1946; Robert Schoelkopf Gallery, New York, 1968; William Benton Museum of Art, University of Connecticut, Storrs, 1979-80.

SELECTED GROUP EXHIBITIONS: San Francisco Art Association, 1927; Salon des Indépendants, Paris, 1929, 1938, 1939; Museum of Modern Art, New York, *Murals by American Painters and Photographers*, 1932; Salon d'Automne, Paris, 1938; Metropolitan Museum of Art, New York, *Portrait of America*, 1942.

FURTHER REFERENCES: Brodsky, Joyce. *The Paintings of Yun Gee*. Storrs: The William Benton Museum of Art, University of Connecticut, 1979.

WORKS IN THE COLLECTION: 1 painting

Yun Gee was a member of San Francisco's feisty modernist art scene in the 1920s. Inspired by Cézanne, Gee's analytical approach to color and composition rhythmically orchestrates images of man in his world. He left San Francisco in 1927 to experience at first hand the international vanguard art being created in Paris.

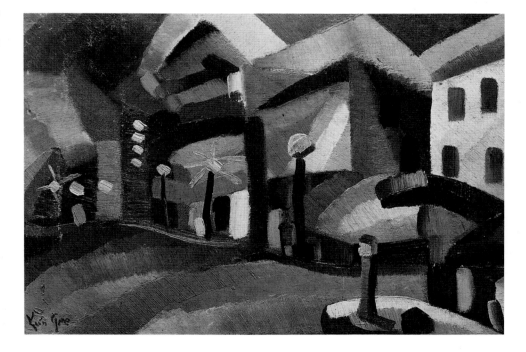

San Francisco Chinatown, 1927 (80.72)
Oil on paperboard
11 × 16 in. (28 × 40.6 cm.)
Gift of Mrs. Frederick G. Novy

EUGEN NEUHAUS

Born August 18, 1879, Barmen (Wuppertal), Germany
Emigrated to United States and traveled to California
1904
Died October 29, 1963, Berkeley, California

EDUCATION: Royal Art School, Kassel, Germany, 1896-99; studied with Otto Eckmann, Max Koch and Carl Brunner at the Royal Institute for Applied Arts, Berlin, Germany, 1900-03.

SELECTED ONE-ARTIST EXHIBITIONS: Vickery, Atkins & Torrey, San Francisco, 1910; California Palace of the Legion of Honor, San Francisco, 1930; Mills College Art Gallery, Oakland, 1964.

SELECTED GROUP EXHIBITIONS: San Francisco Art Association, c. 1906-46; Del Monte Art Gallery, Monterey, California, c. 1907-14; Panama-Pacific International Exposition, San Francisco, 1915; California Pacific International Exposition, San Diego, 1935; Golden Gate International Exposition, San Francisco, 1939-40; The Oakland Museum, *Impressionism, The California View*, 1981-82.

FURTHER REFERENCES: Lenzen, V. F. et al. "Eugen Neuhaus." *In Memorium.* Berkeley: University of California, 1964, pp. 48-51. Neuhaus, Eugen. *Drawn from Memory: A Self Portrait.* Palo Alto, California: Pacific Books, 1964.

WORKS IN THE COLLECTION:
20 paintings, 1 watercolor, 8 drawings, and 2 prints

Eugen Neuhaus was an educator, writer, critic and lecturer, as well as an artist. He wrote numerous books about individual artists, the Panama-Pacific International Exposition, and general art history, most notably The History and Ideals of American Art.

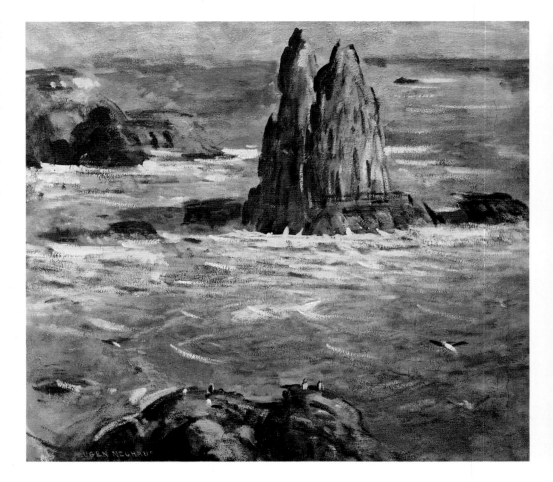

Mendocino Shore, n.d. (63.50.5)
Oil on canvas
34 × 38 in. (86.4 × 96.5 cm.)
Gift of Mr. and Mrs. Robert Neuhaus

IMOGEN CUNNINGHAM

Born April 12, 1883, Portland, Oregon
To California 1917 and settled in the San Francisco Bay Area
Died June 24, 1976, San Francisco, California

EDUCATION: University of Washington, Seattle, 1905 (BA, Chemistry); apprentice to Edward S. Curtis, 1907; Technische Hochschule, Dresden, Germany, 1909 (post-graduate study of photographic chemistry).

SELECTED ONE-ARTIST EXHIBITIONS: Brooklyn Institute of Arts and Sciences, New York, 1912; M. H. de Young Memorial Museum, San Francisco, 1932, 1970; E. B. Crocker Art Gallery, Sacramento, California, 1936; San Francisco Museum of Art, 1951; Mills College Art Gallery, Oakland, 1953; Oakland Art Museum, 1957; George Eastman House, Rochester, New York, 1961; Art Institute of Chicago, 1964; Focus Gallery, San Francisco, 1968; Hall of Photography, National Museum of History and Technology, Smithsonian Institution, Washington, D.C., 1968; Atholl McBean Gallery, San Francisco Art Institute, 1971; Ohio Silver Gallery, Los Angeles, 1972; Metropolitan Museum of Art, New York, 1973; Henry Art Gallery, Seattle, Washington, 1974; California Academy of Sciences, San Francisco, 1983.

SELECTED GROUP EXHIBITIONS: M. H. de Young Memorial Museum, San Francisco, *Group f/64*, 1932; Museum of Modern Art, New York, *Photography 1839-1937*, 1937; Golden Gate International Exposition, San Francisco, *A Pageant of Photography*, 1940; San Francisco Museum of Art, *Perceptions*, 1954; Friends of Photography, Carmel, California, *Platinum Prints*, 1970; Focus Gallery, San Francisco, *Images of Imogen, 1903-1973*, 1973; Gallery of Art and Archeology, University of Missouri, Columbia, and The Oakland Museum, *Group f/64*, 1978.

FURTHER REFERENCES: Daniel, Edna Tartaul (interviewer). *Imogen Cunningham: Portraits, Ideas and Design*. Berkeley: Regional Cultural History Project Interview, University of California, 1961. Heyman, Therese. "Imogen Cunningham: Old Masterpieces, New Visions." *Art* (Art Guild of the Oakland Museum Association), Vol. 2, No. 6, (November-December 1974), n.p. Mann, Margery. *Imogen! Imogen Cunningham Photographs, 1910-1973*. Seattle and London: University of Washington Press, 1974.

WORKS IN THE COLLECTION: 54 vintage and non-vintage photographic prints

In this photograph Cunningham has reached beyond the ordinary view of things to enlarge the heart of the magnolia flower until we see it as a powerful architectonic shape that is both real and abstract.

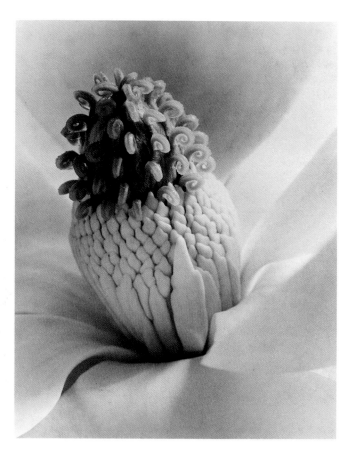

Inside of Magnolia; Tower of Jewels, 1923-25
(66.90) Platinum print
12½ × 9¼ in. (31.8 × 23.5 cm.)
Gift of the Art Guild of the Oakland Museum Association

OTIS OLDFIELD

Born July 3, 1890, Sacramento, California
In Paris, c. 1910-24
Died May 18, 1969, San Francisco, California

EDUCATION: Best Art School, San Francisco, 1908; Académie Julian, Paris, c. 1911.

SELECTED ONE-ARTIST EXHIBITIONS: Galerie Beaux Arts, San Francisco, 1925-36; Montross Gallery, New York, 1929-33; Art Center, San Francisco, 1931; Brownell-Lambertson Galleries, New York, 1931; Downtown Gallery, New York, 1932; San Francisco Museum of Art, 1936; Lucien Labaudt Art Gallery, San Francisco, 1947, 1954, 1971; San Francisco Art Association, 1958; Charles Campbell Gallery, San Francisco, 1976.

SELECTED GROUP EXHIBITIONS: Salon d'Automne and Salon des Indépendants, Paris, c. 1912-24; San Francisco Art Association, 1925-46; Museum of Modern Art, New York, *Painting and Sculpture from 16 American Cities*, 1933; California Palace of the Legion of Honor, San Francisco, *Exhibition of American Painting*, 1935; Golden Gate International Exposition, San Francisco, 1939-40; San Francisco Museum of Art, *Art of Our Time*, 1945.

FURTHER REFERENCES: *California Art Research Monographs*. Ed. Gene Hailey. San Francisco: Works Progress Administration, 1937, Vol. XIX, pp. 29-73.

WORKS IN THE COLLECTION: 5 paintings, 3 watercolors, and 2 prints

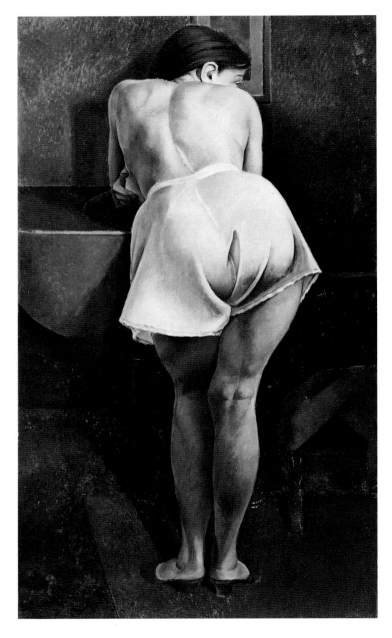

Figure, 1933 (82.30)
Oil on canvas
60½ × 34¼ in. (153 × 86.4 cm.)
Gift of the Estate of Helen Clark Oldfield

In Figure, *Oldfield portrayed his wife in a provocative pose that shocked local art audiences in 1933. Although the artist used austere, earth-colored tones appropriate to the socially conscious realism created by artists of the period, this rear view of a woman in underwear was so unusual for its time that it attracted considerable media attention.*

LUCIEN LABAUDT

Born May 14, 1880, Paris, France
To California 1910 and settled in San Francisco
Died December 12, 1943, Assam, India

EDUCATION: Trained in dressmaking, Paris and
London; primarily self-taught as a painter.

SELECTED ONE-ARTIST EXHIBITIONS:
California Palace of the Legion of Honor, San Fran-
cisco, 1933; Oakland Art Gallery, 1934; San Francisco
Museum of Art, 1944; Rotunda Gallery, City of Paris
department store, San Francisco, 1945; Stendahl Gal-
leries, Los Angeles, 1945; Lucien Labaudt Art Gallery,
San Francisco, 1946-81.

SELECTED GROUP EXHIBITIONS: San
Francisco Art Association, c. 1917-43; Salon des In-
dépendants, Paris, 1921-26; Society of Independent
Artists, New York, 1922-31; Carnegie Institute, Pitts-
burgh, Pennsylvania, *International Exhibitions of
Painting*, 1931, 1935; Museum of Modern Art, New
York, *Painting and Sculpture from 16 American Cit-
ies*, 1933; San Francisco Museum of Art, and Brooklyn
Museum, New York, *Post-Surrealist Exhibition*,
1935; California Palace of the Legion of Honor, San
Francisco, *Exhibition of American Painting*, 1935;
Golden Gate International Exposition, Department of
Fine Arts, Treasure Island, San Francisco, *Contem-
porary Art*, 1939; San Francisco Museum of Modern
Art, and National Collection of Fine Arts, Smithso-
nian Institution, Washington, D.C., *Painting and
Sculpture in California: The Modern Era*, 1976-77;
Crocker Art Museum, Sacramento, California, *From
Exposition to Exposition: Progressive and Conser-
vative Northern California Painting, 1915-1939*,
1981.

FURTHER REFERENCES: *California Art Re-
search Monographs*. Ed. Gene Hailey. San Francisco:
Works Progress Administration, 1937, Vol. XIX, pp.
1-28. San Francisco Museum of Art. *Lucien Labaudt*.
San Francisco, 1944.

WORKS IN THE COLLECTION:
7 paintings

Lucien Labaudt, a leading modernist of the San
Francisco art scene in the 1920s and 1930s, created
figurative works with a three-dimensional solidity
reminiscent of Diego Rivera's muralist style.
L'Atelier *is one of many paintings for which
Labaudt used as subject the dress studio that he
and his wife operated.*

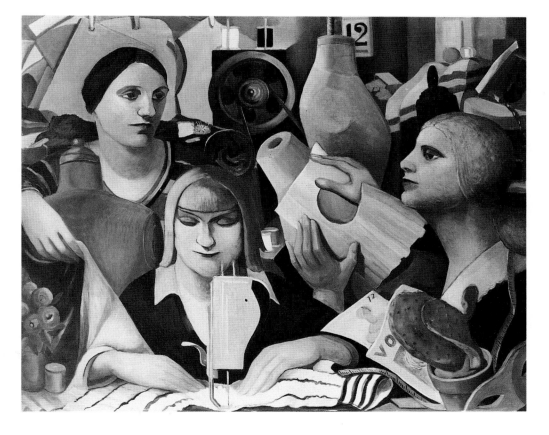

L'Atelier, 1931 (82.2.1)
Oil on canvas
36 × 45 in. (91.4 × 114.3 cm.)
Gift of Marcelle Labaudt

GLEN LUKENS

Born January 15, 1887, Cowgill, Missouri
To California c. 1924
Died December 10, 1967, Los Angeles, California

EDUCATION: Oregon Agricultural College, Corvallis, 1920-21 (BS, Industrial Arts). Self-taught as a ceramist.

SELECTED ONE-ARTIST EXHIBITIONS: Fine Arts Gallery, California State University, Los Angeles, 1982-83.

SELECTED GROUP EXHIBITIONS: California Pacific International Exposition, San Diego, 1935; Amberg-Hirth Gallery, San Francisco, 1935, 1936, 1938; Syracuse Museum of Fine Arts, New York, *National Ceramic Exhibitions*, 1935, 1936, 1938, 1940, 1941; Golden Gate International Exposition, Treasure Island, San Francisco, *Decorative Arts*, 1939; The Oakland Museum, and Lang Gallery, Scripps College, Claremont, California, *The Potter's Art in California, 1885 to 1955*, 1978.

FURTHER REFERENCES: Fine Arts Gallery. *Glen Lukens: Pioneer of the Vessel Aesthetic.* Los Angeles: California State University, 1982.

WORKS IN THE COLLECTION: 6 ceramic pieces

Glen Lukens is remembered today for his impact on a generation of California ceramic students. Overlooked for many years, Lukens' pottery is admired once again for its classic qualities and richly colored glazes. The artist made his inspiration from nature apparent in his simple, thick-walled vessels.

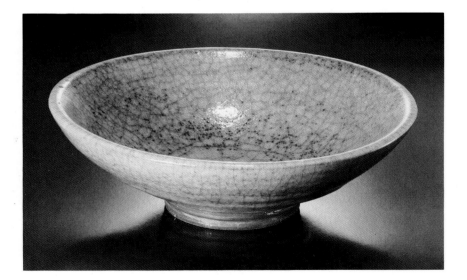

Bowl, 1936 (67.40)
Earthenware with "Death Valley" alkaline crackle glaze
Height: 3⅝ in. (9.2 cm.)
Diameter: 12 in. (30.5 cm.)
Gift of the Collectors Gallery

L. MAYNARD DIXON

Born January 24, 1875, Fresno, California
Left California 1939 for the American Southwest
Died November 13, 1946, Tucson, Arizona

EDUCATION: Primarily self-taught, except for one term at California School of Design, San Francisco, 1893.

SELECTED ONE-ARTIST EXHIBITIONS: Vickery, Atkins & Torrey, San Francisco, 1914; Bohemian Club, San Francisco, 1915; Palace of Fine Arts, San Francisco, 1916; Oakland Art Gallery, 1919; Galerie Beaux Arts, San Francisco, 1920-32; Gump's Gallery, San Francisco, 1920; Stendahl Gallery, Los Angeles, 1921; Macbeth Gallery, New York, 1923-24; Mills College, Oakland, California, 1927; Pasadena Art Museum, California, 1928; Haggin Memorial Museum, Stockton, California, 1934; M. H. de Young Memorial Museum, San Francisco, 1956, 1968; Phoenix Art Museum, Arizona, 1970; Brigham Young University, Provo, Utah, 1973; California Historical Society, San Francisco, 1975; Fresno Arts Center, California, 1975; California Academy of Sciences, San Francisco, 1981.

SELECTED GROUP EXHIBITIONS: San Francisco Art Association; National Academy of Design, New York, 1911-12, 1932, 1934-35; Panama-Pacific International Exposition, San Francisco, 1915; Corcoran Gallery, Washington, D.C., 1933, 1935; Denver Art Museum, Colorado, 1935; California Palace of the Legion of Honor, San Francisco, *Exhibition of American Painting*, 1935; San Francisco Museum of Modern Art, and National Collection of Fine Arts, Smithsonian Institution, Washington, D.C., *Painting and Sculpture in California: The Modern Era*, 1976-77; Whitney Museum of American Art, New York, *Turn-of-the-Century America*, 1977-78.

FURTHER REFERENCES: Burnside, Wesley M. *Maynard Dixon: Artist of the West*. Provo, Utah: Brigham Young University Press, 1974.

WORKS IN THE COLLECTION:
4 paintings, 6 watercolors, and 7 drawings

During his long career, Maynard Dixon created hundreds of paintings and drawings of native Americans that conveyed a strong sense of the West. The Earth Knower demonstrates Dixon's characteristic elimination of all but the most essential details of his subjects. In this painting, the artist emphasized flat planes with forceful diagonal movements that weave in and out to create a dynamic composition with a strong impact.

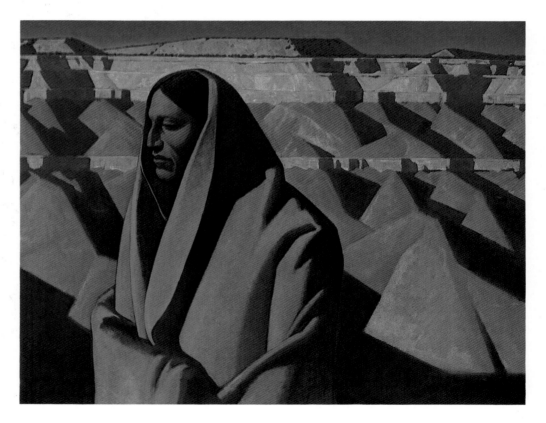

Earth Knower, 1931, 1932, 1935 (59.72.1)
Oil on canvas
40 × 50 in. (101.6 × 127 cm.)
Bequest of Abilio Reis

AGNES PELTON

Born August 22, 1881, Stuttgart, Germany
To California 1931
Died March 13, 1961, Cathedral City, California

EDUCATION: Pratt Institute, Brooklyn, New York, 1900; studied with Arthur W. Dow, Ipswitch, Massachusetts; studied with W. L. Lathrop, Old Lynn, Connecticut; studied with Hamilton F. Field, Ogunquit, Maine; informal studies in France, England, Lebanon, Syria, Greece, and Turkey.

SELECTED ONE-ARTIST EXHIBITIONS: Crossroads Studio, Honolulu, Hawaii, 1924; Jack Zeitlin, Los Angeles, 1929; Grace Nicholson Galleries, Pasadena, California, 1929; Montross Gallery, New York, 1929; Argent Gallery, New York, 1931; Delphic Studios, New York, 1932; Desert Art Galleries, Palm Springs, California, 1932; Fine Arts Galleries of San Diego, California, 1934; Desert Inn Galleries, Palm Springs, California, 1936, 1938, 1940; San Francisco Museum of Art, 1943; San Diego Museum of Art, 1943; E. B. Crocker Art Gallery, Sacramento, California, 1944, 1947; Pomona College, Claremont, California, 1947; University of Redlands, California, 1951; Desert Art Center, Cathedral City, California, 1951, 1955.

SELECTED GROUP EXHIBITIONS: International Exhibition of Modern Art (Armory Show), New York, 1913; Knoedler Galleries, New York, *Imaginative Paintings*, 1917; National Association of Women Artists until 1932; Pennsylvania Academy of the Fine Arts, Philadelphia, *125th Annual Exhibition*, 1932; California Pacific International Exposition, San Diego, 1935; Golden Gate International Exposition, Department of Fine Arts, San Francisco, *Contemporary Art*, 1939.

FURTHER REFERENCES: Stainer, Margaret. "Agnes Pelton." In *Staying Visible: The Importance of Archives*. Ed. Jan Rindfleisch. Cupertino, California: Helen Euphrat Gallery, De Anza College, 1981, pp. 7-9.

WORKS IN THE COLLECTION:
3 paintings

One of the few women artists whose works were included in the 1913 Armory Show in New York, Pelton is best known for her Surrealist landscapes. The night-blue sky of Orbits provides a background for star forms revolving in interlocking or free-wheeling orbits.

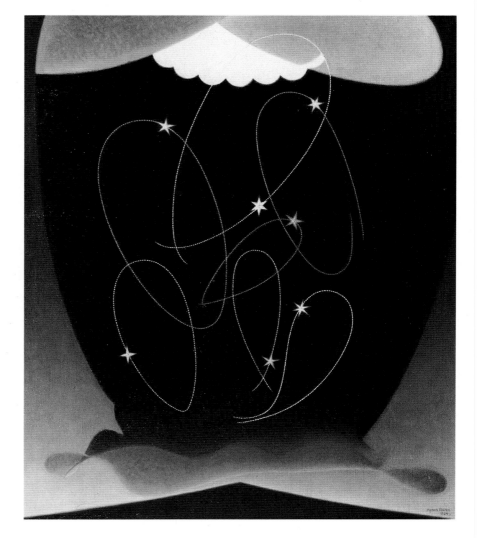

Orbits, 1934 (76.84)
Oil on canvas
36¼ × 30 in. (97.84 × 76.2 cm.)
Gift of Concours d'Antiques

KNUD MERRILD

Born May 10, 1894, Odum, Jutland, Denmark
In California 1923-54
Died December, 1954, Copenhagen, Denmark

EDUCATION: Arts and Crafts School, Copenhagen, 1914-16; Royal Academy of Fine Arts, Copenhagen, 1917; traveled and studied in Scandinavia and England, 1919-21.

SELECTED ONE-ARTIST EXHIBITIONS: Santa Fe Museum, New Mexico, 1923; Stanley Rose Gallery, Hollywood, California, 1933; Hollywood Gallery of Modern Art, California, 1935; San Francisco Museum of Art, 1937; Boyer Galleries, Philadelphia, Pennsylvania, 1937; Boyer Galleries, New York, 1939; American Contemporary Gallery, Hollywood, California, 1944; Modern Institute of Art, Beverly Hills, California, 1948; Pasadena Art Institute, California, 1952; Bertha Schaefer Gallery, New York, 1952; Los Angeles County Museum of Art, 1965.

SELECTED GROUP EXHIBITIONS: San Francisco Museum of Art, and Brooklyn Museum, New York, *Post-Surrealist Exhibition*, 1935-36; California Pacific International Exposition, San Diego, 1935; Museum of Modern Art, New York, *Fantastic Art, Dada and Surrealism*, 1936; Golden Gate International Exposition, Palace of Fine Arts, San Francisco, *American Paintings*, 1940; Whitney Museum of American Art, New York, *Between Two Wars*, 1941; Museum of Modern Art, New York, *Americans 1942*, 1942; Art Institute of Chicago, *Abstract and Surrealist American Art*, 1947; University of Illinois, Champaign-Urbana, *Contemporary American Painting*, 1952; Long Beach Museum of Art, California, *Arts of Southern California—Early Moderns*, 1964; San Francisco Museum of Modern Art, and National Collection of Fine Arts, Smithsonian Institution, Washington, D.C., *Painting and Sculpture in California: The Modern Era*, 1976-77; Rutgers University Art Gallery, New Brunswick, New Jersey, *Vanguard American Sculpture: 1913-1939*, 1979; Los Angeles County Museum of Art, *Painting and Sculpture in Los Angeles, 1900-1945*, 1980; The Oakland Museum, *100 Years of California Sculpture*, 1982.

FURTHER REFERENCES: Los Angeles County Museum of Art. *Knud Merrild 1894-1954*. Los Angeles, 1965.

WORKS IN THE COLLECTION: 2 sculptures and 3 paintings

Volume and Space Organization is one of the most important vanguard pieces created by a California artist before World War II. With deft placement of geometric and organic forms, Merrild created a construction that is alive with subtle spatial tensions.

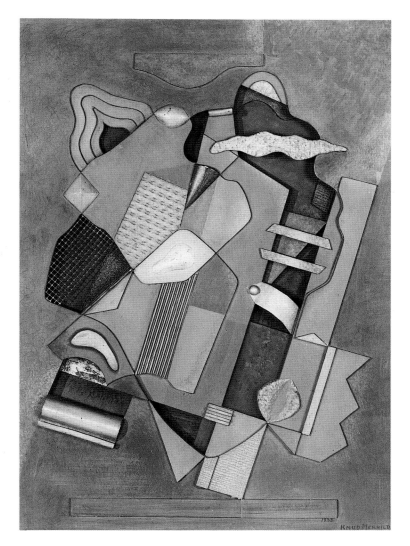

Volume and Space Organization, 1933 (78.13.1)
Painted wood and metal construction
30¼ × 22⅜ in. (82.6 × 65.38 cm.)
Gift of Mrs. Knud Merrild

JOHN LANGLEY HOWARD

Born February 5, 1902, Upper Montclair, New Jersey
To California 1902
Lives in San Francisco, California

EDUCATION: University of California, Berkeley,
1920, 1921; California School of Arts and Crafts,
Berkeley, c. 1922; studied with Kenneth Hayes Miller,
Art Students League, New York, for 2 years; France,
6 months.

SELECTED ONE-ARTIST EXHIBITIONS:
Modern Gallery, San Francisco, 1927; Art Center,
San Francisco, 1936; Rotunda Gallery, City of Paris
department store, San Francisco, 1947; Capricorn
Asunder, San Francisco Art Commission Gallery,
1973 (with Blanche Phillips Howard); Lawson Gal-
leries, San Francisco, 1974; San Francisco Museum
of Modern Art Rental Gallery, 1982.

SELECTED GROUP EXHIBITIONS: Gale-
rie Beaux Arts, San Francisco, 1928 (with Charles
and Robert Howard); San Francisco Art Associa-
tion, c. 1928-51; Cincinnati Art Museum, Ohio,
Cincinnati Annual, 1936; Golden Gate Interna-
tional Exposition, Department of Fine Arts, Treas-
ure Island, San Francisco, *Contemporary Art*, 1939,
and Palace of Fine Arts, San Francisco, *California
Art Today*, 1940; Carnegie Institute, Pittsburgh,
Pennsylvania, *Directions in American Painting*,
1941; Corcoran Gallery, Washington, D.C., *18th
Biennial of Contemporary American Oil Paintings*,
1943; M. H. de Young Memorial Museum, San Fran-
cisco, *Meet the Artist*, 1943; Whitney Museum of
American Art, New York, Annual, 1947; Santa Bar-
bara Museum of Art, California, *Illusion and Real-
ity in Contemporary American Art*, 1956; de Saisset
Art Gallery and Museum, University of Santa Clara,
California, *New Deal Art: California*, 1976.

FURTHER REFERENCES: *California Art
Research Monographs*. Ed. Gene Hailey. San Fran-
cisco: Works Progress Administration, 1937, Vol.
XVII, pp. 54-92.

WORKS IN THE COLLECTION:
1 painting, 1 watercolor, and 1 print

In The Unemployed, *Howard depicts a scene of
economic despair caused by the Great Depression
of the 1930s. The artist uses a social realist style
featuring expressive distortions to comment on the
economic catastrophe that prompted San Francis-
co's violent Maritime Strike and the General Strike
in 1934.*

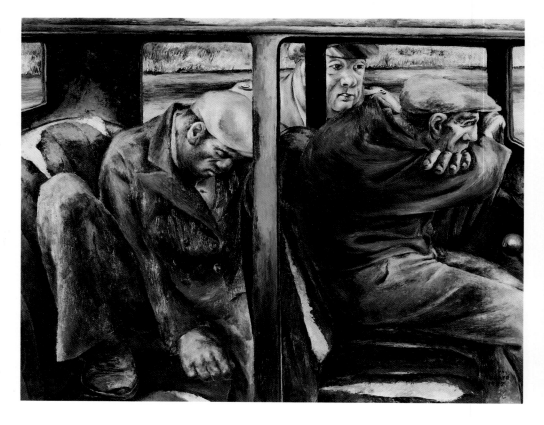

The Unemployed, 1937 (82.67)
Oil on board
24 × 30¼ in. (60.96 × 82.6 cm.)
Gift of Anne and Stephen Walrod

DOROTHEA LANGE

Born May 25, 1895, Hoboken, New Jersey
To California 1919
Died October 11, 1965, San Francisco, California

EDUCATION: Apprenticed in Arnold Genthe's portrait studio, New York, 1912-14; employed at studio of Aram Kazanjian, New York, 1914; employed by Mrs. A. Spencer-Beatty in portrait studio as camera operator, New York, 1915-16; New York Training School for Teachers, 1914-17; photography class taught by Clarence White, Columbia College, New York, 1917-18.

SELECTED ONE-ARTIST EXHIBITIONS: Brockhurst Gallery, Oakland, California, 1934; San Francisco Public Library, 1934; Carl Siembab Gallery, Boston, Massachusetts, 1961; Museum of Modern Art, New York, 1966; Los Angeles County Museum of Art, 1968; The Oakland Museum, 1970, 1972, 1978; Victoria and Albert Museum, London, 1973.

SELECTED GROUP EXHIBITIONS: Grand Palais, Paris, *International Photographic Exhibition*, 1938; Museum of Modern Art, New York, *Diogenes with a Camera*, 1952, *Family of Man*, 1955, and *The Bitter Years*, 1962; Biblioteca Communale, Milan, *La Donna Rurale Americana di Dorothea Lange*, 1960; The Oakland Museum, *The Japanese Evacuation*, 1970, *Women and Women's Work*, 1971, and *Silver & Ink*, 1978.

FURTHER REFERENCES: *Dorothea Lange: Photographs of a Lifetime*. Essay by Robert Coles. Afterword by Therese Heyman. New York: Aperture, Inc. in association with The Oakland Museum, 1982. Heyman, Therese Thau. *Celebrating a Collection: The Work of Dorothea Lange*. Oakland: The Oakland Museum, 1978.

WORKS IN THE COLLECTION: Over 20,000 negatives, more than 200 photographic prints (some vintage), and personal archives

Once in a great while, the work of one artist captures the spirit of an entire era. Although Woman of the High Plains *is the portrait of one person, in Lange's hands it became a general vision of human suffering and strength in the Great Depression.*

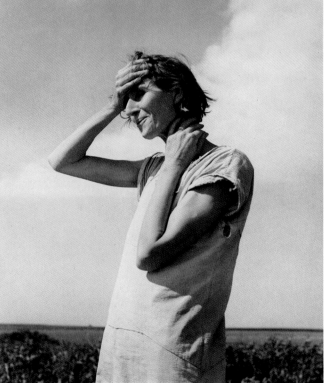

Woman of the High Plains, Texas Panhandle, 1938
(67.137.38258) Gelatin silver print
8 × 10 in. (20.3 × 25.4 cm.)
The Dorothea Lange Collection. Gift of Paul S. Taylor.
© 1983. The City of Oakland, The Oakland Museum, Oakland, California. All rights reserved.

CHARLES HOWARD

Born January 2, 1899, Montclair, New Jersey
In Berkeley, California 1902-21 and in San Francisco,
California 1940-46
Died November 11, 1978, Bagni di Lucca, Italy

EDUCATION: University of California, Berkeley,
1921 (BA); Harvard University, Cambridge, Massa-
chusetts; Columbia University, New York; journeyman
painter and designer in decorating shop of Louis
Bouché and Rudolph Guertler, New York, 1926-31.

SELECTED ONE-ARTIST EXHIBITIONS:
Whitney Studio Club, New York, 1926; Julien Levy
Gallery, New York, 1933; Bloomsbury Gallery, Lon-
don, 1935; Guggenheim-Jeune Gallery, London, 1939;
Courvoisier Gallery, San Francisco, 1941; San Fran-
cisco Museum of Art, 1942; Karl Nierendorf Gallery,
New York, 1946; California Palace of the Legion of
Honor, San Francisco, 1946, 1953; Santa Barbara Mu-
seum of Art, California, 1953; Whitechapel Art Gal-
lery, London, 1956; McRoberts & Tunnard Ltd., Lon-
don, 1963.

SELECTED GROUP EXHIBITIONS: New
Burlington Galleries, London, *International Surrealist
Exhibition*, 1936; São Paulo, Brazil, 1938; San Fran-
cisco Art Association, 1936-48; Carnegie Institute,
Pittsburgh, Pennsylvania, *Directions in American
Painting*, 1941; Metropolitan Museum of Art, New
York, *Artists for Victory Exhibition*, 1942; Museum
of Modern Art, New York, *Americans 1942*, 1942;
Pasadena Art Institute, California, *Exhibition of Con-
temporary Art*, 1946; Art Institute of Chicago, *Ab-
stract and Surrealist American Art*, 1947; Museum
of Modern Art, New York, *Abstract Painting and
Sculpture in America*, 1951; The Oakland Museum,
A Period of Exploration: San Francisco 1945-1950,
1973; San Francisco Museum of Modern Art, and
National Collection of Fine Arts, Smithsonian Insti-
tution, Washington, D.C., *Painting and Sculpture in
California: The Modern Era*, 1976-77.

FURTHER REFERENCES: *California Art Re-
search Monographs*. Ed. Gene Hailey. San Francisco:
Works Progress Administration, 1937, Vol. XVII, pp.
40-53. Cummings, Paul. *Dictionary of Contempo-
rary American Artists*. New York: St. Martin's Press,
1977, pp. 251-52.

WORKS IN THE COLLECTION:
2 paintings and 1 print

*Charles Howard became a prominent champion of
modernist art in California in the 1930s. In Pre-
cinct, which is typical of the artist's Post-Surrealist
style, Howard displays a skillful combination of
abstract and symbolic forms arranged in the context
of a landscape.*

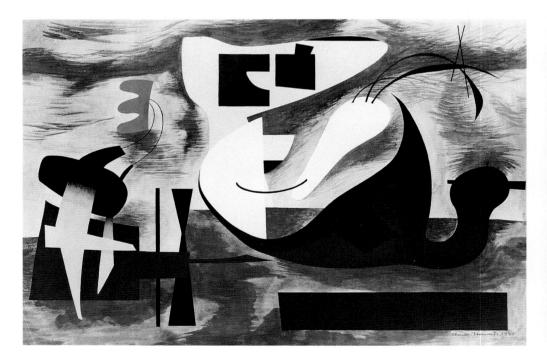

Precinct, 1938 (83.44)
Gouache on paper
18½ × 27 in. (46.99 × 68.58 cm.)
Gift of Marguerite Laird

HANS BURKHARDT

Born December 20, 1904, Basel, Switzerland
Emigrated to New York 1924
To California 1936 and settled in Los Angeles
Lives in Los Angeles, California

EDUCATION: Cooper Union School of Art and Architecture, New York, c. 1925-28; Grand Central School of Art, New York, c. 1928-29; studied with Arshile Gorky, New York, c. 1927-29, c. 1933-36.

SELECTED ONE-ARTIST EXHIBITIONS: Stendahl Galleries, Los Angeles, 1939; Los Angeles County Museum, 1945; Paul Kantor Gallery, Los Angeles, 1952; Falk-Raboff Gallery, Los Angeles, 1954; Pasadena Art Museum, California, 1957; Santa Barbara Museum of Art, California, 1961, 1977; San Diego Art Institute, California, 1966; Fine Arts Gallery of San Diego, California, 1968; Long Beach Museum of Art, California, 1972; Fine Arts Gallery, California State University, Northridge, 1973; Pasquale Iannetti Gallery, San Francisco, 1977; Robert Schoelkopf Gallery, New York, 1979; Jack Rutberg Fine Arts, Los Angeles, 1982 (with Arshile Gorky), 1983.

SELECTED GROUP EXHIBITIONS: Art Institute of Chicago, *Abstract and Surrealist American Art*, 1947; Metropolitan Museum of Art, New York, *American Painting Today*, 1950; Museu de Arte Moderna, São Paulo, Brazil, *III Bienal*, 1955; Whitney Museum of American Art, New York, 1955, 1958; Santa Barbara Museum of Art, California, *Two Hundred Years of American Painting*, 1961; Long Beach Museum of Art, California, *Arts of Southern California — Early Moderns*, 1964; Los Angeles Institute of Contemporary Art, *Nine Senior Southern California Painters*, 1974; San Francisco Museum of Modern Art, and National Collection of Fine Arts, Smithsonian Institution, Washington, D.C., *Painting and Sculpture in California: The Modern Era*, 1976-77; Los Angeles County Museum of Art, *Los Angeles Prints, 1883-1980*, 1980-81; Laguna Beach Museum of Art, California, *Southern California Artists: 1940-1980*, 1981.

FURTHER REFERENCES: San Diego Art Institute. *Hans Burkhardt*. San Diego, California, 1966.

WORKS IN THE COLLECTION:
3 paintings and 7 drawings

Burkhardt was introduced to modernist painting as a student of Arshile Gorky in New York. After his move to California in 1936, he became a forceful advocate of modern art in Los Angeles. This drawing, done in a rich Czechoslovakian charcoal on brown paper, is a good example of the figurative, cubistic work the artist produced in the late 1930s.

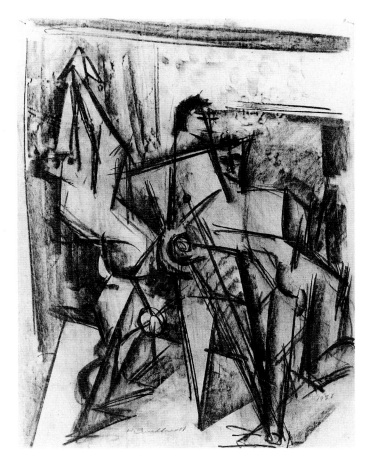

Untitled, 1938 (81.54.3)
Charcoal on paper
24 × 18 in. (61 × 45.7 cm.)
Gift of Hans and Thordis Burkhardt

MINÉ OKUBO

Born June 27, 1912, Riverside, California
In California 1912-42, 1950-52
Lives in New York, New York

EDUCATION: Riverside Junior College, California, 1931-33; University of California, Berkeley, 1933-35 (BA), 1936 (MA).

SELECTED ONE-ARTIST EXHIBITIONS: Mission Inn, Riverside, California, 1937; San Francisco Museum of Art, 1940, 1941; Rockefeller Center, New York, 1944; New School for Social Research, New York, 1945; Mortimer Levitt Gallery, New York, 1951; Image Gallery, Stockbridge, Massachusetts, 1968; The Oakland Museum, Special Exhibits and Education Department, 1972; Riverside City College Art Gallery, California, 1974.

SELECTED GROUP EXHIBITIONS: San Francisco Art Association, 1937-53; San Francisco Museum of Art, *Art of Our Time*, 1945; Riverside Fine Arts Council, California, *As Nisei Saw It*, 1946; California Historical Society, San Francisco, *Months of Waiting*, 1972; Syntex Corporation, Palo Alto, California, *Transcendent Blossoms*, 1975.

FURTHER REFERENCES: The Oakland Museum. *Miné Okubo: An American Experience*. Oakland, 1972. Okubo, Miné. *Citizen 13660*. New York: Columbia University Press, 1946.

WORKS IN THE COLLECTION:
3 paintings and 1 print

Okubo's flattened planes and linearity reveal interests ranging from Giotto's fourteenth-century frescoes to the monumental murals Diego Rivera painted in the 1930s. Here, she has assimilated these influences to create an intentionally naive portrait of her mother.

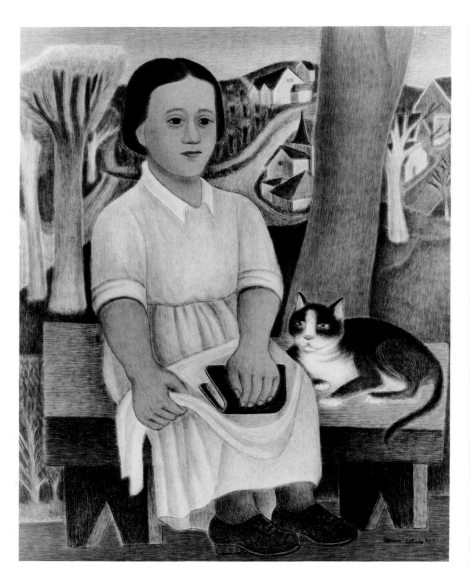

Mother and Cat, 1941 (72.74)
Tempera on masonite
29¾ × 24 in. (75.6 × 61 cm.)
Gift of the Collectors Gallery

124

SARGENT JOHNSON

Born October 1, 1888, Boston, Massachusetts
To San Francisco, California 1915
Died October 10, 1967, San Francisco, California

EDUCATION: Massachusetts Art School, Worcester; A. W. Best School of Art, San Francisco, c. 1915-18; California School of Fine Arts, San Francisco, 1919-23, summer 1958.

SELECTED ONE-ARTIST EXHIBITIONS: The Oakland Museum, 1971; Capricorn Asunder, San Francisco Art Commission Gallery, San Francisco Art Commission Honor Award Show, 1977.

SELECTED GROUP EXHIBITIONS: San Francisco Art Association Annuals, 1925-52; Harmon Foundation Exhibitions of Negro Art, New York, 1926-39; Delphic Studios, New York, (with Malvina Gray Johnson and Richmond Barthe), 1935; San Francisco Museum of Art, *Thirty Years of Sculpture in California*, 1935; Golden Gate International Exposition, Palace of Fine Arts, San Francisco, *California Art Today*, 1940; Albany Institute of History and Art, New York, *The Negro Artist Comes of Age*, 1945; UCLA Art Galleries, University of California, Los Angeles, *The Negro in American Art*, 1966-67; Los Angeles County Museum of Art, *Two Centuries of Black American Art*, 1976-77; San Francisco Museum of Modern Art, and National Collection of Fine Arts, Smithsonian Institution, Washington, D.C., *Painting and Sculpture in California: The Modern Era*, 1976-77; de Saisset Art Gallery and Museum, University of Santa Clara, California, *New Deal Art: California*, 1976; The Oakland Museum, and Lang Gallery, Scripps College, Claremont, California, *The Potter's Art in California, 1885 to 1955*, 1978.

FURTHER REFERENCES: Montgomery, Evangeline J. *Sargent Johnson: Retrospective*. Oakland: The Oakland Museum, 1971.

WORKS IN THE COLLECTION: 1 print, 2 sculptures, and 1 ceramic teapot

The broadly curving lines in this lithograph by Sargent Johnson echo the full-bodied, lyrical music created by the singing musicians. Johnson's skillfully economic use of line to create strong forms is also visible in the friezes and sculptures for which he is well known.

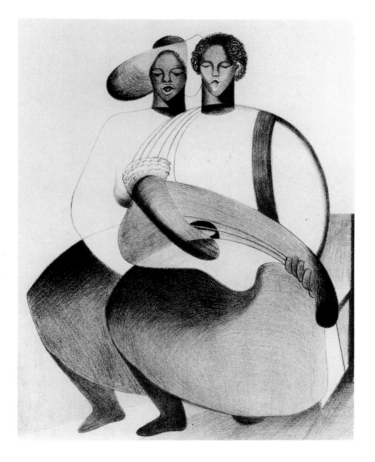

Singing Saints, 1940 (71.4.2)
Lithograph
12 × 9¼ in. (30.5 × 23.5 cm.) (image)
Gift of Arthur C. Painter

ROGER STURTEVANT

Born January 26, 1903, Alameda, California
Died July 3, 1982, Oakland, California

EDUCATION: Primarily self-taught.

SELECTED ONE-ARTIST EXHIBITIONS:
M. H. de Young Memorial Museum, San Francisco,
1934; San Francisco Museum of Art, 1949; American
Institute of Architects Convention, San Francisco,
1960.

SELECTED GROUP EXHIBITIONS: Oak-
land Art Gallery, *Pictorialism Exhibition*, 1923;
Deutsche Werkbund, Stuttgart, Germany, *Film und
Foto*, 1929; Oakland Art Museum, *f/64 and Before*,
1966, and *Photography and the West*, 1967; The
Oakland Museum, *Man Ray and the Surreal in Cal-
ifornia*, 1972, and *Silver & Ink*, 1978.

FURTHER REFERENCES: Artist's File, Ar-
chives of California Art, The Oakland Museum.

WORKS IN THE COLLECTION: Over
15,000 negatives and more than 5,000 photographic
prints

*One challenge of architectural photography is
making three-dimensional space understandable in
two dimensions at a much-reduced scale. Sturte-
vant became a master of making a building "read"
photographically in relation to its site, its use, and
its building form.*

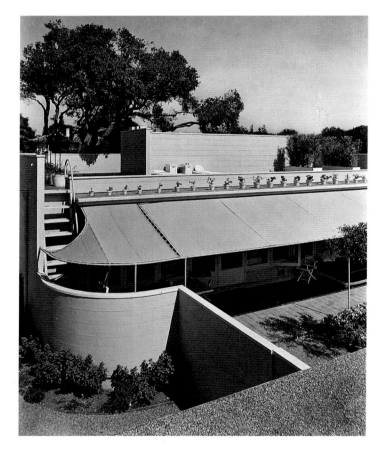

Mendenhall House (Palo Alto, California), 1937
(80.76.4047) Gelatin silver print
13⅝ × 10⅞ in. (34.6 × 27.6 cm.)
Bequest of Roger Sturtevant

ANSEL ADAMS

Born February 20, 1902, San Francisco, California
Died April 22, 1984, Monterey, California

EDUCATION: Primarily self-taught as a photographer.

SELECTED ONE-ARTIST EXHIBITIONS: Smithsonian Institution, Washington, D.C., 1931; M. H. de Young Memorial Museum, San Francisco, 1932, 1963; Delphic Gallery, New York, 1933; Mills College Art Gallery, Oakland, 1933, 1977; An American Place, New York, 1936; Museum of Modern Art, New York, 1944, 1980; Pasadena Art Institute, California, 1950; George Eastman House, Rochester, New York, 1952, 1965; Fine Arts Gallery, University of British Columbia, Vancouver, 1964; San Francisco Museum of Art, California, 1965, 1973; Sacramento State Art Gallery, California, 1966; Witkin Gallery, New York, 1972; Stanford University Museum, California, 1972; Cowboy Hall of Fame, Oklahoma City, Oklahoma, 1977; Grapestake Gallery, San Francisco, 1979; Monterey Peninsula Museum of Art, Monterey, California, 1982.

SELECTED GROUP EXHIBITIONS: San Francisco Museum of Art, *Perceptions*, 1954; Worcester Art Museum, Massachusetts, *Ideas in Images*, 1962; Oakland Art Museum, *f/64 and Before*, 1966; The Oakland Museum, *Pollution Show*, 1970, *More than One*, 1971, *Yosemite*, 1979, and *Silver & Ink*, 1978; The Art Galleries, California State University, Long Beach, *The Photograph As Artifact*, 1978; University of Missouri, Columbia, and The Oakland Museum, *Group f/64*, 1978.

FURTHER REFERENCES: Artist's File, Archives of California Art, The Oakland Museum. Newhall, Nancy. *The Eloquent Light*. Berkeley, California: Sierra Club, 1963. Witkin, Lee D., and Barbara London. *The Photograph Collector's Guide*. Boston: New York Graphic Society, 1979.

WORKS IN THE COLLECTION:
85 photographic prints

More than any other twentieth-century photographer, Ansel Adams brought the power of his photographic vision to the attention of a mass audience. Here, Adams joined his grand view of the Western landscape with a special sense of majestic spaces free from human intrusion.

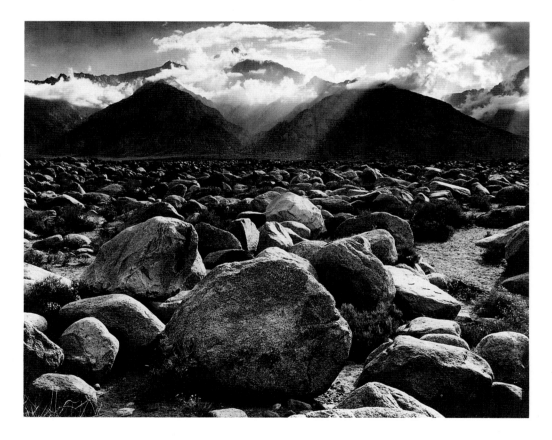

Mount Williamson from Manzanar, California, n.d.
(65.126.4) Gelatin silver print
15⅛ × 18¾ in. (38.4 × 47.6 cm.)
Purchased with funds donated by Dr. and Mrs. Dudley P. Bell

MAN RAY
(né Emmanuel Rudnitsky)

Born August 27, 1890, Philadelphia, Pennsylvania
In California 1942-50
Died November 18, 1976, Paris, France

EDUCATION: National Academy of Design, New York, 1908; Ferrer Center, New York, 1911-13.

SELECTED ONE-ARTIST EXHIBITIONS: Daniel Gallery, New York, 1915, 1916, 1919; Libraire Six, Paris, 1921; Galerie Surréaliste, Paris, 1926; Galerie Myrbor, Paris, 1929; Curt Valentin Gallery, New York, 1936; London Gallery, London, 1939; Frank Perls Gallery, Beverly Hills, California, 1941; Pasadena Art Institute, California, 1944; Julien Levy Gallery, New York, 1945; Copley Gallery, Hollywood, California, 1949; Paul Kantor Gallery, Beverly Hills, California, 1953; Galerie Rive Droite, Paris, 1959; Bibliothèque Nationale, Paris, 1962; Galerie Schwarz, Milan, Italy, 1964; Los Angeles County Museum of Art, 1966; Noah Goldowsky Gallery, New York, 1970; Museum Boymans-van Beuningen, Rotterdam, Holland, 1972; Metropolitan Museum of Art, New York, 1973; G. Ray Hawkins Gallery, Los Angeles, 1975; Milwaukee Art Center, Wisconsin, 1978; Birmingham Museum of Art, Alabama, 1980; Stephen Wirtz Gallery, San Francisco, 1982.

SELECTED GROUP EXHIBITIONS: International Exhibition of Modern Art (Armory Show), New York, 1913; Montross Gallery, New York, *Duchamp: Crotti: Gleizes: Man Ray*, 1916; Société Anonyme, New York, 1920; Galerie Pierre Colle, Paris, 1925; Ateneo, Santa Cruz de Tenerife, Canary Isles, *Exposicion Surrealista*, 1934; Museum of Modern Art, New York, *Fantastic Art, Dada and Surrealism*, 1936, and *The Machine*, 1968; Contemporary Arts Museum, Houston, Texas, *The Disquieting Muse*, 1958; Fine Arts Gallery of San Diego, California, and The Oakland Museum, *Color and Form*, 1972; The Oakland Museum, *Man Ray and the Surreal in California*, 1972.

FURTHER REFERENCES: Stephen Wirtz Gallery. *Man Ray*. San Francisco, 1982.

WORKS IN THE COLLECTION:
2 photographic prints

"Rayogram" was the term Man Ray gave the camera-less photographs he used to extend his ideas about surreal situations. Chance and accident were essential elements. The picture is created by manipulating objects directly on photosensitive paper.

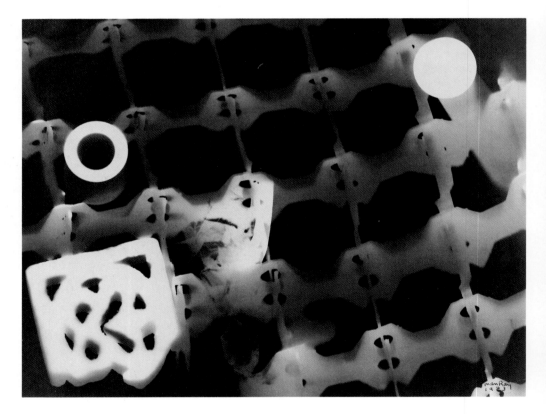

Rayograph, 1943 (72.214)
Solarized gelatin silver print
10⅞ × 13⅞ in. (27.6 × 35.2 cm.)
Purchased with funds donated by Dr. and Mrs. Dudley P. Bell

HELEN LUNDEBERG

Born June 24, 1908, Chicago, Illinois
To Pasadena, California 1912 and settled in Los Angeles 1933
Lives in Los Angeles, California

EDUCATION: Studied with Lawrence Murphy and Lorser Feitelson, Stickney Memorial School of Art, Pasadena, California, c. 1930-33.

SELECTED ONE-ARTIST EXHIBITIONS: Stanley Rose Gallery, Hollywood, California, 1933, 1935; Pasadena Art Institute, California, 1953; Santa Barbara Museum of Art, California, 1959; Paul Rivas Gallery, Los Angeles, 1959, 1960, 1961, 1962; David Stuart Galleries, Los Angeles, 1970, 1971, 1977; La Jolla Museum of Contemporary Art, California, 1971; Los Angeles Municipal Art Gallery, 1979; San Francisco Museum of Modern Art, and Frederick S. Wight Art Gallery, University of California, Los Angeles, *Lorser Feitelson and Helen Lundeberg: A Retrospective Exhibition*, 1980-81; Graham Gallery, New York, 1982.

SELECTED GROUP EXHIBITIONS: San Francisco Museum of Art, and Brooklyn Museum, New York, *Post-Surrealist Exhibition*, 1935-36; Museum of Modern Art, New York, *Fantastic Art, Dada and Surrealism*, 1936, and *Americans 1942*, 1942; Art Institute of Chicago, *Abstract and Surrealist American Art*, 1947; Museu de Arte Moderna, São Paulo, Brazil, *III Bienal*, 1955; Whitney Museum of American Art, New York, *Geometric Abstraction in America*, 1962, and *Fifty California Artists*, 1962-63; Los Angeles Institute of Contemporary Art, *Nine Senior Southern California Painters*, 1974; San Francisco Museum of Modern Art, and National Collection of Fine Arts, Smithsonian Institution, Washington, D.C., *Painting and Sculpture in California: The Modern Era*, 1976-77; Rutgers University Art Gallery, New Brunswick, New Jersey, *Surrealism and American Art: 1931-1947*, 1977, and *Realism and Realities: The Other Side of American Painting, 1940-1960*, 1982.

FURTHER REFERENCES: San Francisco Museum of Modern Art. *Lorser Feitelson and Helen Lundeberg: A Retrospective Exhibition*. San Francisco, 1980.

WORKS IN THE COLLECTION: 1 painting

As early as the 1930s, Lundeberg was one of an important group of California artists who explored new ways to express themselves in a Surrealist manner. Poetic Justice features shells, flowers and other objects as symbols that form an ironic, dreamlike narrative enigmatically set in a barren, mountainous landscape.

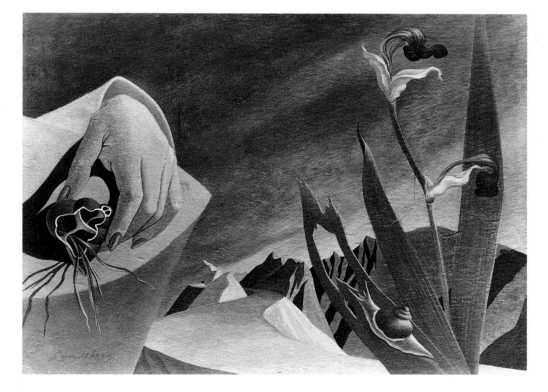

Poetic Justice, 1945 (76.144)
Oil on cardboard
13 × 17½ in. (33 × 44.4 cm.)
Museum Donors' Acquisition Fund

CHARLES GRIFFIN FARR

Born May 30, 1908, Birmingham, Alabama
To San Francisco, California 1948
Lives in San Francisco, California

EDUCATION: Studied with George B. Bridgman, Art Students League, New York, and in private atelier of George Luks, New York, 1927-28; studied with Jean Despujols, Académie Américaine, Paris, 1928-29; California School of Fine Arts, San Francisco, 1948-50.

SELECTED ONE-ARTIST EXHIBITIONS: Rackham Galleries, University of Michigan, 1947; Raymond & Raymond, San Francisco, 1952; Hansen Gallery, San Francisco, 1963; Capricorn Asunder, San Francisco Art Commission Gallery, 1972; Charles Campbell Gallery, San Francisco, 1981, 1984; The Oakland Museum, 1984.

SELECTED GROUP EXHIBITIONS: Carnegie Institute, Pittsburgh, Pennsylvania, *Directions in American Painting*, 1941; Whitney Museum of American Art, New York, *Annual of Sculpture, Watercolor and Drawing*, 1946; Metropolitan Museum of Art, New York, *American Watercolors, Drawings and Prints*, 1952; Santa Barbara Museum of Art, California, and California Palace of the Legion of Honor, San Francisco, *First Pacific Coast Biennial Exhibition*, 1955; Oakland Art Museum, *Bay Area Realists*, 1955; Santa Barbara Museum of Art, California, *Illusion and Reality in Contemporary American Art*, 1956; California Palace of the Legion of Honor, San Francisco, Invitationals, 1960-62; Art Institute of Chicago, *Sixty-fourth American Exhibition: Paintings, Sculpture*, 1961; California Palace of the Legion of Honor, San Francisco, *Painters Behind Painters*, 1967; Butler Institute of American Art, Youngstown, Ohio, 1968-80; Art Museum of South Texas, Corpus Christi, *Contemporary Landscapes*, 1982; Redding Museum, California, *Northern California Realist Painters*, 1982; Laguna Beach Museum of Art, California, *West Coast Realism*, 1983.

FURTHER REFERENCES: Orr-Cahall, Christina. *Charles Griffin Farr: A Restrospective.* Oakland: The Oakland Museum, 1984.

WORKS IN THE COLLECTION:
4 paintings

Scenes of military life recorded by American artists in times of war are rare in the twentieth century. Even more unusual is this portrait of the artist as a young soldier depicted, not in combat, but in the quieter garrison activities of a U.S. Army camp in Normandy during World War II.

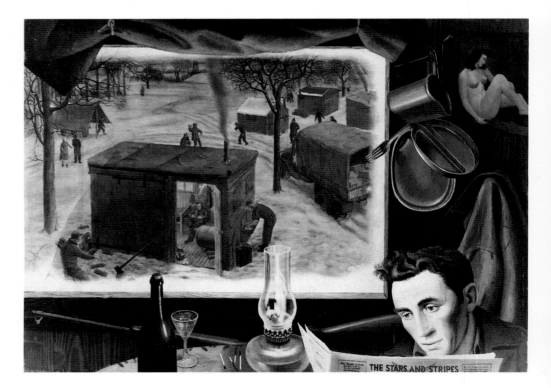

Pipeline Station in Normandy, 1945 (82.43)
Casein on cardboard
22 × 30 in. (55.6 × 76.2 cm.)
Gift of the Collectors Gallery

CLAY SPOHN

Born November 24, 1898, San Francisco, California
Left California 1950 for New York and Taos, New Mexico
Died December 19, 1977, New York, New York

EDUCATION: California School of Arts and Crafts, Berkeley, 1912; University of California, Berkeley, 1918-21; California School of Fine Arts, San Francisco, 1921; Art Students League, New York, 1922-25; Académie Moderne, Paris, 1926.

SELECTED ONE-ARTIST EXHIBITIONS: Art Center, San Francisco, 1931; San Francisco Museum of Art, *Fantastic War Machines and Guerragraphs*, 1942; Rotunda Gallery, San Francisco, 1946; Artium Orbis, Santa Fe, New Mexico, 1969; The Oakland Museum, 1974.

SELECTED GROUP EXHIBITIONS: Golden Gate International Exposition, Palace of Fine Arts, San Francisco, *California Art Today*, 1940; San Francisco Museum of Art, *Art of Our Time*, 1945; California Palace of the Legion of Honor, San Francisco, *Contemporary American Painting*, 1945, and, *Mobiles and Articulated Sculpture*, 1948; University of Illinois, Champaign-Urbana, *Contemporary American Painting and Sculpture*, 1953; The Oakland Museum, *A Period of Exploration: San Francisco, 1945-1950*, 1973; de Saisset Art Gallery and Museum, University of Santa Clara, California, *New Deal Art: California*, 1976; San Francisco Museum of Modern Art, and National Collection of Fine Arts, Smithsonian Institution, Washington, D.C., *Painting and Sculpture in California: The Modern Era*, 1976-77; The Oakland Museum, *Watercolors from the California Collection*, 1977.

FURTHER REFERENCES: Fuller, Mary. "Portrait." *Art in America*, Vol. 51, No. 6 (December 1963), pp. 78-85. St. John, Terry. *Clay Spohn*. Oakland: The Oakland Museum, 1974.

WORKS IN THE COLLECTION:
4 paintings, 1 gouache, 25 drawings, 2 prints, and 1 sculpture

Well-known for his often zany assemblage and drawings, Spohn was one of the most inventive artists California has produced. Fantastic War Machine is from a series of drawings based on hallucinatory dreams the artist had in the early years of World War II.

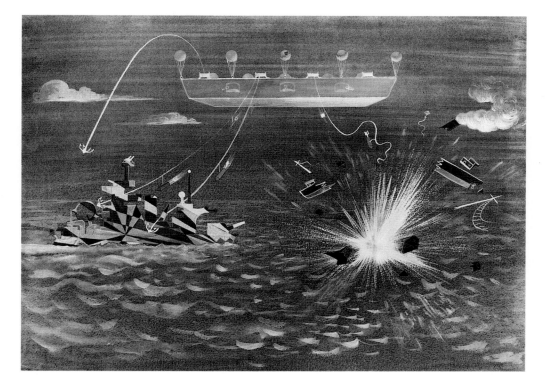

Fantastic War Machine, 1942 (76.121.91)
Gouache on paper
15 × 20 in. (38.1 × 50.8 cm.)
Gift of the Estate of Peggy Nelson Dixon

HASSEL SMITH

Born April 24, 1915, Sturgis, Michigan
In California 1930-66 and 1977-80, moved to England 1966
Lives in Bath, England

EDUCATION: Northwestern University, Evanston, Illinois, 1932-36 (BS); California School of Fine Arts, San Francisco, 1936-38.

SELECTED ONE-ARTIST EXHIBITIONS: San Francisco Museum of Art, 1941 (with Lloyd Wulf), 1975; California Palace of the Legion of Honor, San Francisco, 1947, 1953; Lucien Labaudt Art Gallery, San Francisco, 1950 (with Richard Diebenkorn); King Ubu Gallery, San Francisco, 1953; East & West Gallery, San Francisco, 1953, 1955; Ferus Gallery, Los Angeles, 1956, 1958, 1959, 1961, 1962; Dilexi Gallery, San Francisco, 1958, 1962, 1964, 1965; Gimpel Fils, London, 1960, 1963; Pasadena Art Museum, California, 1961; André Emmerich Gallery, New York, 1961, 1962, 1963; David Stuart Galleries, Los Angeles, 1964, 1965, 1966, 1968, 1969, 1973; Santa Barbara Museum of Art, California, 1968; Bristol Art Gallery, England, 1972; Gallery Paule Anglim, San Francisco, 1977, 1978, 1979, 1980, 1982; The Oakland Museum, 1981.

SELECTED GROUP EXHIBITIONS: San Francisco Art Association, 1937-63; San Francisco Museum of Art, *Paintings by Elmer Bischoff, David Park and Hassel Smith*, 1948; Contemporary Arts Museum, Houston, Texas, *Pacemakers*, 1957; Whitney Museum of American Art, New York, *Fifty California Artists*, 1962-63; Los Angeles County Museum of Art, *Late Fifties at the Ferus*, 1968; Stedelijk van Abbemuseum, Eindhoven, The Netherlands, *Kompas 4: Westkust USA*, 1969-70; The Oakland Museum, *A Period of Exploration: San Francisco 1945-1950*, 1973; San Francisco Museum of Modern Art, and National Collection of Fine Arts, Smithsonian Institution, Washington, D.C., *Painting and Sculpture in California: The Modern Era*, 1976-77; Rutgers University Art Gallery, New Brunswick, New Jersey, *Realism and Realities: The Other Side of American Painting, 1940-1960*, 1982.

FURTHER REFERENCES: McChesney, Mary Fuller. *A Period of Exploration: San Francisco 1945-1950*. Oakland: The Oakland Museum, 1973. San Francisco Museum of Art. *Hassel Smith: Paintings 1954-1975*. San Francisco, 1975.

WORKS IN THE COLLECTION:
39 paintings, 1 drawing, 4 collages, and 2 prints

Untitled (Abstraction) *displays the command of improvised line that is a characteristic visual element of the Abstract Expressionist paintings Hassel Smith did from 1940 through 1960.*

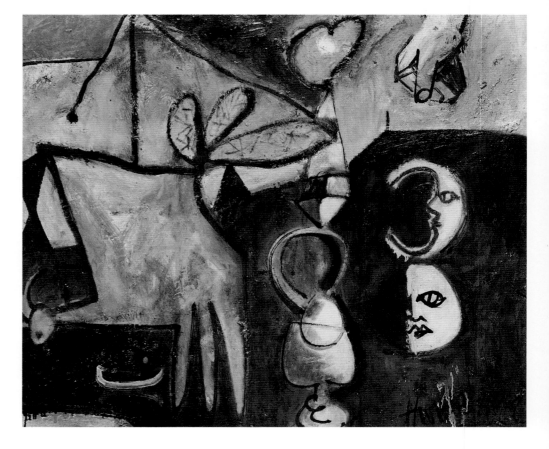

Untitled (Abstraction), 1948 (66.122.25)
Oil on canvas
34 × 39¾ in. (86.4 × 101 cm.)
Gift of Hassel Smith

JAMES BUDD DIXON

Born November 26, 1908, San Francisco, California
Died December 1, 1967, San Francisco, California

EDUCATION: University of California, Berkeley,
1920-21, 1922-23; Mark Hopkins Institute of Art,
San Francisco, 1923-26, 1929; California School of
Fine Arts, San Francisco, 1946-49.

SELECTED ONE-ARTIST EXHIBITIONS:
San Francisco Museum of Art, 1939; Area Arts Gal-
lery, San Francisco, 1953; College of Notre Dame,
Belmont, California, 1977.

SELECTED GROUP EXHIBITIONS: San
Francisco Art Association, 1936-64; Golden Gate In-
ternational Exposition, Palace of Fine Arts, San Fran-
cisco, *California Art Today*, 1940; Landau Gallery,
Los Angeles, *6 San Francisco Painters*, 1953; San
Francisco Museum of Art, *Three Bay Area Artists*
(with Claire Falkenstein and Walter Kuhlman), 1958;
Contemporary Arts Museum, Houston, Texas, *San
Francisco 9*, 1962; San Francisco Museum of Art, *On
Looking Back*, 1968; The Oakland Museum, *A Pe-
riod of Exploration: San Francisco 1945-1950*, 1973;
San Francisco Museum of Modern Art, and National
Collection of Fine Arts, Smithsonian Institution,
Washington, D.C., *Painting and Sculpture in Cali-
fornia: The Modern Era*, 1976-77.

FURTHER REFERENCES: Artist's File, Ar-
chives of California Art, The Oakland Museum.

WORKS IN THE COLLECTION:
20 paintings, 80 drawings, 59 watercolors, 4 prints,
and memorabilia

*James Budd Dixon created a remarkable body of
Abstract Expressionist works from the late 1940s
until his death in 1967. His San Francisco studio
was the center of stimulating gatherings which in-
spired a younger generation of artists to more
daring, innovative visual approaches.*

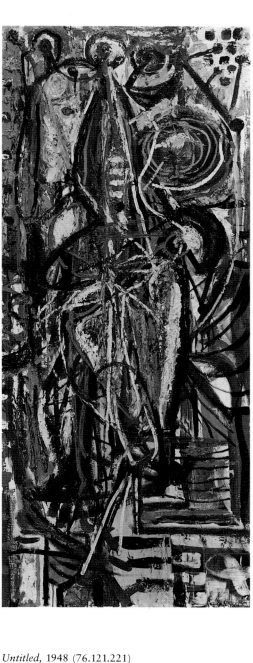

Untitled, 1948 (76.121.221)
Oil on canvas
52 × 22 in. (101.6 × 127 cm.)
Gift of the Estate of Peggy Nelson Dixon

133

EDWARD CORBETT

Born August 22, 1919, Chicago, Illinois
In San Francisco, California 1937-51
Died June 7, 1971, Provincetown, Massachusetts

EDUCATION: California School of Fine Arts, San
Francisco, 1937-41.

SELECTED ONE-ARTIST EXHIBITIONS:
Pat Wall Gallery, Monterey, California, 1948; San
Francisco Museum of Art, 1949, 1969, 1971; Grace
Borgenicht Gallery, New York, 1956-81; Massachu-
setts Institute of Technology, Boston, 1959; Walker
Art Center, Minneapolis, Minnesota, 1961; Quay
Gallery, San Francisco, 1967; The Phillips Collection,
Washington, D.C., 1973.

SELECTED GROUP EXHIBITIONS: San
Francisco Art Association, 1946, 1949; Art Institute
of Chicago, *Abstract and Surrealist American Art*,
1947; Museum of Modern Art, New York, *15 Amer-
icans*, 1952; Whitney Museum of American Art, New
York, Annuals, 1953-65; Museu de Arte Moderna,
São Paulo, Brazil, *II Bienal*, 1954; National Collection
of Fine Arts, Smithsonian Institution, Washington,
D.C., *American Landscape: A Changing Frontier*,
1966; The Oakland Museum, *A Period of Explora-
tion: San Francisco 1945-1950*, 1973; San Francisco
Museum of Modern Art, and National Collection of
Fine Arts, Smithsonian Institution, Washington, D.C.,
*Painting and Sculpture in California: The Modern
Era*, 1976-77.

FURTHER REFERENCES: San Francisco Mu-
seum of Art. *Edward Corbett*. San Francisco, 1969.

WORKS IN THE COLLECTION:
2 paintings and 1 print

*Untitled is a metaphorical landscape with sensuous
hues of grey that both veil and stabilize the more
active black-and-white forms. The mysterious,
chalky atmospheric field of grey creates a contem-
plative mood.*

Untitled, 1950 (79.108)
Oil on canvas
49⅛ × 40¾ in. (124.8 × 103.5 cm.)
Museum Donors' Acquisition Fund

ROBERT HOWARD

Born September 20, 1896, New York, New York
To California 1901, in New York and Paris 1915-22
Died February 18, 1983, Santa Cruz, California

EDUCATION: School of the California Guild of
Arts and Crafts, Berkeley, California, c. 1915-16; Art
Students League, New York, c. 1917-18.

SELECTED ONE-ARTIST EXHIBITIONS:
The Print Rooms, San Francisco, 1922; Galerie Beaux
Arts, San Francisco, 1923; California Palace of the
Legion of Honor, San Francisco, 1945; University Art
Gallery, University of California, Berkeley, 1949; California School of Fine Arts, San Francisco, 1956; San
Francisco Museum of Art, 1963; Capricorn Asunder,
San Francisco Art Commission Gallery, 1971; San
Francisco Art Institute, 1973; Artist's studio, San
Francisco, 1976.

SELECTED GROUP EXHIBITIONS: San
Francisco Art Association, c. 1921-72; National
Sculpture Society, New York, *Exhibition of American
Sculpture*, 1923; San Francisco Museum of Art,
Thirty Years of Sculpture in California, 1935; Golden
Gate International Exposition, Palace of Fine Arts,
San Francisco, *California Art Today*, 1940; Art Institute of Chicago, *Abstract and Surrealist American
Art*, 1947; California Palace of the Legion of Honor,
San Francisco, *Mobiles and Articulated Sculpture*,
1948; Metropolitan Museum of Art, New York,
American Sculpture, 1951; Museu de Arte Moderna
São Paulo, Brazil, *I Bienal*, 1951, and *III Bienal*, 1955;
Musée d'Art Moderne, Paris, *Salon de Mai*, 1962-64;
The Oakland Museum, *Public Sculpture/Urban Environment*, 1974; San Francisco Museum of Modern
Art, and National Collection of Fine Arts, Smithsonian Institution, Washington, D.C., *Painting and
Sculpture in California: The Modern Era*, 1976-77;
The Oakland Museum, *100 Years of California Sculpture*, 1982.

PUBLIC WORKS: Murals and reliefs, Pacific
Coast Stock Exchange, San Francisco, 1930; *Whales
Fountain*, California Academy of Sciences (originally
at Golden Gate International Exposition), San Francisco, 1938-39; *Hydro-Gyro Fountain*, IBM, San
Jose, 1958; reliefs, Pacific Gas and Electric Company,
San Francisco, 1948.

FURTHER REFERENCES: *California Art Research Monographs*. Ed. Gene Hailey. San Francisco:
Works Progress Administration, 1937, Vol. XVII, pp.
13-39.

WORKS IN THE COLLECTION:
3 sculptures

*The multi-dimensional structure of this curvilinear
abstract sculpture is formed with a fine sense of
balance and power of expression that combine to
activate the captured air space as well as the piece.
Robert Howard experimented successfully with
new materials for sculpture and with modern aesthetic principles.*

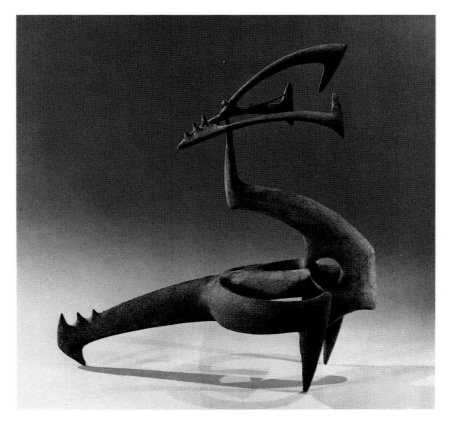

Study for Custodian, 1950 (77.25.1)
Wood, metal, and gypsum
16 × 17½ × 8 in. (40.6 × 44.4 × 20.3 cm.)
Gift of Robert Howard

MARGUERITE WILDENHAIN

Born October 11, 1896, Lyons, France
To California 1940
Lives in Guerneville, California

EDUCATION: School of Fine and Applied Arts, Berlin, Germany, 1914; apprentice in wood sculpture and designer for a porcelain factory, Thuringia, Germany, 1915-19; apprentice and journeyman at the Bauhaus, Weimar, Germany, with Max Krehan and Gerhard Marcks, 1919-26 (master's degree).

SELECTED ONE-ARTIST EXHIBITIONS: Mint Museum of Art, Charlotte, North Carolina, 1942; E. B. Crocker Art Gallery, Sacramento, California, 1946, 1973; Pasadena Art Museum, California, 1960; Oakland Art Museum, 1960; Detroit Institute of Arts, Michigan, 1962; North Carolina Museum of Art, Raleigh, 1968; Mills College, Oakland, 1976; Herbert F. Johnson Museum of Art, Ithaca, New York, 1980-81.

SELECTED GROUP EXHIBITIONS: Paris, *Arts et Techniques*, 1937; Syracuse Museum of Fine Arts, New York, *National Ceramic Exhibitions*, 1940, 1946, 1947, 1958; Brooklyn Museum, New York, *Designer Craftsmen USA*, 1953-54; Museum of Contemporary Crafts, New York, *Craftsmanship in a Changing World*, 1956; Ostend, Belgium, *Second International Congress of Contemporary Ceramics*, 1959; San Francisco Museum of Art, *Twentieth Century Design USA*, 1960; Pasadena Art Museum, California, *California Design/Eight-Nine*, 1962, 1965; National Collection of Fine Arts, Smithsonian Institution, Washington, D.C., *Objects: USA*, 1969-71; The Oakland Museum, and Lang Gallery, Scripps College, Claremont, California, *The Potter's Art in California, 1885 to 1955*, 1978; Everson Museum of Art, Syracuse, New York, *A Century of Ceramics in the United States, 1878-1978*, 1979.

FURTHER REFERENCES: Herbert F. Johnson Museum of Art. *Marguerite: A Retrospective Exhibition of the Work of Master Potter Marguerite Wildenhain*. Ithaca, New York: Cornell University, 1980.

WORKS IN THE COLLECTION:
14 ceramic pieces

Marguerite Wildenhain's early Bauhaus training influenced her vision of the potter's life as an integration of hard work, mastery of technique, and dedication to excellence. Her ability to balance function and decoration is evident in the incised figurative design applied to the surface of this simple stoneware vase.

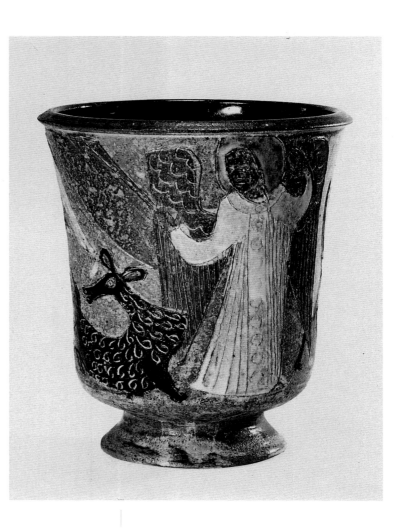

Vase (Angels and Dragons), 1952 (77.182.7)
Stoneware with glazes
8⅞ × 7¹¹⁄₁₆ in. (22.53 × 19.53 cm.)
Gift of Marguerite Wildenhain

MARGARET DE PATTA

Born March 18, 1903, Tacoma, Washington
To California c. 1921
Died March 19, 1964, Oakland, California

EDUCATION: Academy of Fine Arts, San Diego, California, 1921-23; California School of Fine Arts, San Francisco, 1923-25; Art Students League, New York, 1926-29; studied metalwork with Armin Hairenian, San Francisco, 1929; studied enameling and engraving, San Francisco, 1932; studied with Laszlo Moholy-Nagy, Mills College, Oakland, 1940; studied with Laszlo Moholy-Nagy, School of Design, Chicago, 1940-41.

SELECTED ONE-ARTIST EXHIBITIONS: Amberg-Hirth Gallery, San Francisco, 1936, 1938, 1940; San Francisco Museum of Art, 1964; Museum of Contemporary Crafts, New York, 1964; The Oakland Museum, 1976.

SELECTED GROUP EXHIBITIONS: California Pacific International Exposition, San Diego, 1935; Golden Gate International Exposition, Palace of Fine Arts, San Francisco, *Artists-Craftsmen in Action*, 1940; Huntington Galleries, West Virginia, *American Jewelry and Related Objects*, 1955; Museum of Contemporary Crafts, New York, *Craftsmanship in a Changing World*, 1956; Brussels International Exposition, Belgium, 1958; Museum of Contemporary Crafts, New York, *Designer-Craftsmen USA 1960*, 1960; International Jewelry Exhibition, London, 1961.

FURTHER REFERENCES: The Oakland Museum. *The Jewelry of Margaret De Patta: A Retrospective Exhibition.* Oakland, 1976.

WORKS IN THE COLLECTION: 45 pieces of jewelry and archival materials

Dissatisfied with traditionally cut transparent stones, De Patta designed custom specifications for stones and new structural techniques for holding them. Illustrated here is a rhomboid quartz with faceting in opposing courses. This cut causes optical refraction of the pendant's structure through the stone, and the unique optical effect is a featured part of the total design.

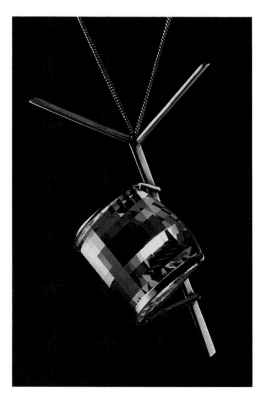

Pendant, 1956 (67.21.6)
White gold and ebony with rhomboid quartz crystal faceted in opposing courses
3¾ × 2½ × 1 in. (9.53 × 6.35 × 2.54 cm.)
Gift of Eugene Bielawski

ELMER BISCHOFF

Born July 9, 1916, Berkeley, California
Lives in Berkeley, California

EDUCATION: University of California, Berkeley,
1938 (BA), 1939 (MA).

SELECTED ONE-ARTIST EXHIBITIONS:
California Palace of the Legion of Honor, San Fran-
cisco, 1947; Paul Kantor Gallery, Los Angeles, 1955;
Staempfli Gallery, New York, 1960, 1962, 1964, 1969;
San Francisco Museum of Art, 1971; The Oakland
Museum, 1975; John Berggruen Gallery, San Fran-
cisco, 1979, 1983; Contemporary Arts Museum,
Houston, Texas, 1980; University Art Museum, Berke-
ley, California, 1982.

SELECTED GROUP EXHIBITIONS: Art
Institute of Chicago, *Abstract and Surrealist Amer-
ican Art*, 1947; Oakland Art Museum, *Contemporary
Bay Area Figurative Painting*, 1957; Whitney Mu-
seum of American Art, New York, *Fifty California
Artists*, 1962-63; Museum of Modern Art, New York,
Recent Painting USA: The Figure, 1962-63; Tate Gal-
lery, London, *'54 to '64: Painting and Sculpture of a
Decade*, 1964; The Oakland Museum, *A Period of
Exploration: San Francisco 1945-1950*, 1973; San
Francisco Museum of Modern Art, and National Col-
lection of Fine Arts, Smithsonian Institution, Wash-
ington, D.C., *Painting and Sculpture in California:
The Modern Era*, 1976-77; Albright-Knox Art Gal-
lery, Buffalo, New York, *American Painting of the
1970s*, 1979-80; Rutgers University Art Gallery, New
Brunswick, New Jersey, *Realism and Realities: The
Other Side of American Painting, 1940-1960*, 1982.

FURTHER REFERENCES: St. John, Terry.
Elmer Bischoff: Figurative Paintings, 1957-1972.
Oakland: The Oakland Museum, 1975.

WORKS IN THE COLLECTION: 4 paintings
and 1 drawing

*Bischoff's stature as a major proponent of the Bay
Area Figurative movement of the 1950s is evident
in* Figure in Landscape. *Its romantic, introspective
mood is captured by loosely brushed forms and
luminous color.*

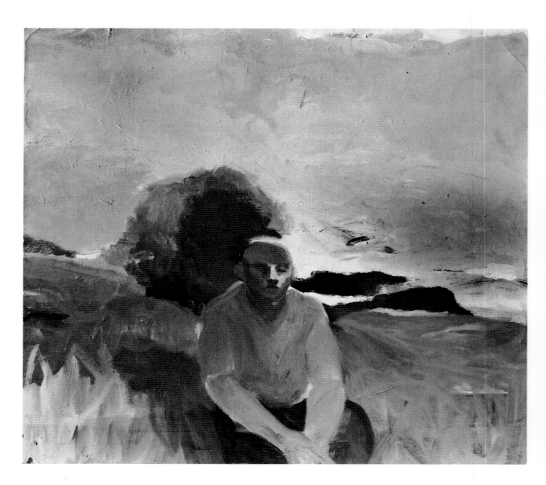

Figure in Landscape, c. 1957 (57.17.2)
Oil on canvas
52 × 57½ in. (132 × 146 cm.)
Gift of the Women's Board of the Oakland Museum
Association

DAVID PARK

Born March 17, 1911, Boston, Massachusetts
To California 1928
Died September 20, 1960, Berkeley, California

EDUCATION: Primarily self-taught; Otis Art Institute, Los Angeles, 1928.

SELECTED ONE-ARTIST EXHIBITIONS:
East & West Gallery, San Francisco, 1934; Oakland
Art Gallery, 1934; San Francisco Museum of Art,
1936, 1939, 1940; Delphic Studios, New York, 1936;
California Palace of the Legion of Honor, San Francisco, 1946; King Ubu Gallery, San Francisco, 1953;
Paul Kantor Gallery, Los Angeles, 1954; Oakland Art
Museum, 1957, 1960; M. H. de Young Memorial Museum, San Francisco, 1959; Staempfli Gallery, New
York, 1959, 1961; University Art Gallery, University
of California, Berkeley, 1964; Santa Barbara Museum
of Art, California, 1968; Newport Harbor Art Museum, Newport Beach, California, and The Oakland
Museum, 1977-78.

SELECTED GROUP EXHIBITIONS: San
Francisco Art Association, c. 1931-58; Museu de Arte
Moderna, São Paulo, Brazil, *III Bienal*, 1955; Oakland Art Museum, *Contemporary Bay Area Figurative Painting*, 1957-58; Staempfli Gallery, New York,
Elmer Bischoff, Richard Diebenkorn, David Park,
1960; Amon Carter Museum of Western Art, Fort
Worth, Texas, *The Artist's Environment: West Coast*,
1962-63; The Oakland Museum, *A Period of Exploration: San Francisco 1945-1950*, 1973; Rutgers University Art Gallery, New Brunswick, New Jersey,
*Realism and Realities: The Other Side of American
Painting, 1940-1960*, 1982.

FURTHER REFERENCES: Mills, Paul. *Contemporary Bay Area Figurative Painting*. Oakland:
Oakland Art Museum, 1957. Newport Harbor Art
Museum. *David Park*. Newport Beach, California,
1977.

WORKS IN THE COLLECTION:
23 paintings, 162 drawings, and 7 prints

*In 1950, Park became the first Abstract Expressionist in California to abandon abstraction and
work with a new type of figurative painting style
that featured loosely handled paint with representational images. Park played an influential role
in the Bay Area Figurative movement of the 1950s
and 1960s.*

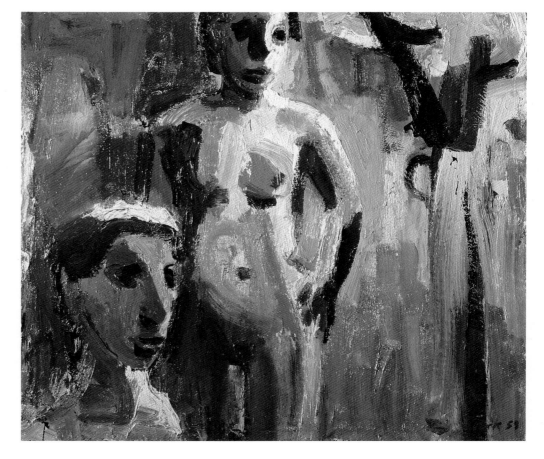

Women in a Landscape, 1958 (60.35.1)
Oil on canvas
50 × 56 in. (127 × 142.2 cm.)
Anonymous Donor Program of the American Federation of the Arts

ANTONIO PRIETO

Born August 23, 1912, Valdepeñas, Spain
To California 1916
Died March 11, 1967, Oakland, California

EDUCATION: California School of Fine Arts, San
Francisco, early 1940s; Alfred State University, Alfred,
New York, c. 1945-46.

SELECTED ONE-ARTIST EXHIBITIONS:
Instituto de Estudios Norteamericanos, Barcelona,
Spain, 1964; Museum West, San Francisco, 1964.

SELECTED GROUP EXHIBITIONS: Syr-
acuse Museum of Fine Arts, New York, *National Ce-
ramic Exhibitions*, 1946-62; Wichita Art Association,
Kansas, *National Decorative Arts-Ceramics Exhi-
bitions*, 1948, 1950, 1953; Richmond Art Center, Cal-
ifornia, *Annual Water Color, Print, Decorative Arts
Exhibitions*, 1952-56; Brooklyn Museum, New York,
Designer Craftsmen USA, 1953-54; Cannes, France,
First International Ceramics Exposition, 1955; Mu-
seum of Contemporary Crafts, New York, *Crafts-
manship in a Changing World*, 1956; M. H. de Young
Memorial Museum, San Francisco, *Designer-Crafts-
men of the West*, 1957; Museum of Contemporary
Crafts, New York, *Designer-Craftsmen of the Far
West*, 1961; Tokyo, Japan, *International Exhibition
of Contemporary Ceramic Art*, 1964; The Oakland
Museum, and Lang Gallery, Scripps College, Clare-
mont, California, *The Potter's Art in California, 1885
to 1955*, 1978.

FURTHER REFERENCES: Bray, Hazel V. *The
Potter's Art in California, 1885 to 1955*. Oakland:
The Oakland Museum, 1978.

WORKS IN THE COLLECTION: 7 ceramic
pieces

*An influential master potter and teacher who
established an important ceramics center at Mills
College in the 1950s, Prieto created works that
aptly represent the finesse of the decorative tradi-
tion of that time. His work acknowledges Califor-
nia's indebtedness to Asian ceramics, but remains
highly personal in form and surface decoration.*

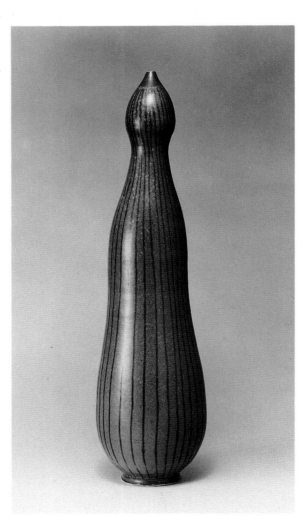

Bottle, 1957 (63.29)
Stoneware
Height: 25 in. (63.5 cm.)
Diameter: 6½ in. (16.5 cm.)
Gift of Antonio Prieto

BRUCE CONNER

Born November 18, 1933, McPherson, Kansas
To California 1957
Lives in San Francisco, California

EDUCATION: University of Wichita, Kansas,
1951-52; University of Nebraska, Lincoln, 1952-56
(BFA); Brooklyn Museum Art School, New York,
1956; University of Colorado, Boulder, 1957.

SELECTED ONE-ARTIST EXHIBITIONS:
East & West Gallery, San Francisco, 1958; Spatsa
Gallery, San Francisco, 1959; Alan Gallery, New York,
1960, 1961, 1964, 1965; Batman Gallery, San Fran-
cisco, 1960, 1962, 1964; Ferus Gallery, Los Angeles,
1962; San Francisco Art Institute, 1963, 1967, 1971;
Robert Fraser Gallery, London, 1963; Rose Art Mu-
seum, Brandeis University, Boston, 1965; Quay Gal-
lery, San Francisco, 1967, 1974; Institute of Contem-
porary Art, University of Pennsylvania, Philadelphia,
1967; Reese Palley Gallery, San Francisco, 1971, 1972;
Martha Jackson Gallery, New York, 1972; Nicholas
Wilder Gallery, Los Angeles, 1972; James Willis Gal-
lery, San Francisco, 1973; M. H. de Young Memorial
Museum, San Francisco, 1974-75; Braunstein/Quay
Gallery, San Francisco, 1975; Braunstein/Quay Gal-
lery, New York, 1976; North Point Gallery, San Fran-
cisco, 1980, 1981.

SELECTED GROUP EXHIBITIONS: Mu-
seum of Modern Art, New York, *The Art of Assem-
blage*, 1961; Whitney Museum of American Art, New
York, *Fifty California Artists*, 1962-63; University Art
Museum, Berkeley, California, *Funk*, 1967; Los An-
geles County Museum of Art, and Philadelphia Mu-
seum of Art, Pennsylvania, *American Sculpture of the
Sixties*, 1967; Stedelijk van Abbemuseum, Eindhoven,
The Netherlands, *Kompas 4: Westkust USA*, 1969-
70; Whitney Museum of American Art, New York,
and University Art Museum, Berkeley, California, *Hu-
man Concern/Personal Torment: The Grotesque in
American Art*, 1969-70; Dallas Museum of Fine Arts,
Texas, *Poets of the Cities/New York and San Fran-
cisco, 1950-1965*, 1974-75; The Oakland Museum,
Hybrid Vigor (with Robert Heinecken and Jack Ful-
ton), 1976; Indianapolis Museum of Art, Indiana,
*Perceptions of the Spirit in Twentieth-Century Amer-
ican Art*, 1977-78; Whitney Museum of American
Art, New York, *Biennial Exhibition*, 1979; Walnut
Creek Civic Arts Gallery, California, *Remember: It's
Only Art*, 1981; The Oakland Museum, *100 Years
of California Sculpture*, 1982.

FURTHER REFERENCES: The Oakland Mu-
seum. *100 Years of California Sculpture*. Oakland,
1982, p. 23.

WORKS IN THE COLLECTION:
1 sculpture, 49 prints, and 1 painting

*Conner's works are frequently visual metaphors of
loss, death, and aberrance. Here, the artist brings
together the attic-dusty remains of memorabilia and
throw-away miscellany, and embalms them,
reveals them, in eerie webs of old nylons.*

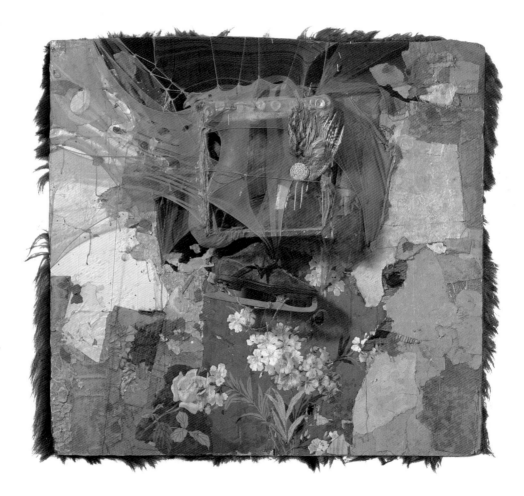

Spider Lady House, 1957-59 (79.143)
Mixed media
47¾ × 48 × 9 in. (121.3 × 122 × 22.8 cm.)
Gift of the Collectors Gallery and the National En-
dowment for the Arts

PETER VOULKOS

Born January 29, 1924, Bozeman, Montana
To California 1954
Lives in Berkeley, California

EDUCATION: Apprentice molder, Western Foundry Company, Portland, Oregon, 1942-43; Montana State College, Bozeman, 1946-51 (BS); California College of Arts and Crafts, Oakland, 1951-52 (MFA).

SELECTED ONE-ARTIST EXHIBITIONS: Scripps College, Claremont, California, 1954; Art Institute of Chicago, 1957; Pasadena Art Museum, California, 1958; Penthouse Gallery, Museum of Modern Art, New York, 1960; Primus-Stuart Gallery, Los Angeles, 1961, 1964; David Stuart Galleries, Los Angeles, 1963, 1965, 1967, 1969; Los Angeles County Museum of Art, 1965; Quay Gallery, San Francisco, 1968, 1974; San Francisco Museum of Art, 1972; Detroit Institute of Arts, Michigan, 1976; Museum of Contemporary Crafts, New York, 1978; Charles Cowles Gallery, New York, 1981, 1983; Braunstein Gallery, San Francisco, 1982.

SELECTED GROUP EXHIBITIONS: Scripps College, Claremont, California, *Ceramic Annuals*, 1950-55; Syracuse Museum of Fine Art, New York, *National Ceramic Exhibitions*, 1950-62; Palais des Festivals, Cannes, France, *Premier Festival International de la Céramique*, 1955; Musée des Beaux-Arts, Ostend, Belgium, *La Céramique Contemporaine*, 1959; Whitney Museum of American Art, New York, *Fifty California Artists*, 1962-63; San Francisco Museum of Art, *Molten Images: 7 Sculptors*, 1962; Museum of Contemporary Crafts, New York, *Creative Casting*, 1963; Oakland Art Museum, *Contemporary California Sculpture*, 1963; London City Council, Battersea Park, *Sculpture in the Open Air*, 1963; University of California, Irvine, *Abstract Expressionist Ceramics*, 1966; University Art Museum, Berkeley, California, *Funk*, 1967; Los Angeles County Museum of Art, and Philadelphia Museum of Art, Pennsylvania, *American Sculpture of the Sixties*, 1967; Stedelijk van Abbemuseum, Eindhoven, The Netherlands, *Kompas 4: Westkust USA*, 1969-70; National Collection of Fine Arts, Smithsonian Institution, Washington, D.C., *Objects: USA*, 1969-71; National Museum of Modern Art, Kyoto, Japan, and National Museum of Modern Art, Tokyo, *Contemporary Ceramic Art: Canada, USA, Mexico and Japan*, 1971-72; The Oakland Museum, *Public Sculpture/Urban Environment*, 1974; Whitney Museum of American Art, New York, *200 Years of American Sculpture*, 1976; San Francisco Museum of Modern Art, and National Collection of Fine Arts, Smithsonian Institution, Washington, D.C., *Painting and Sculpture in California: The Modern Era*, 1976-77; San Francisco Museum of Modern Art, *20 American Artists*, 1980; Los Angeles County Museum of Art, and San Antonio Museum of Art, Texas, *Art in Los Angeles: Seventeen Artists in the Sixties*, 1981-82; Whitney Museum of American Art, New York, and San Francisco Museum of Modern Art, *Ceramic Sculpture: Six Artists*, 1981-82; The Oakland Museum, *100 Years of California Sculpture*, 1982.

FURTHER REFERENCES: Slivka, Rose. *Peter Voulkos: A Dialogue with Clay*. New York: New York Graphic Society in association with American Crafts Council, 1978.

WORKS IN THE COLLECTION:
3 sculptures and 7 crafts

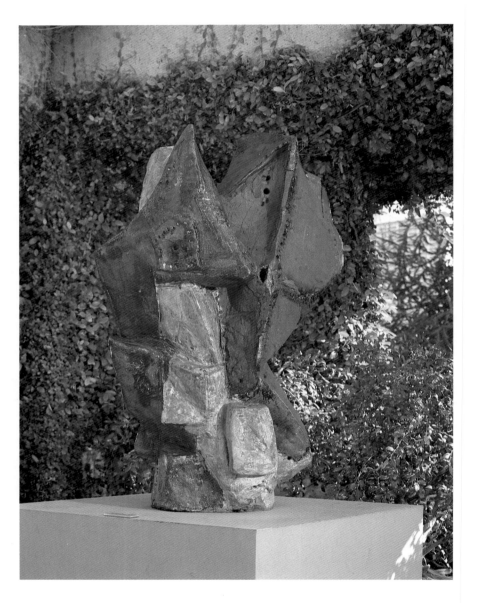

Little Big Horn, 1959 (63.42.1)
Stoneware, polychrome and underglazes
62 × 40 × 40 in. (157.5 × 101.6 × 101.6 cm.)
Gift of the Art Guild of the Oakland Museum Association

Voulkos' non-traditional use of clay is exemplified in Little Big Horn. *Voulkos, who also did Abstract Expressionist painting, broke new ground with his large-scale experiments in fired clay, using color and form more spontaneously than had been attempted before, thereby influencing an entire generation of ceramicists.*

RICHARD DIEBENKORN

Born April 22, 1922, Portland, Oregon
To California 1924
Lives in Santa Monica, California

EDUCATION: Stanford University, California, 1940-43, 1949 (BA); University of California, Berkeley, 1943; studied with David Park, California School of Fine Arts, San Francisco, 1945; University of New Mexico, Albuquerque, 1950-51 (MFA).

SELECTED ONE-ARTIST EXHIBITIONS: California Palace of the Legion of Honor, San Francisco, 1948, 1960; San Francisco Museum of Art, 1954, 1966, 1972; Poindexter Gallery, New York, 1956, 1958, 1961, 1963, 1965, 1966, 1968, 1969, 1971; Oakland Art Museum, 1956; Pasadena Art Museum, California, 1960; Washington Gallery of Modern Art, Washington, D.C., 1964-65; Los Angeles County Museum of Art, 1969; Marlborough Gallery, New York, 1971, 1975; John Berggruen Gallery, San Francisco, 1975, 1980, 1983; Albright-Knox Art Gallery, Buffalo, New York, 1976-77; M. Knoedler & Co., New York, 1977, 1979, 1980, 1982; UCSB Art Museum, University of California, Santa Barbara, 1979; Crown Point Gallery, Oakland, 1982; San Francisco Museum of Modern Art, 1983.

SELECTED GROUP EXHIBITIONS: Solomon R. Guggenheim Museum, New York, *Younger American Painters*, 1954; Museu de Arte Moderna, São Paulo, Brazil, *III Bienal*, 1955, and *VI Bienal*, 1961; Oakland Art Museum, *Contemporary Bay Area Figurative Painting*, 1957-58; Museum of Modern Art, New York, *New Images of Man*, 1959; Whitney Museum of American Art, New York, *Fifty California Artists*, 1962-63; Tate Gallery, London, *'54 to '64: Painting and Sculpture of a Decade*, 1964; Stedelijk van Abbemuseum, Eindhoven, The Netherlands, *Kompas 4: Westkust USA*, 1969-70; Hayward Gallery, London, *11 Los Angeles Artists*, 1971; San Francisco Museum of Modern Art, and National Collection of Fine Arts, Smithsonian Institution, Washington, D.C., *Painting and Sculpture in California: The Modern Era*, 1976-77; Albright-Knox Art Gallery, Buffalo, New York, *American Paintings of the 1970s*, 1978-79; Rutgers University Art Gallery, New Brunswick, New Jersey, *Realism and Realities: The Other Side of American Painting, 1940-1960*, 1982.

FURTHER REFERENCES: Albright-Knox Art Gallery. *Richard Diebenkorn: Paintings and Drawings, 1943-1976*. Buffalo, New York, 1976.

WORKS IN THE COLLECTION:
4 paintings and numerous prints

Figure on a Porch is an important work from Diebenkorn's Bay Area Figurative period. This work is a significant antecedent to the Ocean Park *paintings of the 1970s, in which the artist translates similar pictorial concerns for color, light, and plane into spatial abstractions.*

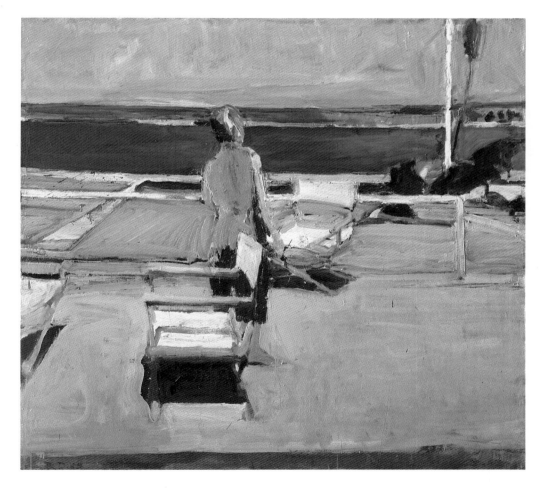

Figure on a Porch, 1959 (60.35.5)
Oil on canvas
57 × 62 in. (144.8 × 157.5 cm.)
Anonymous Donor Program of the American Federation of Arts

BOB STOCKSDALE

Born May 25, 1913, Warren, Indiana
To California 1944
Lives in Berkeley, California

EDUCATION: Self-taught as a woodlathe artist.

SELECTED ONE-ARTIST EXHIBITIONS: Long Beach Museum of Art, California, 1959; Arizona State University, Tempe, 1962; Museum of Contemporary Crafts, New York, 1969; St. Louis Craft Alliance Gallery, Missouri, 1970; Richard Kagan Gallery, Philadelphia, Pennsylvania, 1976; The Oakland Museum, 1981.

SELECTED GROUP EXHIBITIONS: Detroit Institute of Arts, Michigan, *For Modern Living*, 1949; Richmond Art Center, California, *Designer-Craftsmen Exhibitions*, 1954, 1955, 1958, 1963; Museum of Contemporary Crafts, New York, *Craftsmanship in a Changing World*, 1956; M. H. de Young Memorial Museum, San Francisco, *Designer-Craftsmen of the West*, 1957; Brussels International Exposition, 1958; Museum of Contemporary Crafts, New York, *Designer-Craftsmen of the Far West*, 1961; Oakland Art Museum, *First and Second California Craftsmen's Biennials*, 1961, 1963; Pasadena Art Museum, California, *California Design/Eight-Eleven*, 1962, 1965, 1968, 1971; The Oakland Museum, *Excellence of the Object*, 1969; National Collection of Fine Arts, Smithsonian Institution, Washington, D.C., *Objects: USA*, 1969-71; Buffalo Craftsmen, and Burchfield Center, Buffalo, New York, *Language of Wood*, 1975; Philadelphia Museum of Art, Pennsylvania, *American Crafts 1977*, 1977; American Crafts Council, Lake Placid, New York, *Art for Use*, 1980; American Craft Museum, New York, *The Art of Wood Turning*, 1983.

FURTHER REFERENCES: Nordness, Lee. *Objects: USA*. New York: The Viking Press, 1970, p. 261.

WORKS IN THE COLLECTION: 2 plates and 2 bowls

Innate sensitivity and respect for his materials have placed Stocksdale in the forefront of the California woodcraft movement. The bowl illustrated is an early example of a limited number of unique but similar types of turned objects. The artist carefully selects the portion of wood used in order to enhance the display of its natural color and pattern.

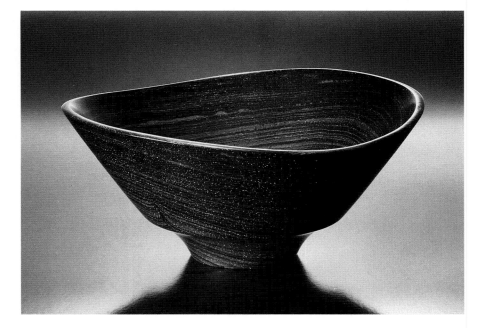

Oval Bowl, n.d. (63.16)
Brazilian rosewood
Height: 3½ in. (8.89 cm.)
Diameter: 8¾ in. (22.23 cm.)
Yvonne Greer Thiel Collection

ARTHUR ESPENET CARPENTER (Espenet)

Born January 20, 1920, New York, New York
To California 1948
Lives in Bolinas, California

EDUCATION: Dartmouth College, Hanover, New Hampshire, 1942 (BA).

SELECTED ONE-ARTIST EXHIBITIONS: Long Beach Museum of Art, California, 1961; California College of Arts and Crafts, Oakland, 1972.

SELECTED GROUP EXHIBITIONS: Museum of Modern Art, New York, *Good Design* exhibitions, c. 1949-53; Museum of Contemporary Crafts, New York, *Craftsmanship in a Changing World*, 1956; M. H. de Young Memorial Museum, San Francisco, *Designer-Craftsmen of the West*, 1957; Museum of Contemporary Crafts, New York, *Designer-Craftsmen of the Far West*, 1961; Pasadena Art Museum, California, *California Design/Eight-Eleven*, 1962, 1965, 1968, 1971; Museum of Contemporary Crafts, New York, *Designed for Production: the Craftsmen's Approach*, 1964; National Collection of Fine Arts, Smithsonian Institution, Washington, D.C., *Objects: USA*, 1969-71; Sterling Associates, Palo Alto, California, *Furniture as Works of Art*, 1970; Renwick Gallery, National Collection of Fine Arts, Smithsonian Institution, Washington, D.C., *Woodenworks*, 1972, and *Craft Multiples*, 1975; The Oakland Museum, *California Woodworking*, 1980.

FURTHER REFERENCES: Renwick Gallery. *Woodenworks*. Washington, D.C.: National Collection of Fine Arts, Smithsonian Institution, 1972.

WORKS IN THE COLLECTION: 1 turned bowl, 2 jewelry cases, and 1 domino set

Although Carpenter is known primarily as a furniture maker, this small domino set exemplifies the clean-line simplicity of form and the mastery of craft which distinguish his cabinetry.

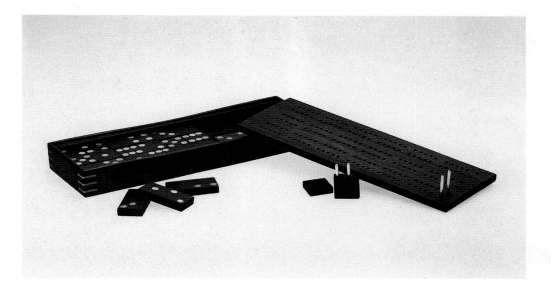

Domino Set, 1960 (61.79)
Rosewood, ebony, and sterling silver
1¼ × 10¾ × 3¾ in. (3.2 × 27.3 × 9.5 cm.)
Yvonne Greer Thiel Collection

145

HARRY ST. JOHN DIXON

Born June 22, 1890, Fresno, California
Died September 4, 1967, Santa Rosa, California

EDUCATION: School of the California Guild of Arts and Crafts, Berkeley, 1909-14; apprentice in metalworking to Dirk Van Erp, San Francisco, 1909-11.

SELECTED GROUP EXHIBITIONS: Panama-Pacific International Exposition, San Francisco, 1915; Richmond Art Center, California, *Annual Designer-Craftsmen Exhibitions*, 1958, 1962; 5th Annual Art Festival, San Francisco, 1951; California State Fair, Sacramento, 1957, 1962; Oakland Art Museum, *California Craftsmen's Second Biennial*, 1963; Santa Rosa Junior College, California, *Artrium '67*, 1967; The Oakland Museum, *Metal Works 1910-1940*, 1971; Pasadena Center, California, *California Design 1910*, 1974.

FURTHER REFERENCES: Artist's File, Archives of California Art, The Oakland Museum.

WORKS IN THE COLLECTION: 10 pieces: bowls, vases, 1 ladle, and shop sign with logo

Dixon began working in the Arts and Crafts era and continued for more than fifty years. In the 1960 copper container shown here, he masterfully incorporates the artisan coppersmith's seam into the landscape design.

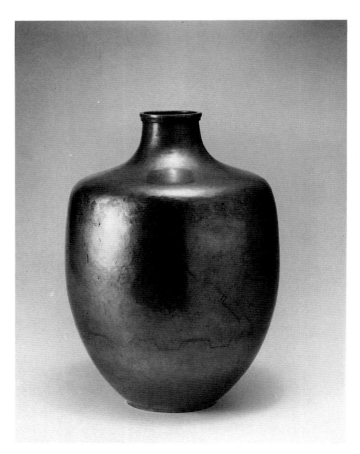

Thunder Over Mesa, c. 1960 (79.191.2)
Fabricated and raised copper
Height: 14 in. (35.6 cm.)
Diameter: 12 in. (30.5 cm.)
Gift of Florence Dixon in memory of Harry Dixon and his son, Dudley Dixon

FRANK LOBDELL

Born August 21, 1921, Kansas City, Missouri
To California 1946
Lives in Palo Alto, California

EDUCATION: St. Paul School of Fine Arts, St. Paul, Minnesota, 1938-39; California School of Fine Arts, San Francisco, 1947-50; Académie de la Grande Chaumière, Paris, 1950.

SELECTED ONE-ARTIST EXHIBITIONS: Lucien Labaudt Art Gallery, San Francisco, 1949 (with George Stillman); Martha Jackson Gallery, New York, 1958, 1960, 1963, 1972, 1974, 1975; Ferus Gallery, Los Angeles, 1962; Galerie D. Benador, Geneva, Switzerland, 1964; Galerie Anderson-Mayer, Paris, 1965; Pasadena Art Museum, and Stanford University Museum of Art, California, 1966; San Francisco Museum of Art, 1969; Smith Andersen Gallery, Palo Alto, California, 1977; College of Notre Dame, Belmont, California, 1981; Smith Andersen Gallery, San Francisco, 1982; San Francisco Museum of Modern Art, 1983.

SELECTED GROUP EXHIBITIONS: San Francisco Art Association, c. 1948-63; Museu de Arte Moderna, São Paulo, Brazil, *III Bienal*, 1955; Whitney Museum of American Art, New York, *Fifty California Artists*, 1962-63; Stedelijk van Abbemuseum, Eindhoven, The Netherlands, *Kompas 4: Westkust USA*, 1969-70; The Oakland Museum, *A Period of Exploration: San Francisco 1945-1950*, 1973; San Francisco Museum of Modern Art, and National Collection of Fine Arts, Smithsonian Institution, Washington, D.C., *Painting and Sculpture in California: The Modern Era*, 1976-77.

FURTHER REFERENCES: San Francisco Museum of Modern Art. *Frank Lobdell: Paintings and Monotypes*. San Francisco, 1983.

WORKS IN THE COLLECTION:
3 paintings, 2 prints, and memorabilia

Lobdell, a well-known Bay Area abstractionist, creates here a heavily impastoed atmosphere in which a strange, orb-like form uncoils and strains to expand beyond the picture plane.

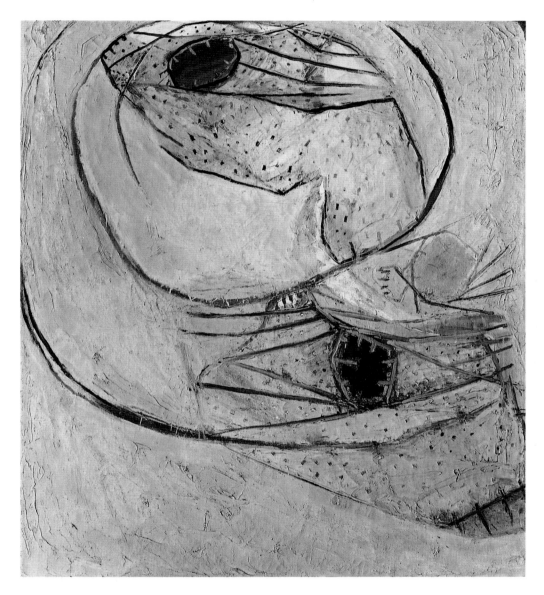

15 April, 1962 (65.117)
Oil on canvas
70 × 61¼ in. (177.8 × 155.5 cm.)
Gift of the Art Guild of the Oakland Museum Association

NATHAN OLIVEIRA

Born December 19, 1928, Oakland, California
Lives in Stanford, California

EDUCATION: California College of Arts and Crafts, Oakland, 1947-52 (MFA); studied with Max Beckmann, Mills College, Oakland, summer 1950.

SELECTED ONE-ARTIST EXHIBITIONS: Eric Locke Gallery, San Francisco, California, 1957; Alan Gallery, New York, 1958, 1960, 1962, 1963, 1965; Walker Art Center, Minneapolis, Minnesota, 1961; UCLA Art Galleries, University of California, Los Angeles, 1963-64; Stanford University Museum of Art, California, and San Francisco Museum of Art, 1965; Martha Jackson Gallery, New York, 1969; San Francisco Museum of Art, 1969; Charles Campbell Gallery, San Francisco, 1971, 1972, 1975, 1977, 1978, 1979; The Oakland Museum, and Portland Center for Visual Arts, Oregon, 1973; Baxter Art Gallery, California Institute of Technology, Pasadena, 1979-80; John Berggruen Gallery, San Francisco, 1979, 1982; California State University, Long Beach, 1980-82; Charles Cowles Gallery, New York, 1980; San Francisco Museum of Modern Art, 1984.

SELECTED GROUP EXHIBITIONS: Museum of Modern Art, New York, *New Images of Man*, 1959, and *Recent Painting USA: The Figure*, 1962-63; Whitney Museum of American Art, New York, *Fifty California Artists*, 1962-63; Museum of Modern Art, New York, *Contemporary Painters and Sculptors as Printmakers*, 1966; San Francisco Museum of Modern Art, and National Collection of Fine Arts, Smithsonian Institution, Washington, D.C., *Painting and Sculpture in California: The Modern Era*, 1976-77; San Francisco Museum of Modern Art, *20 American Artists*, 1980; Rutgers University Art Gallery, New Brunswick, New Jersey, *Realism and Realities: The Other Side of American Painting, 1940-1960*, 1982.

FURTHER REFERENCES: The Art Museum and Galleries and The Center for Southern California Studies in the Visual Arts. *Nathan Oliveira, Print Retrospective: 1949-1980*. Long Beach: California State University, 1980. Jones, Harvey L. *Nathan Oliveira: Paintings 1959-1973*. Oakland: The Oakland Museum, 1973.

WORKS IN THE COLLECTION: 2 paintings, 1 watercolor, 2 drawings, and 26 prints

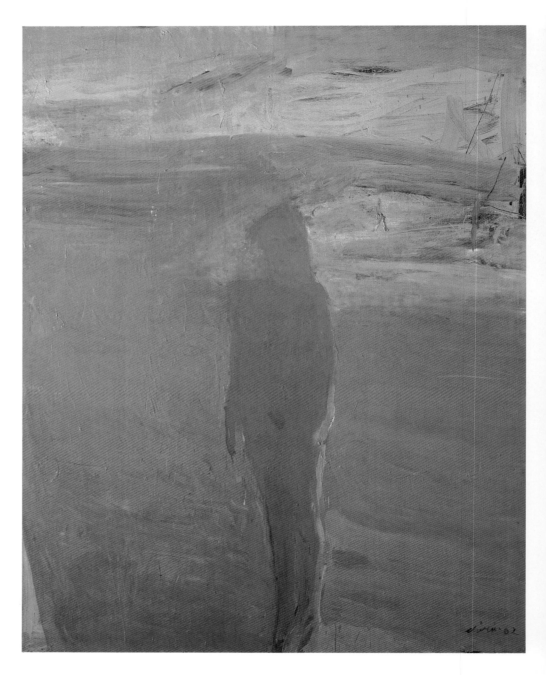

Spring Nude, 1962 (66.175)
Oil on canvas
96 × 76 in. (243.8 × 193 cm.)
Gift of Nathan Oliveira in memory of Edna Stoddard Siegriest

Oliveira, who played a prominent role in the Bay Area Figurative movement, has translated his haunting visions of the human form into painting and, very recently, into sculpture. Spring Nude is one of the artist's important early works. The ethereal figure appears like an apparition from some forgotten dream world.

JOAN BROWN

Born February 13, 1938, San Francisco, California
Lives in San Francisco, California

EDUCATION: California School of Fine Arts, San Francisco, 1955-59 (BA), 1960 (MA).

SELECTED ONE-ARTIST EXHIBITIONS: 6 Gallery, San Francisco, 1957 (with Mike Nathan); Spatsa Gallery, San Francisco, 1959; Batman Gallery, San Francisco, 1959; Staempfli Gallery, New York, 1960, 1961, 1964; David Stuart Galleries, Los Angeles, 1964 (with Manuel Neri); San Francisco Museum of Art, 1971; Charles Campbell Gallery, San Francisco, 1974, 1975; University Art Museum, Berkeley, California, 1974, 1979; Allan Frumkin Gallery, New York, 1974, 1976, 1979, 1981, 1982; Hansen Fuller Gallery, San Francisco, 1976; Newport Harbor Art Museum, Newport Beach, California, 1978; Hansen Fuller Goldeen Gallery, San Francisco, 1978, 1979, 1980; Fuller Goldeen Gallery, San Francisco, 1982, 1983; Koplin Gallery, Los Angeles, 1982, 1983.

SELECTED GROUP EXHIBITIONS: San Francisco Art Association, 1957, 1958, 1963; Whitney Museum of American Art, New York, *Young America 1960*, 1960; University Art Museum, Berkeley, California, *Funk*, 1967; The Oakland Museum, *A Period of Exploration: San Francisco 1945-1950*, 1973; San Francisco Museum of Modern Art, and National Collection of Fine Arts, Smithsonian Institution, Washington, D.C., *Painting and Sculpture in California: The Modern Era*, 1976-77; Albright-Knox Art Gallery, Buffalo, New York, *American Painting of the 1970s*, 1979-80; The New Museum, New York, *The 1970s: New American Painting*, 1979-81; Rutgers University Art Gallery, New Brunswick, New Jersey, *Realism and Realities: The Other Side of American Painting, 1940-1960*, 1982.

FURTHER REFERENCES: Richardson, Brenda. *Joan Brown*. Berkeley, California: University Art Museum, 1974.

WORKS IN THE COLLECTION: 3 paintings and 1 watercolor

In this powerful early work, Brown, an artist identified with the second generation of Bay Area Figurative painters, uses strong color and gutsy brushwork to imbue Girl Sitting *with a direct and riveting physicality.*

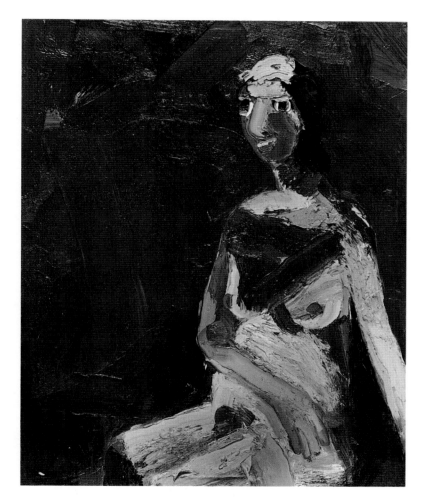

Girl Sitting, 1962 (67.128.2)
Oil on canvas
47¾ × 60 in. (121.3 × 152.4 cm.)
Gift of Dr. Samuel A. West

ROBERT HUDSON

Born September 8, 1938, Salt Lake City, Utah
To San Francisco, California 1957
Lives in Cotati, California

EDUCATION: San Francisco Art Institute, 1962
(BFA), 1963 (MFA).

SELECTED ONE-ARTIST EXHIBITIONS:
Richmond Art Center, California, 1961; Batman Gallery, San Francisco, 1961; Bolles Gallery, San Francisco, 1962; San Francisco Art Institute, 1965; Allan Frumkin Gallery, New York, 1965, 1971, 1976, 1978, 1981; Nicholas Wilder Gallery, Los Angeles, 1967; Allan Frumkin Gallery, Chicago, 1969, 1972, 1976; University Art Museum, Berkeley, California, *The Star Show*, 1972; San Francisco Museum of Art, *Robert Hudson/Richard Shaw: Work in Porcelain*, 1973; Hansen Fuller Gallery, San Francisco, 1973, 1975; Hansen Fuller Goldeen Gallery, San Francisco, 1977, 1979; Moore College of Art Gallery, Philadelphia, Pennsylvania, 1977; Fuller Goldeen Gallery, San Francisco, 1982.

SELECTED GROUP EXHIBITIONS: Oakland Art Museum, *Contemporary California Sculpture*, 1963; Whitney Museum of American Art, New York, *Young America 1965*, 1965; University Art Museum, Berkeley, California, *Funk*, 1967; Los Angeles County Museum of Art, and Philadelphia Museum of Art, Pennsylvania, *American Sculpture of the Sixties*, 1967; Walker Art Center, Minneapolis, Minnesota, *14 Sculptors: The Industrial Edge*, 1969; Hayward Gallery, London, *The Condition of Sculpture*, 1975; San Francisco Museum of Modern Art, and National Collection of Fine Arts, Smithsonian Institution, Washington, D.C., *Painting and Sculpture in California: The Modern Era*, 1976-77; San Francisco Museum of Modern Art, *Aesthetics of Graffiti*, 1978; The Oakland Museum, *100 Years of California Sculpture*, 1982.

FURTHER REFERENCES: Allan Frumkin Gallery. *Robert Hudson*. New York, 1976.

WORKS IN THE COLLECTION:
4 sculptures and 2 drawings

Hudson, an important artist of the Bay Area Funk movement, creates sculpture of upbeat wit and optical illusion in Double Time. Brassy comic-book colors and syncopated forms play off one another like a well-meshed juggling performance.

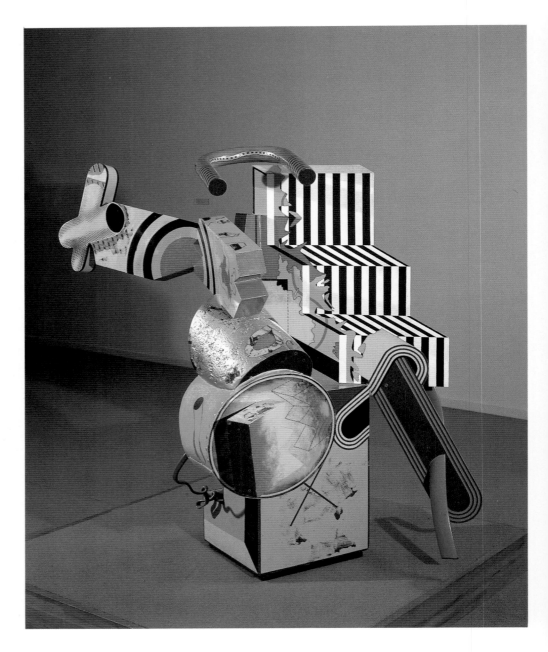

Double Time, 1963 (65.196)
Painted metal
58¾ × 50 × 35 in. (149.2 × 127 × 88.9 cm.)
Gift of the Women's Board of the Oakland Museum
Association

150

KENNETH PRICE

Born 1935, Los Angeles, California
In California 1935-72
Lives in Taos, New Mexico

EDUCATION: Chouinard Art Institute, Los Angeles, 1953-54; University of Southern California, Los Angeles, 1956 (BFA); Otis Art Institute, Los Angeles, 1957-58; State University of New York, Alfred, 1959 (MFA).

SELECTED ONE-ARTIST EXHIBITIONS: Ferus Gallery, Los Angeles, 1960, 1961, 1964; Los Angeles County Museum of Art, *Robert Irwin/Kenneth Price*, 1966; Kasmin Gallery, London, 1968, 1970; Whitney Museum of American Art, New York, 1969; Galerie Neuendorf, Cologne and Hamburg, West Germany, 1971; Nicholas Wilder Gallery, Los Angeles, 1973; Felicity Samuel Gallery, London, 1974; Willard Gallery, New York, 1974, 1979, 1982; James Corcoran Gallery, Los Angeles, 1976, 1980, 1982; Los Angeles County Museum of Art, 1978; Hansen Fuller Goldeen Gallery, San Francisco, 1979; Contemporary Arts Museum, Houston, Texas, 1980; Leo Castelli, New York, 1983.

SELECTED GROUP EXHIBITIONS: Whitney Museum of American Art, New York, *Fifty California Artists*, 1962-63; Oakland Art Museum, *Contemporary California Sculpture*, 1963; University of California, Irvine, *Abstract Expressionist Ceramics*, 1966; Los Angeles County Museum of Art, and Philadelphia Museum of Art, Pennsylvania, *American Sculpture of the Sixties*, 1967; Stedelijk van Abbemuseum, Eindhoven, The Netherlands, *Kompas 4: Westkust USA*, 1969; National Museum of Modern Art, Kyoto, Japan, and National Museum of Modern Art, Tokyo, *Contemporary Ceramic Art: Canada, USA, Mexico and Japan*, 1971-72; Hayward Gallery, London, *11 Los Angeles Artists*, 1971; Kunstverein, Hamburg, West Germany, *USA West Coast*, 1972; Whitney Museum of American Art, New York, *200 Years of American Sculpture*, 1976; San Francisco Museum of Modern Art, and National Collection of Fine Arts, Smithsonian Institution, Washington, D.C., *Painting and Sculpture in California: The Modern Era*, 1976-77; Everson Museum of Art, Syracuse, New York, *A Century of Ceramics in the United States, 1878-1978*, 1979; Museum of Modern Art, New York, *Contemporary Sculpture*, 1979; Los Angeles County Museum of Art, and San Antonio Museum of Art, Texas, *Art in Los Angeles: Seventeen Artists in the Sixties*, 1981-82; Whitney Museum of American Art, New York, and San Francisco Museum of Modern Art, *Ceramic Sculpture: Six Artists*, 1981-82; The Oakland Museum, *100 Years of California Sculpture*, 1982.

FURTHER REFERENCES: Marshall, Richard and Suzanne Foley. *Ceramic Sculpture: Six Artists*. New York: Whitney Museum of American Art in association with the University of Washington Press, Seattle and London, 1981. Simon, Joan. "An Interview with Ken Price." *Art in America*, Vol. 68, No. 1 (January 1980), pp. 98-104.

WORKS IN THE COLLECTION: 1 ceramic piece

Price, who has studied and worked outside the traditional craft community, has shown a sustained interest in the cup as a sculptural form. Rock Cup is one of a series which wittily combines unlikely objects such as animals or rocks with the conventional vessel form.

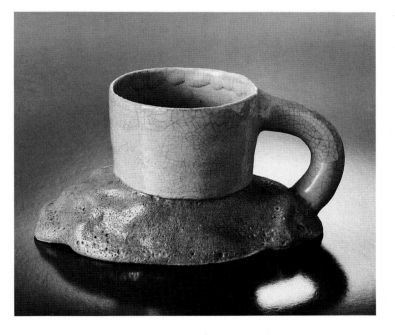

Rock Cup, 1964 (79.137)
Glazed ceramic
2⅝ × 5⅛ × 3 in. (6.67 × 13.02 × 7.62 cm.)
Gift of the Collectors Gallery

SAM FRANCIS

Born June 25, 1923, San Mateo, California
In Europe and the Orient 1950-61
Lives in Santa Monica, California

EDUCATION: Studied with David Park, San Francisco, 1945-46; University of California, Berkeley, 1949 (BA), 1950 (MA); Académie Fernand Léger, Paris, 1950.

SELECTED ONE-ARTIST EXHIBITIONS: Galerie du Dragon, Paris, 1952; Martha Jackson Gallery, New York, 1956-70; San Francisco Museum of Art, 1959, 1967; Pasadena Art Museum, California, 1959, 1964, 1966, 1967; Kunsthalle, Bern, Switzerland, 1960; Museum of Fine Arts, Houston, Texas, and University Art Museum, Berkeley, California, 1967; Stedelijk Museum, Amsterdam, 1968; Centre National d'Art Contemporain, Paris, 1968; Los Angeles County Museum of Art, 1970, 1980; Albright-Knox Art Gallery, Buffalo, New York, 1972-73; United States International Communication Agency, (organized by the Institute of Contemporary Art, Boston, Massachusetts), 1980-81 (traveled to Far East); John Berggruen Gallery, San Francisco, 1983.

SELECTED GROUP EXHIBITIONS: Museum of Modern Art, New York, *Twelve Americans*, 1956, and *The New American Painting*, 1958-59; Kassel, Germany, *Documenta 2*, 1959, *Documenta 3*, 1964; Solomon R. Guggenheim Museum, New York, *American Abstract Expressionists and Imagists*, 1961; National Museum of Modern Art, Tokyo, and Municipal Museum of Art, Osaka, Japan, *3rd International Biennial Exhibition of Prints*, 1962; Tate Gallery, London, *'54 to '64: Painting and Sculpture of a Decade*, 1964; Los Angeles County Museum of Art, *Post Painterly Abstraction*, 1964; Museum of Modern Art, New York, *Contemporary Painters and Sculptors as Printmakers*, 1966; Albright-Knox Art Gallery, Buffalo, New York, *Color and Field*, 1970; San Francisco Museum of Modern Art, and National Collection of Fine Arts, Smithsonian Institution, Washington, D.C., *Painting and Sculpture in California: The Modern Era*, 1976-77; Louisiana Museum of Art, Humblebaek, Denmark, *Art in Progress*, 1977-79; San Francisco Museum of Modern Art, *20 American Artists*, 1980.

FURTHER REFERENCES: Selz, Peter. *Sam Francis*. New York: Harry N. Abrams, Inc., 1975.

WORKS IN THE COLLECTION:
1 painting, 3 individual prints, and 6 bound prints

Untitled, 1965-66 (73.45)
Acrylic on canvas
101 × 96½ in. (256.5 × 245.1 cm.)
Gift of Concours d'Antiques

Francis typically paints in bright primary and secondary colors on barely stained white canvas. This painting is characteristic of the artist's more minimal mid-1960s period, during which he refined his former color drips and blobs into elegant, edge-defining bands, leaving vacant a vast middle field of white.

152

JOHN McLAUGHLIN

Born May 21, 1898, Sharon, Massachusetts
To Dana Point, California 1946
Died March 22, 1976, Dana Point, California

EDUCATION: Primarily self-taught.

SELECTED ONE-ARTIST EXHIBITIONS:
Felix Landau Gallery, Los Angeles, 1953, 1958, 1962,
1963, 1966, 1968, 1970; Pasadena Art Museum, California, 1963; Corcoran Gallery of Art, Washington,
D.C., 1968; Nicholas Wilder Gallery, Los Angeles,
1972, 1979; La Jolla Museum of Contemporary Art,
California, 1973; Whitney Museum of American Art,
New York, 1974; André Emmerich Gallery, New York,
1974, 1979; Felicity Samuel Gallery, London, 1975;
Art Gallery, California State University, Fullerton,
1975.

SELECTED GROUP EXHIBITIONS: Museu de Arte Moderna, São Paulo, Brazil, *III Bienal*,
1955; Los Angeles Museum of History, Science and
Art, and San Francisco Museum of Art, *Four Abstract
Classicists*, 1959; Whitney Museum of American Art,
New York, *Geometric Abstraction in America*, 1962;
Museum of Modern Art, New York, and Pasadena
Art Museum, California, *The Responsive Eye*, 1965;
Pasadena Art Museum, California, *West Coast 1945-
1969*, 1969-70; Hayward Gallery, London, *11 Los
Angeles Artists*, 1971; Los Angeles Institute of Contemporary Art, *Nine Senior Southern California
Painters*, 1974; San Francisco Museum of Modern
Art, and National Collection of Fine Arts, Smithsonian Institution, Washington, D.C., *Painting and
Sculpture in California: The Modern Era*, 1976-77;
Los Angeles County Museum of Art, and San Antonio
Museum of Art, Texas, *Art in Los Angeles: Seventeen
Artists in the Sixties*, 1981-82.

FURTHER REFERENCES: Art Gallery, California State University. *John McLaughlin Retrospective Exhibition 1946-1975*. Fullerton, California,
1975.

WORKS IN THE COLLECTION: 1 painting

*The flat geometric shapes of John McLaughlin's
#1 stem from a modernist tradition established by
the Constructivists and de Stijl groups. McLaughlin was one of the leading Abstract Classicists, a
group concerned with severe, hard-edged planar
forms.*

#1, 1966 (68.80)
Acrylic and oil on canvas
60 × 42 in. (152.4 × 106.7 cm.)
Gift of Anonymous Donor

JOHN MASON

Born March 30, 1927, Madrid, Nebraska
To Los Angeles, California 1949
Lives in Los Angeles, California

EDUCATION: Otis Art Institute, Los Angeles, c. 1949-51, 1954; Chouinard Art Institute, Los Angeles, c. 1951-54.

SELECTED ONE-ARTIST EXHIBITIONS: Gump's Gallery, San Francisco, 1956; Ferus Gallery, Los Angeles, 1957, 1959, 1961, 1963; Pasadena Art Museum, California, 1960; Los Angeles County Museum of Art, 1966; Pasadena Museum of Modern Art, California, 1974; Hansen Fuller Gallery, San Francisco, 1976; Hudson River Museum, Yonkers, New York, 1978; University of Nevada, Reno, 1979.

SELECTED GROUP EXHIBITIONS: Museum of Contemporary Crafts, New York, *Young Americans*, 1958; Second International Congress of Contemporary Ceramics, Ostend, Belgium, *Moderne Amerikanst Keramik*, 1960; Whitney Museum of American Art, New York, *Fifty California Artists*, 1962-63; Oakland Art Museum, *Contemporary California Sculpture*, 1963; Los Angeles County Museum of Art, and Philadelphia Museum of Art, Pennsylvania, *American Sculpture of the Sixties*, 1967; Stedelijk van Abbemuseum, Eindhoven, The Netherlands, *Kompas 4: Westkust USA*, 1969-70; National Collection of Fine Arts, Smithsonian Institution, Washington, D.C., *Objects: USA*, 1969-71; National Museum of Modern Art, Kyoto, Japan, and National Museum of Modern Art, Tokyo, *Contemporary Ceramic Art: Canada, USA, Mexico and Japan*, 1971-72; Grand Rapids Art Museum, Michigan, *Sculpture Off the Pedestal*, 1973; The Oakland Museum, *Public Sculpture/Urban Environment*, 1974; Whitney Museum of American Art, New York, *200 Years of American Sculpture*, 1976; San Francisco Museum of Modern Art, and National Collection of Fine Arts, Smithsonian Institution, Washington, D.C., *Painting and Sculpture in California: The Modern Era*, 1976-77; Everson Museum of Art, Syracuse, New York, *A Century of Ceramics in the United States, 1878-1978*, 1979-80; Whitney Museum of American Art, New York, and San Francisco Museum of Modern Art, *Ceramic Sculpture: Six Artists*, 1981-82; The Oakland Museum, *100 Years of California Sculpture*, 1982.

FURTHER REFERENCES: Haskell, Barbara. *John Mason Ceramic Sculpture*. Pasadena, California: Pasadena Museum of Modern Art, 1974. Marshall, Richard, and Suzanne Foley. *Ceramic Sculpture: Six Artists*. New York: Whitney Museum of American Art in association with the University of Washington Press, Seattle and London, 1981.

WORKS IN THE COLLECTION:
1 sculpture

This totemic work dates from the 1960s, an era in California when ceramic expression thrust into large-scale sculpture. Mason has combined the austerity of a massive cruciform with the intensity of a brilliant yellow-green glaze to make a statement of powerful spiritual directness.

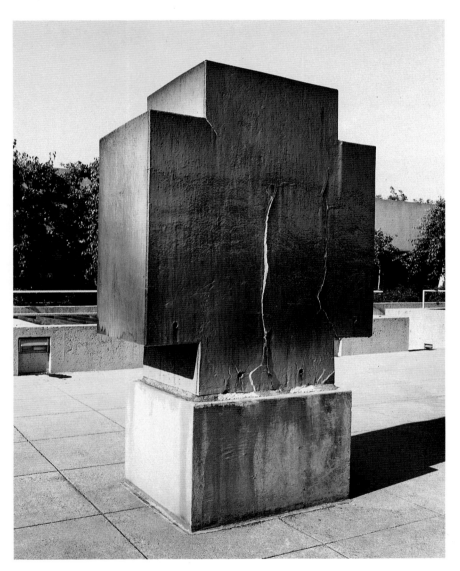

Yellow Cross Form, 1966 (71.96)
Ceramic
63½ × 54½ × 25½ in. (161.3 × 138.4 × 64.8 cm.)
Gift of The Oakland Museum Founders Fund

LARRY BELL

Born December 6, 1939, Chicago, Illinois
In California 1945-73
Lives in Taos, New Mexico

EDUCATION: Chouinard Art Institute, Los Angeles, 1957-59.

SELECTED ONE-ARTIST EXHIBITIONS:
Ferus Gallery, Los Angeles, 1962, 1963, 1965; Pace Gallery, New York, 1965-73; Stedelijk Museum, Amsterdam, 1967; Galerie Ileana Sonnabend, Paris, 1967; Galerie Rudolf Zwirner, Cologne, West Germany, 1970; Pasadena Art Museum, California, 1970; The Oakland Museum, 1973; Marlborough Galleria d'Arte, Rome, 1974-75; Fort Worth Art Museum, Texas, 1975; Santa Barbara Museum of Art, California, 1976; Hansen Fuller Goldeen Gallery, San Francisco, 1979; Janus Gallery, Venice, California, 1979; Hudson River Museum, Yonkers, New York, 1981; Newport Harbor Art Museum, Newport Beach, California, 1982; Museum of Fine Arts, Museum of New Mexico, Santa Fe, 1982.

SELECTED GROUP EXHIBITIONS: Museum of Modern Art, New York, *The Responsive Eye*, 1965; Museo de Arte Moderna, São Paulo, Brazil, *VIII Bienal*, 1965-66; The Jewish Museum, New York, *Primary Structures: Younger American and British Sculptors*, 1966; Los Angeles County Museum of Art, and Philadelphia Museum of Art, Pennsylvania, *American Sculpture of the Sixties*, 1967; Kassel, West Germany, *Documenta 4*, 1968; Stedelijk van Abbemuseum, Eindhoven, The Netherlands, *Kompas 4: Westkust USA*, 1969; Walker Art Center, Minneapolis, Minnesota, *14 Sculptors: The Industrial Edge*, 1969; Tate Gallery, London, *Larry Bell, Robert Irwin, Doug Wheeler*, 1970; Hayward Gallery, London, *11 Los Angeles Artists*, 1971; Seattle Art Museum, Washington, *American Art: Third Quarter Century*, 1973; Whitney Museum of American Art, New York, *Illuminations and Reflections*, 1974, and *200 Years of American Sculpture*, 1976; Hayward Gallery, London, *The Condition of Sculpture*, 1975; San Francisco Museum of Modern Art, and National Collection of Fine Arts, Smithsonian Institution, Washington, D.C., *Painting and Sculpture in California: The Modern Era*, 1976-77; Los Angeles County Museum of Art, and San Antonio Museum of Art, Texas, *Art in Los Angeles: Seventeen Artists in the Sixties*, 1981-82; The Oakland Museum, *100 Years of California Sculpture*, 1982.

FURTHER REFERENCES: Haskell, Barbara. *Larry Bell*. Pasadena, California: Pasadena Art Museum, 1972. Museum of Fine Arts, Museum of New Mexico. *Larry Bell: The Sixties*. Santa Fe, New Mexico, 1982.

WORKS IN THE COLLECTION:
1 sculpture

Bell's glass cube, at once transparent and reflecting, poses contradictions in spatial perception. Minimal in conception and form, the glass box conjures up a lyrical, illusory space for and about the viewer, while remaining a solitary object of beauty.

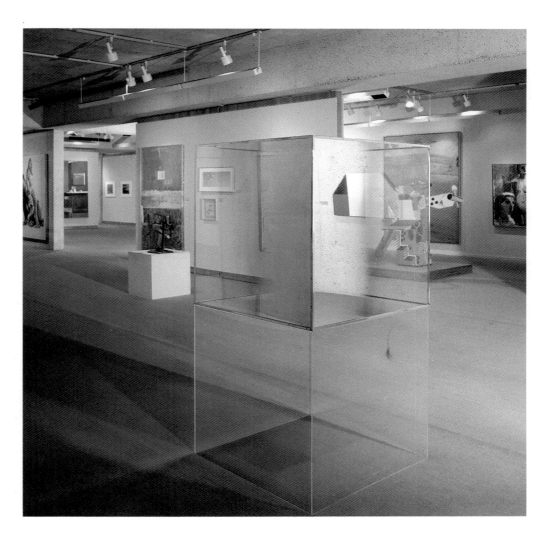

Untitled, 1967 (73.1)
Coated glass, Plexiglas and metal stripping
Top: 36¼ × 36¼ × 36¼ in. (92 × 92 × 92 cm.)
Base: 33¾ × 36 × 36 in. (85.7 × 92 × 92 cm.)
Carl A. Rietz Collection, Courtesy of Concours d'Antiques

JAMES WEEKS

Throughout his career, Weeks painted realistic images, greatly simplified, in strong, dramatic light. In the 1940s, Weeks was one of the few artists associated with the California School of Fine Arts who chose to work in a figurative vein.

Born December 1, 1922, Oakland, California
Left California 1970
Lives in Bedford, Massachusetts

EDUCATION: California School of Fine Arts, San Francisco, 1940-42, 1946-48; Hartwell School of Design, San Francisco, c. 1946-47; Escuela de Pintura y Escultura, Mexico City, 1951.

SELECTED ONE-ARTIST EXHIBITIONS: Lucien Labaudt Art Gallery, San Francisco, 1951; California Palace of the Legion of Honor, San Francisco, 1953; 6 Gallery, San Francisco, 1955; Poindexter Gallery, New York, 1960, 1963, 1965, 1968, 1974; San Francisco Museum of Art, 1965; Boston University Art Gallery, Massachusetts, 1971; Sunne Savage Gallery, Boston, 1976; Charles Campbell Gallery, San Francisco, 1977, 1981; Rose Art Museum, Brandeis University, Waltham, Massachusetts, and The Oakland Museum, 1978.

SELECTED GROUP EXHIBITIONS: Oakland Art Museum, *Contemporary Bay Area Figurative Painting,* 1957-58; Carnegie Institute, Pittsburgh, Pennsylvania, *Pittsburgh International Exhibition of Contemporary Painting and Sculpture,* 1964, 1967; The Oakland Museum, *A Period of Exploration: San Francisco 1945-1950,* 1973; United States Department of the Interior, Washington, D.C., *America 1976,* 1976; San Francisco Museum of Modern Art, and National Collection of Fine Arts, Smithsonian Institution, Washington, D.C., *Painting and Sculpture in California: The Modern Era,* 1976-77.

FURTHER REFERENCES: Rose Art Museum. *James Weeks.* Waltham, Massachusetts: Brandeis University, 1978.

WORKS IN THE COLLECTION:
3 paintings and 1 drawing

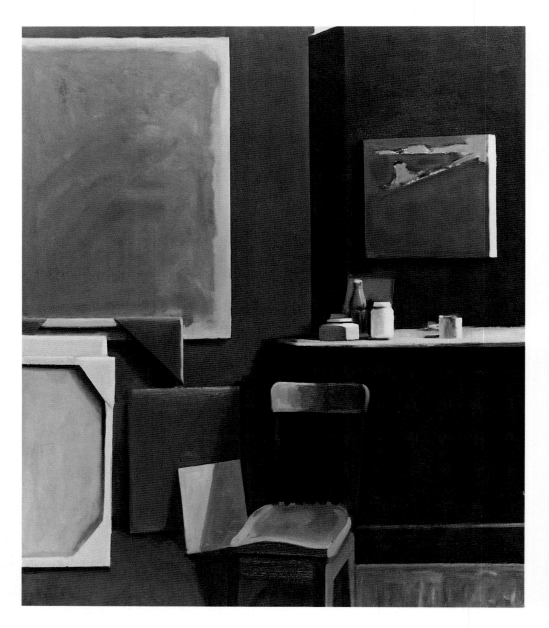

Large Studio, Embarcadero, 1964 (81.1)
Oil and acrylic on canvas
79½ × 65 in. (202 × 165.1 cm.)
Gift of the American Academy and Institute of Arts
and Letters, Hassam and Speicher Purchase Fund

PAUL WONNER

Born April 24, 1920, Tucson, Arizona
To California 1937
Lives in San Francisco, California

EDUCATION: California College of Arts and Crafts, Oakland, 1937-41 (BA); Art Students League, New York, 1947; University of California, Berkeley, 1952 (BA), 1953 (MA), 1955 (MLS).

SELECTED ONE-ARTIST EXHIBITIONS: M. H. de Young Memorial Museum, San Francisco, 1956; Felix Landau Gallery, Los Angeles, 1959, 1960, 1962, 1963, 1964, 1968, 1971; Santa Barbara Museum of Art, California, 1960, 1972; Poindexter Gallery, New York, 1962, 1964, 1971; Waddington Galleries, London, 1965; Landau-Alan Gallery, New York, 1967; Charles Campbell Gallery, San Francisco, 1972, 1974; John Berggruen Gallery, San Francisco, 1978, 1981; James Corcoran Gallery, Los Angeles, 1979, 1980; San Francisco Museum of Modern Art, 1981-82.

SELECTED GROUP EXHIBITIONS: Solomon R. Guggenheim Museum, New York, *Younger American Painters*, 1954; Museu de Arte Moderna, São Paulo, Brazil, *III Bienal*, 1955; Oakland Art Museum, *Contemporary Bay Area Figurative Painting*, 1957-58; Museum of Modern Art, New York, *Recent Painting USA: The Figure*, 1962-63; Carnegie Institute, Pittsburgh, Pennsylvania, *1964 Pittsburgh International Exhibition of Contemporary Painting and Sculpture*, 1964; San Francisco Museum of Modern Art, and National Collection of Fine Arts, Smithsonian Institution, Washington, D.C., *Painting and Sculpture in California: The Modern Era*, 1976-77; Pennsylvania Academy of Fine Arts, Philadelphia, *Contemporary American Realism since 1960*, 1981-82; Rutgers University Art Gallery, New Brunswick, New Jersey, *Realism and Realities: The Other Side of American Painting, 1940-1960*, 1982.

FURTHER REFERENCES: San Francisco Museum of Modern Art. *Paul Wonner: Abstract Realist*. San Francisco, 1981.

WORKS IN THE COLLECTION: 4 paintings, 1 drawing, and 1 watercolor

Though originally part of the Bay Area Figurative movement of the early 1960s, Paul Wonner is now best known for his punctuated placement of objects on tabletops. Jar, Glass, Narcissus is a transitional piece, retaining the more painterly concerns of the Bay Area Figurative tradition, while foretelling the artist's sharpening focus on the individual tabletop object.

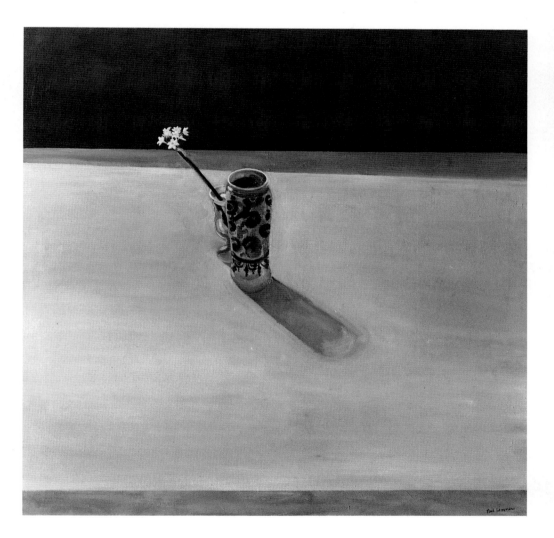

Jar, Glass, Narcissus, 1968 (79.158.8)
Oil on canvas
48 × 48 in. (122 × 122 cm.)
Gift of Mr. and Mrs. Harry W. Anderson

ROBERT ARNESON

Born September 4, 1930, Benicia, California
Lives in Benicia, California

EDUCATION: College of Marin, Kentfield, California, 1949-51; California College of Arts and Crafts, Oakland, 1952-54 (BA); Mills College, Oakland, California, 1958 (MFA).

SELECTED ONE-ARTIST EXHIBITIONS: Oakland Art Museum, 1960 (with Tony DeLap); Richmond Art Center, California, 1963; Allan Stone Gallery, New York, 1964, 1969; San Francisco Museum of Art, 1967; Hansen Fuller Gallery, San Francisco, 1968-77; Museum of Contemporary Art, Chicago, and San Francisco Museum of Art, 1974; Allan Frumkin Gallery, New York, 1975, 1977, 1979, 1981, 1983; Allan Frumkin Gallery, Chicago, 1976, 1978; Moore College of Art, Philadelphia, Pennsylvania, 1979; Hansen Fuller Goldeen Gallery, San Francisco, 1980; Richard L. Nelson Gallery, University of California, Davis, 1982.

SELECTED GROUP EXHIBITIONS: Oakland Art Museum, *Contemporary California Sculpture,* 1963; Museum of Contemporary Crafts, New York, *Creative Casting,* 1963; University Art Museum, Berkeley, California, *Funk,* 1967; Museum of Modern Art, New York, *Dada, Surrealism and Their Heritage,* 1968; National Collection of Fine Arts, Smithsonian Institution, Washington, D.C., *Objects: USA,* 1969-71; Museum of Contemporary Crafts, New York, *Clayworks: 20 Americans,* 1971; National Museum of Modern Art, Kyoto, Japan, and National Museum of Modern Art, Tokyo, *Contemporary Ceramic Art: Canada, USA, Mexico and Japan,* 1971-72; San Francisco Museum of Modern Art, and National Collection of Fine Arts, Smithsonian Institution, Washington, D.C., *Painting and Sculpture in California: The Modern Era,* 1976-77; Everson Museum of Art, Syracuse, New York, *A Century of Ceramics in the United States, 1878-1978,* 1979; Stedelijk Museum, Amsterdam, *West Coast Ceramics,* 1979; Whitney Museum of American Art, New York, and San Francisco Museum of Modern Art, *Ceramic Sculpture: Six Artists,* 1981; American Craft Museum, New York, *The Clay Figure,* 1981.

FURTHER REFERENCES: Moore College of Art. *Robert Arneson: Self-Portraits.* Philadelphia, Pennsylvania, 1979. Prokopoff, Stephen. *Robert Arneson.* Chicago: Museum of Contemporary Art in collaboration with the San Francisco Museum of Art, 1974. Whitney Museum of American Art. *Clay.* New York, 1974.

WORKS IN THE COLLECTION: 7 ceramic pieces, 1 painting, and 1 drawing

Breaking away from traditional ceramics in the 1960s, Arneson's work amused, startled, and sometimes outraged the viewer's sense of propriety. Illustrated here is a sculptural form from the Alice Street *series, in which Arneson depicts his suburban tract home.*

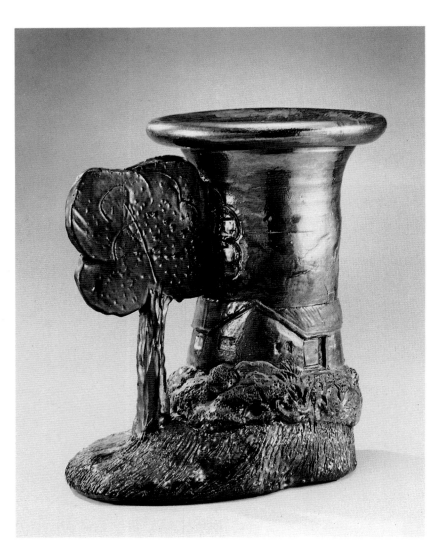

House Pot, 1967 (69.83)
Ceramic with low-fire glazes and lusters
19⅜ × 16 × 11 in. (40.2 × 40.6 × 28 cm.)
Bequest of Dorothea Adams McCoy

EDWARD RUSCHA

Born December 16, 1937, Omaha, Nebraska
To Los Angeles, California 1956
Lives in Los Angeles, California

EDUCATION: Chouinard Art Institute, Los Angeles, 1956-60.

SELECTED ONE-ARTIST EXHIBITIONS: Ferus Gallery, Los Angeles, 1963, 1964, 1965; Alexander Lolas Gallery, New York, 1967; Leo Castelli Gallery, New York, 1973, 1974, 1980, 1981, 1982; John Berggruen Gallery, San Francisco, 1973, 1982; Arts Council of Great Britain, 1975-76; Stedelijk Museum, Amsterdam, 1976; Los Angeles Institute of Contemporary Art, 1976, 1979; Albright-Knox Art Gallery, Buffalo, New York, 1976; San Francisco Museum of Modern Art, 1982-83.

SELECTED GROUP EXHIBITIONS: Oakland Art Museum, *Pop Art USA*, 1963; Solomon R. Guggenheim Museum, New York, *Word and Image*, 1965; Museu de Arte Moderna, São Paulo, Brazil, *IX Bienal*, 1967; Stedelijk van Abbemuseum, Eindhoven, The Netherlands, *Kompas 4: Westkust USA*, 1969-70; Museum of Modern Art, New York, and Museo Nacional de Bellas Artes, Buenos Aires, Argentina, *Tamarind: Homage to Lithography*, 1969; Hayward Gallery, London, *11 Los Angeles Artists*, 1971; Kassel, West Germany, *Documenta 5*, 1972; Whitney Museum of American Art, New York, *American Pop Art*, 1974; San Francisco Museum of Modern Art, and National Collection of Fine Arts, Smithsonian Institution, Washington, D.C., *Painting and Sculpture in California: The Modern Era*, 1976-77; Albright-Knox Art Gallery, Buffalo, New York, *American Painting of the 1970s*, 1978; Museum of Modern Art, New York, *Printed Art/A View of Two Decades*, 1980; Los Angeles County Museum of Art, and San Antonio Museum of Art, Texas, *Art in Los Angeles: Seventeen Artists in the Sixties*, 1981-82.

FURTHER REFERENCES: San Francisco Museum of Modern Art. *The Works of Edward Ruscha*. New York: Hudson Hills Press, 1982.

WORKS IN THE COLLECTION:
1 painting, 1 drawing, and 8 prints

Hollywood, 1968 (69.177)
Serigraph
12½ × 40¾ in. (31.75 × 103.51 cm.) (image)
The Oakland Museum Founders Fund

In this serigraph, Ruscha has transformed an actual sign into a Pop image and symbol by magnifying the scale of the letters in relation to the hills and by silhouetting them against an expansive, lurid sunset.

ARTHUR CARRAWAY

Born April 25, 1927, Fort Worth, Texas
To California 1945
Lives in San Francisco, California

EDUCATION: Academy of Advertising Art, San Francisco, 1947-50; California School of Fine Arts, San Francisco, 1950-53; Institute of African Studies, University of Ghana, Legon, 1971-72.

SELECTED ONE-ARTIST EXHIBITIONS: E. B. Crocker Art Gallery, Sacramento, California, 1958; Bank of America World Headquarters, San Francisco, 1972; Capricon Asunder, San Francisco Art Commission Gallery, 1975 (with Clare Ernst Struble); The Studio Museum in Harlem, New York, 1978; San Jose City Art Gallery, California, 1979; Pro Arts, Oakland, 1983; University Art Museum, Berkeley, California, 1983.

SELECTED GROUP EXHIBITIONS: San Francisco Art Association, 1954-56; Oakland Art Museum at Kaiser Center Gallery, *New Perspectives in Black Art*, 1966; La Jolla Museum of Art, California, *Dimensions of Black*, 1970; New York Cultural Center, New York, *Blacks: USA: 1973*, 1973; Herbert F. Johnson Museum of Art, Cornell University, Ithaca, New York, *Directions in Afro-American Art*, 1974; San Jose Museum of Art, California, *20th Century Black Artists*, 1976; African-American Historical and Cultural Society, San Francisco, *Prints and Drawings 1977*, 1977; Alternative Center for International Arts, New York, *Africa: Emergent Artists, Tribal Roots and Influences*, 1978; Tangeman Fine Arts Gallery, University of Cincinnati, Ohio, *Symbols, Visions and Images*, 1981.

FURTHER REFERENCES: Lewis, Samella S., and Ruth G. Waddy. *Black Artists on Art*. Los Angeles: Contemporary Craft Publishers, 1969, Vol. I, pp. 5-6.

WORKS IN THE COLLECTION: 1 painting

Since the 1960s, Carraway has incorporated images inspired by African art into his work. The artist deals with motifs of myth and magic through a vocabulary of loosely brushed shapes and forms depicted in muted colors.

Fetish Form—Series II, 1968 (69.6)
Oil on canvas
49¾ × 30 in. (126.3 × 76.2 cm.)
Gift of the Art Guild of the Oakland Museum Association

CHARLES WHITE

Born April 2, 1918, Chicago, Illinois
To Los Angeles, California 1956
Died October 3, 1979, Los Angeles, California

EDUCATION: School of the Art Institute of Chicago, 1937-39; Art Students League, New York, 1942-43; Taller de Grafica, Mexico, 1946-47.

SELECTED ONE-ARTIST EXHIBITIONS: Barnett-Aden Gallery, Washington, D.C., 1947; ACA Gallery, New York, 1947-65; University of Southern California, Los Angeles, 1958; Heritage Gallery, Los Angeles, 1964-82; Howard University, Washington, D.C., 1967; Forum Gallery, New York, 1970, 1976; James Willis Gallery, San Francisco, 1975; High Museum of Art, Atlanta, Georgia, 1976-77.

SELECTED GROUP EXHIBITIONS: UCLA Art Galleries, University of California, Los Angeles, *The Negro in American Art*, 1967; Oakland Art Museum at Kaiser Center Gallery, *New Perspectives in Black Art*, 1968; Whitney Museum of American Art, New York, *Contemporary Black Artists in America*, 1971; E. B. Crocker Art Gallery, Sacramento, California, *West Coast 74: The Black Image*, 1974; Los Angeles County Museum of Art, *Two Centuries of Black American Art*, 1976-77, and *Los Angeles Prints, 1883-1980*, 1980-81.

FURTHER REFERENCES: Los Angeles County Museum of Art. *Two Centuries of Black American Art*. New York: Alfred A. Knopf, 1976, pp. 77-79, 110, 177, 188-89. "Charles White: Art and Soul." Entire issue of *Freedomways*, Vol. 20, No. 3 (1980).

WORKS IN THE COLLECTION: 1 drawing

Silent Song, 1968 (68.57)
Charcoal on cardboard
43 × 70 in. (109.22 × 177.8 cm.)
The Oakland Museum Founders Fund

This large-scale charcoal drawing, entitled Silent Song, *is a poignant portrait of a young black child, seemingly in the presence of a higher power. It is characteristic of the masterful, humanistic portraits that have established White's reputation as a leading black American artist.*

SAM MALOOF

Born January 24, 1916, Chino, California
Lives in Alta Loma, California

EDUCATION: Worked as an architectural draftsman, graphic artist, and industrial designer before concentrating on woodworking and furniture design.

SELECTED ONE-ARTIST EXHIBITIONS: Oakland Art Museum, 1958; Long Beach Museum of Art, California, 1970; Edward-Dean Museum of Decorative Arts, Cherry Valley, California, 1971; Contemporary Crafts Gallery, Portland, Oregon, 1977.

SELECTED GROUP EXHIBITIONS: Pasadena Art Museum, California, *California Design/One-Eleven*, 1954-71; Municipal Art Center, Long Beach, California, and Oakland Art Museum, *California Designed*, 1956; Museum of Contemporary Crafts, New York, *Furniture by Craftsmen*, 1957, and *Designer-Craftsmen USA 1960*, 1960; National Collection of Fine Arts, Smithsonian Institution, Washington, D.C., *Objects: USA*, 1969-71; Renwick Gallery, National Collection of Fine Arts, Smithsonian Institution, Washington, D.C., and Minnesota Museum of Art, St. Paul, *Woodenworks*, 1972; Museum of Contemporary Art, Chicago, *American Crafts '76*, 1976; American Craft Museum, New York, *New Handmade Furniture*, 1979; The Oakland Museum, *California Woodworking*, 1980.

FURTHER REFERENCES: Renwick Gallery. *Woodenworks*. Washington, D.C.: National Collection of Fine Arts, Smithsonian Institution, 1972.

WORKS IN THE COLLECTION: 1 settee

A major figure in the field of post-World War II American handcrafted furniture, Sam Maloof has created timeless designs that are classics of the modern idiom. His careful attention to structural articulation and elegant simplicity are illustrated here.

Settee, 1969 (69.101)
Walnut with leather seats
30½ × 39½ × 20¼ in. (77.8 × 100.3 × 51.4 cm.)
Bequest of Dorothea Adams McCoy

JUNE SCHWARCZ

Born June 10, 1918, Denver, Colorado
To California 1954
Lives in Sausalito, California

EDUCATION: University of Colorado, Denver, 1936-38; University of Chicago, 1938-39; Pratt Institute, Brooklyn, New York, 1939-41.

SELECTED ONE-ARTIST EXHIBITIONS: La Jolla Art Center, California, 1957; M. H. de Young Memorial Museum, San Francisco, 1964 (with Trude Guermonprez); Museum of Contemporary Crafts, New York, 1965; University of California, Davis, 1967; Temple Emanu-El, San Francisco, 1967; Anneberg Gallery, San Francisco, 1974; University of North Dakota, Grand Forks, 1976.

SELECTED GROUP EXHIBITIONS: Museum of Contemporary Crafts, New York, *Craftsmanship in a Changing World*, 1956; Richmond Art Center, California, *Designer-Craftsmen Exhibitions*, 1955, 1959-61; Museum of Contemporary Crafts, New York, *Enamels*, 1959; Oakland Art Museum, *First and Second California Craftsmen's Biennials*, 1961, 1963; Pasadena Art Museum, California, *California Design/Eight-Eleven*, 1962, 1965, 1968, 1971; National Collection of Fine Arts, Smithsonian Institution, Washington, D.C., *Objects: USA*, 1969-71; The Oakland Museum, *The Metal Experience*, 1971; Renwick Gallery, National Collection of Fine Arts, Smithsonian Institution, Washington, D.C., *The Goldsmith*, 1974; Limoges, France, *International Biennial Exhibitions—The Art of Enamel*, 1975, 1978, 1982; Coburg Fine Arts Society, Coburg, Germany, *International Enamel Exhibition*, 1981; Craft and Folk Art Museum, Los Angeles, *Enamelists Vera Ronnen-Wall, June Schwarcz, William Harper*, 1982.

FURTHER REFERENCES: Save, Colette (from an interview with June Schwarcz, Sausalito, California, n.d.). "Les Reliefs du Bain" (The Imprints of the Bath). Paris, France: *L'Atelier* 70, July–September 1982, pp. 18-19.

WORKS IN THE COLLECTION: 2 enamels on copper

The work of nationally recognized enamelist, June Schwarcz, is illustrated here by this electroformed copper bowl in which she combines a new metal-forming method with the traditional enameling technique of plique-a-jour.

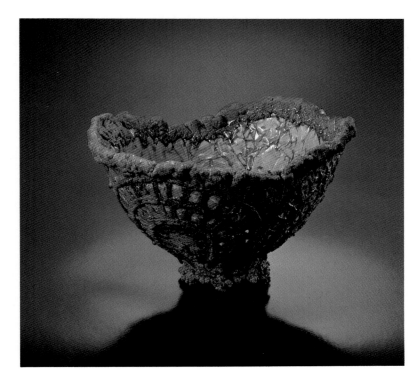

Bowl, n.d. (69.79)
Electroformed copper, iron, and enamel
Height: 4⅛ in. (10.5 cm.)
Diameter: 8 in. (20.3 cm.)
Bequest of Dorothea Adams McCoy

TRUDE GUERMONPREZ

Born November 9, 1910, Danzig, Germany
To California 1949
Died May 8, 1976, San Francisco, California

EDUCATION: School of Art, Cologne, Germany, 1930-31; School of Fine and Applied Arts, Halle/Saale, Germany, 1931-33 (Diploma of Arts); Textile Engineering School, Berlin, 1933; studied Scandinavian weaving techniques, Helsinki & Hämeenlinna, Finland, 1937; studied Swedish weaving institutions, Stockholm & Insjön, Sweden, 1946.

SELECTED ONE-ARTIST EXHIBITIONS: M. H. de Young Memorial Museum, San Francisco, 1964, 1971; Galeria del Sol, Santa Barbara, California, 1970; Gallery Tom Thomason, Albuquerque, New Mexico, 1971; Art Center, Bergen, The Netherlands, 1972; Center of Performing Arts, Tiburg, The Netherlands, 1972; Anneberg Gallery, San Francisco, 1974; University Art Museum, Iowa City, Iowa, 1975; The Oakland Museum, 1982.

SELECTED GROUP EXHIBITIONS: M. H. de Young Memorial Museum, San Francisco, *Designer-Craftsmen of the West*, 1957; Museum of Contemporary Crafts, New York, *Wall Hangings and Rugs*, 1958; American Pavilion, Brussels International Exposition, 1958; Cleveland Institute of Art, Ohio, *Contemporary Weaving*, 1960; Museum of Contemporary Crafts, New York, and Philadelphia Museum College of Art, Pennsylvania, *Fabrics International*, 1961; Oakland Art Museum, *First and Second California Craftsmen's Biennials*, 1961, 1963; Victoria and Albert Museum, London, *Modern American Wall Hangings*, 1962; Pasadena Art Museum, California, *California Design/Eight-Nine*, 1962, 1965; National Collection of Fine Arts, Smithsonian Institution, Washington, D.C., *Objects: USA*, 1969-71; Katonah Gallery, Katonah, New York, *Woven Hangings— Pliable Planes*, 1970; University of Texas, Austin, *7 Weavers*, 1974.

FURTHER REFERENCES: The Oakland Museum. *The Tapestries of Trude Guermonprez.* Oakland, 1982.

WORKS IN THE COLLECTION: 2 tapestries

An incomparable teacher, Guermonprez introduced Bauhaus concepts of structural weaving and design that inspired countless students to go beyond technique alone. She continued to find self-portraiture and personal narrative a fertile subject for her pictorial textile graphics of the 1970s. In the work illustrated here, she combines repetition of personal image with subtle gradation of tones.

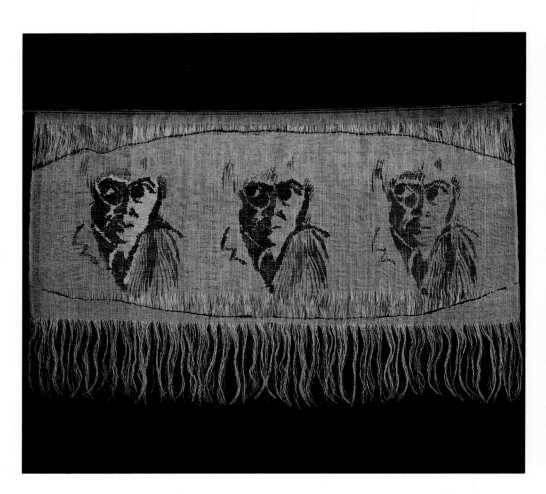

Family Portrait, c. 1969-70 (77.129)
Warp-faced tapestry, linen with wool and rayon
32 × 50½ in. (81.5 × 128.3 cm.)
Museum Donors' Acquisition Fund

RUPERT GARCIA

Born September 29, 1941, French Camp, California
Lives in Oakland, California

EDUCATION: San Francisco State College, 1968
(BA), 1970 (MA); University of California, Berkeley,
1973-75 (advanced studies).

SELECTED ONE-ARTIST EXHIBITIONS:
The Oakland Museum, 1970; Center for Chicano
Studies, University of California, Santa Barbara, 1972;
St. Mary's College, Moraga, California, 1972; Uni-
versidad de Sonora, Hermosillo, Mexico, 1972; San
Francisco Museum of Modern Art, 1978; Mexican
Museum, San Francisco, 1981; University Press
Books, Berkeley, California, 1983.

SELECTED GROUP EXHIBITIONS: San
Francisco Museum of Art, *Posters and Society*, 1974;
Galeria de la Raza, San Francisco, and Jackson Street
Gallery, San Francisco, *Garcia y Fuentas*, 1975; The
Oakland Museum, *Prints California*, 1975; National
Collection of Fine Arts, Smithsonian Institution,
Washington, D.C., *Images of an Era: The American
Poster 1945-75*, 1975-76; San Francisco Art Institute,
Other Sources: An American Essay, 1976; Tucson
Museum of Art, Arizona, *Raices Antiguas/Visiones
Nuevas*, 1977-78; Mexican Museum, San Francisco,
*Mexican American Artists of the San Francisco Bay
Area*, 1978; Fondo del Sol, Washington, D.C., *Califas:
Works on Paper*, 1982; Laguna Beach Museum of
Art, California, *California: Art on the Road*, 1982;
Staatliche Kunsthalle, West Berlin, *Das Andere Amer-
ika*, 1983.

FURTHER REFERENCES: San Francisco Mu-
seum of Modern Art. *Rupert Garcia/Pastel Drawings.*
San Francisco, 1978.

WORKS IN THE COLLECTION: 1 drawing
and 6 prints

*Garcia's sense of social purpose in art shows him
to be an artistic descendant of the Mexican mural
and poster painters. In this brilliantly colored
silkscreen print, Garcia presents the Mayan as a
symbol of the strength and character of native
American people.*

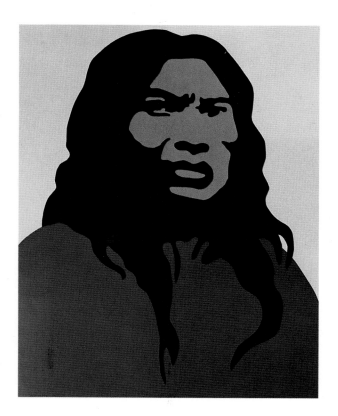

Mayan, 1970 (72.66.1)
Silkscreen on paper
24½ × 18¾ in. (62.2 × 47.6 cm.) (image)
The Oakland Museum Founders Fund

MEL RAMOS

Born July 24, 1935, Sacramento, California
Lives in Oakland, California

EDUCATION: Sacramento Junior College, California, 1953-54; San Jose State College, California, 1954-55; Sacramento State College, California, 1955-57 (BA), 1958 (MA).

SELECTED ONE-ARTIST EXHIBITIONS: Bianchini Gallery, New York, 1964, 1965; David Stuart Galleries, Los Angeles, 1965, 1967, 1968, 1969, 1974, 1976; San Francisco Museum of Art, 1967; Reese Palley Gallery, San Francisco, 1969; Galerie Bruno Bischofberger, Zurich, Switzerland, 1971; Louis K. Meisel Gallery, New York, 1974, 1976, 1977, 1981; The Oakland Museum, 1977; Rose Art Museum, Brandeis University, Waltham, Massachusetts, 1980; Modernism, San Francisco, 1981; Malinda Wyatt Gallery, Venice, California, 1982.

SELECTED GROUP EXHIBITIONS: Oakland Art Museum, *Pop Art USA*, 1963; Akademie Der Kunst, Berlin, Germany, *Neue Realisten und Pop Art*, 1965; Hayward Gallery, London, *Pop Art*, 1969; Whitney Museum of American Art, New York, *American Pop Art*, 1974; San Francisco Museum of Modern Art, and National Collection of Fine Arts, Smithsonian Institution, Washington, D.C., *Painting and Sculpture in California: The Modern Era*, 1976-77; de Saisset Museum, University of Santa Clara, California, *Northern California Art of the Sixties*, 1982.

FURTHER REFERENCES: Claridge, Elizabeth. *The Girls of Mel Ramos*. Chicago: Playboy Press, 1975. Jones, Harvey L. *Mel Ramos: Paintings 1959-1977*. Oakland: The Oakland Museum, 1977. Rose Art Museum. *Mel Ramos: A Twenty-Year Survey*. Waltham, Massachusetts: Brandeis University, 1980.

WORKS IN THE COLLECTION:
2 paintings

In Browned Bare, *Ramos combines blatant Pop California images with the immortal theme of beauty and the beast. The artist both celebrates and satirizes popular culture while leaving room for an old-fashioned belly laugh.*

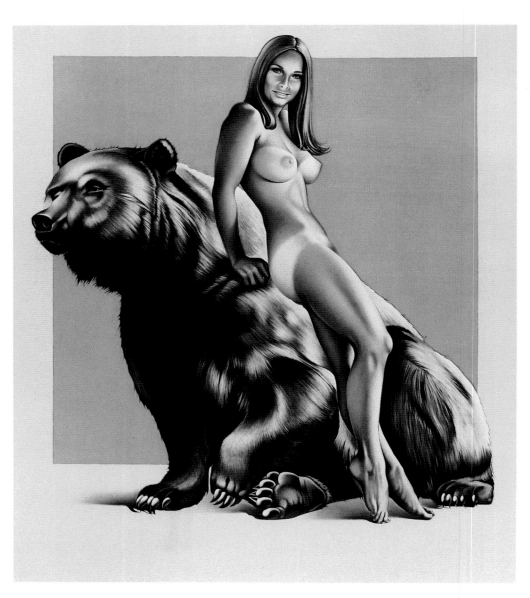

Browned Bare, 1970-71 (71.15)
Oil on canvas
82⅝ × 70⅝ in. (209.9 × 179.4 cm.)
The Oakland Museum Founders Fund

JUDY DATER

Born June 21, 1941, Hollywood, California
Lives in San Anselmo, California

EDUCATION: California State University, San Francisco, 1963 (BA), 1966 (MA); University of California, Los Angeles, 1959-62.

SELECTED ONE-ARTIST EXHIBITIONS: Aardvark Gallery, San Francisco, California, 1965; School of the Art Institute of Chicago, 1972; Studio Gallery, Bolinas, California, 1972; Witkin Gallery, New York, 1972, 1978; The Oakland Museum, 1975; Silver Image Gallery, Tacoma, Washington, 1975; Grapestake Gallery, San Francisco, 1977; Susan Spiritus Gallery, Newport Beach, California, 1977; G. Ray Hawkins Gallery, Los Angeles, California, 1979; Yuen Lui Gallery, Seattle, Washington, 1979, 1982; Contemporary Arts Center, New Orleans, Louisiana, 1979; Camera Obscura Gallery, Denver, Colorado, 1981; Burton Gallery, Toronto, Canada, 1982; Catskill Center for Photography, Woodstock, New York, 1982; Victor Hasselblad Aktiebolag Gallery, Göteborg, Sweden, 1983; The Photographic Center, Dallas, Texas, 1983.

SELECTED GROUP EXHIBITIONS: Massachusetts Institute of Technology, Cambridge, *Light 7*, 1967; International Museum of Photography, George Eastman House, Rochester, New York, *Vision and Expression*, 1968; San Francisco Museum of Art, *Bishop, Dater, Dilley, Rice and Wier: Photographs*, 1969; Friends of Photography, Carmel, California, 1969, 1972, 1975; Pasadena Art Museum, California, *California Photographers*, 1970; The Oakland Museum, *Portfolios and Series*, 1972; International Museum of Photography, George Eastman House, New York, *Sixties Continuum*, 1973; Musée Réattu, Arles, France, 1973; Museum of Fine Arts, Boston, Massachusetts, *Private Realities*, 1974; Whitney Museum of American Art, New York, *Photography in America*, 1974; San Francisco Museum of Art, *Women of Photography*, 1975; United States Information Service, *Five Women Photographers*, 1975 (traveled to Germany and Italy); Philadelphia Museum of Art, Pennsylvania, *American Family Portraits*, 1976; Lyman Allyn Museum, New London, Connecticut, *Remarkable American Women*, 1976; Los Angeles County Museum of Art, *Women in Art 1550-1950*, 1976; Museum of Modern Art, New York, *Mirrors and Windows*, 1978; Boise Gallery of Art, Idaho, *The Arranged Image*, 1983; The Port of History Museum at Penn's Landing, Philadelphia, Pennsylvania, *Printed by Women: A National Exhibition of Photographs and Prints*, 1983.

FURTHER REFERENCES: Markowski, Gene. *The Art of Photography: Image and Illusion*. New Jersey: Prentice Hall, 1983, pp. 82-83, 102-3. Witkin, Lee D., and Barbara London. *The Photograph Collector's Guide*. Boston: New York Graphic Society, 1979, pp. 119-20, 302-07.

WORKS IN THE COLLECTION:
8 photographic prints

In her portraits, Dater pushes her images beyond simple likeness to give visual clues to the way her subjects feel about themselves and their surroundings. Here, in Mother and Daughters, Beverly Hills, *she has made psychological relationships central.*

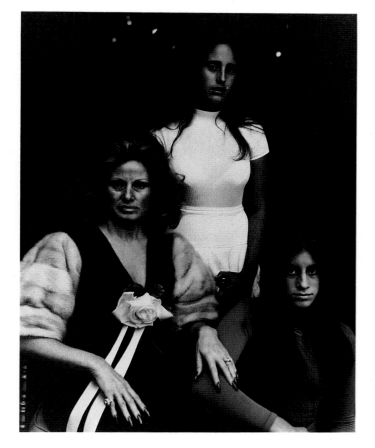

Mother and Daughters, Beverly Hills, 1972 (74.80.2)
Gelatin silver print
9⅜ × 7¼ in. (23.81 × 18.42 cm.)
Dorothea Lange Purchase Award

RONALD DAVIS

Born June 29, 1937, Santa Monica, California
Lives in Malibu, California

EDUCATION: University of Wyoming, Laramie, 1955-56 (Engineering); San Francisco Art Institute, 1960-64; studied with Philip Guston, Yale-Norfolk School of Music and Art, Norfolk, Connecticut, summer 1962.

SELECTED ONE-ARTIST EXHIBITIONS: Nicholas Wilder Gallery, Los Angeles, 1965, 1967, 1969, 1973, 1977, 1979; Tibor de Nagy Gallery, New York, 1966; Leo Castelli Gallery, New York, 1968, 1969, 1971, 1974, 1975; Kasmin Gallery, London, 1968, 1971; Pasadena Art Museum, California, 1971; David Mirvish Gallery, Toronto, 1971, 1975; John Berggruen Gallery, San Francisco, 1973, 1975, 1978, 1980, 1982; The Oakland Museum, 1976; San Diego State University, California, 1980; Blum-Helman Gallery, New York, 1981; Asher/Faure Gallery, Los Angeles, 1982.

SELECTED GROUP EXHIBITIONS: Ciudad Universitaria, Cordoba, Argentina, *II Bienal Americana de Arte*, 1964; Washington Gallery of Modern Art, Washington, D.C., *A New Aesthetic*, 1967; Kassel, Germany, *Documenta 4*, 1968; Museum of Contemporary Art, Chicago, *Permutations: Light and Color*, 1970; Kunstverein, Hamburg, West Germany, *USA West Coast*, 1972; Detroit Institute of Arts, Michigan, *Art in Space: Some Turning Points*, 1973; Museum of Modern Art, New York, and Museo de Arte Moderno, Bogotá, Colombia, *Color*, 1975; San Francisco Museum of Modern Art, and National Collection of Fine Arts, Smithsonian Institution, Washington, D.C., *Painting and Sculpture in California: The Modern Era*, 1976-77; Albright-Knox Art Gallery, Buffalo, New York, *American Painting of the 1970s*, 1979-80; Denver Art Museum, Colorado, and University Art Galleries, University of Southern California, Los Angeles, *Reality of Illusion*, 1979-80; Los Angeles County Museum of Art, and San Antonio Museum of Art, Texas, *Art in Los Angeles: Seventeen Artists in the Sixties*, 1981-82.

FURTHER REFERENCES: The Oakland Museum. *Ronald Davis: Paintings 1962-1976*. Oakland, 1976.

WORKS IN THE COLLECTION:
3 paintings

Left Lean, 1971 (71.82)
Polyester resin with fiberglass
50 × 132½ in. (127 × 336.6 cm.)
The Oakland Museum Founders Fund

In this painting Davis has substituted fiberglass and pigmented polyester resin for traditional paint on canvas to achieve a unity of painting and ground. Pictorially, the arrangement of overlapping flat planes creates a three-dimensional illusion in perspective that is further activated by the literal shape of the two-dimensional surface.

STEPHEN DE STAEBLER

Born March 24, 1933, St. Louis, Missouri
To California 1957
Lives in Berkeley, California

EDUCATION: Black Mountain College, Black
Mountain, North Carolina, 1951 (summer); Princeton
University, New Jersey, 1950-54 (AB, Religion); University
of California, Berkeley, 1958-61 (MA, Sculpture).

SELECTED ONE-ARTIST EXHIBITIONS:
The Oakland Museum, 1974; James Willis Gallery,
San Francisco, 1977, 1978, 1979; Sheehan Gallery,
Whitman College, Walla Walla, Washington, 1981;
Hansen Fuller Goldeen Gallery, San Francisco, 1981;
Fuller Goldeen Gallery, San Francisco, 1982; Tortue
Gallery, Santa Monica, California, 1982; John Berggruen
Gallery, San Francisco, 1982; Charles H. Scott
Gallery, Emily Carr College of Art, Vancouver, British
Columbia, 1983.

SELECTED GROUP EXHIBITIONS: Oakland
Art Museum, *Contemporary California Sculpture*,
1963; Musée d'Art Moderne, Paris, *Troisième
Biennale de Paris*, 1963; Museum of Contemporary
Crafts, New York, *Creative Casting*, 1963; National
Collection of Fine Arts, Smithsonian Institution,
Washington, D.C., *Objects: USA*, 1969-70; The Oakland
Museum, *Public Sculpture/Urban Environment*,
1974; Museum of Contemporary Art, Chicago, *American
Crafts '76*, 1976; Indianapolis Museum of Art,
Indiana, *Perceptions of the Spirit in Twentieth-Century
American Art*, 1977-78; Everson Museum of Art,
Syracuse, New York, *A Century of Ceramics in the
United States, 1878-1978*, 1979-80; Pennsylvania
Academy of the Fine Arts, Philadelphia, *Seven on the
Figure*, 1979; San Francisco Museum of Modern Art,
20 American Artists, 1980; American Craft Museum,
New York, *The Clay Figure*, 1981; The Oakland Museum,
100 Years of California Sculpture, 1982; Museum
of Fine Arts, Boston, *Directions in Contemporary
American Ceramics*, 1984.

PUBLIC WORKS: Sanctuary, Holy Spirit Chapel,
Newman Hall, Berkeley, California, 1967; Water
Sculpture, Bay Area Rapid Transit Station, Concord,
California, 1970-72; *Wall Canyon*, Bay Area Rapid
Transit Station, Embarcadero, San Francisco, 1975-76.

FURTHER REFERENCES: Emily Carr College
of Art and Design, and The Art Museum Association
of America. *Stephen De Staebler*. Vancouver,
British Columbia, and San Francisco, 1983. Jones,
Harvey L. *Stephen De Staebler, Sculpture*. Oakland:
The Oakland Museum, 1974.

WORKS IN THE COLLECTION:
4 sculptures

*De Staebler's work in fired clay, Moab II, emerges
much like natural landforms from the surrounding
grass of the museum courtyard. Though restrained
in profile, Moab II is compelling in its intense,
subliminal energy and in its allusions to the ageless
land.*

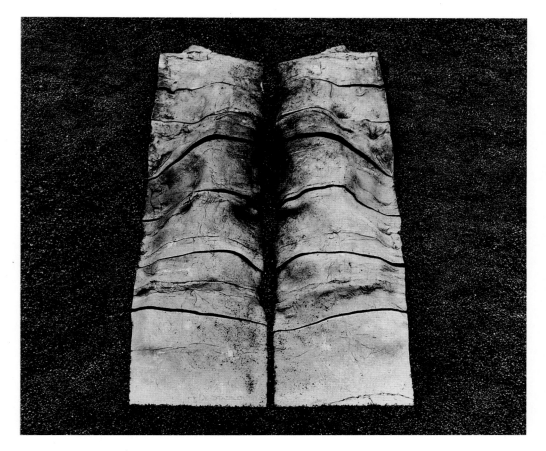

Moab II, 1972 (73.88)
Fired clay
1 ft. 4½ in. × 13 ft. 6 in. × 7 ft. 6 in. (41.9 × 411.5
× 228.6 cm.)
Gift of the Art Guild of the Oakland Museum Association
in honor of George W. Neubert

MARK DI SUVERO

Born September 18, 1933, Shanghai, China
To California 1941
Lives in Petaluma, California, and New York, New
York

EDUCATION: San Francisco City College, 1953-
54; University of California, Santa Barbara, 1954-55;
University of California, Berkeley, 1956 (BA, Philos-
ophy).

SELECTED ONE-ARTIST EXHIBITIONS:
Green Gallery, New York, 1960; Dwan Gallery, Los
Angeles, 1965; Park Place Gallery, New York, 1966,
1967; LoGiudice Gallery, Chicago, 1968; Stedelijk
van Abbemuseum, Eindhoven, The Netherlands,
1972; Wilhelm-Lehmbrück-Museum, Duisburg, West
Germany, 1972; La Ville de Chalon-sur-Saône, France,
1972-74; Le Jardin des Tuileries, Paris, 1975; Whitney
Museum of American Art, New York, 1975; Hansen
Fuller Gallery, San Francisco, 1976 (with Richard
Smith), 1977 (with Philip Makanna); Hansen Fuller
Goldeen Gallery, San Francisco, 1979 (with William
Wareham); Janie C. Lee Gallery, Houston, Texas,
1978; ConStruct, Chicago, 1979; Ace Gallery, Los
Angeles, 1980; Oil & Steel Gallery, New York, 1983;
John Berggruen Gallery, San Francisco, 1983.

SELECTED GROUP EXHIBITIONS: The
Jewish Museum, New York, *Recent American Sculp-
ture*, 1964; Musée Rodin, Paris, *Contemporary
American Sculpture*, 1965; Los Angeles County Mu-
seum of Art, and Philadelphia Museum of Art, Penn-
sylvania, *American Sculpture of the Sixties*, 1967;
Kassel, West Germany, *Documenta 4*, 1968; Grand
Rapids Art Museum, Michigan, *Sculpture Off the
Pedestal*, 1973; Seattle Art Museum, Washington,
American Art: Third Quarter Century, 1973; The
Oakland Museum, *Public Sculpture/Urban Environ-
ment*, 1974; Whitney Museum of American Art, New
York, *200 Years of American Sculpture*, 1976; The
Oakland Museum, *100 Years of California Sculpture*,
1982; San Francisco Museum of Modern Art, *20
American Artists: Sculpture 1982*, 1982.

FURTHER REFERENCES: Monte, James K.
Mark di Suvero. New York: Whitney Museum of
American Art, 1975.

WORKS IN THE COLLECTION:
1 sculpture and memorabilia

*Mark di Suvero has used industrial materials in
their raw, unadorned state in this monumental
outdoor sculpture,* Homage to Charlie Parker, *which
is displayed at Oakland's Estuary Park adjacent
to the museum. With an economy of means, the
artist creates a powerful, aggressive sculptural
statement.*

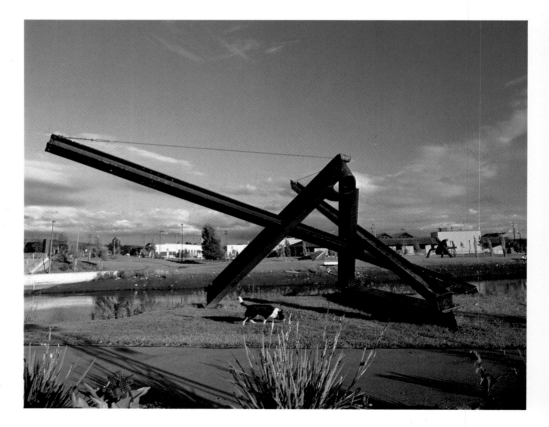

Homage to Charlie Parker, 1970s (78.220)
Steel, 13 ft. 3 in. × 35 ft. 8 in. × 21 ft.
(40.39 × 108.7 × 64 cm.)
Gift of Mark di Suvero, the Women's Board of the
Oakland Museum Association, and the
National Endowment for the Arts

170

FLETCHER BENTON

Born February 25, 1931, Jackson, Ohio
Lives in San Francisco

EDUCATION: Miami University, Oxford, Ohio, 1956 (BFA).

SELECTED ONE-ARTIST EXHIBITIONS: California Palace of the Legion of Honor, San Francisco, 1964; Hansen Galleries, San Francisco, 1965, 1966; San Francisco Museum of Art, 1965, 1970; Esther Robles Gallery, Los Angeles, 1966; San Francisco Art Institute, 1967; Galeria Bonino, Ltd., New York, 1968, 1969; Galerie Françoise Mayer, Brussels, Belgium, 1969; Albright-Knox Art Gallery, Buffalo, New York, 1970; La Jolla Museum of Contemporary Art, California, 1972; Phoenix Art Museum, Arizona, 1973; John Berggruen Gallery, San Francisco, 1977, 1980, 1981; Milwaukee Art Center, Wisconsin, 1979-80; Newport Harbor Art Museum, Newport Beach, California, 1980; Klingspor Museum, Offenbach, West Germany, 1981; San Jose Museum of Art, California, 1982.

SELECTED GROUP EXHIBITIONS: San Francisco Art Institute, *Polychrome Sculpture*, 1964; University Art Museum, Berkeley, California, *Directions in Kinetic Sculpture*, 1966; Whitney Museum of American Art, New York, 1966, 1968, 1973; Los Angeles County Museum of Art, and Philadelphia Museum of Art, Pennsylvania, *American Sculpture of the Sixties*, 1967; University of California, Los Angeles, *Electric Art*, 1969; Hayward Gallery, London, *Kinetics*, 1970; Hudson River Museum, Yonkers, New York, *Kinetic Art*, 1971; Denver Art Museum, Colorado, *Constructivist American Art*, 1971; The Oakland Museum, *Public Sculpture/Urban Environment*, 1974; San Francisco Museum of Modern Art, and National Collection of Fine Arts, Smithsonian Institution, Washington, D.C., *Painting and Sculpture in California: The Modern Era*, 1976-77; Crocker Art Museum, Sacramento, California, *Aspects of Abstract*, 1979; The Oakland Museum, *100 Years of California Sculpture*, 1982; San Francisco Museum of Modern Art, *20 American Artists: Sculpture 1982*, 1982.

FURTHER REFERENCES: *Fletcher Benton: New Sculpture*. Ed. Gerald Nordland. San Francisco: John Berggruen Gallery in association with the Milwaukee Art Center, Wisconsin, 1979. San Jose Museum of Art. *Fletcher Benton*. San Jose, California, 1982.

WORKS IN THE COLLECTION:
5 sculptures and 1 drawing

The monumental "M" of 1974 from Fletcher Benton's Alphabet Series represents an important period of transition in the artist's work. Elements of his kinetic painting concepts are retained within the context of a sculptural statement based on a three-dimensional alphabetical character. The tilted placement of the M achieves a dynamic balance that belies the weight of the piece and further abstracts its form.

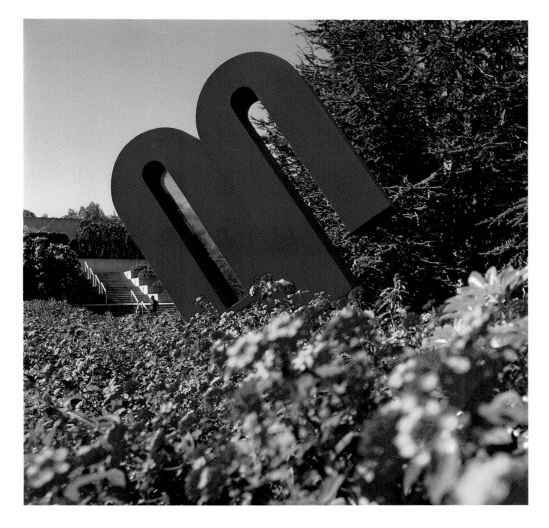

M, 1974 (75.36)
Aluminum and Plexiglas
7½ × 12 ft. (228.6 × 365.76 cm.)
Gift of Dr. and Mrs. A. H. Ellenberg

RAYMOND SAUNDERS

Born October 28, 1934, Pittsburgh, Pennsylvania
To Oakland, California 1960
Lives in Oakland, California

EDUCATION: Carnegie Institute of Technology, Pittsburgh, Pennsylvania, 1950-53, 1959-60 (BFA); Pennsylvania Academy of the Fine Arts, Philadelphia, 1953-57; University of Pennsylvania, Philadelphia, 1954-57; The Barnes Foundation, Merion, Pennsylvania, 1953-55; California College of Arts and Crafts, Oakland, 1960-61 (MFA).

SELECTED ONE-ARTIST EXHIBITIONS: Terry Dintenfass Gallery, New York, 1962-75; San Francisco Museum of Art, 1971; University Art Museum, Berkeley, California, 1976; Smith Andersen Gallery, San Francisco, 1976; Mythology Gallery, New York, 1978; Stephen Wirtz Gallery, San Francisco, 1979, 1980, 1982, 1983; Mythology and Hunter Gallery, New York, 1981; Seattle Art Museum, Washington, 1981; Hunsaker/Schlesinger Gallery, Los Angeles, 1983.

SELECTED GROUP EXHIBITIONS: UCLA Art Galleries, University of California, Los Angeles, *The Negro in American Art*, 1966-67; Philadelphia Museum of Art, Pennsylvania, *Afro-American Artists (1800-1969)*, 1969; Whitney Museum of American Art, New York, *Contemporary Black Artists in America*, 1971; The Oakland Museum, *Five Oakland Artists*, 1974; Cranbrook Academy of Art, Bloomfield Hills, Michigan, *Drawings by Contemporary American Artists*, 1975; San Francisco Museum of Modern Art, *Aesthetics of Graffiti*, 1978; Crocker Art Museum, Sacramento, California, *Aspects of Abstract*, 1979; Municipal Art Gallery, Los Angeles, *Afro-American Abstraction*, 1982; Corcoran Gallery of Art, Washington, D.C., *Second Western States Exhibition/The 38th Corcoran Biennial Exhibition of American Painting*, 1983-84.

FURTHER REFERENCES: Cederholm, Theresa Dickason. *Afro-American Artists*. Boston: Trustees of the Boston Public Library, 1973. Cummings, Paul. *Dictionary of Contemporary American Artists*. 3rd ed. New York: St. Martin's Press, 1977. Shere, Charles. "Wirtz Gallery Exhibits Art of Lyric Optimism." *Oakland Tribune*, May 27, 1983.

WORKS IN THE COLLECTION: 1 painting

Saunders has drawn both literally and metaphorically from his personal experiences as a black American to create 125th Street. The artist incorporates found objects, written words, and universal symbols such as a heart and a cross, into a collaged painting that is both intimate and expansive.

125th Street, 1973 (73.81)
Oil, lacquer and collaged paper on canvas
79 × 50½ in. (200.6 × 128.3 cm.)
Gift of Concours d'Antiques

GORDON ONSLOW-FORD

Born December 26, 1912, Wendover, England
To San Francisco, California 1947
Lives in Inverness, California

EDUCATION: Royal Naval Colleges, Dartmouth and Greenwich, England, 1925-27, 1933. Resigned from Navy in 1937 to become a painter. Studied Chinese and Japanese calligraphy with Hodo Tobase, 1954-58.

SELECTED ONE-ARTIST EXHIBITIONS: Karl Nierendorf Gallery, New York, 1946; San Francisco Museum of Art, 1948, 1964, 1970; Alexander Rabow Galleries, San Francisco, 1956; Rose Rabow Galleries, San Francisco, 1960, 1964, 1967, 1973; M. H. de Young Memorial Museum, San Francisco, 1962; California College of Arts and Crafts, Oakland, 1966; Art Gallery of Greater Victoria, British Columbia, 1971; Pyramid Galleries Ltd., Washington, D.C., 1975; The Oakland Museum, 1977.

SELECTED GROUP EXHIBITIONS: San Francisco Museum of Art, *Dynaton*, 1951; Whitney Museum of American Art, New York, *Fifty California Artists*, 1962-63; Museum of Modern Art, New York, *Dada, Surrealism and Their Heritage*, 1968; Städtische Kunsthalle, Düsseldorf, West Germany, *Surrealität-Bildrealität 1924-1974*, 1974-75; San Francisco Museum of Modern Art, and National Collection of Fine Arts, Smithsonian Institution, Washington, D.C., *Painting and Sculpture in California: The Modern Era*, 1976-77; Los Angeles County Museum of Art, *California: 5 Footnotes to Modern Art History*, 1977.

FURTHER REFERENCES: Jones, Harvey L. *Gordon Onslow-Ford: Retrospective Exhibition.* Oakland: The Oakland Museum, 1980.

WORKS IN THE COLLECTION: 2 paintings

Birds from Home #3 *reveals the artist's Surrealist roots. Discovery is an important part of Onslow-Ford's work. He employs spontaneous imagery that flows, unpremeditated, from the subconscious to the canvas.*

Birds from Home #3, 1975 (75.154.1)
Acrylic on canvas
75 × 48 in. (190.5 × 121.92 cm.)
Gift of the Estate of Helen Hathaway White

JOSEPH RAFFAEL

Born February 22, 1933, Brooklyn, New York
In California 1966. Moved permanently to California
1969
Lives in San Geronimo, California

EDUCATION: Cooper Union School of Art and
Architecture, New York, 1951-54; Yale University,
New Haven, Connecticut, 1954-56 (BFA).

SELECTED ONE-ARTIST EXHIBITIONS:
Stable Gallery, New York, 1965, 1966, 1968; Berkeley
Gallery, San Francisco, 1968; Reese Palley Gallery, San
Francisco, 1970; Nancy Hoffman Gallery, New York,
1972, 1973, 1974, 1976, 1979, 1980, 1981, 1983;
University Art Museum, Berkeley, California, 1973-
74; Braunstein/Quay Gallery and Quay Ceramics Gal-
lery, San Francisco, 1976; San Francisco Museum of
Modern Art, 1978-79; John Berggruen Gallery, San
Francisco, 1978, 1981, 1982; Richard Gray Gallery,
Chicago, 1983.

SELECTED GROUP EXHIBITIONS: Mu-
seu de Arte Moderna, São Paulo, Brazil, *IX Bienal*,
1968; Whitney Museum of American Art, New York,
*Human Concern Personal Torment: The Grotesque
in American Art*, 1969-70; Worcester Art Museum,
Massachusetts, *Three Realists: Close, Estes, Raffael*,
1974; San Francisco Museum of Modern Art, and
National Collection of Fine Arts, Smithsonian Insti-
tution, Washington, D.C., *Painting and Sculpture in
California: The Modern Era*, 1976-77; Pennsylvania
Academy of the Fine Arts, Philadelphia, and North
Carolina Museum of Art, Raleigh, *8 Contemporary
American Realists*, 1977; Philbrook Art Center, Tulsa,
Oklahoma, *Realism/Photo-Realism*, 1980; Santa
Barbara Museum of Art, California, *Photo-Realist
Painting in California: A Survey*, 1980; San Antonio
Museum of Art, Texas, *Real, Really Real, Super Real*,
1981-82; Pennsylvania Academy of the Fine Arts,
Philadelphia, *Contemporary American Realism since
1960*, 1981-82.

FURTHER REFERENCES: Garver, Thomas
H. *Joseph Raffael: The California Years, 1969-1978*.
San Francisco Museum of Modern Art, 1978.

WORKS IN THE COLLECTION:
2 paintings, 1 watercolor, and 1 print

Lily Painting — Hilo II, 1975 (75.141)
Oil on canvas
7 × 11 ft. (213.4 × 335.5 cm.)
Gift of the Collectors Gallery and the National
Endowment for the Arts

In Lily Painting—Hilo II, *Raffael creates a water
environment that bursts and shimmers with viva-
cious color and light. The artist translates his
photo-realistic vision into a kaleidoscopic delight
for the eyes.*

DAVID SIMPSON

Born January 20, 1928, Pasadena, California
Lives in Berkeley, California

EDUCATION: Pasadena City College, California, 1942-43; California School of Fine Arts, San Francisco, 1949-51, 1955-56 (BFA); San Francisco State College, 1956-58 (MFA).

SELECTED ONE-ARTIST EXHIBITIONS: Santa Barbara Museum of Art, California, 1960; M. H. de Young Memorial Museum, San Francisco, 1961; Robert Elkon Gallery, New York, 1961, 1963, 1964; David Stuart Galleries, Los Angeles, 1963, 1966, 1968; San Francisco Museum of Art, 1967; Hank Baum Gallery, San Francisco, 1971, 1972; Mills College Art Gallery, Oakland, 1973; St. Mary's College Art Gallery, Moraga, California, 1973; The Oakland Museum, 1978; Fine Arts Gallery, California State University, Los Angeles, 1980; Modernism, San Francisco, 1982, 1984.

SELECTED GROUP EXHIBITIONS: Whitney Museum of American Art, New York, *Fifty California Artists*, 1962-63; Museum of Modern Art, New York, *Americans 1963*, 1963; Los Angeles County Museum of Art, *Post Painterly Abstraction*, 1964; Portland Art Museum, Oregon, *The West Coast Now*, 1968; Osaka, Japan, *Expo '70*, 1970, and *Expo '74*, 1974; San Francisco Museum of Modern Art, and National Collection of Fine Arts, Smithsonian Institution, Washington, D.C., *Painting and Sculpture in California: The Modern Era*, 1976-77; de Saisset Museum, University of Santa Clara, California, *Northern California Art of the Sixties*, 1982; Walnut Creek Civic Arts Gallery, California, *The Planar Dimension: Geometric Abstraction in the Bay Area 1950-83*, 1983.

FURTHER REFERENCES: Jones, Harvey L. *David Simpson: Paintings*. Oakland: The Oakland Museum, 1978. San Francisco Museum of Art. *David Simpson, 1957-1967*. San Francisco, 1967.

WORKS IN THE COLLECTION:
5 paintings

The delicate balance of colors and shapes as well as an evenness of surface are critical to the success of this painting. Simpson applied more than twenty hand-brushed layers of paint to build up the final surface of this deceptively simple work.

Gradiva's Palace, 1976 (78.221)
Acrylic on canvas
84 × 84 in. (213.4 × 213.4 cm.)
Gift of David Simpson

MASAMI TERAOKA

Born January 13, 1936, Onomichi, Japan
Emigrated to Los Angeles, California 1961
Lives in Los Angeles, California

EDUCATION: Kwansei Gwakuin University, Kobe, Japan, 1959 (BA, Aesthetics); Otis Art Institute, Los Angeles, 1964-68 (BA, MFA).

SELECTED ONE-ARTIST EXHIBITIONS: David Stuart Galleries, Los Angeles, 1973; Space Gallery, Los Angeles, 1975, 1977, 1979, 1982; Minneapolis Institute of the Arts, Minnesota, 1976; Santa Barbara Museum of Art, California, 1977; Whitney Museum of American Art, New York, 1979-80; Jehu Gallery, San Francisco, 1980; Zolla/Lieberman Gallery, Chicago, 1981; Jacksonville Art Museum, Florida, 1983; The Oakland Museum, 1983.

SELECTED GROUP EXHIBITIONS: Baxter Art Gallery, California Institute of Technology, Pasadena, *In the Japanese Tradition*, 1974; Los Angeles County Museum of Art, *LA 8: Painting and Sculpture 1976*, 1976; Whitney Museum of American Art, New York, *Art About Art*, 1978; Los Angeles Municipal Art Gallery, *The Artist as Social Critic*, 1979; Los Angeles Institute of Contemporary Art, *Humor in Art*, 1981; Western Association of Art Museums, *Déjà Vu: Masterpieces Updated*, 1981-82; Corcoran Gallery of Art, Washington, D.C., *Second Western States Exhibition/38th Corcoran Biennial Exhibition of American Painting*, 1983.

FURTHER REFERENCES: The Oakland Museum. *Masami Teraoka*. Oakland, 1983. Whitney Museum of American Art. *Masami Teraoka*. New York, 1979.

WORKS IN THE COLLECTION:
1 watercolor

With the style and imagery derived from the artistic conventions of traditional Japanese Ukiyo-e woodblock prints, Masami Teraoka creates masterful contemporary watercolors infused with humorous eroticism and commentary on the cross-cultural influences between Japan and the United States.

31 Flavors Invading Japan/Ready to Lick, 1975
(83.34)
Watercolor on paper
14⅓ × 21¼ in. (36 × 54 cm.)
Gift of the Art Guild of the Oakland Museum Association

ROBERT COLESCOTT

Born August 26, 1925, Oakland, California
Lived in Washington and Oregon, 1952-64, 1965-66;
Egypt 1964-65, 1966-67; France 1967-69. Returned
to California 1970
Lives in Oakland, California

EDUCATION: University of California, Berkeley,
1949 (AB), 1952 (MA); Atelier Fernand Léger, Paris,
1949-50.

SELECTED ONE-ARTIST EXHIBITIONS:
Miller-Pollard, Seattle, Washington, 1953, 1954; Portland Art Museum, Oregon, 1958, 1966; Victoria Art
Gallery, British Columbia, 1965; Friedlander Gallery,
Seattle, Washington, 1972; John Bolles Gallery, San
Francisco, 1972; Spectrum Gallery, New York, 1973,
1975, 1977; John Berggruen Gallery, San Francisco,
1975, 1978; Hamilton Gallery, New York, 1978,
1979; Semaphore Gallery, New York, 1981, 1982.

SELECTED GROUP EXHIBITIONS:
Grand Rapids Art Gallery, Michigan, *American Painting Today*, 1961; Seattle World's Fair, Washington,
Northwest Art Today, 1962; San Francisco Museum
of Art, *A Third World Painting/Sculpture Exhibition*,
1974; The Oakland Museum, *Five Oakland Artists*,
1974; San Francisco Museum of Modern Art, and
National Collection of Fine Arts, Smithsonian Institution, Washington, D.C., *Painting and Sculpture in
California: The Modern Era*, 1976-77; Whitney Museum of American Art, New York, *Art About Art*,
1978-79; The New Museum, New York, *Not Just for
Laughs*, 1981; Whitney Museum of American Art,
New York, *1983 Biennial Exhibition*, 1983.

FURTHER REFERENCES: Palm Springs Desert Museum. *The West as Art*. Palm Springs, California, 1982, pp. 18, 155, plate 82.

WORKS IN THE COLLECTION: 1 painting

My Shadow, 1977 (77.191)
Acrylic on canvas
84 × 66⅛ in. (213.3 × 168 cm.)
Gift of Mrs. Elizabeth Ross

*Robert Colescott, a nationally known black artist
who lives and works in Oakland, uses bold, bright
color and humorous, cartoon-like figures to set
the stage for* My Shadow. *A biting, satirical edge
cuts through the seemingly light-hearted surface.*

LELAND RICE

Born April 9, 1940, Los Angeles, California
Lives in Los Angeles, California

EDUCATION: Arizona State University, Tempe, 1964 (BS, Business); California State University, San Francisco, 1969 (MA, Art).

SELECTED ONE-ARTIST EXHIBITIONS: San Francisco Museum of Art, 1969; Friends of Photography, Carmel, California, 1972; Witkin Gallery, New York, 1973; School of the Art Institute of Chicago, 1974; Ross Freeman Gallery, Northridge, California, 1974; Visual Studies Workshop, Rochester, New York, 1976; Jack Glenn Gallery, Newport Beach, California, 1976; Hirshhorn Museum and Sculpture Garden, Smithsonian Institution, Washington, D.C., and The Oakland Museum, 1977; Fisher Art Gallery, University of Southern California, Los Angeles, 1978; Grapestake Gallery, San Francisco, 1980.

SELECTED GROUP EXHIBITIONS: University of New Mexico Art Gallery, Albuquerque, *Young Photographers*, 1968; International Museum of Photography at George Eastman House, Rochester, New York, *Vision and Expression*, 1969; Witkin Gallery, New York, *New Realism: Four San Francisco Photographers*, 1970; The Oakland Museum, *California Photographers 1970*, 1970, and *In Color: Ten California Photographers*, 1983; San Francisco Art Institute, *Centennial Exhibition*, 1971; Los Angeles County Museum of Art, *Survey of Southern California Photographers*, 1972, and *Studio Work: Photographs by Ten LA Artists*, 1982; Museum of Modern Art, New York, *Rooms*, 1976, and *Mirrors and Windows: Photography in America since 1960*, 1978; Light Gallery, New York, *Four California Photographers*, 1979.

FURTHER REFERENCES: Millard, Charles. *The Photography of Leland Rice*. Washington, D.C.: The Hirshhorn Museum and Sculpture Garden, Smithsonian Institution, 1977.

WORKS IN THE COLLECTION: 6 photographic prints

In Blue Door, Sommer Studio, *Leland Rice demonstrates the new awareness of the range of possibilities modern color films offer the fine art photographer. In this photograph of his friend's studio, Rice has made his style reflect the scale and color of contemporary painting.*

Blue Door, Sommer Studio, 1978 (83.16.3)
Type C color print
16 × 20 in. (46.64 × 50.8 cm.)
Gift of Dr. Robert Shimshak

ANTHONY HERNANDEZ

Born July 7, 1947, Los Angeles, California
Lives in Los Angeles, California

EDUCATION: East Los Angeles College, California, 1966-67; studied with Lee Friedlander, Center of the Eye, Aspen, Colorado, 1969.

SELECTED ONE-ARTIST EXHIBITIONS: The Corcoran Gallery of Art, Washington, D.C., 1976; Max Protetch Gallery, Washington, D.C., 1976; Cerro Coso College, Ridgecrest, California, 1978; Orange Coast College, Costa Mesa, California, 1978; School for Creative Studies Gallery, University of California, Santa Barbara, 1979; California Museum of Photography, University of California, Riverside, 1982.

SELECTED GROUP EXHIBITIONS: University of California, Davis, *California Photographers*, 1970, and *The Crowded Vacancy*, 1971; The Oakland Museum, *West of the Rockies*, 1972; University of New Mexico Art Gallery, Albuquerque, *Peculiar to Photography*, 1976; Museum of Fine Arts, Houston, Texas, *Contemporary American Photo Works*, 1977; Security Pacific National Bank, Los Angeles, *Photographic Directions: LA*, 1979; Santa Barbara Museum of Art, California, *Attitudes: Photography in the 1970s*, 1979; Seattle Art Museum, Washington, *Long Beach: A Photographic Survey*, 1980; The Oakland Museum, *Slices of Time: California Landscape 1860-1880, 1960-1980*, 1982; San Francisco Museum of Modern Art, *Facets of the Collection: Urban America*, 1982.

FURTHER REFERENCES: Artist's File, Archives of California Art, The Oakland Museum. Heyman, Therese Thau. *Slices of Time: California Landscape 1860-1880, 1960-1980*. Oakland: The Oakland Museum, 1982.

WORKS IN THE COLLECTION:
4 photographic prints

In Public Fishing Areas #1, *Hernandez documents the look, size, and location of this recreation site without giving the viewer a sense of his feelings about the place.*

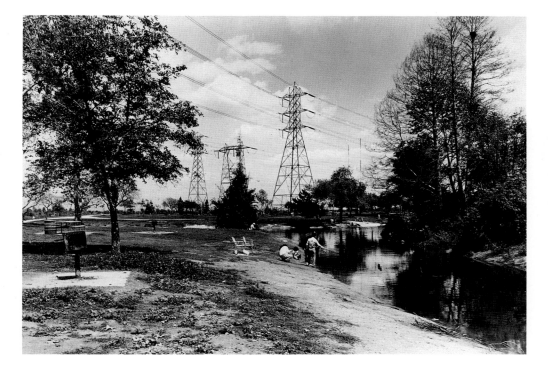

Public Fishing Areas #1 Herbert C. Legg Lake, 1979
(82.48)
Gelatin silver print
12¾ × 18⅜ in. (32.4 × 46.7 cm.)
Gift of Prints and Photography Fund

MANUEL NERI

Throughout his career, Neri has continued to explore the expressive content of the human form. Chalk-white and faceless, each of his plaster figures carries the marks both of its emergence and of its erosion, intimating the change inherent in the apparently static present.

Born April 12, 1930, Sanger, California
Lives in Benicia, California

EDUCATION: University of California, Berkeley, 1951-52; California College of Arts and Crafts, Oakland, 1952-53, 1955-57; Archie Bray Foundation, Helena, Montana, 1953 (summer); California School of Fine Arts, San Francisco, 1957-59.

SELECTED ONE-ARTIST EXHIBITIONS: Six Gallery, San Francisco, 1957; Spatsa Gallery, San Francisco, 1959; Dilexi Gallery, San Francisco, 1960; Berkeley Gallery, Berkeley, California, 1964; Quay Gallery, San Francisco, 1966, 1968, 1971, 1975; San Francisco Museum of Art, 1971; Braunstein/Quay Gallery, New York, 1976; The Oakland Museum, 1976; Gallery Paule Anglim, San Francisco, 1979; Seattle Art Museum, Washington, 1981; Charles Cowles Gallery, New York, 1981, 1982; John Berggruen Gallery, San Francisco, 1981; Middendorf/Lane, Washington, D.C., 1983.

SELECTED GROUP EXHIBITIONS: San Francisco Museum of Art, *Four Man Show: Sam Francis, Wally Hedrick, Fred Martin, Manuel Neri*, 1959; Oakland Art Museum, *Contemporary California Sculpture*, 1963; University of California, Irvine, *Abstract Expressionist Ceramics*, 1966; University Art Museum, Berkeley, California, *Funk*, 1967; Whitney Museum of American Art, New York, *Annual Exhibition: Contemporary American Sculpture*, 1970; Art Gallery of New South Wales, Sydney, Australia, *The Biennale of Sydney*, 1976; San Francisco Museum of Modern Art, and National Collection of Fine Arts, Smithsonian Institution, Washington, D.C., *Painting and Sculpture in California: The Modern Era*, 1976-77; Everson Museum of Art, Syracuse, New York, *A Century of Ceramics in the United States 1878-1978*, 1979; San Francisco Museum of Modern Art, *20 American Artists*, 1980; The Oakland Museum, *100 Years of California Sculpture*, 1982.

FURTHER REFERENCES: Neubert, George W. *Manuel Neri: Sculptor*. Oakland: The Oakland Museum, 1976. Seattle Art Museum. *Manuel Neri: Sculpture and Drawings*. San Francisco: John Berggruen Gallery in association with the Seattle Art Museum, Washington, 1981.

WORKS IN THE COLLECTION:
4 sculptures and 2 paintings

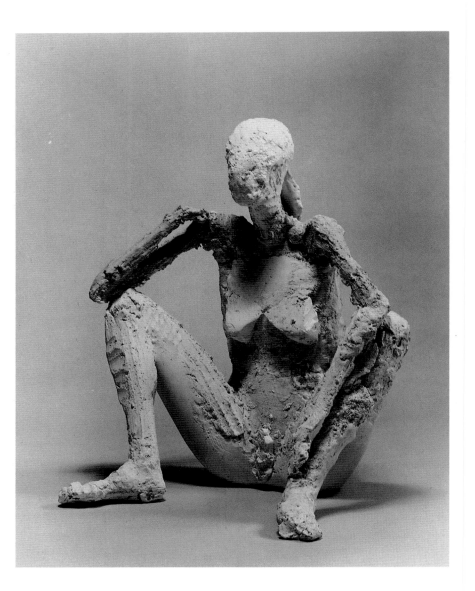

Untitled (Seated Woman), 1979 (79.97)
Plaster, dry pigments, steel armature, and styrofoam core
33¾ × 28 × 21½ in. (85.7 × 71.1 × 54.6 cm.)
Gift of the Collectors Gallery and the National Endowment for the Arts

RICHARD SHAW

Born September 12, 1941, Hollywood, California
Lives in Fairfax, California

EDUCATION: Orange Coast College, Costa Mesa, California, 1961-63; State University of New York at Alfred, 1965; San Francisco Art Institute, 1965 (BFA); University of California, Davis, 1968 (MFA).

SELECTED ONE-ARTIST EXHIBITIONS: San Francisco Art Institute, 1967; Dilexi Gallery, San Francisco, 1968; Quay Gallery, San Francisco, 1970, 1971, 1973; San Francisco Museum of Art, *Robert Hudson/Richard Shaw: Work in Porcelain*, 1973; Braunstein/Quay Gallery, San Francisco and New York, 1976; Jacqueline Anhalt Gallery, Los Angeles, 1977; Braunstein/Quay Gallery, San Francisco, 1979; Allan Frumkin Gallery, New York, 1980; Braunstein Gallery, San Francisco, 1981-83.

SELECTED GROUP EXHIBITIONS: Museum of Contemporary Crafts, New York, *New Ceramic Forms*, 1965; National Collection of Fine Arts, Smithsonian Institution, Washington, D.C., *Objects: USA*, 1969-71; National Museum of Modern Art, Kyoto, Japan, and National Museum of Modern Art, Tokyo, *Contemporary Ceramic Art: Canada, USA, Mexico and Japan*, 1971-72; Victoria and Albert Museum, London, *International Ceramics 1972*, 1972; Museum of Contemporary Art, Chicago, *American Crafts '76: An Aesthetic View*, 1976; San Francisco Museum of Modern Art, and National Collection of Fine Arts, Smithsonian Institution, Washington, D.C., *Painting and Sculpture in California: The Modern Era*, 1976-77; Stedelijk Museum, Amsterdam, *West Coast Ceramics*, 1979; Everson Museum of Art, Syracuse, New York, *A Century of Ceramics in the United States, 1878-1978*, 1979-80; Denver Art Museum, Colorado, *Reality of Illusion*, 1979-80; Renwick Gallery, National Collection of Fine Arts, Smithsonian Institution, Washington, D.C., *American Porcelain: New Expressions in an Ancient Art*, 1980-83; American Craft Museum, New York, *The Clay Figure*, 1981; Whitney Museum of American Art, New York, and San Francisco Museum of Modern Art, *Ceramic Sculpture: Six Artists*, 1981-82.

FURTHER REFERENCES: Braunstein Gallery. *Richard Shaw/Ceramic Sculpture*. San Francisco, 1981. Marshall, Richard and Suzanne Foley. *Ceramic Sculpture: Six Artists*. New York: Whitney Museum of American Art in association with the University of Washington Press, Seattle and London, 1981.

WORKS IN THE COLLECTION: 3 ceramic pieces

Richard Shaw turns a homogeneous clay surface into a three-dimensional still life with illusionistic painting and silkscreened decals. The elegant arrangement of House of Cards #3 *raises issues of tension, balance, and fragility while transforming everyday subject matter into an object of contemplation.*

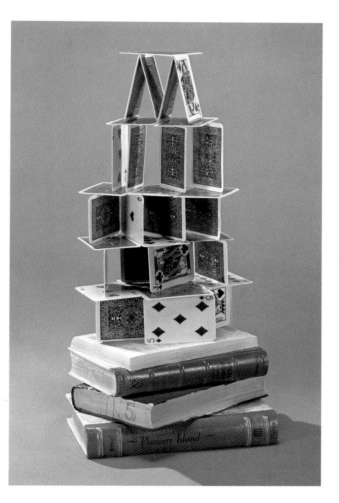

House of Cards #3, 1979 (79.153)
Porcelain with overglaze transfers
19½ × 9¼ × 9½ in. (49.5 × 23.5 × 24.1 cm.)
Gift of the Collectors Gallery

MICHAEL C. McMILLEN

Born April 6, 1946, Los Angeles, California
Lives in Santa Monica, California

EDUCATION: San Fernando Valley State College, Northridge, California, 1969 (BA); University of California, Los Angeles, 1972 (MA), 1973 (MFA).

SELECTED ONE-ARTIST EXHIBITIONS: "Traveling Mystery Museum," Venice, California, 1973; Los Angeles County Museum of Art, and Whitney Museum of American Art, New York, *Inner City* (installation), 1977-78; Art Gallery of New South Wales, Sydney, Australia, 1980; MacQuarie Galleries, Sydney, Australia, 1980, 1982; Asher/Faure Gallery, Los Angeles, 1980, 1982; Pittsburgh Center for the Arts, Pennsylvania, *The Floating Diner* (installation), 1981.

SELECTED GROUP EXHIBITIONS: Los Angeles Institute of Contemporary Art, *Collage and Assemblage*, 1975; Newport Harbor Art Museum, Newport Beach, California, *Sounds: Sound/Environments by 4 Artists*, 1975; Art Gallery of New South Wales, Sydney, Australia, *Biennale of Sydney*, 1976; Fort Worth Art Museum, Texas, *Los Angeles in the Seventies*, 1977; ARCO Center for Visual Art, Los Angeles, *Eccentric Los Angeles Art*, 1978; Walker Art Center, Minneapolis, Minnesota, *Eight Artists: The Elusive Image*, 1979; San Diego Museum of Art, California, *Sculpture in California, 1975-80*, 1980; Los Angeles County Museum of Art, *Art in Los Angeles/ The Museum as Site: Sixteen Projects*, 1981; The Oakland Museum, *100 Years of California Sculpture*, 1982; Solomon R. Guggenheim Museum, New York, *New Perspectives in American Art: 1983 Exxon National Exhibition*, 1983.

FURTHER REFERENCES: Artist's File, Archives of California Art, The Oakland Museum. Larsen, Susan. "Michael McMillen at Asher/Faure." *Artforum*, February, 1983, pp. 85-86. Whelan, Richard. "Michael McMillen at the Whitney." *Art in America*, May-June, 1979, pp. 134-35.

WORKS IN THE COLLECTION:
1 sculpture

A small-scale, derelict billboard stands isolated, only to receive the many pierces of arrows from without. A statement inscribed around the base begins, "Mary couldn't understand why those around her ignored her so much. . ." adding emotional overtones to the sense of desolation.

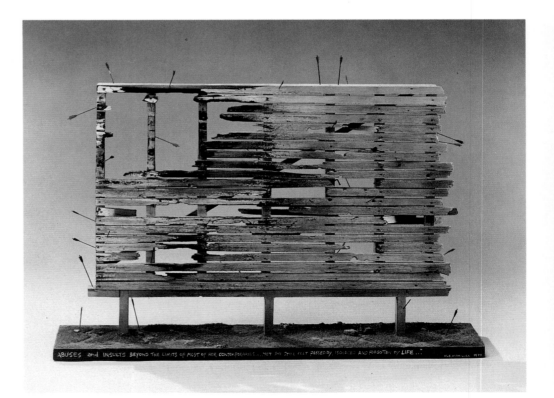

Mary Couldn't, 1977 (82.104)
Wood
12 × 16½ × 3½ in. (30.5 × 41.9 × 8.9 cm.)
Gift of the Art Guild of the Oakland Museum Association

KAY SEKIMACHI

Born September 30, 1926, San Francisco, California
Lives in Berkeley, California

EDUCATION: California College of Arts and
Crafts, Oakland, 1946-49; Haystack Mountain
School of Crafts, Liberty, Maine, 1956 (summer).

SELECTED ONE-ARTIST EXHIBITIONS:
Oakland Art Museum, 1962 (with Herbert Sanders);
College of Holy Names, Oakland, California, 1965;
Richmond Art Center, California, 1965; Galeria del
Sol, Santa Barbara, California, 1968; Lee Nordness
Galleries, New York, 1970; Anneberg Gallery, San
Francisco, 1971; Contemporary Crafts Gallery, Port-
land, Oregon, 1973; Pacific Basin Textile Arts, Berke-
ley, California, 1974; California College of Arts and
Crafts, Oakland, 1975; California Craft Museum,
Palo Alto, California, 1982 (with Nancy Selvin); Fi-
berworks Center for the Textile Arts, Berkeley, Cali-
fornia, 1982; Textiles by Design, Berkeley, California,
1983.

SELECTED GROUP EXHIBITIONS: Mu-
seum of Contemporary Crafts, New York, *Crafts-
manship in a Changing World*, 1956; Museum of
Contemporary Crafts, New York, and Philadelphia
Museum College of Art, Pennsylvania, *Fabrics Inter-
national*, 1961; Oakland Art Museum, *First and
Second California Craftsmen's Biennials*, 1961,
1963; Victoria and Albert Museum, London, *Modern
American Wall Hangings*, 1962-63; Museum of Mod-
ern Art, New York, *Wall Hangings*, 1969; National
Collection of Fine Arts, Smithsonian Institution,
Washington, D.C., *Objects: USA*, 1969-71; Pasadena
Art Museum, California, *California Design Eleven*,
1971; UCLA Art Galleries, University of California,
Los Angeles, *Deliberate Entanglements*, 1971-72;
Camden Art Centre, London, *Woven Structures*,
1972; Lausanne, Switzerland, *6th Biennale Interna-
tionale de la Tapisserie*, 1973; The Oakland Museum,
Statements, 1973; Govett-Brewster Art Gallery, New
Plymouth, New Zealand, *Three Dimensional Fibre*,
1974; National Museum of Modern Art, Kyoto, Ja-
pan, and National Museum of Modern Art, Tokyo,
Fiber Art: Americas and Japan, 1977-78; San Fran-
cisco Museum of Modern Art, *The Art Fabric: Main-
stream*, 1981; Central Museum of Textiles, Lodz, Po-
land, *4th Triennale, Lodz '81*, 1981; Institute of
Contemporary Art, Boston, *Basketry: Tradition in
New Form*, 1982.

FURTHER REFERENCES: Artist's File, Ar-
chives of California Art, The Oakland Museum.

WORKS IN THE COLLECTION:
5 weavings

*This recent work relies on the complexities of
multiple-warp weaving, yet it offers exquisite sim-
plicity of form. With its pictorial interest, the
balance of surface and form is maintained while
richly acknowledging the artist's heritage.*

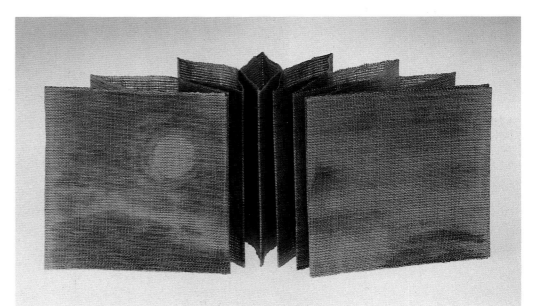

Moon & Fog, 1981 (83.27)
Double-weave natural linen
4½ × 20 in. (11.4 × 50.8 cm.)
Gift of the Art Guild and Docent Council of the Oak-
land Museum Association

ROBERT BECHTLE

Born May 14, 1932, San Francisco, California
Lives in San Francisco, California

EDUCATION: California College of Arts and Crafts, Oakland, 1950-54 (BA), 1956-58 (MFA).

SELECTED ONE-ARTIST EXHIBITIONS: San Francisco Museum of Art, 1959, 1964, 1967; Berkeley Gallery, Berkeley, California, 1965; Richmond Art Center, California, 1965; E. B. Crocker Art Gallery, Sacramento, California, 1966, 1973; Berkeley Gallery, San Francisco, 1967; Achenbach Foundation for Graphic Arts, San Francisco, 1969; O. K. Harris Gallery, New York, 1971, 1974, 1977, 1981; John Berggruen Gallery, San Francisco, 1973; University Art Museum, Berkeley, California, 1980.

SELECTED GROUP EXHIBITIONS: Milwaukee Art Center, Wisconsin, *Aspects of a New Realism*, 1969; Museum of Contemporary Art, Chicago, *Radical Realism*, 1971; Kassel, Germany, *Documenta 5*, 1972; San Francisco Museum of Modern Art, and National Collection of Fine Arts, Smithsonian Institution, Washington, D.C., *Painting and Sculpture in California: The Modern Era*, 1976-77; Santa Barbara Museum of Art, California, *Photo-Realist Painting in California: A Survey*, 1980; San Antonio Museum of Art, Texas, *Real, Really Real, Super Real*, 1981-82; Pennsylvania Academy of the Fine Arts, Philadelphia, *Contemporary American Realism since 1960*, 1981-82; de Saisset Museum, University of Santa Clara, California, *Northern California Art of the Sixties*, 1982.

FURTHER REFERENCES: Meisel, Louis K. *Photo-Realism*. 2nd ed. New York: Harry N. Abrams, Inc., 1981, pp. 25-54.

WORKS IN THE COLLECTION: 1 painting, 1 drawing, 1 watercolor, and 6 prints

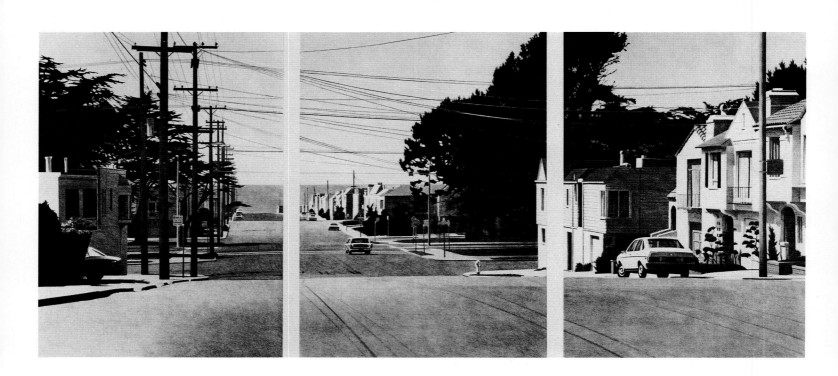

Sunset Intersection, 1983 (83.28)
Soft-ground color etching on paper, triptych
22 × 50 in. (55.88 × 127 cm.) (image)
Gift of Agnes Bourne

Virtuoso printing techniques are involved in this unusual color aquatint, Sunset Intersection, *which Bechtle produced in collaboration with Crown Point Press in Oakland. Important to this triptych print is its presentation of the flat, bright California light as it floods across the street.*

WAYNE THIEBAUD

Born November 15, 1920, Mesa, Arizona
To California 1922
Lives in Sacramento, California

EDUCATION: Frank Wiggins Trade School, Los Angeles, 1938; Long Beach City College, California, 1940-41; San Jose State University, California, 1949-50; California State University, Sacramento, 1951 (BA), 1953 (MA).

SELECTED ONE-ARTIST EXHIBITIONS: E. B. Crocker Art Gallery, Sacramento, California, 1950, 1951, 1952, 1958, 1970; San Francisco Museum of Art, 1960, 1961, 1964, 1974; Allan Stone Gallery, New York, 1962, 1963-69, 1971-74, 1977-79; Metropolitan Museum of Art, New York, 1963; Pasadena Art Museum, California, 1968; John Berggruen Gallery, San Francisco, 1971, 1972, 1973, 1980; Whitney Museum of American Art, New York, 1971; Corcoran Gallery of Art, Washington, D.C., 1972; Stedelijk van Abbemuseum, Eindhoven, The Netherlands, 1973; Phoenix Art Museum, Arizona, 1976-77; Walker Art Center, Minneapolis, Minnesota, 1981; Crocker Art Museum, Sacramento, California, 1983.

SELECTED GROUP EXHIBITIONS: Pasadena Art Museum, California, *New Paintings of Common Objects*, 1962; Oakland Art Museum, *Pop Art USA*, 1963; Institute of Contemporary Arts, London, *The Popular Image*, 1963; Haags Gemeentemuseum, The Hague, The Netherlands, *Nieuwe Realisten*, 1964; Museu de Arte Moderna, São Paulo, Brazil, *IX Bienal*, 1967-68; Stedelijk van Abbemuseum, Eindhoven, The Netherlands, *Kompas 4: Westkust USA*, 1969-70; Kassel, Germany, *Documenta 5*, 1972; The Cleveland Museum of Art, Ohio, *Aspects of the Figure*, 1974; San Francisco Museum of Modern Art, and National Collection of Fine Arts, Smithsonian Institution, Washington, D.C., *Painting and Sculpture in California: The Modern Era*, 1976-77; San Antonio Museum of Art, Texas, *Real, Really Real, Super Real*, 1981; Pennsylvania Academy of the Fine Arts, Philadelphia, *Contemporary American Realism since 1960*, 1981.

FURTHER REFERENCES: Cooper, Gene. *Wayne Thiebaud Survey 1947-1976.* Phoenix, Arizona: Phoenix Art Museum, 1976.

WORKS IN THE COLLECTION: 4 paintings, 7 individual prints, and 17 bound prints

Well-known in the 1960s for his paintings of pies, cakes, and other common objects of the Pop idiom, Wayne Thiebaud has since turned his realist vision to the urban California landscape. With lively color and creamy strokes of paint, Thiebaud in his recent work brings vivacity and sensuousness to the vertiginous street scenes of San Francisco.

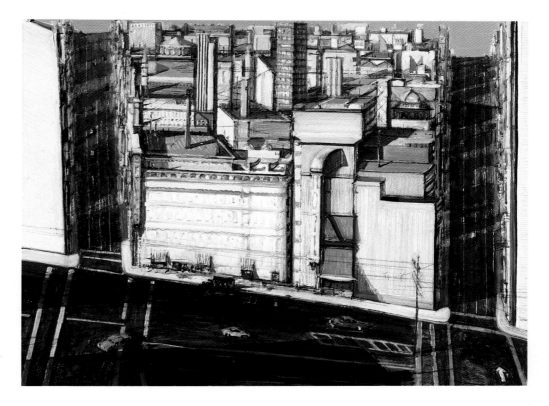

Urban Square, 1980 (80.93)
Oil on canvas
36 × 48 in. (91.4 × 122 cm.)
Gift of Dr. and Mrs. James B. Graeser

WILLIAM T. WILEY

Born October 21, 1937, Bedford, Indiana
To California 1956
Lives in Woodacre, California

EDUCATION: California School of Fine Arts, San Francisco, 1956-60 (BFA), 1962 (MFA).

SELECTED ONE-ARTIST EXHIBITIONS: Staempfli Gallery, New York, 1960, 1962, 1964; Oakland Art Museum, 1961; Lanyon Gallery, Palo Alto, California, 1965; Hansen Fuller Gallery, San Francisco, 1968, 1969, 1971, 1972, 1974, 1975; Allan Frumkin Gallery, New York, 1968, 1970, 1973, 1976, 1981; University Art Museum, Berkeley, California, 1971-72; Stedelijk van Abbemuseum, Eindhoven, The Netherlands, 1973; Museum of Modern Art, New York, 1976; Hansen Fuller Goldeen Gallery, San Francisco, 1978; Walker Art Center, Minneapolis, Minnesota, 1979-81; Realities Galleries, Melbourne, Australia, and Institute of Modern Art, Brisbane, Queensland, Australia, 1980; Hansen Fuller Goldeen Gallery, San Francisco, 1981; Fuller Goldeen Gallery, San Francisco, 1983; Charles H. Scott Gallery, Emily Carr College of Art, Vancouver, British Columbia, and Allan Frumkin Gallery, New York, 1981-82.

SELECTED GROUP EXHIBITIONS: Whitney Museum of American Art, New York, *Fifty California Artists*, 1962-63; Los Angeles County Museum of Art, and Philadelphia Museum of Art, Pennsylvania, *American Sculpture of the Sixties*, 1967; University Art Museum, Berkeley, California, *Funk*, 1967; Kunsthalle, Bern, Switzerland, *When Attitudes Become Form*, 1969; Stedelijk van Abbemuseum, Eindhoven, The Netherlands, *Kompas 4: Westkust USA*, 1969-70; Kassel, West Germany, *Documenta 5*, 1972; Whitney Museum of American Art, New York, *Extraordinary Realities*, 1973-74; Städtische Kunsthalle, Düsseldorf, West Germany, *Surrealität-Bildrealität 1924-1974*, 1974-75; Whitney Museum of American Art, New York, *200 Years of American Sculpture*, 1976; San Francisco Museum of Modern Art, and National Collection of Fine Arts, Smithsonian Institution, Washington, D.C., *Painting and Sculpture in California: The Modern Era*, 1976-77; Albright-Knox Art Gallery, Buffalo, New York, *American Painting of the 1970s*, 1979-80; The Oakland Museum, *100 Years of California Sculpture*, 1982; Whitney Museum of American Art, New York, *1983 Biennial Exhibition*, 1983.

FURTHER REFERENCES: Beal, Graham W. J., and John Perrault. *Wiley Territory*. Minneapolis, Minnesota: Walker Art Center, 1979.

WORKS IN THE COLLECTION: 6 paintings, 1 watercolor, 3 drawings, 6 prints, and 2 sculptures

William Wiley interweaves his ideas and visions of California and Japan in this intricate woodblock print, which he produced by using twenty-six blocks and eighty-five colors. Puzzling through the many puns and humorous references to wood within the content of the print, one sees Wiley making his own illustration within a larger story of his invention.

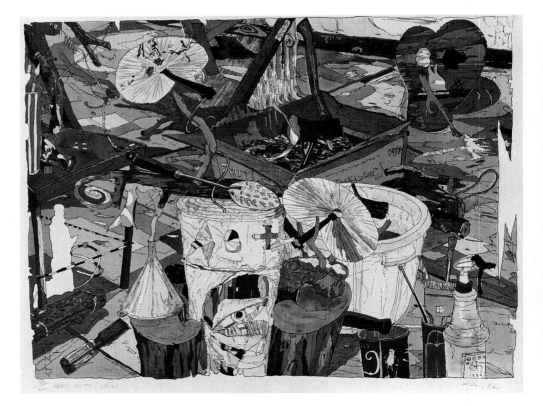

Eerie Grotto ? Okini, 1982 (83.25)
Wood block print on paper
20½ × 26¾ in. (52.07 × 67.95 cm.) (image)
Gift of the Collectors Gallery

BILLY AL BENGSTON

Born June 7, 1934, Dodge City, Kansas
To California 1948
Lives in Venice, California

EDUCATION: Los Angeles City College, 1953;
Los Angeles State College, 1954; California College
of Arts and Crafts, Oakland, 1955; Otis Art Institute,
Los Angeles, 1956.

SELECTED ONE-ARTIST EXHIBITIONS:
Ferus Gallery, Los Angeles, 1958, 1960-62; Martha
Jackson Gallery, New York, 1962; Los Angeles County
Museum of Art, 1968-69; San Francisco Museum of
Art, 1968; Pasadena Art Museum, California, 1969;
Santa Barbara Museum of Art, California, 1970; La
Jolla Museum of Art, California, 1971; Felicity Samuel
Gallery, London, 1972; Contemporary Arts Museum,
Houston, Texas, 1973; Nicholas Wilder Gallery, Los
Angeles, 1973, 1974; Texas Gallery, Houston, 1973,
1974, 1976-79; John Berggruen Gallery, San Fran-
cisco, 1974, 1978, 1983; James Corcoran Gallery, Los
Angeles, 1977, 1978, 1980-83; Acquavella Contem-
porary Art, New York, 1979, 1981; Honolulu Acad-
emy of Arts, Hawaii, 1980; Corcoran Gallery of Art,
Washington, D.C., 1981; Linda Farris Gallery, Seattle,
Washington, 1982.

SELECTED GROUP EXHIBITIONS:
Whitney Museum of American Art, New York, *Fifty
California Artists*, 1962-63; Oakland Art Museum,
Pop Art USA, 1963; Museu de Arte Moderna, São
Paulo, Brazil, *VIII Bienal*, 1965; Art Gallery, Univer-
sity of California, Irvine, *Abstract Expressionist Ce-
ramics*, 1966; Museum of Modern Art, New York,
New Media: New Methods, 1969, and *Tamarind:
Homage to Lithography*, 1969; Stedelijk van Abbe-
museum, Eindhoven, The Netherlands, *Kompas 4:
Westkust USA*, 1969-70; Kunstverein, Hamburg,
West Germany, *USA West Coast*, 1972; Everson Mu-
seum of Art, Syracuse, New York, *New Works in Clay
by Contemporary Painters and Sculptors*, 1976; San
Francisco Museum of Modern Art, and National Col-
lection of Fine Arts, Smithsonian Institution, Wash-
ington, D.C., *Painting and Sculpture in California:
The Modern Era*, 1976-77; Institute of Contemporary
Art, University of Pennsylvania, Philadelphia, *The
Decorative Impulse*, 1979; Los Angeles County Mu-
seum of Art, and San Antonio Museum of Art, Texas,
Art in Los Angeles: Seventeen Artists in the Sixties,
1981-82; Contemporary Arts Museum, Houston,
Texas, *The Americans: The Collage*, 1982; ARCO
Center for Visual Art, Los Angeles, *Los Angeles Pat-
tern Painters*, 1983; The Oakland Museum, *On and
Off the Wall: Shaped and Colored*, 1983-84.

FURTHER REFERENCES: Tuchman, Mau-
rice. *Art in Los Angeles: Seventeen Artists in the
Sixties*. Los Angeles County Museum of Art, 1981.

WORKS IN THE COLLECTION:
4 paintings, 1 watercolor, and 1 print

Nui Ipo Poo, 1983 (83.30)
Acrylic on canvas
80 × 76 in. (203.2 x 193 cm.)
Timken Fund Purchase

*Billy Al Bengston flaunts popular imagery, decora-
tion, and lush color in this electric and immediate
painting. Based on symbols of Hawaiian tourism,
this painting comments on present-day culture
with painterly sensuousness.*

RUTH ASAWA

Born January 27, 1926, Norwalk, California
Lives in San Francisco, California

EDUCATION: Milwaukee State Teachers College,
Wisconsin, 1943-46; studied with Josef Albers, Black
Mountain College, Black Mountain, North Carolina,
1946-49.

SELECTED ONE-ARTIST EXHIBITIONS:
Design Research, Cambridge, Massachusetts, 1953;
Peridot Gallery, New York, 1954, 1956, 1958; M. H.
de Young Memorial Museum, San Francisco, 1960;
Pasadena Art Museum, California, 1965; San Fran-
cisco Museum of Art, 1973; Capricorn Asunder, San
Francisco Art Commission Gallery, San Francisco Art
Commission Honor Award Show, 1976; Fresno Arts
Center, California, 1978; Cedar Street Gallery, Ca-
brillo College Gallery, and Santa Cruz County Build-
ing, Santa Cruz, California, 1979; Fiberworks Center
for the Textile Arts, Berkeley, California, 1982.

SELECTED GROUP EXHIBITIONS: San
Francisco Museum of Art, 4 Artist Craftsmen (Ida
Dean, Merry Renk, Marguerite Wildenhain, Ruth
Asawa), 1954; Museu de Arte Moderna, São Paulo,
Brazil, III Bienal, 1955; Whitney Museum of Amer-
ican Art, New York, Annuals, 1955, 1956, 1958; Mu-
seum of Modern Art, New York, Recent Sculpture
USA, 1959-60; Museum of Contemporary Crafts,
New York, Cookies and Breads: The Baker's Art,
1965, and Made with Paper, 1967; San Francisco
Museum of Art, Drawings by Ruth Asawa and Ar-
thur Holman, 1973; The Oakland Museum, Public
Sculpture/Urban Environment, 1974; San Francisco
Museum of Modern Art, and National Collection of
Fine Arts, Smithsonian Institution, Washington, D.C.,
Painting and Sculpture in California: The Modern
Era, 1976-77; The Oakland Museum, 100 Years of
California Sculpture, 1982.

PUBLIC WORKS: Fountain Commissions: Fox
Plaza, San Francisco, 1965; Ghirardelli Square, San
Francisco, 1966; Hyatt on Union Square Plaza, San
Francisco, 1970-73; Buchanan Mall, Post and Bu-
chanan Streets, San Francisco, 1976.

FURTHER REFERENCES: Nordland, Gerald.
Ruth Asawa: A Retrospective View. San Francisco
Museum of Art, 1973.

WORKS IN THE COLLECTION:
2 sculptures, 1 drawing, and 1 lithograph

Illustration, page 31

BRUCE BEASLEY

Born May 20, 1939, Los Angeles, California
Lives in Oakland, California

EDUCATION: Dartmouth College, Hanover, New
Hampshire, 1957-59; University of California, Berke-
ley, 1959-62 (BA).

SELECTED ONE-ARTIST EXHIBITIONS:
Richmond Art Center, California, 1961; Everett Ellin
Gallery, Los Angeles, 1963; Kornblee Gallery, New
York, 1964; Hansen Galleries, San Francisco, 1965;
David Stuart Galleries, Los Angeles, 1966; André Em-
merich Gallery, New York, 1971; M. H. de Young
Memorial Museum, San Francisco, 1972; Hansen
Fuller Goldeen Gallery, San Francisco, 1981.

SELECTED GROUP EXHIBITIONS: Mu-
seum of Modern Art, New York, The Art of Assem-
blage, 1961; Musée d'Art Moderne, Paris, Biennale
de Paris, 1963; Oakland Art Museum, Contemporary
California Sculpture, 1963; Hansen Fuller Gallery,
San Francisco, Plastics West Coast, 1967; Institute of
Contemporary Art, University of Pennsylvania, Phil-
adelphia, Plastics and New Art, 1969; The Jewish
Museum, New York, A Plastic Presence, 1969; Osaka,
Japan, Expo '70, 1970; The Oakland Museum,
Pierres de Fantaisie, 1970, Public Sculpture/Urban
Environment, 1974, and 100 Years of California
Sculpture, 1980; XI International Sculpture Confer-
ence, Washington, D.C., Forty American Sculptors,
1980.

FURTHER REFERENCES: M. H. de Young
Memorial Museum. Bruce Beasley: An Exhibition of
Acrylic Sculpture. San Francisco, 1972.

WORKS IN THE COLLECTION:
1 sculpture

Illustration, page 4

BENIAMINO BUFANO

Born October 14, 1898, San Fele, Italy
Died August 16, 1970, San Francisco, California

EDUCATION: Art Students League, New York, c. 1913-15; studio assistant to Herbert Adams, James Earl Fraser, and Paul Manship.

SELECTED ONE-ARTIST EXHIBITIONS: City of Paris Galleries, San Francisco, 1925; Arden Galleries, New York, 1925; San Francisco Museum of Art, 1935, 1936, 1937, 1939; St. Mary's Square, San Francisco, 1954; Fox Plaza Building, San Francisco, 1966; California Academy of Sciences, San Francisco, 1974.

SELECTED GROUP EXHIBITIONS: *Salon d'Automne*, Paris, 1927; San Francisco Museum of Art, *Thirty Years of Sculpture in California*, 1935; California Pacific International Exposition, San Diego, California, 1935; Golden Gate International Exposition, Palace of Fine Arts, San Francisco, *California Art Today*, 1940; California Palace of the Legion of Honor, San Francisco, *Four San Francisco Sculptors*, 1967; Osaka, Japan, *Expo '70*, 1970; The Oakland Museum, *Public Sculpture/Urban Environment*, 1974, and *100 Years of California Sculpture*, 1982.

FURTHER REFERENCES: *California Art Research Monographs*. Ed. Gene Hailey. San Francisco: Works Progress Administration, 1937, Vol. XIV, pp. 92-138.

WORKS IN THE COLLECTION: 7 sculptures, 3 paintings, and 1 ceramic piece

Illustration, page 8

MICHAEL HEIZER

Born 1944, Berkeley, California
Lives in Hiko, Nevada

EDUCATION: San Francisco Art Institute, 1962-66.

SELECTED ONE-ARTIST EXHIBITIONS: Galerie Konrad Fischer, Düsseldorf, West Germany, 1969; Galerie Heiner Friedrich, Munich, West Germany, 1969, 1977; Dwan Gallery, New York, 1970; Detroit Institute of Arts, Michigan, 1971; Ace Gallery, Los Angeles, 1974, 1977; Fourcade, Droll Inc., New York, 1974; Xavier Fourcade Inc., New York, 1976, 1977, 1979, 1980, 1983; Galerie im Taxispalais, Innsbruck, Austria, 1977; Galerie am Promenadeplatz, Munich and Frankfurt, West Germany, 1977-78; Galerie Der Spiegel, Cologne, West Germany, 1978; Museum Folkwang, Essen, West Germany, and Rijksmuseum Kröller-Müller, Otterlo, The Netherlands, 1979; St. Louis Art Museum, Missouri, 1980; Flow Ace Gallery, Venice, California, 1982.

SELECTED GROUP EXHIBITIONS: Dwan Gallery, New York, *Earthworks*, 1968; Stedelijk Museum, Amsterdam, *Square Pegs in Round Holes*, 1969; Kunsthalle, Bern, Switzerland, *When Attitudes Become Form*, 1969; Galleria Civica d'Arte Moderna, Turin, Italy, *Arte Povera—Land Art—Conceptual Art*, 1970; Whitney Museum of American Art, New York, *200 Years of American Sculpture*, 1976; Kassel, West Germany, *Documenta 6*, 1977; Hirshhorn Museum and Sculpture Garden, Smithsonian Institution, Washington, D.C., *Probing the Earth: Contemporary Land Projects*, 1977; Indianapolis Museum of Art, Indiana, *Painting and Sculpture Today: 1978*, 1978; Art Institute of Chicago, *73rd American Exhibition*, 1979; The Oakland Museum, *100 Years of California Sculpture*, 1982; San Francisco Museum of Modern Art, *20 American Artists: Sculpture 1982*, 1982.

PUBLIC WORKS: *Nine Nevada Depressions*, Nevada, 1968; *Displaced/Replaced Mass*, Silver Springs, Nevada, 1969; *Double Negative*, Virgin River Mesa, Nevada, 1969-70; *Complex One/City*, Nevada, 1972-76; *Adjacent/Against, Upon*, Seattle, Washington, 1976; *Guennette*, New York, 1979; *This Equals That,* Lansing, Michigan, 1980.

FURTHER REFERENCES: Museum Folkwang, and Rijksmuseum Kröller-Müller. *Michael Heizer*. Essen, West Germany and Otterlo, The Netherlands, 1979.

WORKS IN THE COLLECTION: 1 sculpture and memorabilia

Illustration, page 36

APPENDIX OF ARTISTS REPRESENTED IN THE COLLECTION

Asterisks indicate major holdings in the collection.

AALAND, Mikkel
ABBENSETH, William
ABDY, Rowena Meeks
ABEND, George
ACTON, Arlo
ADAMS, Allen
ADAMS, Ansel
ADAMS, Mark
ADAMS, Robert
AHLBERG, Florence
AITKEN, Robert
AKAWIE, Thomas
ALBERTSON, James
ALBRIGHT, Gertrude Partington
ALBRO, Maxine
ALEXANDER, Henry
ALEXANDER, James M.
ALLAN, William
ALLIGER, Frank
ALMOND, John
ALTOON, John
ANDERSON, David
ANDERSON, Jeremy
ANDERSON, John
ANDRESON, Laura
ANDREWS, Michael
APOTHEKER, Gary
*AREQUIPA POTTERY
ARMER, Laura Adams
ARMER, Ruth
ARMSTRONG, William W.
ARNAUTOFF, Victor
ARNESON, Robert
ARRIOLA, Fortunato
ASAWA, Ruth
ATKINS, Arthur
AUDUBON, John James
AUDUBON, John Woodhouse
AYHERNS, Olive
AYLON, Helene
AYRES, Thomas A.
BADEN, Mowry
BAER, Martin
BAER, Morley
BAILEY, James
BAKER, George H.
BAKER, Isaac W.
BALDESSARI, John
BALDWIN, Carol
BALL, F. Carlton
BALL, George
BALLAINE, Jerrold
BALTZ, Lewis
BARBERA, Melinda
BARLETTA, Joel
*BARNES, Matthew

BARNES, Ursula
BARNETT, Will
BARRYMORE, Lionel
BARUCH, Ruth Marion
BASKIN, Leonard
BASS, Joel
BATCHELDER, Ernest Alan
BATCHELDER, Perez M.
BATTENBERG, John
BAUMANN, Gustave
BAXTER, John
BEALL, Dennis
BEASLEY, Bruce
BEATTIE, Paul
BECHTLE, Robert
BECKWITH, Arthur
BELL, Larry
BELLOW, Cleveland
BENGSTON, Billy Al
BENNETT, Garry
BENTON, Fletcher
BENVENUTO, Elio
BERGMANN, Frank W.
BERK, Henrietta
BERLANDINA, Jane
BERLANT, Tony
BERNHARD, Ruth
BERTOLDI, Allen
BEST, Arthur W.
BEST, David
BEST, Harry Cassie
BIELEFELD, Theodore
BIERSTADT, Albert
BIERSTADT, Charles
BIGGER, Michael
BIRGE, Priscilla
BISCHOFF, Elmer
BISCHOFF, Franz
BISHOP, Michael
BLACK, Glen
BLACKBURN, Ed
BLAKE-ALVERSON, Margaret
BLAKELOCK, Ralph
BLOOMER, Hiram Reynolds
BLOS, Peter
BLUNK, J. B.
BOERS, Marianne
BOLOMEY, Roger
BONNET, Leon
BOREIN, Edward
BORG, Carl Oscar
BORGE, Ralph

BORGLUM, John Gutzon
BORNT-LANGDON, Janice
BORONDA, Lester
BORU, Sorcha
BOTHWELL, Dorr
BOTKE, Cornelis
BOTTINI, David
BOUNDEY, Burton
BOWDEN, Harry
BOWEN, Michael
BOWERS, Cheryl
BOWERS, Harry
BOWMAN, Geoffrey
BOWMAN, Richard
BOYLE, Keith
BOYNTON, Ray
BRADFORD, David
BRADLEY & RULOFSON
BRADY, Robert
BRANDT, Rex
BRASTOFF, Sascha
BRAUCKMAN, Cornelius
BRAUN, Ernest
BRAUN, Maurice
BREMER, Anne
BRESCHI, Karen
BREUER, Gustav
BREUER, Henry
BREWERTON, George D.
BRIGANTE, Nick
BRIGGS, Ernest
*BRIGMAN, Anne
BRODERSON, Morris
BRODSKY, Joel
*BRODT, Helen Tanner
BROOKES, Samuel Marsden
BROOKS, Joseph
BROSI, Fred
BROWERE, Alburtus Del Orient
BROWN, Benjamin
BROWN, Christopher
BROWN, Florinne
BROWN, Grafton Tyler
BROWN, Joan
BROWN, Kathan
BROWN, Laurie
BROWN, Robert E.
BROWN, William T.
BROWNE, Tom
BRUGUIÈRE, Francis
BRUTON, Margaret
BUFANO, Beniamino

BUFF, Conrad
BULLEN, Reese
BULLOCK, Wynn
BURCHARD, Jerry
BURDEN, Chris
BURDEN, Shirley C.
BURGDORFF, Ferdinand
BURGESS, Anna Kang
BURGESS, George Henry
BURKHARDT, Hans
BURNS, Pauline Powell
BURR, Alice
BUSH, Norton
BUSKIRK, Mary Balzer
BUTMAN, Frederick A.
CADENASSO, Giuseppi
CAGE, John
CAKEBREAD, Jack
CALCAGNO, Lawrence
CALDER, A. Stirling
*CALIFORNIA FAIENCE CO.
CALLIS, Jo Ann
CANOGAR, Raphael
CAPPS, Kenneth
CAREY, Paul
CARLSEN, Emil
CARLTON, Brents
CARMEAN, Harry
CARNWATH, Squeak
CARPENTER, Arthur Espenet
CARRAWAY, Arthur
CARSON, Lew
CAVAGNARO, David
CAVALLI, Guy John
CELMINS, Vija
CERVANTES, Luis
CHAMBERLIN, Wesley
CHASE, William Merritt
CHAVEZ, Charles
CHESNEY, Lee
CHESSÉ, Ralph
CHICAGO, Judy
CHIN, Chee
CHITTENDEN, Alice
CHONG, Fay
CHORIS, Louis
CHOY, Katherine
CLAPP, William H.
CLARK, Alson Skinner
CLARK, Claude
CLARK, Joe
CLEMENTS, Grace
COHEN, Becky
COHEN, Moses
COHN, Michael
COLBURN, Henry

COLESCOTT, Robert
COLETTE
COLLINS, Jess
CONNELL, Julie
CONNER, Bruce
CONNER, Linda
CONRAT, Richard
COOK, Gordon
COOK, John
COOPER, Astley D. M.
COOPER, Colin Campbell
COOPER, George Victor
COOPER, Michael
COOPER, Ron
COPLANS, John
CORBETT, Edward
CORNELIUS, Philip
COSTANZO, Tony
COULTER, Mary
COULTER, William A.
COUTTS, Gordon
COVARRUBIAS, Ygnacio W.
CRAVATH, Ruth
CREMEAN, Robert
CREMER, Marva
CROCKER, Charles
CROMEY, Edward
CRUESS, Marie
CRUMPLER, Dewey
CUMMINGS, Melvin Earl
CUNEO, Rinaldo
CUNNINGHAM, Ben
*CUNNINGHAM, Imogen
CURRAN, Darryl
CURRENT, William R.
CURRIER, Nathaniel
CURRIER & IVES
CURTIS, Edward S.
CURTIS, Miles
D'ESTRELLA, Theophilus
DAHL, Ronald
DAHLGREN, Carl
DAHLGREN, Marius
DAKIN, S. Tilden
DANE, William Z.
DARLEY, F. O. C.
DASSONVILLE, William Edward
DATER, Judy
DAVIES, Arthur B.
DAVIES, Harold C.
DAVIS, Jerrold
DAVIS, Ronald
DAVIS, Steve
DE FEO, Jay
DE FOREST, Roy
DE JOINER, Luther
DE JONG, Betty
DE LAP, Tony
DE LARIOS, Dora
DE LEON, Oscar
DE NIRO, Robert
*DE PATTA, Margaret

DE ROCKERE, Herbert
DE STAEBLER, Stephen
*DEAKIN, Edwin
DEAL, Joe
DEL MUE, Maurice
DENG, Ming-Dao
DENNY, Gideon Jacques
DeWILDE, Victor
di SUVERO, Mark
DICKENSON, Eleanor
DICKMAN, Charles John
DIEBENKORN, Richard
DILL, Laddie John
DIVOLA, John
DIXON, Florence
*DIXON, Harry St. John
*DIXON, James Budd
DIXON, L. Maynard
DIXON, Willard
DOHERTY, William
DOLE, William
DOUGHERTY, Elizabeth Z.
DOYLE, Joe
DRAEGERT, Joe
DREW, Clement
DRISCOLL, Harold
DU BOIS, Patterson
DU CASSE, Ralph
DUNCAN, Charles Stafford
DUNING, Richard A.
DYE, Clarkson
ECKART, Charles
EDWARDS, John Paul
EGGLESTON, William
*EL CAMINO GROUP
ELDER, Muldoon
EMERSON, Adeline
ENGLEHARDT, Joseph
ESPOY, Angel
*ESTEY & ROGERS
EUBANKS, Jonathan
EVANS, Jan
EVERSLEY, Frederick
EVERTS, Connor
FALKENSTEIN, Claire
FANSHEL, Nora
FARALLA, Duane
FARNSWORTH, Alfred
FARR, Charles Griffin
FECHIN, Nicolai I.
FEITELSON, Lorser
FELDMAN, Bella
FELTER, June
FENN, Harry
FICHTER, Robert
FISHER, Hugo
FISHER, Paul
FISKE, George

FITCH, Steve
FLEMING, Linda
FLICK, Robbert
FONG, Freddie
FOOTE, Howard
FORBES, Deanna
FORBES, Helen
FORD, Henry Chapman
FOREMAN, Doyle
FORRESTER, Patricia
FORTUNE, E. Charlton
FOSTER, Ben
FOULKES, Llyn
FOX, Terry
FRANCIS, Sam
FREY, Viola
FRIED, Robert
FRIEDLANDER, Alfred
FRIEDLANDER, Lee
FRIEDMAN, Ken
FRITZ, Robert
FROELICH, Maren
FROLICH, Finn
FROST, A. B.
FUJIOKA, Henry
FULLER, Esther Torosian
FULLER, Fenner
FULTON, Jack
FURMAN, David
*FURNITURE SHOP
GAETHKE, George
GAGLIANI, Oliver L.
GAINES, Charles
GAMBLE, John
GARABEDIAN, Charles
GARCIA, Rupert
GARDNER, Charles
GARNETT, William
GASKIN, William
GASPARD, Leon
GATES, Jeff
GAUL, Gilbert
GAW, D'Arcy
GAW, William
*GAY, August
GECHTOFF, Sonya
GEE, Yun
GEIS, William
GENN, Nancy
*GENTHE, Arnold
GHIRARDELLI, Alida
GIAMBRUNI, Tibaldo
GILBERT, Arthur Hill
*GILE, Selden Connor
GILHOOLY, David J.
GILL, Charles E.
GILPIN, Laura
GINTNER, Anton

GLAUBMAN, Evelyn
GLAVIN, Matt
GOLD, Betty
GOLDEN, Judith
GOLDIN, Leon
GOLDSTEIN, Daniel Joshua
GONZALES, Christopher
GONZALES, Robert
GOOCH, Gerald
GOODE, Joe
GORDIN, Sidney
GORDON, Russell T.
GORDON-CUMMING, Constance
GOSSAGE, John
GOVER, Roy
GRAF, Richard
GRAHAM, Ellwood
GRAHAM, Robert
*GRAND FEU ART POTTERY
GRANT, Art
GRANT, James
GRAVES, Morris
GRAY, Larry
GRAY, Percy
GREENE, Michael
GREER, Charles
GREMKE, Henry D.
GRILLO, John
GRIPPI, Vince
GRONBORG, Erik
GROSBECK, Daniel Sayre
*GUERMONPREZ, Trude
GUTIERREZ, Louis
GUTKIN, Peter
GUTMANN, John
HACK, Howard
HAGEDORN, Edward
HAGEMEYER, Johann
HAGERUP, Nels
HAHN, William
HALEY, John
HALLMAN, Ted
HAMILTON, Frank
HAMILTON, James
HAMLIN, Edith
HAMMERBECK, Wanda
HAMMERSLEY, Fred
HAMROL, Lloyd
HANNAH, David
HANSCOM, Adelaide
*HANSEN, Armin C.
HANSEN, Hermann W.
HARDING, John
HARDY, Edward
HARE, Chauncey
HARMON, Charles
HARRINGTON, Joseph
HARRIS, Michael
HARSHE, Robert
HART, Alfred
HARTMAN, Donald
HARTMAN, Robert

HARVEY, Robert
HASEGAWA, Sabro
HASKELL, Eben W.
HASSAM, F. Childe
*HASSEL, Paul
HAVEMAN, Josepha
HAYES, Elah Hale
HAYTER, Stanley William
HEADE, Martin Johnson
HEATH, Francis
HEDRICK, Wally
HEINECKEN, Robert
HEIZER, Michael
HELGESON, John
HELLYER, Sally
HENDEL, Meta
HENDERSON, Miles
HENDERSON, William
HENDLER, Maxwell
HENSLEY, Virginia
HERING, David
HERMS, George
HERNANDEZ, Anthony
HERNANDEZ, Robert
HERNANDEZ, Sam
HERSHMAN, Lynn
HERZOG, Herman
HESS, Charles
HIBI, Hisako
HILER, Hilaire
HILGER, Charles
HILL, Edward Rufus
*HILL, Thomas
HIMELFARB, Harvey
HINE, Charles
HINKLE, Clarence
HINZ, Randle
HIPKISS, Cynthia
HIRST, Ivars
HOARE, Tyler James
HOBART, Clark
HOBBS, Frederick
HOCKNEY, David
HOEFFER, Wade
HOEL, Max
HOFFMAN, Miriam
HOFMANN, Hans
HOGAN, Patrick E.
HOLDEN, James
HOLDEN, Marian
HOLDEN, Octavia
HOLDREDGE, Ransom Gillet
HOLLAND, Tom
HOLMAN, Art
HOMSY, Joe
HOOVEN, Coille
HOUSEWORTH, Thomas & Co.
HOWARD, Blanche Phillips
HOWARD, Charles
HOWARD, David
HOWARD, John Langley
HOWARD, Robert

HOWELL, Raymond
HU, Sandria
HUBACEK, William
HUDSON, Grace Carpenter
HUDSON, Robert
HULTBERG, John
HUMBLE, Patrick
HUMPHREY, Margo
HUNT, Esther
HUNT, Richard
HUNTER, Isabel
HURRELL, George
HUSSEY, Henry
ILYIN, Peter A.
INNESS, George
ITAMI, Michi
IVANOFF, Eugene
JACKSON, Oliver
JACKSON, William
JACKSON, William Henry
JACOBS, Mimi
JACOBSEN, Rodger
*JALANIVICH, Manuel
JAMPOL, Glenn
JEFFERSON, Bob
JEFFERSON, Jack
JENKINS, Dorothy
JENS, Karl
JEWETT, William Smith
JOHNS, Harriet
JOHNSON, Bruce
JOHNSON, Caroline Rexford
JOHNSON, Marie
JOHNSON, Robert Emory
JOHNSON, Sargent
JOHNSON, William
JOHNSTON, Inez
JONES, David
JONES, John Paul
JONES, Pirkle
JONNEVOLD, Carl H.
JORGENSEN, Christian A.
JOULLIN, Amédée
JUAREZ, Nicolus Rodriguez
JUDD, Ron
JUDSON, C. Chapel
KADAR, Bela
KADISH, Reuben
KAGANOFF, Sheldon
KAHN, Steve
KALTENBACH, Steve
KANEMITSU, Matsumi
KANNO, Gertrude Boyle
KARINA, Elena
KASEBIER, Gertrude
KASTEN, Karl
KAUFFMAN, Craig
KAUFMAN, Donald

*KEITH, William
KELLEY, James
KENT, Adaline
KESTER, Bernard
KETCHUM, Robert Glenn
KEY, John Ross
KIENHOLZ, Edward
KING, Albert
KING, Hayward
KINGMAN, Dong
KINMONT, Robert
KINNELL, Judy
KISHI, Masatoyo
KNIGHT, David
KNIGHT, George
KOBAYASHI, Akio
KOBLICK, Freda
KOLAWOLE, Lawrence Compton
KOMISAR, John
KONDOS, Gregory
KRASNOW, Peter
KRIZ, Vilem
KUHLMAN, Walter
KUNIYOSHI, Utagawa
LA VIGNE, Robert
LABAUDT, Lucien
LANDACRE, Paul
LANDWEBER, Victor
LANE, Doyle
*LANGE, Dorothea
LANGLET, Ragnhild
LAPINI, Cesare
LAPP, Maurice
LARK, Sylvia
*LARSEN, Morten
*LATIMER, Lorenzo P.
LAURITZEN, Frederick
*LAVENSON, Alma
LAWRENCE & HOUSEWORTH
LAWSON, George
LEARY, John S.
LEBRUN, Rico
LeCONTE, J. N.
LEE, Bertha Stringer
LEE, Joseph
LEMMY
LEMOS, Pedro J.
LENTELLI, Leo
LEON, Dennis
LEONARD, Joanne
LEVINE, Marilyn
LEW, Weyman M.
LEWIS, Jeanette Maxfield
LEWIS, Phillips
LEWIS, Samella
LEWIS, Tom
*LIEBES, Dorothy Wright
LIGHT, Alvin B.

LINDEMANN, Robert
LINHARES, Philip
LIPOFSKY, Marvin
LOBDELL, Anne
LOBDELL, Frank
LOBERG, Robert
LOCKS, Seymour
LOCKWOOD, Norman
LOGAN, Maurice
LOGTON, Ben
LONG, Jeffrey
LONGSTREET, Stephen
LONIDIER, Fred
LOPEZ, Michael J.
LORAN, Erle
LORENZ, Frank
LOTZ, Matilda
LOVERA, James
LUCERO, Fred
LUKENS, Glen
LUNBORG, Florence
LUNDEBERG, Helen
MACCHIARINI, Peter
MACDONALD-WRIGHT, Stanton
MacKENZIE, David
MACKY, Constance
MAGDANZ, Andrew
MAGNUS, Randy
MALOOF, Sam
MANATT, W. W.
MANN, Margery
MANNHEIM, Jean
MARCUS, Irving
MARIONI, Tom
MARPLE, William
MARRYAT, Frank
MARSHALL, James
MARTIN, E. Hall
MARTIN, Fred
*MARTINEZ, Xavier
MASON, John
MASON, Philip
MATHAN, Gerda S.
MATHER, Margrethe
*MATHEWS, Arthur F.
MATHEWS, Felix
*MATHEWS, Lucia K.
MATTOX, Charles
*MAURER, Oscar
MAYBECK, Bernard
MAYES, Elaine
McCHESNEY, Robert
McCOMAS, Francis
McCOMAS, Gene
McCRACKEN, John
McCRAY, James
McDOWELL, Barrie
McDOWELL, John H.
McGAW, Bruce
McGILL, Robert
McGLYNN, Thomas A.
McINTOSH, Harrison

McKEE, Charles
McLAUGHLIN, John
McLEAN, Richard
McMILLEN, Michael C.
MELCHERT, James A.
MENDENHALL, Jack
MENDENHALL, Kim Wolfman
MERRILD, Knud
MERSFELDER, Jules
MERYON, Charles
MEYER, Frederick H.
MIDDLEBROOK, David
MILES, John
MILLER, Artine
MILLER, Barse
MILLER, Henry
MILLER, Wayne
MINICK, Roger
MISRACH, Richard
MITCHELL, J. Oliver
MIYAMOTO, Richard
MIYASAKI, George
MODOTTI, Tina
MOMENT, Joan
MOON, Robert
MOQUIN, Richard
MORA, Joseph
MOREHOUSE, William
MORGAN, Julia
MORGAN, Mary DeNeale
MORRIS, Carl
MORRIS, David
MORTENSEN, William
MOSCOSO, Victor
MOSES, Ed
MOULIN, Gabriel & Studios
MOULTON, Dorcas
MOYA, Sam
MOYA del PINO, Jose
MUIR, Douglas
MULLICAN, Lee
MUNGER, Gilbert
MURRAY, Elizabeth
MURRAY, Joan
*MUYBRIDGE, Eadweard James
MYERS, Frank
MYERS, Joan
MYERS, Martin
NAGLE, Ron
NAHL, Charles Christian
NAHL, Hugo Wilhelm Arthur
NAHL, Perham Wilhelm
NANAO, Kenjilo
NAPPENBACH, Henry
NARJOT, Ernest
NATZLER, Gertrud & Otto
NAUMAN, Bruce
NELSON, E. Bruce
NEPOTE, Alexander
NERI, Manuel
NESTOR, Helen
NETHERBY, Elena M.

NEUHAUS, Eugen
NEWELL, Gordon
NG, Win
NICHOLSON, Lillie May
NICHOLSON, Natasha
NIELSON, Jack
NIVOLA, Constantino
NONG
NORMAN, Emile
NORMAN, Irving
NOSKOWIAK, Sonya
NUTT, James
O'LEARY, Dennis
O'NEAL, Mary Lovelace
O'SULLIVAN, Timothy H.
OBATA, Chiura
OKAMURA, Arthur
OKUBO, Miné
OKULICK, John
OLDENBURG, Claes
OLDFIELD, Otis
OLIVEIRA, Nathan
OLLMAN, Arthur
OLSON, Meredith Ann
ONSLOW-FORD, Gordon
OPPENHEIM, Dennis
ORLAND, Ted
OTIS, George Demont
OUTTERBRIDGE, John
OVERSTREET, Joe
OW, Samuel
OWENS, Bill
PACKARD, Emmy Lou
PAGES, Jules
PAJUNEN, Timo
PALMER, Jon
PAPWORTH, Frank
PARIS, Harold
PARK, David
PARKER, Harold A.
PARKER, James
PARKER, Leroy
PARKER, Wilma
PARKINSON, Ariel
PARSHALL, Douglas
PARTINGTON, John Herbert Evelyn
PARTINGTON, Richard L.
PARTRIDGE, Roi
PARTRIDGE, Rondal
PATIGIAN, Haig
PATTERSON, Marion
PAYNE, Edgar Alwyn
PECK, Orrin
PECORARO, Salvatore
PELTON, Agnes
PENNOYER, Sheldon
PENNUTO, James W.
PERALTA, Vincinte F.

PEREZ, Vincent
PERKINS, Granville
PERNISH, Paul
PERRY, Bart
PERRY, E. Wood
PETERS, Charles Rollo
PETERSEN, Roland
PETERSON, Margaret
PETERSON, Susan H.
PETERSON, Will
PIAZZONI, Gottardo
PIERCE, Joshua
PITCHFORD, Emily
PLAGENS, Peter
PODCHERNIKOFF, Alexis M.
*POLLAK, Max
POLOS, Theodore
POMEROY, Jim
POOLE, H. Nelson
POON, Irene
POOR, Henry Varnum
PORTER, William S.
POSEY, Ernest
POST, George
POTTS, Don
POUPENEY, Mollie
PRESTON, Astrid
PRICE, Clayton S.
PRICE, Joe
PRICE, Kenneth
PRICE, Leslie
PRIETO, Antonio
PRIETO, Eunice
PRIMUS, Nelson
PROVENZANO, Sam
PROVISOR, Janis
PRUNER, Gary
PUCCINELLI, Dorothy Wagner
PUCCINELLI, Raymond
PUGLIESE, Joseph A.
PURIFOY, Noah
PUTHUFF, Hanson
PUTNAM, Arthur
QUICK, Herb
RAFFAEL, Joseph
RAFFAEL, Judith
RAMOS, Mel
RANDOLPH, Lee
RAPHAEL, Joseph
RAPOPORT, Sonya
RAPPE, Eleanor
RASCHEN, Henry
RAUGH, Fritz
RAY, Man
REDMOND, Granville
REFREGIER, Anton
REICH, Don
REICHMAN, Fred

REINEKING, James
REMINGTON, Deborah
REMSING, Gary
RENFROW, Gregg
RENK, Merry
RESNICK, Milton
RESNIKOFF, Florence
*RHEAD, Frederick
RICE, Leland
RICHARDSON, Mary Curtis
RICHARDSON, Sam
*RICHARDT, Ferdinand
RICKEY, George
RIES, Victor
RISHELL, Robert
RITSCHEL, William
RIVERA, Diego
RIVERA, Gustavo
RIX, Julian
*ROBERTSON, Alexander
*ROBERTSON, Fred H.
ROBINSON, Charles Dormon
ROBLIN ART POTTERY
ROEBER, Philip
ROEDER, John
ROGERS, Barbara
ROGERS, Randolph
ROITZ, Charles
ROLLINS, Henry
ROLLINS, Warren Eliphalet
ROLOFF, John
ROMANO, Joseph
ROSE, Guy
ROSENE, Caroline
ROSENTHAL, Toby
ROSS, Don
ROSS, Merg
RUBEN, Richards
RUDINGER, Hugo P.
RUSCHA, Edward
RUSSELL, Charles M.
RUVOLO, Felix
RYDER, Worth
SAAR, Betye
SACCARO, John
SAFFORD, Charles
SALZ, Helen
SAMORE, Sam
SANCHEZ, Stephanie
SANDERS, Herbert H.
SANDONA, Matteo
SANZENBACH, Keith
SARKISIAN, Paul
SAUNDERS, Raymond
SAZEVICH, Zygmund
SCARLETT, Patricia
SCHAFER, Frederick Ferdinand
SCHMID, Rupert
SCHNIER, Jacques
SCHOLDER, Fritz
SCHULER, Melvin
SCHWAMM, Louise

SCHWARCZ, June
SCOTT, Dorothy M.
SECUNDA, Arthur
SEKIMACHI, Kay
SERRA, Richard
SHANNON, Alice
SHAW, Richard
SHERIDAN, Joseph
SHEW, William
SHOEMAKER, Peter
SHORE, Henrietta
SHORE, Stephen
SIEGFRIED, Edwin
*SIEGRIEST, Louis
SIEGRIEST, Lundy
SILVER, Pat
SILVERBERG, Leonard
SIMPSON, David
SIMPSON, Marian
SINTON, Nell
SKOFF, Gail
SLAVIN, Neal
SMALL, Carole
SMILLIE, George
SMILLIE, James D.
SMITH, Cedric
*SMITH, Hassel
SNELGROVE, Walter
SNOWDEN, Everett
SNOWDEN, Mary
SNYDER, William
SOLDNER, Paul
SPARKS, Will
SPOHN, Clay E.
SPRING, Barbara
STACKPOLE, Peter
STACKPOLE, Ralph
STANLEY, Weyland
STAPRANS, Raimonds
STEAKLEY, Douglas
STECCATI, Alva
STECCATI, Hugo
STIEGELMEYER, Norman
STIEGLITZ, Alfred
STILLMAN, George
STOCKSDALE, Bob
STOCKTON ART POTTERY
STODDART, Edna
STORER, Inez
STRINI, Robert Louis

STRONG, Charles
STRONG, Joseph D.
STRUCK, Herman
STRUSS, Karl
STUART, James Everett
*STURTEVANT, Roger
SULLY, Alfred
SURENDORF, Charles
SUTTON, Carol Shaw
SUZUKI, James Hiroshi
SWIFT, Florence Alston
SWIFT, Henry
TABER, Isaac West
TAKAHASHI, Henry
TALIABUE, Carlo
TASHEIRA, George
TASSANANCHALEE, Kamol
TAUSSIG, Arthur
TAVENNER, Pat
TAVERNIER, Jules
TAYLOR, Paul Schuster
TCHAKALIAN, Sam
TERAOKA, Masami
TESIO
*TESKE, Edmund
THIEBAUD, Wayne
THURSTON, Jacqueline
TIFT, Mary
TILDEN, Douglas
TIMERIASIEFF, Vivika
TODD, Michael
TOJETTI, Domenico
TOJETTI, Eduardo
TOJETTI, Virgilio
TOLERTON, David
TORLAKSON, James
TRAISMAN, Barbara
TREIMAN, Joyce
TRUMAN, Stanley R.
TSUKAHARA, Takuya
ULLBERG, Lloyd
UNDERHILL, William
UNTERSEHER, Chris
UTTER, Carolyn
VAEA
VALENCIA, Manuel
VALENTIEN POTTERY
VALLEDOR, Leo
VAN DYKE, Willard
*VAN ERP, Dirk

*VAN HOESEN, Beth
*VAN SLOUN, Frank
*VAN WIE, Carrie
VANCE, R.H.
VANDUINWYK, George P.
VANDENBERGE, Peter
VANDERSLICE & CO.
VARDA, Jean
VIGNES, Michelle
VILLA, Carlos
VILLAMOR, Manuel
VOISARD, Ray
von EICHMAN, Bernard
VON HEUNE, Stephen
von PERBANDT, Carl
VOULKOS, Peter
VREDAPARIS, Frieda
WACHTEL, Elmer
WACHTEL, Marian
WADDY, Ruth
WAGNER, Harald
WAGNER, Richard
WALBURG, Gerald
WALKER, James
WALKER, Larry
WALKER, Roy
WALKER & FARGERSTEIN
WALL, Brian
WALL, Gertrude
*WALRICH POTTERY
WANDESFORDE, Juan Buckingham
WAREHAM, William
WASHBURN, Stanley
WASSERSTEIN, Julius
WATKINS, Carleton E.
WAYNE, James U.
WAYNE, June
WEARE, Shane
WEBER, Stephanie
WEED, Charles
WEEKS, James
WEIR, John Spence
WELCH, Ludmilla P.
WELCH, Thaddeus
WELLS, Cady
WELLS, Francis Marion
WELLS, Mason B.
WELPOTT, Jack
WENDT, Julia Bracken
WERTHEIM, Anne

WESSEL, Henry
WESSELS, Glenn
WEST, Isabelle Percy
WESTDAHL, Larry
WESTON, Brett
WESTON, Edward
WHEELOCK, Margery
WHITE, Charles
WHITE, John A.
WHITE, Minor
WHITE, Neal
WHITE, Orin A.
WILDENHAIN, Marguerite
WILEY, William T.
WILLIAMS, Franklin
WILLIAMS, Virgil
WILSON, Bryan
WILSON, Jeremy
WING & ALLEN
WINKLER, John W.
WINSTON, Robert
WISBY, Jack
WOFNER, Catherine
WOLF, William
WONG, Jade Snow
WONNER, Paul
WOOD, Beatrice
WOODALL, John
WOODS, Charles
WOODS, Gurdon
WOODWARD, W. W.
WOOLLEY, Ellamarie
WOOLLEY, Jackson
*WORDEN, Willard E.
WORES, Theodore
WORTH, Don
WRIGHT, Rufus
YAMAMOTO, Gordon
YAMAMOTO, Nori
YANEZ, Rene
YAVNO, Max
YELLAND, Raymond Dabb
YELLAND, William R.
YOKOI, Rita
YOKOYAMA, William K.
YOUNG, Harvey O.
ZAJAC, Jack
ZAKHEIM, Bernard
ZOGBAUM, Wilfrid
ZORACH, William

This reference section emphasizes sources that contain a large body of information relating directly to California art and artists. Many valuable references which briefly mention California artists, but that primarily cover Western, American, and international art and artists have been omitted. Reference books, not published by The Oakland Museum, that are specific to individual artists highlighted in this book are cited as further references after each artist's biography rather than listed in this selected bibliography. Monographic books and catalogues published by The Oakland Museum are included in the selected publication listing at the end of this section. Reference libraries marked with an asterisk contain not only secondary but also primary research materials.

MAJOR SOURCES OF RESEARCH MATERIAL

*California Historical Society Library, San Francisco
Information on California and western United States history and artists.

*California State Library, Sacramento, California Section
Research collection documents California's history from 1540 to the present.

Los Angeles County Museum of Art, Art Research Library
Artists' files, exhibition catalogues, and books that relate to the visual arts in California, the United States, and the world.

*The Oakland Museum, Art Library and Archives of California Art
Collection documents the history of nineteenth and twentieth-century art and artists in California.

*San Francisco Art Institute, Anne Bremer Memorial Library
Research collection pertains to California art and artists, with an emphasis on the San Francisco Art Institute (formerly named the California School of Design, the Mark Hopkins Institute of Art, and the California School of Fine Arts) and the artists associated with the school.

San Francisco Museum of Modern Art, Louise Sloss Ackerman Fine Arts Library
Information on twentieth-century international and American art, as well as much information on California artists.

*Smithsonian Institution, Washington, D.C., Archives of American Art
Original records and manuscript papers of American artists, collectors, dealers, critics, and historians that document the history of the visual arts in the United States. Available on microfilm in the regional offices in San Francisco, Los Angeles, Boston, Detroit, and New York City.

Smithsonian Institution, Washington, D.C., The National Museum of American Art and The National Portrait Gallery, Ferdinand Perret Art Research Library
Collection of research materials relating to nineteenth and twentieth-century art and artists, primarily of Southern California.

*Society of California Pioneers Library, San Francisco
Collection documents the history of California, with an emphasis on the gold rush era.

*University of California, Berkeley, The Bancroft Library
Rare printed and manuscript collections that document the history of western North America, with an emphasis on California and Mexico. Collection includes transcribed interviews with artists, dealers, and art educators conducted by the Regional Oral History Office.

University of California, Davis, University Library, Department of Special Collections, Baird Archive of California Art
Personal research files and notes pertaining to nineteenth and early twentieth-century California art and artists assembled by Dr. Joseph Armstrong Baird, Jr.

BIBLIOGRAPHIES, DICTIONARIES, AND ENCYCLOPEDIAS

Baird, Joseph Armstrong, Jr., and Ellen Schwartz. *Northern California Art: An Interpretive Bibliography to 1915.* Davis, California: Library Associates, University Library, University of California, 1977.

Dawdy, Doris Ostrander. *Artists of the American West.* 2 vols. Chicago: The Swallow Press, Inc., 1974, 1981.

Evans, Paul. *Art Pottery of the United States: An Encyclopedia of Producers and Their Marks.* New York: Charles Scribner's Sons, 1974.

Moure, Nancy Dustin Wall. *Artists' Clubs and Exhibitions in Los Angeles Before 1930.* Los Angeles: privately printed, 1975.

———. *The California Water Color Society: Prize Winners 1931-1945; Index to Exhibitions 1921-1954.* Los Angeles: privately printed, 1975.

———. *Dictionary of Art and Artists in Southern California Before 1930.* Los Angeles: privately printed, 1975.

Samuels, Peggy and Harold. *The Illustrated Biographical Encyclopedia of Artists of the American West.* Garden City, New York: Doubleday, 1976.

Schwartz, Ellen. *Nineteenth-Century San Francisco Art Exhibition Catalogues: A Descriptive Checklist and Index.* Davis, California: Library Associates, University Library, University of California, 1981.

BOOKS

Art in California: A Survey of American Art with Special Reference to California Painting, Sculpture and Architecture, Past and Present, Particularly as Those Arts were Represented at the Panama-Pacific International Exposition. Essays by Bruce Porter et al. San Francisco: R. L. Bernier, 1916.

California Art Research Monographs. 20 vols. Ed. Gene Hailey. San Francisco: Works Progress Administration, 1937.

California's Magazine. Edition de Luxe. 2 vols. San Francisco: California's Magazine Company, 1916.

Catalogue de Luxe of the Department of Fine Arts, Panama-Pacific International Exposition. 2 vols. Eds. John E. Trask and J. Nilsen Laurvik. San Francisco: Paul Elder and Company, 1915.

Hart, James D. *A Companion to California.* New York: Oxford University Press, 1978.

Hopkins, Henry. *50 West Coast Artists: A Critical Selection of Painters and Sculptors Working in California.* San Francisco: Chronicle Books, 1981.

Neuhaus, Eugen. *The Art of Treasure Island.* Berkeley, California: University of California Press, 1939.

Peters, Harry T. *California on Stone.* Garden City, New York: Doubleday, Doran and Company, 1935.

Plagens, Peter. *Sunshine Muse: Contemporary Art on the West Coast.* New York: Praeger Publishers, 1974.

BOOKS, cont.

Snipper, Martin. *A Survey of Art Work in the City and County of San Francisco.* San Francisco: San Francisco Art Commission, 1975.

Spangenberg, Helen. *Yesterday's Artists on the Monterey Peninsula.* Monterey, California: Monterey Peninsula Museum of Art, 1976.

Taft, Robert. *Artists and Illustrators of the Old West 1850-1900.* New York: Charles Scribner's Sons, Ltd., 1953.

Thiel, Yvonne Greer. *Artists and People.* New York: Philosophical Society, Inc., 1959.

Van Nostrand, Jeanne. *The First Hundred Years of Painting in California 1775-1875.* San Francisco: John Howell—Books, 1980.

_____. *Monterey: Adobe Capital of California 1770-1847.* San Francisco: California Historical Society, 1968.

_____. *San Francisco, 1806-1906, In Contemporary Paintings, Drawings and Watercolors.* San Francisco: The Book Club of California, 1975.

Van Nostrand, Jeanne, and Edith M. Coulter. *California Pictorial: A History in Contemporary Pictures, 1786-1859, With Descriptive Notes on Pictures and Artists.* Berkeley and Los Angeles: University of California Press, 1948.

Westphal, Ruth Lilly. *Plein Air Painters of California: The Southland.* Essays by Terry De Lapp et al. Irvine, California: Westphal Publishing, 1982.

COLLECTION AND EXHIBITION CATALOGUES

Abstract Expressionist Ceramics. Essay by John Coplans. Irvine, California: Art Gallery, University of California, 1966.

Armstrong, Richard. *Sculpture in California 1975-80.* San Diego, California: San Diego Museum of Art, 1980.

The Artist's Environment: West Coast. Fort Worth, Texas: Amon Carter Museum of Western Art in collaboration with the UCLA Art Galleries and the Oakland Art Museum, 1962-1963.

Assemblage in California: Works from the late 50's and early 60's. Essays by John Coplans et al. Irvine, California: Art Gallery, University of California, 1968.

Baron, Stephanie. *Art in Los Angeles, the Museum as Site: Sixteen Projects.* Los Angeles: Los Angeles County Museum of Art, 1981.

California Design 1910. Eds. Timothy J. Andersen, Eudorah M. Moore, and Robert W. Winter. 1974; rpt. Santa Barbara, California, and Salt Lake City, Utah: Peregrine Smith, Inc., 1980.

Catalogue of Original Paintings, Drawings and Watercolors in the Robert B. Honeyman, Jr. Collection. Compiled by Joseph Armstrong Baird, Jr. Berkeley: The Friends of the Bancroft Library, University of California, 1968.

A Century of California Painting 1870-1970. Introduction by Kent L. Seavey. Essays by Joseph Armstrong Baird, Jr. et al. San Francisco: Crocker Citizens Bank, 1970.

Clark, Garth, and Margie Hughto. *A Century of Ceramics in the United States: 1878-1978.* New York: E. P. Dutton in association with the Everson Museum of Art, 1979.

de Saisset Art Gallery and Museum. *New Deal Art: California.* Introduction by Francis V. O'Connor. Santa Clara, California: University of Santa Clara, 1976.

Driskell, David C. *Two Centuries of Black American Art.* Catalogue notes by Leonard Simon. Los Angeles: Los Angeles County Museum of Art; New York: Alfred A. Knopf, Inc., 1976.

Feinblatt, Ebria, and Bruce Davis. *Los Angeles Prints, 1883-1980.* Los Angeles: Los Angeles County Museum of Art, 1980.

Foley, Suzanne. *Space/Time/Sound: Conceptual Art in the San Francisco Bay Area: The 1970s.* San Francisco: San Francisco Museum of Modern Art, 1981.

From Exposition to Exposition: Progressive and Conservative Northern California Painting, 1915-1939. Ed. Joseph Armstrong Baird, Jr. Sacramento, California: The Crocker Art Museum, 1981.

Images of El Dorado: A History of California Photography: 1850-1975. Ed. Joseph Armstrong Baird, Jr. Davis, California: Memorial Union Art Gallery, University of California, 1975.

Katzman, Louise. *Photography in California, 1945-1980.* New York: Hudson Hills Press in association with the San Francisco Museum of Modern Art, 1984.

Mann, Margery. *California Pictorialism.* San Francisco: San Francisco Museum of Modern Art, 1977.

Miller, Dwight. *California Landscape Painting, 1860-1885: Artists around Keith and Hill.* Stanford, California: Stanford Art Gallery, 1975.

Moure, Nancy Dustin Wall. *Painting and Sculpture in Los Angeles, 1900-1945.* Los Angeles: Los Angeles County Museum of Art, 1980.

Naef, Weston J., and James N. Wood. *Era of Exploration: The Rise of Landscape Photography in the American West, 1860-1885.* Buffalo, New York: Albright-Knox Art Gallery; New York: Metropolitan Museum of Art, 1975.

Painting and Sculpture in California: The Modern Era. Ed. Henry T. Hopkins. San Francisco: San Francisco Museum of Modern Art, 1977.

Selz, Peter. *Funk.* Berkeley: University Art Museum, University of California, 1967.

Southern California Artists 1890-1940. Biographies by Nancy Moure. Laguna Beach, California: Laguna Beach Museum of Art, 1979.

Southern California Artists: 1940-1980. Introduction by Maudette W. Ball. Laguna Beach, California: Laguna Beach Museum of Art, 1981.

Tuchman, Maurice, et al. *Art in Los Angeles: Seventeen Artists in the Sixties.* Los Angeles: Los Angeles County Museum of Art, 1981.

The West as Art: Changing Perceptions of Western Art in California Collections. Essay by Patricia Jean Trenton. Palm Springs, California: Palm Springs Desert Museum, 1982.

SELECTED OAKLAND MUSEUM ART PUBLICATIONS

Architectural Drawings by Julia Morgan: Beaux-Arts Assignments and Other Buildings. Essays by Therese Heyman and John Beach. 1976.

Arkelian, Marjorie Dakin. *William Hahn: Genre Painter 1829-1887.* 1976.

_____. *Thomas Hill: The Grand View.* 1980.

_____. *The Kahn Collection of Nineteenth-Century Paintings by Artists in California.* 1975.

_____. *Tropical Scenes by the 19th-Century Painters in California.* 1971.

Arkelian, Marjorie Dakin, and George W. Neubert. *George Inness Landscapes: His Signature Years 1884-1894.* 1978.

Baird, Joseph A., Jr. *Theodore Wores: The Japanese Years.* 1976.

Bettelheim, Judith. *On and Off the Wall: Shaped and Colored.* Preface by Christina Orr-Cahall. 1983.

Black Untitled III/Graphics: Benny Andrews/Marion Epting/Leon N. Hicks/Margo Humphrey. 1973.

Bray, Hazel. *The Potter's Art in California 1885 to 1955.* 1978.

_____. *The Tapestries of Trude Guermonprez.* 1982.

Broekhoff, Helen V. *Thad Welch: Pioneer and Painter.* 1966.

California Woodworking: An Exhibition of Contemporary Handcrafted Furniture. Introduction by Harvey L. Jones. Essay by John Kelsey. 1980.

Contemporary Prints from Northern California. For Art in the Embassies Program, United States State Department. Introduction by Paul Mills. Essay by Therese Heyman. 1966.

Coplans, John. *Pop Art USA.* Oakland Art Museum in association with California College of Arts and Crafts. 1963.

Ronald Davis: Paintings 1962-1976. Essay by Charles Kessler. 1976.

Early Paintings of California in the Robert B. Honeyman, Jr. Collection. Ed. Paul Mills. 1956.

196

OAKLAND MUSEUM PUBLICATIONS, cont.

Heyman, Therese Thau. *Anne Brigman: Pictorial Photographer/Pagan/Member of the Photo-Secession.* 1974.

——. *Celebrating a Collection: The Work of Dorothea Lange.* Essays by Daniel Dixon, Joyce Minick, and Paul Schuster Taylor. 1978.

——. *Mirror of California: Daguerreotypes.* 1974.

——. *Monotypes in California.* 1972.

——. *Slices of Time: California Landscape 1860-1880, 1960-1980.* Essay by Ted Hedgpeth. 1982.

——. *Beth Van Hoesen: Prints, Drawings, Watercolors.* 1980.

Heyman, Therese Thau, and Terry St. John. *Harry Bowden: Artist Out of the Mainstream.* 1979.

Impressionism, The California View. Introduction by Harvey L. Jones. Essays by John Caldwell and Terry St. John. 1981.

The Jewelry of Margaret De Patta: A Retrospective Exhibition. Essays by Yoshiko Uchida, Eugene Bielawski, and Hazel Bray. 1976.

Jones, Harvey L. *Stephen De Staebler, Sculpture.* 1974.

——. *Mathews: Masterpieces of the California Decorative Style.* 1972.

——. *Nathan Oliveira: Paintings 1959-1973.* 1973.

——. *Gordon Onslow-Ford: Retrospective Exhibition.* Essays by Herschel B. Chipp, Frederic Spiegelberg, and Gordon Onslow-Ford. 1980.

——. *Mel Ramos: Paintings 1959-1977.* 1977.

——. *David Simpson: Paintings.* 1978.

McChesney, Mary Fuller. *A Period of Exploration: San Francisco 1945-1950.* Based on taped interviews with Jeremy Anderson et al. Introduction by Terry St. John. 1973.

Mills, Paul. *An Introduction to the Art of William Keith.* 1956.

——. *Contemporary Bay Area Figurative Painting.* 1957.

Montgomery, Evangeline J. *Sargent Johnson: Retrospective.* 1971.

Neubert, George W. *Xavier Martinez.* 1974.

——. *Manuel Neri: Sculptor.* 1976.

——. *Public Sculpture/Urban Environment.* 1974.

1974 California Ceramics and Glass. 1974.

100 Years of California Sculpture. Essays by Harvey L. Jones, Paul Tomidy, Terry St. John, and Christopher Knight. Preface by Christina Orr-Cahall. 1982.

Orr-Cahall, Christina. *Charles Griffin Farr: A Retrospective.* 1984.

Prints California: Profile of an Exhibition. Ed. Therese Thau Heyman. 1975.

St. John, Terry. *Elmer Bischoff: Figurative Paintings 1957-1972.* 1975.

——. *Louis Siegriest: Retrospective.* 1972.

——. *Society of Six.* 1972.

——. *Sam Tchakalian: Painting 1958-1978.* 1978.

Masami Teraoka. Introduction by Harvey L. Jones. Essay by Gerard Haggerty. 1983.

Tomidy, Paul. *Site Strategies: Terry Allen, Chris Burden, Terry Fox.* Preface by Christina Orr-Cahall. 1983.